Music for Plea

For Gill

Music for Pleasure

Essays in the Sociology of Pop

SIMON FRITH

Routledge · New York

First published in the United States of America by Routledge
an imprint of Routledge, Chapman & Hall, Inc.
29 West 35 Street, New York, New York 10001

Library of Congress Cataloguing in Publication Data

Frith, Simon.
 Music for pleasure.

 Includes bibliographies and index.
 1. Rock music——History and criticism. 2. Music
trade. I. Title.
ML3534.F75 1988 784.5'4'009 88–6678
ISBN 0–415–90051–4
ISBN 0–415–90052–2 (pbk.)

Printed in Great Britain

Contents

Sources and Acknowledgements

The author and publishers are grateful to the following for permission to reproduce material originally published elsewhere:

Melody Maker for 'From Bobbysox to Dungarees' (1979) and 'A Different Drum' (1979).

New York Rocker for 'Get Funky Make Money' (1981) and 'A-Blinga-A-Blanga, A-Bippity Bop, I'm Going down to the Record Shop' (1982).

New Society for 'Coventry Sound' (1980), 'Unreconstructed Rock'n' Roller' (1980), 'Hooked on Love' (1981) and 'The Art of Posing' (1981).

New Statesman for 'The Voices of Women' (1981), 'Confessions of a Rock Critic' (1985), and 'Singing in a Strange Land' (1982).

Marxism Today for 'Something to be' (1981).

Collusion for 'Northern Soul' (1982) and 'Sound and Vision' (1981).

Sunday Times for 'Breaking the Mould' (1984), 'And Now, the Message' (1983), 'Pop Go the Graduates' (1985) and 'Artistic Ambitions' (1985).

Village Voice for 'Walls Come Tumbling Down' (1985), 'Send for your Free Trial Issue of Money Power Today' (1985), 'Oh Boy!' (1985), 'Pretty Vacant' (1986), 'Whistling in the Dark' (1984), 'The Revenge of the Nerds' (1986), and 'On and On and On' (1987).

City Limits for 'All Wrapped Up' (1984).

The Observer for 'The Critics' Choice' (1986).

Musica E Dossier for 'The Real Thing' (1987).

'The Industrialization of Music' first appeared (in a different form) in *Popular Music and Communication*, ed. James Lull (Sage, Beverly Hills 1987).

'The Pleasures of the Hearth' first appeared in *Formations of Pleasure*, (Routledge & Kegan Paul, London, 1983).

'Playing with Real Feeling' first appeared in *New Formations*, 4 (Methuen, London, 1988).

'Why Do Songs Have Words' was written in 1980, revised in 1986 and first appeared in *Lost In Music. Sociological Review Monograph* 34 ed. Avron L. White (Routledge & Kegan Paul, London, 1988).

'Hearing Secret Harmonies' was originally written for *Screen* in 1984, and in this revised form first appeared in *High Theory/Low Culture*, ed. Colin MacCabe (Manchester University Press, Manchester, 1986).
'Making Sense of Video' is previously unpublished.

Acknowledgement to EMI Records Ltd, owner of the Music for Pleasure record label.

We are grateful to authors and publishers for permission to use lines from the following songs. Every effort has been made to trace copyright holders who should come forward if they recognize their material.

Winter Wonderland by Victor B. Smith. Reproduced by permission of Redwood Music Ltd. Love's Like Anthrax by Jonathan King, David Allen, Andrew Gill and Hugo Burnham. Reproduced by permission of EMI Music Publishing Ltd. The Beauty of God's Plan by Dee McNeil and Claude Samard © 1979 Al-Bait Publishing. Reproduced by permission of Rondor Music (London) Ltd. Hit'n'Run Lover by Sandy Wilbur. Reproduced by permission of Memory Lane Music Ltd.

Illustrations on pp. 82, 84 and 86 appear by kind permission of Ray Lowry.

Introduction
Everything Counts

I mean, there isn't *that* much to say about rock'n'roll.
Nik Cohn

I am now quite sure that the rock era is over. People will go on playing and enjoying rock music, of course (though the label is increasingly vague), but the music business is no longer organized around rock, around the selling of records of a particular sort of musical event to young people.[1] The rock era – born around 1956 with Elvis Presley, peaking around 1967 with *Sgt Pepper*, dying around 1976 with the Sex Pistols – turned out to be a by-way in the development of twentieth-century popular music, rather than, as we thought at the time, any kind of mass-cultural revolution. Rock was a last romantic attempt to preserve ways of music-making – performer as artist, performance as 'community' – that had been made obsolete by technology and capital. The energy and excitement of the music indicated, in the end, the desperation of the attempt. Given what has happened, the despair was justified. Nowadays, rock anthems are used to sell banks and cars. As I write, *Rolling Stone* magazine is celebrating its twentieth anniversary as though it had always meant to be what it has now become – a slick vehicle for delivering the middle-class, middle-aged leisure market to the USA's most conservative corporate advertisers.

There are two ways to read this situation. Either what is being packaged now is no longer rock (*Rolling Stone* ceased to be a rock magazine years ago; 'I Feel Free' died as a rock song the moment it became a Renault jingle). Or else rock's 'new' commercial function proves that it was actually no different from any other leisure product all along. The first argument (the fanzine line) means developing a myth of 'true' rock – and there are plenty of 'authentic' stars and 'no sell out' fans from Bruce Springsteen on down ready to believe in it. I do not, if only for aesthetic reasons – there is something *essentially* tedious these days about that 4:4 beat and the hoarse (mostly male) cries for freedom. On the other hand, to reabsorb rock into general pop history, to discount its belief that it is 'different', means listening afresh to other forms of mass-produced music – maybe they don't work in the way we thought, either.

In Britain, more clearly than in the States (where it was quickly reassimilated as suburban rock and roll), new thinking about music and

mass culture was inspired by punk, and the pieces in this book are all determinedly post-punk. Even at the time I was writing *The Sociology of Rock*[2] in the late 1970s, there were the first signs of 'crisis' in the rock business – the demographic shift from teenager to young adults, the rise of the cassette and the cassette player, the abrupt end to a decade of remarkable growth in sales and profit figures. I still think that its account of the rock world was accurate, but *The Sociology of Rock* came out just as that world was unravelling. In my subsequent rewrite of the story, *Sound Effects*,[3] all I could do was register the contradictions: the way in which rock naturalism was being called into question by punk's do-it-yourself make-up; the fact that far from being 'counter-cultural', rock articulated the *reconciliation* of rebelliousness and capital.

After *Sound Effects* my critical interests pulled two ways. As an academic researcher I wanted to do more systematic work on the history of pop, on the organization of the music industry before rock and roll, on the aesthetics of show business and Tin Pan Alley, on the everyday use of music as a casual commercial soundtrack. As a rock critic I wanted to pay closer attention to the surfaces of musical events, taking genre labels for granted while charting the mechanisms through which different sounds give different pleasures. For three years, from 1983–6, I went to two or three concerts a week – and it was a sign of the collapsing categories that I was appointed the *Sunday Times*'s 'rock critic' (to complement Derek Jewell's 'pop' criticism) at the moment when I no longer found the distinction sensible (and, in the event, it was Derek who went on celebrating old rock acts in all their pomp and circumstance, I who was enthralled by the 'new pop' acts in all their glitzy hype).

If I was confident that I knew what was going on in the record business – I enjoyed the music more than ever – developments in the academy at this time did bemuse me. Just as rock lost its privileged place as any sort of counter-culture, 'cultural studies' emerged to restate its radical significance – on the syllabus. By 1983–4 the music industry may have been organised 'like punk never happened', but the cultural studies industry was still wallowing in its consequences – semiotic readings of style, postmodernist accounts of video, psychoanalytic interpretations of the voice. These gave pop scholars a theoretical weight which rock studies in the 1970s had never had. What disturbed me was the apparent assumption that it did not matter now how pop production and consumption were organized *materially*. Because the 'reality' of a sound or style or image was just another ideological effect, it was quite OK, it seemed, to write about records, stars and videos as if they did just, somehow, fall to earth.

It is true that writing about pop music was much more fun in the 1980s than it had been in the 1970s. The meaning of music was itself up for grabs and rock criticism no longer meant placing each new release in its tradition, describing its *provenance*, codifying sounds in terms of accustomed social codes. But what this meant for me was the reversal of the old terms of my academic/journalist confusion. In the 1970s I had

thought of myself as using sociological research methods to expose rock fan mythology, while depending on my personal involvement in music as a constant reminder that rock's other sociological observers just *didn't understand*. In the 1980s, as a fan I was amazed by academic theorists' cavalier way with social facts, while as an academic I enjoyed upsetting readers' consumer common sense with wild subjective theory.

The pieces in this book reflect these tensions. In terms of subject matter, they cover music long past *and* music immediately present. Methodologically, they contain dogged empiricism *and* subjective speculation. And certain themes appear everywhere – in the academic papers, the columns and the overnight reviews.

Firstly, in trying to place rock in twentieth-century pop history I found myself intrigued less by the organization of the music business, as such, than by the impact on it of technological change and by its dependence on the media of mass dissemination. For example, new technology (and its use by broadcasters) lies behind the current reorganization of the music business around the marketing of compact discs and the servicing of satellite and cable TV companies. And what is hearteningly clear from technological history is that no-one in the business ever knows in advance which people will use which devices for which purposes. Far from manipulating and moulding public demand, the electronic goods industry has always had to adapt *to* it, sometimes quite drastically.

In this process, market forces are not the only ones in play. Because the meaning of popular music this century is inseparable from its use by the other mass media – radio, cinema, TV, video – so their organization and regulation shape the possibilities of pop. For example, there is a familiar rock cliché (most recently voiced in *Rock of Ages*,[4] the official *Rolling Stone* history of rock and roll) which says that because of the heavy hand of the BBC, British youngsters were deprived of good rock music in the 1950s and had to be liberated by 'Top 40' formats on the pirate radio stations before their own rock culture could flourish. Or, as I would rather put it, it was because of the BBC's public service attitude to youth programming that there were specifically *British* pop sounds and attitudes in place to inflect the meaning of 1960s rock. Rather than simply imitating the style of American Top 40 radio, British youth club shows such as 'Saturday Club' promoted local enterprise. Skiffle is a case in point. They also gave groups such as the Beatles a chance to develop a relationship with their radio audience that was not just a sales pitch. The importance of public service broadcasting for the 'indie' British scene is apparent in the continuing role of the John Peel show.

The second theme that runs through this book relates to this, though indirectly. One reason why American rock critics scoff at the BBC is because they assume an equation about the British class system: broadcasters = (patronizing) middle-class; rock and roll = (threatening) young proles. This is to misread British pop history and to misunderstand British rock ideology. Class readings are confused in general about the ways in which musicians 'represent' their audience – imagination is read

as delegation. The continuing influence of subcultural theory is apparent here, and it has resulted in two different sorts of analytic error.

Firstly, it roots 'authentic' rock (or punk or rap or hip hop) in 'the streets' without examining the continuous cultural exchange there between different social fantasies, differently mobile dreams of 'making it'. In both Britain and the USA (if with rather different implications), rock and roll and its associated genres are these days primarily forms of suburban youth expression. The idea of musical 'authenticity' is certainly a suburban idea. As I will argue, to understand British rock culture, in particular, is to understand what it means to grow up in suburbia rather than in the inner city.

The second problem of subcultural sociology (and rock writing) in this context is that it validates the 'amateur' musician (who somehow gives voice and body to the collectivity) at the expense of the 'professional' (who plays to industrial rules). This is a misleading distinction – all pop musicians (or, at least, all pop musicians of any cultural significance) are professionals even though they have different ideologies of professionalism. But it accounts for a peculiarity of much academic pop study: analysis is focused on qualities which musicians cannot help (social background, historical position, gender, ethnicity) rather than on ones which they can (their technical ability, musical judgements, sense of their own creative control). In Britain, the importance of these academically neglected strands of rock life – suburban fantasy and creative professionalism – can be measured by the remarkable pop impact of the art school.[5]

My third major theme follows on from this. In getting their effects – giving us pleasure, constructing cults, becoming stars – rock and pop musicians of whatever type are acting according to *conventions*, and my main interest as a critic in the last few years has been to describe and account for musical rules of expression. My assumption is that no musical event, no way of singing, no rhythm comes *naturally*. This is an obvious enough assumption to make in any other sphere of criticism – no one imagines that books or films just happen – but because of rock's particular ideology of 'raw power' and 'direct energy', identifying the actual mechanisms involved can be difficult. What is at issue, to be more specific, is rock's supposed sexual force, and much of my analysis here turns on speculations about sex in song, on readings of the body in the voice, on the musical decoding of gender.

And this is not just a matter of academic curiosity. One of the most important aspects of the post-punk dissolution of rock certainties was the replacement of authenticity by artifice as the central concern in critical discourse. This was marked (in the pages of *New Musical Express*, for example) by the revaluation of the labels 'rock' and 'pop' themselves. In the last sixties, 'rock' had been established as the praise-word, distinguishing serious or powerful music from 'commercial rubbish' and formula sounds. Now, 'pop' became the term of praise, a way of distinguishing sharp and clever sounds from 'rockist rubbish' and formula flab. I found

myself (as both critic and listener) drawn to certain stars and records because of the persuasiveness of their theorists. Our tastes change, to put this another way, only when we have some new means to *explain* why some sounds are worth our interest and others are not (and I haven't listened to a Genesis or Yes or Grateful Dead or Rolling Stones album all through since 1978).

The 'death' of rock in the 1980s is sometimes described in terms of its fragmentation. There are now just scattered 'taste markets', and the central rock institutions of the seventies – the music press and certain TV and radio shows – can no longer put together a general audience. This is not simply a matter of statistics. The important point is that no single pop taste, no particular rock fragment, seems any weightier, any *truer* than any other. That is why *Smash Hits*, which values acts only in terms of their commercial success, now outsells the rest of the music press put together (and why Q, its grown-up offshoot, is succeeding on the basis of a similar critical assumption – that all musical goods are *equal in the market place*).

What I am describing – 'a culture of margins around a collapsed centre' as *i-D* once put it[6] – is the pop-world version of the 'postmodern condition'. Here, just as much as in academic discourse, 'postmodernism' really describes the condition of the critics not that of the world they watch. When there is no good reason left why a Keith Richard record should be any more or less culturally valuable than a Cliff Richard record, Kate Bush's music any more or less profound than Bananarama's, the Beastie Boys any more or less socially redemptive than Run DMC, then what is under threat is critical authority – there are still good commercial reasons why all these musicians are signed up and sell (or not). I still believe, that is, that relations of cultural production determine the possibilities of cultural consumption. 'Postmodern' pop is less an expression of some *zeitgeist*, than a consequence of the technological shake-up of the entertainment business. What remains undecided is which of the various pop possibilities at any time are realised. That is why trade papers like *Billboard* and *Music Week* offer much more suggestive accounts of what is going on than most cultural theorists. They don't just describe the business empirically, they also draw attention to the points of conflict and confusion. *Billboard*, in particular, continually reveals the work that goes into the preservation of profit opportunities as economic and legal conditions change.

What reading *Billboard* currently suggests, above all, is that, far from being made in a postmodern stupor, popular music is now at the centre of more explicit political arguments than it has been for 50 years. This may seem an odd claim to make in Britain where, unlike any other cultural form, pop is taken to be a necessarily free market phenomenon an inappropriate one for state subsidy or regulation – even the most radical voices in eighties rock, the 'indies', call for the music market to be properly competitive rather than for any form of nationalization. The peculiarity of British pop in terms of cultural politics is its international

profitability. It seems a long time ago (in fact the late 1950s) that British music publishers last campaigned to keep American songs off the airwaves, that the Musicians Union kept ports closed tight against visiting jazz and pop musicians, that a British rock and roll career meant a career in British light entertainment. Since the Beatles, the rock version of cultural imperialism has been directed by Britain as well as America. State protection of popular music as either national culture or national industry (a recurring political issue in the rest of Europe and in such US cultural targets as Canada) long ago ceased to be on the British political agenda.

There are reasons now to expect this situation to change (ironically enough under our most militantly free-market government). Firstly, digital technology threatens the very basis of music business profit – the rights income accruing from ownership of a musical 'property'. This has led to an intense campaign for changes in the copyright law so that the legal myth of the 'fixed' sound is retained even as new storage conditions 'unfix' it. Secondly, the regrouping of music and TV companies in cross-national, multi-media entertainment corporations is raising new questions about national popular culture. And whatever the immediate British decisions about copyright law and the regulation of broadcasting, disputes over both issues are certain to continue, if only in response to different policies and laws in other countries.[7]

This is the political context in which my approach to popular music remains both unashamedly 'empiricist' and biased towards the study of production rather than consumption. I am going against the grain of 'cultural studies' in this and not just because I start from a sociological rather than a literary perspective. The problem of most academic writing about popular culture is, in Geoffrey Nowell-Smith's words, 'the striking absence of any sense of artistic production',[8] or, as I would rephrase it, the neglect of the conditions of artistic production. It is as though academic pop theorists still feel it necessary to defend pop music from the orthodox Marxist mass-cultural critique. Because it cannot be denied that rock and pop are indeed 'commodities', their problem is to show that there is, nevertheless, something 'authentic' to that commodity (the commodity process itself, what it is and what it means, is taken for granted). And because virtually all cultural theory is written on behalf of the consumer, it is she or he who is taken to rescue the real meaning of a record from its market form – hence the importance of subcultural theory, the argument that young people use pop style as a means of symbolic resistance to bourgeois hegemony. The various postmodern writers on pop have simply refined this approach through the concept of simulation – the 'crisis' they describe is still a crisis of consumption.

My starting point is that what is possible for us as consumers – what is available to us, what we can do with it – is a result of decisions made in production, made by musicians, entrepreneurs and corporate bureaucrats, made according to governments' and lawyers' rulings, in response to technological opportunities. The key to 'creative consumption' remains an understanding of those decisions, the constraints under which

they are made, and the ideologies that account for them. Such understanding depends on both industrial research and the intelligence revealed in single songs.

What follows here, then, is a mixture of academic articles and journalism. The academic articles are relatively extensive and have footnotes; they were written cautiously in an attempt, among other things, to guide myself through other people's arguments. The journalism is to the point and unreferenced; these pieces were written to sound good and to deal with my own reactions to events as a way of reporting what I thought was going on. In terms of my general interests and arguments, both sorts of writing have always seemed necessary to me. But I was surprised in making this selection to find that on the whole I was more intrigued by the old journalism than by the 'lasting' scholarship (and the book's contents are balanced accordingly). The reason for this, I think, is that journalism by its nature preserves something that is central to the meaning of pop but is difficult to convey in detached academic terms: its dependence on place and time.

The place I lived while writing all these words was Coventry, which was briefly the centre of a national musical movement (see my piece on 'The Coventry Sound' below). More importantly, it is an industrial city suffering badly from the manufacturing recession. Pop and rock movements have a different resonance there than in London, and I was always pleased to be a national provincial rock critic.

The time of the book was the 1980s, as marked by a series of concerts, records and controversies. I have reproduced these without attempting to edit them in hindsight, partly because I wanted to use them to convey some sense of how post-punk issues and alliances developed, partly to make clear that the notion of 'lasting value' has no place in pop criticism. A song or group or style matters only as far as it illuminates its context, and the pursuit of 'permanent' importance was an early sign that rock was ceasing to have a significant pop presence. I rave here, then, over records I have never listened to since, and puzzle over obscure acts who have remained obscure.

The best thing about the 1980s for me was having to make sense of particular sounds (rather than, as before, general trends). For this, unexpectedly, live performances turned out to be more fruitful than records. Why? Because in live performance I could *see* music in the making (and in the receiving – the audience was always crucial for my understanding and enjoyment of a show). It is also true that 'live' performance (which may now mean the public presentation of 'recorded' sounds) still provides the most intense experience of music as pleasure, still defines what it means to be *surprised* by delight. And as 'magic' (which is what got me writing about it in the first place), pop means sounds that happen *to* me. Why and how are what I address in this book.

If nothing else, this collection gives me a chance to thank the various editors who have let me be pretentious in pop places. I am particularly grateful to Richard Williams for supporting my 'Consuming Passions'

column in *Melody Maker*, to Andy Schwartz for running the 'Striking Back' column in *New York Rocker*, and to Robert Christgau for initiating and Doug Simmons for sustaining 'Britbeat' in *Village Voice*. Thanks also to James Donald, Sue Steward and David Toop, Tony Gould, Martin Jacques and Sally Townsend, Nick Wapshott, Angela McRobbie, Gillian Wilce and Sarah Benton, and above all to John Whitley for his friendship and support while I was rock critic for the *Sunday Times*. While I take full responsibility for everything here, I should also say that my attempts to find great social significance in small pop gestures is a response to the critical example of Dave Laing, Greil Marcus, Jon Savage and Simon Reynolds. I do blame them for a lot.

Notes

1 For the business of pop in the 1980s see my 'Picking Up the Pieces' in *Facing The Music*, ed. Simon Frith (Pantheon, New York, 1988).
2 Simon Frith, *The Sociology of Rock*, (Constable, London, 1978).
3 Simon Frith, *Sound Effects* (Pantheon, New York, 1981).
4 Ed Ward, Geoffrey Stokes and Ken Tucker, *Rock of Ages* (Summit Books, New York, 1986).
5 For the history of the art school influence see Simon Frith and Howard Horne, *Art Into Pop* (Methuen, London, 1987).
6 *i-D*, 46 (April 1987) p. 50.
7 I discuss these issues in detail in 'Music and Copyright', *Popular Music*, 7, 1 (1988).
8 See Geoffrey Nowell-Smith, 'Popular Culture', *New Formations*, 2 (1987).

PART I

Money Changes Everything/That's Entertainment!

The Industrialization
of Music

Introduction

When I was a child I lived in dread of having to sing in public. This was a common forfeit in party games, but I would do anything else humiliating in preference. Singing was too personal, too *exposed* an activity.

Singing still seems to me the rawest form of personal expression (which is why I love soul music) and music-making, more generally, still seems the most spontaneously human activity. Without thinking much about it, people sing in the bath and the playground, beat out a rhythm on the dancefloor and whistle while they work. It is because of our experience of the immediacy of music-making that its industrial production has always been somehow suspect. In fact, of course, people today work with piped music and skip to the beat of a ghetto-blaster; they are more likely to listen to the radio than to sing in the bath. Most of the music we hear now, in public or private, has been mechanically produced and reproduced. It reaches us via an elaborate industrial process and is tied into a complex system of money-making. And we take these 'artificial' sounds for granted. A couple of years ago I went to see Al Green in concert at the Royal Albert Hall in London. At one point he left the stage (and his microphone) and walked through the audience, still singing. As he passed me I realized that this was the first time, in 30 years as a pop fan, that I had ever heard a star's 'natural' voice.

The contrast between music-as-expression and music-as-commodity defines twentieth-century pop experience. It means that however much we may use and enjoy its products, we retain a sense that the music industry is a bad thing – bad for music, bad for us. Read any pop history and you will find in outline the same sorry tale. However the story starts, and whatever the author's politics, the industrialization of music means a shift from active musical production to passive pop consumption, the decline of folk or community or subcultural traditions, and a general loss of musical skill. The only instruments people like me can play today are their record players and tape-decks. The rise of the multi-national leisure corporation means, inevitably, the efficient manipulation

of a new, global pop taste as Dire Straits, for example, reach into every First, Second and Third World household, like Coca-Cola (and with the same irrelevance to real needs).

What such arguments assume (and they are part of the common sense of every rock fan) is that there is some essential human activity, music-making, which has been colonized by commerce. Pop is a classic case of alienation: something human is taken from us and returned in the form of a commodity. Songs and singers are fetishized, made magical, and we can only reclaim them through possession, via a cash transaction in the market place. In the language of rock criticism, what is at stake here is the *truth* of music – truth to the people who created it, truth to our experience. What is bad about the music industry is the layer of deceit and hype and exploitation it places between us and our creativity.

The flaw in this argument is the suggestion that music is the starting point of the industrial process – the raw material over which everyone fights – when it is, in fact, the final product. The industrialization of music cannot be understood as something which happens *to* music, since it describes a process in which music itself is made – a process, that is, which fuses (and confuses) capital, technical and musical arguments. Twentieth-century popular music means the twentieth-century popular record; not the record of something (a song? a singer? a performance?) which exists independently of the music industry, but a form of communication which determines what songs, singers and performances are and can be.

We are coming to the end of the record era now (and so, perhaps, to the end of pop music as we know it) and so what I want to stress here is that, from a historical perspective, rock and roll was not a revolutionary form or moment, but an evolutionary one, the climax of (or possibly footnote to) a story that began with Edison's phonograph. To explain the music industry we have, then, to adopt a much wider perspective of time than rock scholars usually allow. The pop business itself, by the nature of its sales activities, is in a constant state of 'crisis'; business analysts should, by contrast, keep cool. To be examining always the entrails of the 'latest thing' is to mistake the wood for the trees, and, as I hope to show, there is more to be learnt from the continuities in pop history than from the constantly publicized changes. 'New things' are rarely as novel as suggested. In 1892, for example, 'song slides' became a promotional craze for sheet-music publishers: pictures telling the story were, for years, a necessary sales aid for a new song sheet – they survived the coming of radio and talkies and had a measurable effect on the types of song marketed and sold.[1] Video promotion does not just go back to 1930s jazz shorts!

To analyse the music industry through its history means focussing on three issues:

1 *The effects of technological change.* The origins of recording and the recording industry lie in the nineteenth century, but the emergence of the

gramophone record as the predominant musical commodity took place after the 1914–18 war. The history of the record industry is an aspect of the history of the electrical goods industry, related to the development of radio, the cinema and television.

2 *The economics of pop.* The early history of the record industry is marked by cycles of boom (1920s), slump (1930s) and boom (1940s). Record company practices reflected first the competition for new technologies and then the even more intense competition for a shrinking market. By the 1950s the record business was clearly divided into the 'major' companies and the 'independents'. Rock analysts have always taken the oligopolistic control of the industry for granted, without paying much attention to how the majors reached their position. What were the business practices that enabled them to survive the slumps? What is their role in boom times?

3 *A new musical culture.* The development of a large-scale record industry marked a profound transformation in musical experience, a decline in established ways of amateur music-making, the rise of new sorts of musical consumption and use. Records and radio made possible new national (and international) musical tastes and set up new social divisions between 'classical' and 'pop' audiences. The 1920s and 1930s marked the appearance of new music professionals – pop singers, session musicians, record company A&R people, record producers, disc jockeys, studio engineers, record critics, etc. These were the personnel who both resisted and absorbed the 'threat' of rock and roll in the 1950s and of rock in the 1960s.

The making of a record industry

The origins of the record industry are worth describing in some detail because of the light they cast on recent developments. The story really begins with the North American Phonograph Company which, in 1888, was licensed to market both Edison's phonograph and the 'graphophone', a version of the phonograph developed by the Bell Telephone Company. When Edison had predicted, 10 years earlier, how his invention would benefit mankind, he had cited the reproduction of music as one of its capacities, but this was not the sales pitch of the North American Phonograph Company. They sought to *rent* machines, as telephones were rented, via regional franchises to offices: the phonograph was offered as a dictating device.

The resulting marketing campaign was a flop. The only regional company to have any success was the Columbia Phonograph Co (Washington had more offices than anywhere else!). But even it soon found that the phonograph was more successful as a coin-operated 'entertainment' machine, a novelty attraction (like the early cinema) at

fairs and medicine shows and on the vaudeville circuit. And for this purpose 'entertaining' cylinders were needed. Columbia took the lead in providing a choice of 'Sentimental', 'Topical', 'Comic', 'Irish' and 'Negro' songs.

Meanwhile, Emile Berliner, who in 1887–8 was developing the gramophone, a means of reproducing sounds using discs not cylinders, was equally concerned to make recordings – he needed to demonstrate the superiority of his machine over Edison's. He formed the United States Gramophone Company in 1893, and the following year Fred Gaisberg, who had started at Columbia as a piano accompanist and thus taken charge of recording, was poached by Berliner to be recording director and talent scout. Berliner, unlike Edison, regarded the gramophone as primarily a machine for home entertainment and the mass-production of music discs, such that 'prominent singers, speakers or performers may derive an income from royalties on the sale of their phonautograms',[2] and in 1897 Gaisberg opened the first commercial recording studio.

For the next five years there was an intense legal struggle between disc and cylinder. But in 1902 the Victor Talking Machine Company (which controlled Berliner's patents) and the Columbia Graphophone Company (which controlled Edison's) pooled patents. They thus 'controlled every patent bearing on the manufacture of disc machines and records'.[3] This had immediate international effects. In Britain, for example, the Columbia Graphophone Company was started in 1898, as a branch of the American firm Columbia, and the Gramophone Company (with its HMV and Parlophone labels) was licensed by the American firm Victor. After 1902 they also worked together.

By 1914, however, the basic patents were expiring and a rush of new manufacturers appeared. In the US: Sonora, Aeolian (previously piano and player-piano manufacturers), Brunswick-Balke-Collender (makers of billiard tables and bowling balls), and others – by 1916 there were 46 phonograph companies. Between 1914 and 1919 production value rose from $27m to more than $158m. In Britain: Decca (which had begun as Barnett Samuel, nineteenth-century musical instrument makers, marketed in 1914 the first portable record player, the Decca Dulcephone, and boomed as soldiers took it with them to the trenches. By 1920 there were dozens of British record labels, some American licensees, some home-grown, all based in the manufacture of phonograph and phonograph parts. Their profits (and legality) depended on innovations in the techniques and qualities of sound reproduction, and their record-making activities were an aspect of their marketing of record players.

It is useful at this point to make the usual industry distinction between hardware and software: hardware is the equipment, the furniture, the 'permanent' capital of home entertainment; software is what the equipment plays – particular records and tapes. The invention, manufacture and selling of hardware must, obviously, precede the manufacture and selling of software. What normally happens, then, is that hardware companies get involved in software production simply in order to have

something on which to demonstrate their equipment. We can compare the early history of the record industry with the recent history of video: video manufacturers were also confused about what video-buyers would use their machines for. Software was seen at first only as a means of advertising hardware (where the initial profits lay). Another example is the original marketing of stereo equipment, with records of train noises that could be heard to move from one speaker to the other.

At a certain moment in the development of a new electronic medium, though, the logic changes. If people begin by buying records, any records (train noises, the first compact disc releases), just to have something to play, as ownership of the new equipment becomes widespread, records are bought for their own sake, and people begin to buy new, improved players in order to listen to specific sounds. Records cease to be a novelty. In the record industry this switch began in the 1920s, the real boom time for companies making both phonographs and phonograph records. In the words of Edward Lewis, a stockbroker who helped Decca become a public company in 1928, 'a company manufacturing gramophones but not records was rather like making razors but not the consumable blades'.[4] In the video industry the best returns no longer come from hardware manufacture (in Britain the home video market is pretty well exhausted; after its remarkable growth figures the manufacturers now expect a steady decline in sales), but from software rights ownership (hence the interest of media moguls like Rupert Murdoch in film companies: their back catalogues are the basic resource for both home video users and cable television stations).

By the 1920s there were, in both Britain and the USA, numerous phonograph manufacturers, competing for sales by reference to technical advances, design qualities, and a variety of gimmicks, and, of necessity, all issuing their own records. At this stage, record companies were simply part of the electrical goods industry, and quite separate in terms of financial control and ownership from previous musical entrepreneurs. They were owned and run by engineers, inventors and stock market speculators. They had little to do with song publishers, theatre owners, agents, promoters or performers. Their managers did not seem much interested in music. Gaisberg comments in his memoirs that 'for many years Berliner was the only one of the many people I knew connected with the gramophone who was genuinely musical'.[5]

It follows, paradoxically, that these companies' musical decisions, their policies on who and what to record, depended on the judgements and tastes of the 'live' music entrepreneurs. Labels competed to issue material by the same successful stage and concert hall performers, to offer versions of the latest stage show hit or dancefloor craze (a practice that continued well into the 1950s and rock and roll with the 'cover version'). Few companies were interested in promoting new numbers or new stars, and there was a widely held assumption in the industry that while pop records were a useful novelty in the initial publicizing of phonographs, in the long run the industry's returns would depend on

people wanting to build up permanent libraries of 'serious' music. Fred Gaisberg, for example, the first A&R man, whose work soon took him from America to Britain and then across Europe and Asia, was, essentially, a classical music impresario.

This argument has had a continuing resonance: while each new technological change in mass music-making is a further 'threat' to 'authentic' popular music, classical music always benefits from such changes, which from hi-fidelity recording to compact discs have been pioneered by record companies' classical divisions. The record industry has always sold itself by what it could do for 'serious' music. As Cyril Ehrlich points out,[6] the gramophone began as not quite respectable (because of its public novelty value), and so an emphasis on its use for playing classical music was necessary to sell it to middle-class families (the early cinema went respectable with similar tactics – using classical music as accompaniment to silent films). The important point here is that in the history of electric media, the initial 'mass market' (this was true for radio, TV and video as well) is the relatively affluent middle-class household. The organization of the record industry around the pop record (and the pop audience) was a later development – a consequence, indeed, of the slump.

Slump

For anyone writing the history of the record industry in 1932, there would have been as little doubt that the phonograph was a novelty machine that had come and gone as there was about the passing of the piano-roll. Sales of records in the USA had dropped from 104 million in 1927 to 6 million; the number of phonograph machines manufactured had fallen from 987,000 to 40,000. In Roland Gellatt's words, 'the talking machine in the parlor, an American institution of redolent memory, had passed from the scene. There was little reason to believe that it would ever come back.'[7] When the industry did begin to recover it was due not to domestic sales but to jukeboxes – there were 25,000 in 1934, 300,000 in 1939, accounting for the sales of 30 million records. Records had returned to their public starting point – as coin-box entertainment, and, for the first time, began to define (and be defined by) popular, working-class taste.

The 1930s slump was marked not just by an overall decline in leisure spending but also by a major reorganization of people's leisure habits. The spread of radio and the arrival of talking pictures meant that a declining share of a declining income went on records (just as in the recession of the late 1970s and early 1980s, there was less money overall to spend on leisure and more products, such as video recorders and computer games, to spend it on). I will not go into the details of the slump here, but simply note its consequences. Firstly, it caused the collapse of all small recording companies and re-established the record

business as an oligopoly, a form of production dominated by a small number of 'major' companies. This was not just a matter of rationalization in the recording business itself – failing companies going bankrupt or being taken over – it also meant that the surviving companies covered the collapse of record sales by putting together more wide-ranging music interests. In Britain, EMI bought into Chappell's (piano makers and the UK's largest song-publishing and concert-promotion company), a move which marked a subtle but important shift in how record companies regarded themselves – as part of the music industry rather than the electrical goods business. By the end of the 1930s, when EMI and Decca manufactured nearly all the records made in Britain and controlled the process by which they got into the shops, the contemporary meaning of 'a major record company' had been established.

In the USA the development of an oligopoly was equally apparent – by 1938 three-quarters of records sold were manufactured by RCA or Decca, and most of the rest by the American Record Company, which controlled Brunswick and Columbia. But the meaning of a 'record company' was more complicated: the music business was now part of film and radio corporations of a sort that did not yet exist in Britain (where radio was a state monopoly and the film industry feeble).

The development of American radio had parallels with the history of the record industry. Various companies planning how to exploit the new medium (through patent deals) had discovered that in order to persuade people to rent transmitters (and to make money from selling advertising time) they would also need to provide entertaining programmes. By 1926 RCA was networking shows via its National Broadcasting Company. There was, too, an early broadcasting emphasis on 'potted palm music' (to attract relatively affluent and respectable listeners) which meant that while radio did 'kill' record sales it also left pockets of taste unsatisfied. Early radio stations were not interested in black audiences, for example, and so the market for jazz and blues records became, relatively, much more significant.

As radios replaced record players in people's homes, so the source of music profits shifted from record sales to performing rights and royalties. The basic technological achievement of this period – the development of electrical recording by Western Electric – marked a fusion of interests between the radio, cinema and record industries. Western Electric could claim a royalty on all electrical recordings, and was the principal manufacturer of theatre talkie installations; film studios like Warners had to start thinking about the costs (and returns) of publishers' performing rights, and began the Hollywood entry into the music business by taking over the Tin Pan Alley publishers Witmark in 1928. As the head of RCA explained to a senate investigation of RCA's publishing take-overs the same year:

> It is necessary for us to be in the music business to protect ourselves. . . . The movies have bought most of the music houses. . . . We have got to

control the music situation. It is a simple business proposition with a little
touch of sentiment in it.[8]

In 1929 RCA (with money advanced by General Electric and
Westinghouse) took over the Victor Talking Machine Company and,
with General Motors, formed GM Radio Corporation, to exploit the
possibilities of car radio. The subsequent making (and unmaking) of the
USA's electrical-entertainment corporations is too complicated to go into
here, but in the short term, as in Britain, the competition for record sales
intensified and quickly changed its terms. The initial response to falling
sales was a price-war – records were sold for less and less on the
assumption that buyers would favour the cheapest record on the market.
But this policy eventually foundered on the 'irrationality' of pop taste –
people's musical choices are not just a matter of price. New sales tactics
had to be developed. For the first time, record companies, led by Decca,
ran aggressive advertising campaigns in newspapers and on billboards:

> Here they are – your favourites of radio, screen, and stage – in their
> greatest performances of instrument and voice! *Not* obsolete records, cut in
> price to meet a market, but the latest, newest smash hits – exclusively
> DECCA. Hear them *when* you want – as *often* as you want – right in your
> own home.[9]

Decca was the first company to realize that an investment in
advertisement and promotion was more than justified by the consequent
increase in sales. The peculiarity of record-making is that once the break-
even point is passed, the accumulation of profit is stunningly quick – the
costs of reproduction are a small proportion of the costs of producing the
original master disc or tape. It follows that huge sales of one title are
much more profitable than tidy sales of lots of titles, and that money
spent on ensuring those huge sales is thus a 'necessary' cost. Decca
developed the marketing logic that was to become familiar to rock fans in
the late 1960s: promotion budgets were fixed at whatever figure seemed
necessary to produce big sales. Only major companies can afford such
risks (and such sums of capital) and the strategy depends on a star
system, on performers whose general popularity is guaranteed in
advance.

In the 1930s the recording star system depended on a tie-up with film
and radio (hence the arrival of Bing Crosby –Decca was, again, the first
company to realize how valuable he was). In the 1980s recession, there
has been a similar pattern – an emphasis on a few superstars at the
expense of the mass of groups just getting by, those stars being marketed
via films and film soundtracks, with video promotion on TV (the 4–
5,000 new albums-per-year US average of the 1970s had become less
than 2,000 per year in the 1980s).[10]

In the 1930s aggressive selling and the star system meant a new
recording strategy. Companies became less concerned to exploit big stage
names, more interested in building stars from scratch, as *recording* stars.

They became less concerned to service an existing public taste than to create new tastes, to manipulate demand. Electrical recording helped here – crooning stars like Crosby could suggest an intimate, personal relationship with fans that worked best for domestic listeners. His live performances had to reproduce the recorded experience, rather than vice versa. And jukebox programmers offered a direct way to control national taste. But radio mattered most of all. By the end of the 1930s it was the most important musical medium: radio gave record companies a means of promoting their stars, while the record companies provided radio with its cheapest form of programming. Two media which had seemed to be in deadly competition, had become inseparable. Radio, after all, did not kill the record star.

The 1930s marked, in short, a shift in cultural and material musical power – from Tin Pan Alley to broadcasting networks and Hollywood studios, from the publisher/showman/song system to a record/radio/film star system – and the judgement of what was a good song or performance shifted accordingly – from suitability for a live audience to suitability for a radio show or a jukebox. It was in the 1930s that the 'popularity' of music came to be measured (and thus defined) by record sales figures and radio plays. Popular music now described a fixed performance, a recording with the right qualities of intimacy or personality, emotional intensity or ease. 'Broad' styles of singing taken from vaudeville or music hall began to sound crude and quaint; pop expression had to be limited to the two or three minutes of a 78 disc. While musicians still had much the same aims – to write a good tune, to develop a hook, to sum up a feeling in a lyric, to give people something to whistle or dance to – the people who now determined what music was recorded, broadcast and heard, were quite different from their predecessors in the music business. They were no longer directly connected to a public – trying to please it on the spot. Their concern was with a market, with popularity as revealed by sales figures, consumers delivered to advertisers. For the record industry (as for the film industry) the audience was essentially anonymous; popularity meant, by definition, something that crossed class and regional boundaries; the secret of success was to offend nobody.

The technological roots of rock

By 1945 the basic structure of the modern music industry was in place. Pop music meant pop records, commodities, a technological and commercial process under the control of a small number of large companies. Such control depended on the ownership of the means of record production and distribution, and was organized around the marketing of stars and star performances (just as the music publishing business had been organized around the manufacture and distribution of songs). Live music-making was still important but its organization and profits were increasingly dependent on the exigencies of record-making.

The most important way of publicizing pop now – the way most people heard most music – was on the radio, and records were made with radio formats and radio audiences in mind (one factor contributing to the replacement of band leaders by singers as pop's biggest 'names').

The resulting shifts in the distribution of musical power and wealth did not occur without a struggle. The declining significance of New York publishing houses and big city session musicians, the growing importance of radio programmers and record company A&R people, were marked by strikes, recording bans, disputes over broadcasting rights and studio fees, and, outside the USA, such disputes were inflected with the issue of 'Americanization' (and anti-Americanism). The USA's influence on international popular music, beginning with the world-wide showing of Hollywood talkies, was accelerated by America's entry into World War II – servicemen became the record industry's most effective exporters. By the end of the War the pop music heard on radio and records across Europe (and South East Asia) was either directly or indirectly (cover versions, copied styles) American. Hollywood's 1930s success in defining 'popular cinema' was reinforced in the 1940s and 1950s by the American record industry's success in defining 'popular music'.

Outside the USA the ending of the war and war-time austerity and restraint meant immediate expansion for record companies (in Britain, for example, Decca's turnover increased eight-fold between 1946 and 1956). In the USA post-war euphoria was short-lived. By the end of the 1940s TV seemed to carry the same threat to the pop industry as radio 20 years earlier. Resistance to this threat and the subsequent unprecedented profits were due to technological and social changes which, eventually, turned the record industry into the rock business.

The technological developments which began with CBS's experiments with microgroove recording in the late 1940s, and culminated with digital recording and the compact disc in the 1980s, had two objects: to improve recorded sound quality, and to ease record storage and preservation. For the electrical engineers who worked to give their companies a competitive edge in the playback market, the musical aspects of their experiments were straightforward. What they were trying to do was to make recorded sound a more accurate reproduction of 'real' sound – from the start the new processes were marketed in the name of 'high *fidelity*'. But this sales talk of records reaching nearer and nearer to the 'complete' experience of 'live' music is just that – sales talk. Each new advance – stereo discs in the 1960s, compact discs' elimination of surface noise and wear in the 1980s – *changes* our experience of music (and some changes, like quadrophonics, have been rejected by consumers despite their supposed superior truth-to-concert experience). Hi-fi opened our ears to a new appreciation of dynamic range and subtlety – by the end of the 1960s, records, not concerts, defined the 'best' sound. Nowadays both classical and popular musicians have to make sure that their live performances meet the sound standards of their records. The acoustic design of concert halls has changed accordingly, and rock groups take

sound checks, sound mixers and elaborate amplification systems for granted. The increasing 'purity' of recorded sound – no extraneous or accidental noises – is the mark of its artificiality. Pre-war records were always heard as a more or less crackly mediation between listeners and actual musical events; their musical qualities often depended on listeners' own imagination. To modern listeners these old discs (and particularly classical 78s) are 'unlistenable' – we are used to treating records as musical events *in themselves*.

A second point follows from this. All hi-fi inventions (and this includes the compact disc) have been marketed, at first, on the assumption that the consumers most concerned about sound quality and a permanent record library are 'serious' consumers, consuming 'serious' music. The late 1940s 'battle of the speeds' between CBS's 33⅓rpm LPs and RCA's 45rpm singles was resolved with a simple market division – LPs were for classical music collectors, 45s for pop. Pop thus continued to be organized in three-minute segments, as music of convenience and of the moment (a definition reinforced by the continuing significance of jukeboxes for pop sales).

Record companies' assumptions about 'true' reproduction, 'serious' consumption and the 'triviality' of pop were, in the end, undermined by the invention that made hi-fi records feasible – magnetic tape. In the long term, the importance of tape recording was to be its availability to domestic consumers:

> In 1969 the industry produced small, self-contained tape cassettes that could run backward or forward, record or replay, skip to specific selections, and hold as much as an LP. These mass-produced cassettes had all the advantages of tape – high-quality sound, long wear and ease of storage – available, affordable, easy to use, and very popular. By 1970 cassettes accounted for nearly a third of recorded music sales, and in 1971 the value of tape players sold exceeded that of phonographs.[11]

Hence the current problem of home taping which, in the 1950s, was certainly not foreseen. Tape recording, developed by German scientists for broadcasting purposes in the war, was first picked up not by the music business but by radio stations (as a relatively cheap way of pre-recording talk and jingles) and film studios (as an aid to making soundtracks). Record companies quickly realized tape's flexibility and cheapness, and by 1950 tape recording had replaced disc recording entirely. This was the technological change which allowed new, independent producers into the market – the costs of recording fell dramatically even if the problems of large-scale manufacture and distribution remained. Mid-1950s American indie labels like Sun were as dependent on falling studio costs as late-1970s punk labels in Britain (the latter benefitting from scientific break-throughs and falling prices in electronic recording).

But tape's importance was not just in reduced costs. Tape was an intermediary in the recording process: the performance was recorded on

tape; the tape was used to make the master disc. And it was what could be done during this intermediary stage, to the tape itself, that transformed pop music-making. Producers no longer had to take performances in their entirety. They could cut and splice, edit the best bits of performances together, cut out the mistakes, make records of ideal not real events. And, on tape, sounds could be added artificially. Instruments could be recorded separately. A singer could be taped, sing over the tape, and be taped again. Such techniques gave producers a new flexibility and enabled them to make records of performances, like a double-tracked vocal, that were impossible live (though musicians and equipment manufacturers were soon looking for ways to get the same effects on stage). By the mid-1960s the development of multi-track recording enabled sounds to be stored separately on the same tape and altered in relationship to each other at the final mixing stage, rather than through the continuous process of sound addition. Producers could now work on the tape itself to 'record' a performance that was actually put together from numerous, quite separate events, happening at different times and, increasingly, in different studios. The musical judgements, choices and skills of producers and engineers became as significant as those of the musicians and, indeed, the distinction between engineers and musicians has become meaningless. Studio-made music need no longer bear any relationship to anything that can be performed live; records use sounds, the effects of tape tricks and electronic equipment, that no-one has ever even heard before as musical.[12]

It is, to conclude, a pleasing irony of pop history that while classical divisions of record companies led the way in studio technology, their pursuit of fidelity limited their studio imagination. It was pop producers, unashamedly using technology to 'cheat' audiences (double-tracking weak voices, filling out a fragile beat, faking strings) who, in the 1950s and 1960s, developed recording as an art form, thus enabling rock to develop as a 'serious' music in its own right. It was pop producers, straightforwardly employed to realise raw musicians' ideas as attention-grabbing commodities for the teen mass-market, who developed recording as a new form of communication, thus enabling rock to give its own account of 'authenticity'. This account, or, rather, its 1980s rewriting, is the subject of much of the rest of this book.

Notes

1 Isidore Witmark and Isaac Goldberg, *From Ragtime to Swingtime, the Story of the House of Witmark* Lee Furman, New York, 1939), pp. 116–8.

2 Quoted in Roland Gelatt, *The Fabulous Phonograph 1877–1977* (Cassell, London, 1977), p. 13.

3 Gelatt, *The Fabulous Phonograph 1877–1977*, p. 133.

4 See Edward Lewis, *No C.I.C.* (Decca, privately published, London, 1956). The British details of the history sketched out here are discussed in Simon Frith, 'The Making of the British Record Industry 1920–1964', in *Impacts and Images*, eds James Curran et al. (Methuen, London, 1987).

5 Fred W. Gaisberg, *Music on Record* (Robert Hale, London, 1946), p. 25.
6 Cyril Ehrlich, *The Piano* (Dent, London, 1976), pp. 185–6.
7 Gelatt, *The Fabulous Phonograph 1877–1977*, p. 256.
8 Erik Barnouw, *A Tower in Babel* (Oxford University Press, New York, 1966), p. 232.
9 Gelatt, *The Fabulous Phonograph 1877–1977*, p. 268.
10 Thanks to Reebee Garofalo for these figures.
11 Robert C. Toll, *The Entertainment Machine* (Oxford University Press, Oxford, 1982), p. 74.
12 This description of the impact of tape is taken from Simon Frith, 'Popular Music 1950–1980' in *Making Music*, ed. George Martin (Muller, London, 1983), and for a more general discussion see Simon Frith, 'Art *vs* Technology', *Media Culture and Society* 8, 3 (1986).

The Pleasures of the Hearth – The Making of BBC Light Entertainment

> Broadcasting, in short, is the greatest ally that the divine Muse ever had on earth. It is the final step in the democratisation of music that had its beginnings in a community singsong among missing links in a primeval forest – who knows?
> (BBC Handbook, 1928)

The cultural prospect in Britain in the 1920s was, in F. R. Leavis' words, dismal: 'the American stage of our developing industrial civilization was upon us.'[1] The spectre of Americanization has always been an aspect of the mass-culture critique and in the 1920s there were good material reasons for Leavis' terms: the mass media in Britain were becoming subject to American capital and American ideas. By the end of the decade Hollywood films organized the cinema experience, American agencies dominated the advertising world, the popular papers were copying US tabloid techniques, and popular musicians played American or *ersatz* American songs. If mass communication made possible a new national culture – as everyone in the country read the same news, walked past the same hoardings, hummed the same tunes – Britain's traditional cultural intellectuals were detached from it. The mass media were forms of cultural production in which they had no obvious place, and their aesthetic response to popular prose and film and music combined bafflement, hostility and fascination. This was, in Bernard Bergonzi's words, 'the first literary generation in England to have to face mass civilization directly, though with a sensitivity formed by traditional minority culture'.[2]

The Americanization of popular culture was, in other words, a threat to the cultural hegemony of Britain's intellectuals and there were a variety of reactions to this threat – not only the straight hostility of Leavis and Orwell, but also attempts at participation. Mass-cultural forms could be used in high-cultural production (by Auden and Isherwood, for example), and even the most Americanized media were

still sources of intellectual employment. Numerous would-be literary and artistic figures came down from Oxbridge and found jobs in advertising agencies or wrote for the tabloid press or, like Anthony Powell, became screenwriters – he worked for Warner Brothers. They brought to their work a contempt for their audience which marked (and maintained) their own sense of detachment from the new cultural forces. The serious artist became, by necessity, an observer, a recorder, a camera. The most complex expression of this position was, perhaps, Mass Observation. Its project – to make public behaviour a matter of aesthetic as well as political contemplation – combined the approaches of anthropology, surrealism and market research. Other intellectuals registered, more simply, a sort of cultural resignation. Graham Greene, for example, used popular songs and song titles throughout his work (in *Brighton Rock*, most obviously, as well as in 'entertainments' like *The Confidential Agent*) to encapsulate the irony of mass-produced signs of private love and tenderness. Such songs (and Greene often wrote his own, efficient lyrics) *stood* for 'bitter sweetness', but it was clear that Greene himself felt no involvement in mass culture, whether as producer or consumer. Like other writers, he was concerned to use popular forms for serious purposes, but he was not interested in any attempt to take control of the mass media themselves, to use the new *means* of cultural production.

For more explicitly socialist intellectuals, the task was to oppose the media, to nurture 'real' working-class culture. Communists, for example, committed themselves to the folk-song movement, while the British documentary film-makers, (whether state-sponsored educators like John Grierson or more explicitly proletarian agitators like Kino, the Progressive Film Institute and the Workers' Film and Photo League) defined their work against Hollywood – realism was to replace escapism. Mass culture was resisted in the name of a working-class 'community' that was itself, more often than not, the product of a decidedly middle-class nostalgia. 'Can these dry bones live?' asked C. Day Lewis in *Letter to a Young Revolutionary*.[3] 'Can they live on the tinned foods, cheap cigarettes, votes, synthetic pearls, jazz records and standardized clothing which the town gives them back, as a "civilized" trader gives savages beads for gold? They damn well can't, and you know it. And it's up to you, if you want to see the country sound again, to put its heart back in the right place, even though it means what the progress-mongers call "putting the clock back".'

This is the background against which we have to understand the BBC. BBC culture was, first of all, a response to the fear of Americanization. Reith himself always related mass culture to America. The development of the popular press, for example, had 'subverted the role of the printed word as an instrument of religious, cultural, social and political enlightenment', and so left the British vulnerable to the influence of American films ('silly and vulgar and false') and music. In 1929 the BBC's Director of Outside Broadcasting was commissioned to prepare a

report on the 'ramifications of the Transatlantic octopus'. The company had become concerned about American control of the most popular musicians, composers, writers, performers: 'it is even possible that the national outlook and, with it, character, is gradually becoming Americanized.'[4]

The BBC also opposed the concept of the mass audience. Its attitude to its listeners was summarised in its statement to the Beveridge Committee in 1949:

> Under any system of competitive broadcasting all these things would be at the mercy of Gresham's Law. For, at the present stage of the nation's general educational progress, it operates as remorselessly in broadcasting as ever it did in currency. The good, in the long run, will inescapably be driven out by the bad. It is inevitable that any national educational pyramid shall have a base immeasurably broader than its upper levels. The truth of this can be seen by comparing those national newspapers which have circulations of over four millions with those whose circulations are counted in hundred-thousands. And because competition in broadcasting must in the long run descend to a fight for the greatest possible number of listeners, it would be be the lower forms of mass appetite which would be more and more catered for in programmes. Any effort to see whether some of that appetite could appreciate something better would be a hostage to fortune. It would be far too dangerous; the winner in *that* race being the loser in competition. This is not merely a matter of BBC versus commercial broadcasting. Even if there were a number of public service corporations they would all be similarly and involuntarily driven down.[5]

If the BBC was in general terms anti-mass culture and anti-American, its position was in other respects quite different from that of the other media critics. Most obviously, the BBC was not socialist, had no interest in developing or articulating 'authentic' popular culture in working-class terms. As Tom Burns puts it:

> BBC culture, like BBC standard English, was not peculiar to itself but to an intellectual ambience composed out of the values, standards and beliefs of the professional middle-class, especially that part educated at Oxford and Cambridge. Sports, popular music and entertainment which appealed to the lower classes were included, in large measure, in the programmes, but the manner in which they were purveyed, the context and presentation, remained indomitably upper-middle-class; and there was, too, the point that they were only there on the menu as ground bait.[6]

At the same time, though, broadcasting was a mass medium and the BBC's upper-middle-class staff could not ignore the popular effect of their work. Neither could they get much support in their shaping of British radio from outside the company. 1920s and 1930s intellectuals were remarkably uninterested in the wireless. The literary establishment was, to use Barbara Coulton's term, wary of the BBC, and journals like

the *New Statesman* and the *Spectator* rarely acknowledged its existence – though they would occasionally register their disdain for the BBC's reflection of 'popular taste'. It took the post-war development of the Third Programme to make the wireless a medium for high culture.[7]

In terms of the mass-culture debate, then, the BBC's production staff found themselves in an odd position. Working in a mass medium with explicitly anti-mass cultural principles, they had daily to answer the questions that other intellectuals avoided. What did it mean to *construct* a national culture? Who were 'the people'? What did it mean to 'please' the public? If market measures (listening figures, advertising revenue, profits) were rejected, how could the 'success' of a programme be defined? The very intensity of Reith's hostility to mass culture armed his staff against the detached cynicism of other media intellectuals. The BBC's programme-makers were attempting to use a mass medium for their own, serious, purposes.

Historians of British broadcasting argue that these purposes involved, in practice, tensions and contradictions between two quite different broadcasting principles – 'public service' and 'entertainment'. What made the BBC unique was its commitment to public service; what linked it to the general development of broadcasting was its need to entertain an audience, to offer its listeners some 'ground bait'. Even Paddy Scannell and David Cardiff,[8] by far the most acute radio historians, use this contrast, suggesting that in the late 1930s the emphasis of BBC programming shifted. Scannell and Cardiff point to the BBC's increasing use of audience research, to the growing competition from the commercial stations on the continent, to the departure of Reith in 1938. They describe the routinization of programme schedules, the changing style of radio talk, the discarding of the pretence that the BBC could unify its audience. A large section of the radio public did use the wireless exclusively for entertainment, as a background sound; the BBC had to distinguish between its 'serious' and 'popular' listeners and make programmes to appeal to them accordingly. The rise of 'popular radio' was unstoppable: 'the BBC no longer sought to lead and reform public taste; it now tried to match or anticipate it.'

The argument is that the BBC began by pitting public service against entertainment broadcasting, but eventually had to come to terms with its popular audience, had to adopt, for such listeners, the programming ideas of the commercial stations (a change of policy that was to be repeated, 30 years later, with the creation of Radio 1). This may be true, but the argument has had an unfortunate consequence for research: much more attention has been paid to the BBC's notion of public service (the Reith issue) than to its equally problematic idea of entertainment. It is the latter idea that I want to examine, and I am concerned to challenge two assumptions in particular: firstly, that 'light entertainment' (the BBC's own peculiar term) can be defined separately from public service; and, secondly, that the popular/serious distinction describes a class division, with serious programmes aimed at the bourgeoisie and popular

programmes reflecting working-class tastes and interests. Rather, BBC light entertainment was a 'middle-brow' form, itself shaped by the idea of public service. The paradox is that this new sort of pleasure quickly became a significant strand in British commercial entertainment too.

According to John Reith, public service broadcasting had four key components. It was not meant to make money. It involved national coverage – BBC programmes aimed to reach the greatest possible number of homes. These programmes were subject to 'unified control', rather than being made in *ad hoc* response to pressure groups (or target audiences defined by advertisers). And it treated the radio listener as 'capable of growth and development'.[9]

None of these principles exclude entertainment as the proper concern of a broadcaster, but they do put constraints on it. The central Reithian principle was that the wireless listener should be treated as active rather than passive, and the recurring BBC distinction between 'serious' and 'tap' listening was applied in particularly pressing terms to entertainment programmes precisely because their staple content, light music, was so obviously liable to 'passive consumption'. The 1928 *BBC Handbook* was positively school-teacherly about this – 'each individual member of an audience. . . must give his or her best receptive faculties if the full entertainment value is to be received and appreciated' – and throughout the 1920s the BBC employed its own radio critic, Filson Young, to spread the message that there was 'a right and a wrong way to use Broadcasting':

> I would urge listeners to cultivate the art of using their wireless receivers intelligently and artistically, so that the immense care and trouble that are taken in compiling and presenting the programmers' skill achieve their true direction and effect.[10]

'Active' listening meant discriminating listening – it mattered less what people listened to than that they had chosen to listen to it. This theme was sounded by programme-makers of all sorts. Hilda Matheson, who had worked in the Talks Department, made a contrast between listening as a vice ('like gin or opium') and listening as 'a source of pleasure, wonder, excitement and stimulus'. Background sounds were, by definition, meaningless; background music meant 'trifling, tea-time sentimentality'. Turning on the radio should be 'an act of will, like choosing a book, or buying a ticket for a concert'. C. A. Lewis, the BBC's first Programme Organiser, called constantly for 'selective' listening – the point of the *Radio Times* was to allow audiences to plan for themselves and, indeed, the BBC deliberately left silence between programmes to discourage casual listeners. Val Gielgud, who took charge of Drama and Variety in 1929, explained that,

a service which is 'on tap' for all the day and much of the night; which encourages every listener to believe that by the payment of his almost insignificant license fee he is entitled as of right to find something which he personally desires to hear at his disposal at any moment, can never hope to establish a genuine artistic or aesthetic prestige.[11]

The problem was that people could *over*-use radio, 'overfamiliarise' themselves with what should be unique experiences. Roger Manvell later commented that 'for the majority of people keeping a radio set which is not giving off its natural sounds is like keeping a parrot without encouraging it to talk'.[12] But it was precisely this analogy, wireless as parrot, that the BBC was determined to avoid, and this meant not only 'balance' (interspersing popular programmes with silence and unpopular programmes) but also 'presence' – entertainment programmes also had to be presented (and heard) as special events.

This approach reflected the BBC's obligation to develop its audience's listening skills. If no-one in Britain really knew how to listen to the radio – there was no experience to draw on – then it was up to Reith and his staff to train them, to give them the means to discriminate. An important aspect of Reithian programming was the education of the listener in the process of radio listening itself. The BBC sought to determine what it meant to be a 'listener', and Reith himself believed that his development of the proper skills and standards among the BBC audience would have a significant cultural ripple effect. The classic statement of his position was his valedictory speech:

> That broadcasting should be merely a vehicle of light entertainment was a limitation of its functions which we declined to accept. It has been our endeavour to give a conscious, social purpose to the exploitation of this medium. Not that we underrated the importance of wholesome entertainment or failed to give it due place; but that we realised in the stewardship vested in us the responsibility of contributing consistently and cumulatively to the intellectual and moral happiness of the community. We have broadcast systematically and increasingly good music; we have developed educational courses for school children and for adults; we have broadcast the Christian religion and tried to reflect that spirit of common-sense Christian ethics which we believe to be a necessary component of citizenship and culture. We have endeavoured to exclude anything that might, directly or indirectly, be harmful. We have proved, as expected, that the supply of good things creates the demand for more. We have tried to found a tradition of public service, and to dedicate the service of broadcasting to the service of humanity in its fullest sense. We believe that a new national asset has been created. . . the asset referred to is of the moral and not the material order – that which, down the years, brings the compound interest of happier homes, broader culture and truer citizenship.[13]

Reith is usually – and rightly – described in terms of moral and cultural arrogance but his position also rested on a number of psychological

assumptions about people's 'needs'. At the beginning of his wireless career, in 1924, he wrote that,

> entertainment, pure and simple, quickly grows tame; dissatisfaction and boredom result. If hours are to be occupied agreeably, it would be a sad reflection of human intelligence if it were contended that entertainment, in the accepted sense of the term, was the only means for doing so.[14]

For Reith 'pure entertainment' meant 'to occupy agreeably', but he rejected the suggestion that 'jazz bands and sketches by humorists' could do this for long. Pop music, as C. A. Lewis put it,[15] had 'nothing really satisfying in it. It is a drug, and when one drug fails to operate a new one must be prescribed'. The BBC's music policy was, therefore, to encourage 'better, healthier music'. To begin with, pop music had to be broadcast, but tastes would soon be 'lifted' – listeners' 'present standard of musical appreciation' simply reflected the fact that most of them had never had the chance to go to the Albert or Wigmore Halls. Once they had heard classical music, though, they would realise its superiority to popular tunes:

> *The music doesn't wear.* It cannot be repeated, whereas good music lasts, mellows and gains fresh beauties at every hearing. It stands, like Shakespeare, through the centuries. No passing craze can shake it. It is the product of greatness, and greatness leaves its mark and endures.[16]

The constant repetition of classical music was Lewis' confident response to the listeners' complaint that the BBC did not broadcast enough popular sounds:

> I prophesy that ere many years have passed a Beethoven symphony or a piano concerto will be every bit as popular an item in our programmes as half-an-hour's dance music.[17]

Tom Burns, like many other commentators, has concluded that with reference to music, at least, Reith's arguments about broadcasting and enlightenment were justified: 'perhaps the greatest single achievement of the BBC has been to transform this country from what was musically the most barbarous nation in Europe into what has some claims to be the musical capital of the world.'[18] This seems to me an unduly complacent reading. The BBC's music policy – its early financial involvement in opera and the proms, for example – was less significant as an exercise in national education than as an expression of support for an existing way of musical social life. Other, non-middle-class uses of music were not treated with such 'discrimination'.

The same set of attitudes was obvious in the Drama Department. Val Gielgud later wrote that his producers' task was to introduce drama to people who had never been to a theatre, to educate in them a 'willingness' to listen, to teach them 'that drama can be a satisfying and rewarding entertainment':

Radio drama never made, by its essence, it never could make what is called 'easy listening' . . . its audience had to be 'built up' . . . an audience which in the beginning was bound either to be 'minority' and in consequence cranky or 'majority' and in consequence 'moronic'. To have chosen the latter target would have been as fatal as it would have been easily popular. And but for the Consistency of Policy at the highest level, and consistency of control at my own, backed by strong personal beliefs and convictions, BBC Drama might have fallen into the translatlantic trap, and gained nothing from its freedom from the quirks, whims and occasional imbecilities of commercial sponsors.[19]

In practice, though, Gielgud's chief concern was with the norms of the established middle-class theatre. His department mostly broadcast West End plays, classics and adaptations of novels. There were 'young experimenters' on Gielgud's staff, but, as he wrote,[20] 'much credit is due to the more old-fashioned stalwarts, such as Howard Rose, who got little of the limelight reserved for the more youthful experimentalists, and yet was quietly building, by steady, unostentatious and perhaps prosaic method, the regular audience of the middle-class fireside.' For Gielgud (and Rose), radio drama was most suited to 'the presentation of characters and situations which the audience can easily identify with its own experience', experience symbolised by the BBC's first soap opera (or 'family serial'), *The English Family Robinson*, which began in 1938. If Gielgud's difficulty was to 'hold a reasonable balance between the claims of intelligent, interesting aesthetics and of normal, accepted standards of entertainment', he had, apparently, no difficulty in deciding what were 'intelligent aesthetics', what were 'normal standards of entertainment'.

The BBC's work in putting together a new sort of national audience was not confined to its coverage of politics and public affairs. Its account of 'normal standards of entertainment' was equally important. C. A. Lewis, using typical BBC rhetoric, praised radio for 'bringing all classes of society into closer touch with their neighbours, and so fostering that mutual trust and understanding which is essential for the well-being of a great democracy'. Reith argued that if radio was to become 'valuable as an index to the community's outlook and personality . . . it was of first importance that the service should be trusted; it must not abuse the confidential footing it had obtained on every man's hearthrug.'[21]

Entertainment's contribution to these ideas of democracy, neighbourliness, the community's personality, lay in its organization of family life: what bound listeners together was *where* they listened. In 1923 the Marconi company claimed that,

many of the older people regret the scattering of the young folk to their various occupations and amusements, and think sadly of the old-fashioned 'family' evening. But broadcasting has brought this back again.[22]

And the 'radio hearth' featured heavily in the advertising of all wireless

manufacturers. Lewis, from the BBC, argued the point even more aggressively:

> Broadcasting means the rediscovery of the home. In these days when house and hearth have been largely given up in favour of a multitude of other interests and activities outside, with the consequent disintegration of family ties and affections, it appears that this new persuasion may to some extent reinstate the parental roof in its old accustomed place, for all will admit that this is, or should be, one of the greatest and best influences on life.[23]

The BBC celebrated the radio hearth in numerous ways, quickly associating itself with the development of the Royal Family, for instance. The implications of domestic listening were clearly symbolized by its *Children's Hour*, 'the pause in the day's occupations' (the quotation was taken from Longfellow), when the corporation's senior personnel became Aunts and Uncles. The *Children's Hour* was obviously part of middle-class family routine and Reith was clear about the significance of this model for working-class children: it offered them 'a happy alternative to the squalor of the streets and backyards'.[24] This idea of domesticity as warm, glowing, safe and loving became just as important for commercial broadcasters – the Ovaltineys live on in television advertisements.

In terms of light entertainment, the contrast of the home and the street had an even wider class significance. As Michael Chanan has written about the development of nineteenth-century pleasures, 'the family cradled the consciousness of the middle-classes while popular working-class consciousness was formed on the streets and on the public stage.'[25] Working-class entertainment was collective, disorderly, immediate – 'vulgar' by definition. Middle-class entertainment was orderly, regulated and calm, and it was this aesthetic that informed the BBC's understanding of listeners' leisure needs. Reith, for example, acknowledged the BBC's obligation to provide relaxation: 'mitigation of the strain of a high-pressure life, such as the last generation scarcely knew, is a primary social necessity, and that necessity must be satisfied.'[26]

Entertainment-as-relaxation meant that no-one should be *disturbed*. A 'hearty laugh', music hall-style, was fine, but as Hilda Matheson observed,[27] 'humour on the microphone has to take into account grandmothers and schoolboys, navvies and invalid ladies, town and country, north and south, rich and poor, sophisticated and unsophisticated', and none of these listeners must be laughed *at*. For the BBC Music Department, meanwhile, the problem was to find 'good light songs', 'music with attractive melodies, used and harmonised with distinction of thought and fancy':[28]

> Generally speaking, when a man gets home tired and 'fed up' he wants to be cheered by a good, lilting tune and harmony that is distinctive without being so 'modernistic' as to disturb the increasing tranquillity of his mental state. Sullivan and Edward German fill this want so adequately that a

TO THE WOMEN OF BRITAIN

The Radio has undoubtedly helped you to keep your husband and boys away from the club and kept them at home where they thus experience the benefits of your gentle charm and influence, but you must now go *one step further* and make your home comfy and cheerful by having Hailglass Shades and Globes on your lights. Hailglass is made only by Hailwood & Ackroyd, Ltd., Morley, near Leeds. It is made in beautiful opals and is decorated or tinted with lovely colours and designs. Each piece is marked "Hailglass." Don't let your supplier foist upon you foreign glass which is made under sweated conditions. Your supplier gets a reasonable profit on our glass. We are putting up a hard fight in the face of unfair foreign competition and against certain atrocious British dealers who want *excessive profits*. Please help us to keep the Trade and British Money in Britain. Your menfolk, as they listen to the Radio in a home made bright and comfy by our charmingly coloured glassware, will indeed feel that they are in a real "Heaven on Earth," and you women of England will mutually join in this pleasure. We have an enormous range of sizes, shapes and designs.

Head Office and Works: MORLEY, Near Leeds

Showrooms { 98 Mansell Street, LONDON, B. 1
32 Shaftesbury Avenue, LONDON, W. 1
21 Waterloo Street, GLASGOW

Women and the wireless: from the *BBC Handbook* 1928.

programme of works by these thoroughly 'English' composers is always welcomed.[29]

Relaxation was earned by hard work and only made sense in reference to it. The spread of suitably entertaining radio programmes would, in C. A. Lewis' words, 'of necessity, promote a healthier and more cheerful mental outlook on work and life, and this in its turn will react on their work itself to the benefit of all concerned'. By the 1930s, radio was playing a significant role in the organization of the rhythms of work and leisure. The BBC Sunday, for example, reflected not only Reith's Protestantism, but also his staff's wider set of assumptions about the place of the weekend in the organization of family life. As the *Radio Times* Music Editor put it in 1930, 'the BBC has always tried to frame these Sunday programmes in a way which might blend the maximum of wholesome brightness with the atmosphere of quiet leisure about the hearth.' Quiet leisure was so central a BBC idea that is a jolt to read that D. G. Bridson (then a producer based in Manchester) wanted to use radio drama to capture something of the *spectacular* appeal of 'film makers like D. W. Griffith and Cecil B. de Mille'. Bridson believed that radio should be a source of emotion – he used verse, for example, to 'charge' his features, not simply as a sign of artistic seriousness, and so in the 1930s he remained an unusual (and unusually high-brow) BBC figure. More typical was Jack Payne, leader of the BBC's first in-house dance band, who described his job as 'to put happiness and sunshine over the air'. His arrangements were made to provide 'moments of relaxation' – not rhythm, but variety: 'plenty of solo work and clever orchestrations are necessary before the microphone, and the melody must be brought out.' A popular song was, he wrote, 'one which everyone can pick up and hum and sing as they feel disposed. After all, no one wants to listen to jazz seriously.'[30]

In his history of music and the middle-class in the nineteenth century, William Weber shows how 'classical' concerts became important public occasions as the link between the bourgeois family and bourgeois society. Shared tastes became symbolic of shared class interests, and concerts were public displays of a particular sort of exclusive community. (And thus they provided a suitable setting for courtship – all the young people on display could be guaranteed eligible.) Artistic judgements were, in other words, tied up with questions of status. 'The art must not be degraded,' wrote a columnist in the *Music World*. 'To play the finest music to an audience which has been admitted at a shilling apiece is what I can never give my consent to.'[31]

It was this model of how entertainment could work to bind together a community that underlay the BBC's vision of a 'common culture' in the 1920s and 1930s. BBC ideology also implied that membership of (and exclusion from) the listening 'public' was, in fact, a matter of right attitudes, shared interests. In one sense, the BBC, as a mass middle-class

medium, faced an obvious problem: how to articulate the *borders* of middle-class taste while being accessible to everyone. But in practice radio use was something that spread down the class ladder and in Britain, at least, the wireless was defined initially as an aspect of middle-class leisure. Even though half the population had a radio by 1934, for example, ownership remained concentrated in the South East and Midlands and was sparsest in the North East and South Wales. Indeed, Mark Pegg[32] argues that the BBC did not really have a solid working-class audience until the spread of the 'utility' set of the 1940s. Even such populist pressures on BBC programming as the *Daily Mail* radio ballot of 1927 were, essentially, middle-class pressures. When the Radio Manufacturers Association began its campaign for audience research and popular shows in the mid 1930s it was in the face of the exhaustion of the middle-class consumer market. New sales meant attracting *new* radio listeners – it was their tastes that needed investigation. There is little evidence that the demands of the *existing* audience for entertainment (reflected in the rising audience figures of the commercial stations, for example) were working-class demands. What was at issue was not different sorts of popular programme, but more of them.

The Reithian principle of broadcasting as enlightenment meant, in practice, that BBC programmes offered listeners direct access to the middle-class community. The pleasure of a BBC 'talk', for example, rested on the assumption that a BBC talker had a particular kind of class authority. Early in the BBC's life, Reith wrote to his regional directors:

> In some stations I see periodically men down to speak whose status, either professionally or socially, and whose qualifications to speak, seem doubtful. It should be an honour in every sense of the word for a man to speak from any broadcasting station, and only those who have a claim to be heard above their fellows on any particular subject in the locality should be put on the programme.[33]

As D. G. Bridson commented:

> That the man in the streets should have anything vital to contribute to broadcasting was an idea slow to gain acceptance. That he should actually use broadcasting to express his own opinions in his own unvarnished words was regarded as almost the end of all good order.[34]

When Bridson did eventually get *Harry Hopeful's Northern Tours* on air (this was an early version of *Down Your Way* – Harry Hopeful, actor Frank Nicholls, travelled to towns and villages in Yorkshire and Lancashire and talked to inhabitants about their lives and work), it was described in the BBC *Yearbook* as a programme of interviews with 'peasants from remote northern districts'. The BBC's usual treatment of 'common' speakers was showcased, rather, by *In Town Tonight*, started by Eric Maschwitz in 1933 on the assumption that his listeners were interested in 'the human verities, the simple fascinating things that

humble folk do, and the high points achieved by men and women of distinction'.[35]

The language here – humble folk, men and women of distinction, Reith's sense of honour – reflects the way in which the BBC's 'common culture' was, at the same time, hierarchically ordered. Listeners were equally honoured to have distinguished people in their homes. This was most obvious in the BBC's treatment of public events. The Outside Broadcasting section was soon providing the most 'popular' programmes of all. In these orchestrated dramas of royalty, sport and patriotism, the listener was addressed as a loyal, grateful spectator/citizen/subject. The listener, in other words, was carefully fixed at the bottom of the chain of privilege that ran from the performers through the commentators into the home.

The same principle was apparent in light entertainment. Producers pointed to the difference between the radio listener – domestic, private – and the usual musical or show-biz public, a crowd gathered for a special occasion. The problem was to fit entertainment as occasion into an intimate routine, to take pleasures that were essentially live (with elements of risk and uncertainty) and script them so that nothing untoward happened. The solution lay in the development of a particular sort of *voice* – intimate and authoritative – and a particular sort of *personality* – relaxing and knowable. The radio star was public figure as private friend. As Leonard Henry, one of Britain's first successful wireless comics wrote: 'it is one of the great charms of broadcasting that we manage to get this intimate family kind of atmosphere through the mike and out of your loudspeakers'.[36] The honour for the listener in this case was to be invited to sit at someone else's hearth.

The BBC began broadcasting dance music in 1923 – the Savoy Havana Band from the studio, live music from the Carlton Hotel. By 1924 the Savoy Orpheans' relay was a weekly routine. By the end of the 1920s the BBC finished each weekday with a band: Lew Stone on Tuesdays, Harry Roy on Fridays, Ambrose on Saturdays, and so on. There were various attempts to change this pattern. Jack Payne, for example, argued that 'dance music should not just become a habit; there must be something else worthy of concluding each day's task – conversely I never saw any reason for putting the bulk of dance music right at the end of the day.'[37] But Payne, as leader of the BBC's own dance band, broadcast every afternoon, as well as in the evenings, and there continued to be an audience demand for live name bands, outside broadcasts, and dance music as late evening listening.

Dance music was American music and the bands were often taken by the BBC's critics (and by subsequent commentators) as symbols of the sort of popular entertainment that Reith had to broadcast, despite himself. But this is misleading. From the beginning this American music signified a British way of life: syncopation in 'a high-class setting', entertainment defined in terms of upper-class glamour and relaxation.

The family audience. John Gilroy, *Radio Times*, 15 April 1938.

The dance bands came from smart hotels or exclusive clubs such as the Embassy. This was not 'popular' music in proletarian terms. Rather, the radio hearth became the setting for vicarious high living. As Albert McCarthy has commented:

> The locations of the major dance bands in England were hotels like the Savoy and the Mayfair, bastions of a class society, with a clientele that was conservative in both politics and taste, and unlikely to extend a welcome to an influx of younger people from the lower orders.[38]

For this audience, jazz was an occasionally exhilarating novelty but too complicated for normal dancing needs. When the Fred Elizalde Band tried playing 'real American music' in 1927, 'the paying customer at the Savoy complained that the band was difficult to dance to; radio audiences complained that they couldn't recognise their favourite tunes dressed up as they were in the filigreed finery of jazz orchestration'. Elizalde was soon off the air, and his experience became that of any band leader who wanted to 'swing' his tunes: 'the BBC and the recording companies would raise their hands and cry "not commercial" anytime the bands tried something more adventurous.' In 1935 the BBC formally banned 'hot music' and 'scat singing', citing listeners' objections. Jazz remained, in Philip Larkin's words, 'a fugitive minority interest'. While *Melody Maker*, the paper for 'dance band *afficionados*', and Edgar Jackson in the *Gramophone*, were slowly assembling a critical vocabulary to distinguish 'hot dance music' from 'popular rhythmic music', and beginning to explain the superiority of black musicians in terms of greater art rather than 'less polish', the BBC employed as their resident dance band leaders Jack Payne and Henry Hall, who were inspired by

Paul Whiteman and Jack Hylton and the idea of 'symphonic jazz'. Their bands put on a show, featured 'personalities', used crooners who, with the aid of the electric microphone, could blend their voices coolly into the easy-on-the-ear harmonies.[39]

By the end of the 1930s the distinction between commercial and non-commercial 'light' music, between 'real jazz' and pop, between respectable and disreputable entertainers was well established, and the BBC had become central to the organization of the music as commerce. It took the war and military service to free musicians from 'the commercial duress their civilian counterparts were subject to – the demands of the dancers, the caution of the recording companies and the rapacity of the bandleaders'. Only in military bands (like the RAF's Squadronaires) could would-be jazz players pursue their interests. For these musicians, the BBC had never represented a non-commercial, alternative way of making music or entertainment. Rather, it was radio that determined the conservatism of band leaders and record companies. The BBC listener was taken to be 'neither a hopeless low-brow nor a supercilious head-in-the-air high-brow'. The BBC demanded familiar tunes in 'interesting settings' and with familiar rhythms – in other words, waltz or fox-trot. As Terpsichorean (dance music reviewer for the *Gramophone Critic*) had earlier observed, the average British listener did not understand 'jazz language': to describe something as 'loud and crazy but mean' was to talk nonsense. The British were fans of 'straight' dance music.[40]

The BBC was well aware of its own commercial significance, and there were numerous discussions about how to prevent song- or record-plugging – in 1929 bands were banned from announcing song titles or singing title choruses, for example. But the BBC's importance for pop was not just as a means of advertisement. The BBC was also instrumental in the spread of dancing and the dance band as a normal part of middle-class and respectable working-class leisure. Dancing became a regulated, decorous form of fun, an evening out according to the 'strict tempo' of Victor Sylvester and his schools of dance. The upper-class bands which the BBC used found themselves with a reputation, a popularity, that spread far beyond their initial exclusive clientele. Band leaders like Jack Payne could sell out provincial theatres and dance halls all over the country; dance bands were added to the attractions of the newly opening holiday camps. And if 'records were important in spreading the popularity of the dance bands', it was, as McCarthy notes, 'success gained from broadcasts that led to bands being sought after and built up by record companies'.[41]

The relationship between radio and the record companies marked a general shift in cultural power in the 1930s – from Tin Pan Alley to Broadcasting House. The emergence of the BBC as the most significant source of musical entertainment meant a change in the organization of popular music – from the publisher/showman/song system to the record company-based star system. In 1933, for example, the BBC changed its song-plugging rules: dance programme producers now dealt directly with

the band leaders rather than the venue managers. Dance programmes were organized less and less as 'transparent' broadcasts of live events, more and more as specially designed radio shows. The judgement (and judges) of what was a good number, a good performance, shifted accordingly. The 'popularity' of pop music became measured by its radio suitability and by record sales – immediate, live, collective audience response mattered less and less.[42]

Christopher Stone, the BBC's first disc jockey, suggested that 'the broadcaster's job is to provide the equivalent of a bath and a change for the tired man's and the tired woman's mind', and, in general, Stone was the voice and had the tastes of the BBC's middle-brow listeners. Ronald Pearsall has suggested that the BBC's 1920s music policy is best understood as a middle brow attempt 'to make classical music popular and popular music classical', but this approach was not confined to Reithians or the BBC. The British record industry was, equally, run by men and women with little experience of or interest in popular culture or popular taste. They too began with the assumption that pop music was worthless – it was its worthlessness that made it commercially exploitable.[43]

The BBC's account of popular music reflected, then, more generally changing attitudes of cultural entrepreneurs towards their audiences. These changes were the effect of the mass media themselves on the power structure of entertainment. The BBC and the record companies spoke differently about audience needs – the record companies in terms of market choices, the BBC in terms of 'giving the public something slightly better than it now thinks it wants'. But with regard to popular music, they both treated listeners the same way: as a mass public with a mass taste, rather than as a number of specific publics with specific tastes. The pop audience was seen as a series of individuals, listening and buying privately rather than publicly. And so there were not really many differences between the BBC's use of pop and Radio Luxembourg's – record companies like Decca learnt from the BBC how to use the time they could buy from Luxembourg and Radio Normandy. The real contrast was with pre-BBC, pre-radio, pre-record entertainment. Popular music had been dominated by promoters and music hall owners and publishers; their skill had been to manage an immediate experience, to understand and service *particular* publics. And the rise of the mass musical media meant, too, a new sort of performing star, with domestic 'charm' rather than larger-than-life appeal.

Not surprisingly, the BBC had an uneasy relationship with British show business. Promoters and managers, and the performers themselves, held aloof from broadcasting. In the 1920s, for example, outside transmissions from music halls and theatres were not allowed: the Society of West End Theatre Managers did a deal with the BBC for the broadcast of play excerpts in 1925, but the Variety Artists Federation remained hostile. The BBC's variety producers themselves were neither recruited from this world nor knew much about it. In 1934 the head of

Variety claimed that the 'war' with music hall was at an end, but it was clear by then that radio Variety bore little resemblance to traditional music hall performances.[44]

This partly reflected the long broadcasting boycott itself. George Black, for example, reintroduced the radio ban on his acts in 1931. By 1932, when his agency, management and theatre company, GTC, merged with Moss Empires, he controlled almost half the performers the BBC had been using. But in developing its own comedy and musical acts, the BBC was also developing its own performing conventions, and music hall stars, even when available, were often unsuitable – too visual, too ribald, too spontaneous, too large; the more middle-class concert parties and revues were a better recruiting ground. Meanwhile, the new radio stars also had to make a living. They could not survive on BBC fees alone, so they had to use their radio name as the draw for a new type of public show – the appearance of the voice, the local display of national attractions, the 'in-person' performance of stars who were much better 'known' in the living room than they ever could be in a theatre. By the end of the 1930s, the BBC was no longer getting its entertainers from the stage – rather, the stage was getting its entertainers from the BBC. Even Christopher Stone had appeared at the Palladium and toured the provinces playing records. The BBC's 'non-commercial' principles of entertainment now determined what commercial entertainment itself sounded like.

'Whole sections of the working-class,' wrote George Orwell influentially in *The Road to Wigan Pier* in 1937, 'who have been plundered of all they really need are being compensated, in part, by cheap luxuries which mitigate the surface of life.' Orwell included radio in his list of working-class palliatives, but 'cheap luxury' does not really seem to describe British broadcasting, and reading the memoirs and public statements of the BBC's employees themselves I was reminded rather of an Orwell passage that other middle-class socialists did not much like:

> All my notions – notions of good and evil, of pleasant and unpleasant, of funny and serious, of ugly and beautiful – are essentially *middle-class* notions; my taste in books and food and clothes, my sense of honour, my table manners, my turns of speech, my accent, even the characteristic movements of my body, are the products of a special kind of upbringing and a special niche about half-way up the social hierarchy.[45]

The same is true of all the BBC's tastes and notions – notions of entertainment included. Eric Maschwitz, the head of Variety from 1933, had a taste for Viennese opera and wanted to organize BBC light music round European rather than American standards. Val Gielgud, the head of Drama, had a taste for well made plays and despised the semi-educated 'puppy-like' mass audience. Jack Payne (who in the General Strike volunteered to drive a London bus) wanted to make jazz 'tasteful'.

The suggestion has often been made (by Asa Briggs most powerfully[46]) that between the wars the BBC was the site of a cultural struggle – entertainment versus enlightenment – which was not resolved until Reithianism was finally routed in the 1940s. Reith's achievement, in other words, was to *prevent* radio being used as mass culture, as a cheap luxury. But this is to accept Reith's own definition of mass culture – as the lowest common denominator of taste, as 'vulgar' by definition. Reith feared an Americanized popular culture that would exclude Britain's educated, 'cultured' elite from the processes of both production and consumption, and the BBC represented his counter-stroke. By keeping broadcasting in cultured hands, he would halt the emergence of the mass audience. In practice, though, Reith faced the same problems as any other broadcaster: how to build up and respond to a new home-based public. The BBC did not have to deliver its audience to commercial sponsors, but it was still a mass medium. We should drop the idea that mass culture has to be American, Hollywood, 'popular'. The BBC was central to another process: the creation of mass, British, *middle-brow* culture. To make sense of British broadcasting we have to relate it to the bourgeois best-sellers analysed in Q. D. Leavis's *Fiction and the Reading Public*, to the British commercial cinema's dependence on actors and writers and dramas drawn from the West End stage, to the values embedded in the *Daily Mail* and *Daily Express*, to the multi-media success of someone like J. B. Priestley.

The mass-culture debate in the 1930s was, as Orwell implied, a debate about needs. Working-class consumption, it seemed, could no longer be defined in terms of subsistence. The very idea of a 'luxury' was becoming suspect, could no longer be confined to bourgeois commodities. The problem was that if new inventions, new goods, could create their own need (no-one had 'needed' a radio before it was invented) then the concept of need itself had to be re-thought. 'Real' needs were based on obvious material problems (food, shelter, warmth). 'Superficial' needs, by contrast, appeared to reflect irrational choices: why did people pick out one fashion rather than another? One sort of washing powder? One tune? Tastes and preferences became a matter of expert investigation – the National Institute of Industrial Psychology was founded in 1921, and psychologists had soon established themselves too as marketing consultants. Advertising was the symbol of mass culture as the manipulation of desire.

The BBC disdained this role and scorned, in Val Gielgud's words, 'the imbecilities of commercial sponsors',[47] but it too had to make assumptions about audience needs, assumptions that shaped the pleasures on offer. Light entertainment, in particular, was defined in terms – balance, access, community – that cannot be separated from an account of the audience gathered round an essentially middle-class hearth. Balanced entertainment thus meant not pluralism, numerous different sorts of humour and music, but relaxation, programmes guaranteed soothing ('wholesome') by their exclusion of all excesses. Balance in light music

meant, similarly, avoiding both sounds that were too high-brow *and* sounds that were too low-brow.

The radio made public events accessible, brought them into the home – outside broadcasting was particularly significant for this process, but at this time *all* broadcasts were live. This was the basis for Reith's claim for radio's contribution to democracy. All listeners could take part in an event equally; no-one's living room was more or less privileged. It was a misleading claim. Domestic listening was a very peculiar form of public participation and the key role was played by the commentator, the BBC talker whose job was, in practice, to teach the audience how to join in a radio event, how to organise their experience. Access was available, then, through an authority. 'Active' listening was a matter of knowing one's place. What was on offer was access to a community, a language, a set of radio manners. To become a BBC listener was to join a club (children could do so literally) which clearly excluded people with bad radio manners – the 'tap' listeners, the passive consumers. The 'I/we/you' of the BBC announcer was, therefore, subtly arranged. The message was that the BBC was honoured to enter your home; the assumption was that your home was a particular kind of place; the promise was that if it was not the BBC, by entering, could make it so. Again, *Children's Hour* with its BBC Aunts and Uncles is the most direct example.

What matters about this is not that the BBC expresses 'middle-class ideology' (an obvious point), but that because of its ideology the BBC developed particular sorts of pleasure. The enjoyment of the wireless came to depend on the processes of *flattery* and *familiarity*. BBC audiences were flattered by a tone of voice, by speakers, comics, singers, addressing them directly, as if each individual listener's pleasure mattered to them personally – compare Stanley Baldwin's radio talks with traditional political rhetoric, for example. Flattery meant offering a sort of knowledge – the King speaks just to you, you can get to know him – which both confirmed the 'ordinariness' of public performers (the new definition of 'personality'), but also structured the 'ordinariness' of the listener – if they are just like us, we must be just like them. Ordinariness became the measure of authenticity, confirmed listeners' sense of belonging. (This was not confined to the BBC, of course. The audience was constructed in similar ways by cinema newsreels and daily newspapers.) The pleasure of familiarity came partly from the radio's organization of time – broadcasting provided a predictable rhythm to leisure – and partly from the use of repetition – the radio audience became the community of the catch phrase. Either way, expectations were always confirmed, and this, in the end, was the joy of listening. The BBC represented its listeners to themselves. What was (and is) enjoyable is the sense that you too can become significant by turning on the switch.

Notes

1 *Towards Standards of Criticism*, ed. F. R. Leavis, (Lawrence & Wishart, London, 1976), p. xvi.

2 B. Bergonzi, *Reading the Thirties* (Macmillan, London, 1978), p. 143. And see D. Hebdige, 'Towards a cartography of taste' in *Block 4* (1981), pp. 42–3.

3 Quoted in Bergonzi, *Reading the Thirties*, p. 142.

4 Quoted in P. Scannell and D. Cardiff, 'Serving the nation: public service broadcasting before the war' in *Popular Culture Past and Present*, eds B. Waites, A. Bennett and G. Thompson, (Macmillan, London, 1981), pp. 180–1. And see T. Burns, *The BBC: Public Institution and Private World* (Macmillan, London, 1977), pp. 38–9.

5 Quoted in R. Manvell, *On the Air* (Andre Deutsch, London, 1953), p. 46

6 Burns, *The BBC: Public Institution and Private World*, p. 42.

7 See D. G. Bridson, *Prospero and Ariel* (Victor Gollancz, London, 1971), p. 205; B. Coulton, *Louis McNeice in the BBC* (Faber & Faber, London, 1980), pp. 44–5; V. Gielgud, *British Radio Drama 1922–1956*, (Harrap, London 1957), p. 195; M. Pegg *British Radio Broadcasting and its Audience, 1918–1939* (Oxford D. Phil, 1979), pp. 199, 227–31.

8 See Scannell and Cardiff 'Serving the Nation'; P. Scannell, 'Music for the multitude? The dilemmas of the BBC's music policy, 1923–1946' in *Media Culture and Society*, 3, 3 (1981); D. Cardiff 'The serious and the popular: aspects of the evolution of style in the radio talk, 1928–1939' in *Media Culture and Society*, 2, 1 (1980).

9 See A. Briggs, *The History of Broadcasting in the UK*, volume 1, (Oxford University Press, London, 1961), pp. 235–9.

10 Young also argued that 'your wireless set, however simple or however elaborate, should never be an ugly thing', *BBC Handbook 1928* (BBC, London, 1928), pp. 115, 349–51. And see F. Young, *Shall I Listen: Studies in the Adventure and Technique of Broadcasting* (Constable, London, 1933), pp. 70–6.

11 Hilda Matheson, *Broadcasting* (Thornton Butterworth, London 1933), p. 156; C. A. Lewis, *Broadcasting from Within* (Newnes, London, 1942), pp. 114–115; V. Gielgud, *Years of the Locust* (Nicholson and Watson, London, 1947), pp. 103–4. And see A. Briggs, *The History of Broadcasting in the UK*, volume 2 (Oxford University Press, London, 1965), p. 74.

12 Manvell, *On the Air*, p. 57.

13 Quoted in J. C. W. Reith, *Into The Wind*, (Hodder and Stoughton, London, 1949), p. 116.

14 J. Reith, *Broadcast Over Britain* (Hodder and Stoughton, London, 1924), pp. 147–8

15 Lewis, *Broadcasting from Within*, pp. 51–2, 155. And see Briggs, *The History of Broadcasting in the UK*, vol. 1, pp. 81, 251–3.

16 Lewis, *Broadcasting from Within*, p. 51.

17 Lewis, *Broadcasting from Within*, p. 52.

18 Burns, *The BBC, Public Institution and Private World*, pp. 19–20.

19 Gielgud, *British Radio Drama*, pp. 33, 5.

20 Ibid. pp. 60–1, 68, 89. And see Gielgud, *Years of the Locust*, chapter IX.

21 Lewis, *Broadcasting from Within*, p. 175; Reith, *Into the Wind*, p. 135.

22 Marconi advertisement, quoted in S. Briggs, *Those Radio Times*, (Weidenfeld and Nicolson, London, 1981), p. 87.

23 Lewis, *Broadcasting from Within*, p. 176.
24 Reith, quoted in *Those Radio Times*, p. 97.
25 M. Chanan, *The Dream That Kicks*, (Routledge and Kegan Paul, London, 1980), p. 148.
26 *BBC Handbook 1928*, p. 34.
27 Matheson, *Broadcasting*, p. 160.
28 *BBC Handbook 1928*, (BBC, London, 1928), p. 89.
29 Matheson, *Broadcasting*, p. 160.
30 Lewis, *Broadcasting from Within*, p. 176; Briggs, *Those Radio Times*, p. 148; Bridson, *Prospero and Ariel*, pp. 57–8; Jack Payne, *This Is Jack Payne* (Sampson Low Marston, London, 1932), pp. 56–8, 83; Jack Payne, *Signature Tune*, (Sampson Low Marston, London, 1947), pp. 109–11.
31 W. Weber, *Music and the Middle Class*, (Croom Helm, London, 1975), pp. 26, 30–3.
32 See Pegg, *British Radio Broadcasting and its Audience, 1918–1939*, and Scannell and Cardiff, 'Serving the nation . . .', pp. 185–8.
33 Quoted in Briggs, *The History of Broadcasting in the UK*, vol. 1, p. 256. See Cardiff, 'The Serious and the popular . . .' for a much fuller discussion of radio talk.
34 Bridson, *Prospero and Ariel*, pp. 51–2.
35 See Coulton, *Louis McNeice in the BBC*, p. 42; J. C. Canell, *In Town Tonight*, (Harrap, London, 1935).
36 L. Henry, *My Laugh Story*, (Stanley Paul, London 1937), p. 36.
37 Payne quoted in A. McCarthy, *The Dance Band Era*, (Spring Book, London 1971), p. 76.
38 ibid. pp. 129–130. And see R. L. Taylor, *Art, an Enemy of the People*, (Harvester, Hassocks, 1978), pp. 145–9.
39 See S. Colin, *And The Bands Played On*, (Elm Tree, London, 1977), pp. 45, 86.
40 *The Gramophone Critic and Society Review*, Oct. 1928 and July 1929. And see Colin, *And The Bands Played On*, pp. 87–9.
41 McCarthy, *The Dance Band Era*, p. 54.
42 I discuss this in more detail in 'The Making of the British record industry, 1920–1964', in *Impacts and Influences*, eds J. Curran, A. Smith and P. Wingate (Methuen, London, 1987).
43 See Christopher Stone, *Christopher Stone Speaking*, (Elkin Mathews and Marrot, London, 1933), passim; R. Pearsall, *Popular Music of the 1920s*, (David & Charles, Newton Abbot, 1976), chapter 1.
44 For the BBC's relationship with show business see Briggs, *The History of Broadcasting in the UK*, vol. 1, pp. 251–3 and vol. 2, pp. 89–94.
45 G. Orwell, *The Road to Wigan Pier*, (Penguin edition, Harmondsworth, 1962), pp. 80–1, 141.
46 See Briggs, *The History of Broadcasting in the UK*, vols 1, 2, *passim*.
47 Gielgud, *British Radio Drama*, p. 37.

Playing with Real Feeling – Jazz and Suburbia

The American spectre

> Britain has several languages and a multiplicity of accents, but the *voice* that dominates British pop is a commercial construct, a phoney diction that says more about our slavish relationship to America than it does about popular expression.[1]

So writes Stuart Cosgrove in a 1987 *City Limits* feature on rock's thirty-sixth birthday. 'It was only with the emergence of Rock'n'Roll,' explain Trevor Blackwell and Jeremy Seabrook, 'that the full impact of American culture thrust to the very heart of working-class experience',[2] and the search for a surviving British pop voice has been an obsessive theme of left-wing cultural criticism ever since. But even before the impact of Elvis and company, there was recurring anxiety about the effect of American music on working-class expression. In 1957 Richard Hoggart brooded in *The Uses of Literacy* on the decline of 'the open-hearted and big-bosomed' songs and singers of his pre-war childhood, while in 1946 vaudeville historian Ernest Short noted that,

> popular songs dating back to the turn of the century reflected the humorous outlook of the Cockney, the Lancashire lad, the Yorkshire lassies, the Tynesider, and the factory hand from 'Glasgie' rather than that of some alien with no firmer hold upon a traditional social atmosphere than an East side New Yorker in the pay of Tin Pan Alley, as is so often the case today.[3]

For Mass-Observation in 1939, 'The Lambeth Walk' was thus remarkable as a *revival* of community music:

> It proves that if you give the masses something which connects on with their own lives and streets, at the same time breaking down the conventions

of shyness and stranger-feeling, they will take to it with far more
spontaneous feeling than they have ever shown for the paradise-drug of the
American dance-tune.[4]

This left-wing dismissal of American pop as a 'paradise-drug' was
matched by conservative contempt for what Rudyard Kipling called 'the
imported heathendom' of 'Americanised stuff', and even before the First
World War there were, from this perspective, disturbing developments:

> With the passing of the old, healthy sensual (but not sensuous) English
> dances came the rushing in of alien elements; chiefest and most deadly, the
> cake-walk, a marvellous, fascinating measure of tremendous significance.
> The cake-walk tells us why the negro and the white can never lie down
> together. It is a grotesque, savage and lustful heathen dance, quite proper in
> Ashanti but shocking on the boards of a London hall.[5]

The twin themes of Americanization – corruption of working-class
culture from above (the pop commodity, large-scale commerce) and
corruption of national culture from below (allegedly by Blacks, Jews, the
masses) – are easily confused. It has become an orthodoxy of cultural
studies that left and right responses to mass culture are in fact different
facets of the same bourgeois defence. 'For there we have it,' writes Iain
Chambers,

> the howls of protest and outrage that accompanied the flamboyant signs of
> a post-war recovery and, by the second half of the 1950s, a newly
> discovered consumerism were not only directed westwards across the
> Atlantic. The fundamental target was industrial society itself. . . 'Educated'
> comment and opinion leaders, generally far removed from the daily
> workings and experience of post-war popular urban culture, claimed that it
> contained the alarming ability to 'level down' culture and sweep it away. . .
> By the 1950s, popular culture was clearly flourishing without the parochial
> blessing and participation of *that* culture. It was increasingly indifferent to
> the accusations launched against it from 'above'. Existing beyond the
> narrow range of school syllabuses, 'serious' comment and 'good taste',
> popular concerns broke 'culture' down into the immediate, the transitory,
> the experienced and the lived.[6]

For Chambers, 1950s 'American' mass culture *was* urban British
popular culture, its authenticity (its 'livedness') guaranteed by its
'heathendom': it was the black elements of the new pop music that made
it relevant for the new experience of age and class and community. In
Dick Hebdige's words:

> Just as the Afro-American musical language emerged from a quite different
> cultural tradition to the classical European one, obeyed a different set of
> rules, moved to a different time and placed a far greater emphasis on the
> role of rhythm, participation and improvisation, so the new economy
> based on the progressive automation and depersonalisation of the

production process and the transformed patterns of consumption it engendered disrupted and displaced the old critical language. This new economy – an economy of consumption, of the signifier, of endless replacement, supercession, drift and play, in turn engendered a new language of dissent.[7]

Hebdige suggests that the British cultural establishment (the BBC, for example) attempted to neutralize pop's subversive language by making it available only after 'elaborate monitoring and framing procedures' – rock 'n' roll was mediated by 'already-established "professional" presenters' such as Pete Murray and David Jacobs. But this move was thwarted by the *materiality* of American goods, by the sound and look and shape of things. Just by being – by being desired – they mocked the values of their working-class users' supposed 'cultural heritage'.

The oppositions set up here – Afro-American *versus* European music, 'popular urban' *versus* 'educated' culture, the dissenting consumer *versus* the established professional – underpin a new reading of pop culture: American sounds cross the sea to liberate not enslave us; the back-beat supplies the symbolic means of *resistance* to bourgeois hegemony. This is a cheering picture but increasingly misleading (the Tories are in favour of such American 'liberation' too – freeing market forces, and all that) and in this chapter I want to make a counter-point: 'Americanization' means not the rise (or fall) of urban subcultures but the increasing importance of *suburbia*. I will argue, in particular, that the 'dissenting' British use of black American music only makes sense in terms of middle-class ideology and that a 'European' sensibility has been just as important to the making of mass culture as American ways of doing things. I quite agree with Hebdige and Chambers that the so-called American 'takeover' really describes a series of local appropriations, but the question is who is doing the appropriating and why.

Making music safe for suburbia – minstrelsy

White men put on black masks and become another self, one which was loose of limb, innocent of obligation to anything outside itself, indifferent to success. . . and thus a creature totally devoid of tension and deep anxiety. The verisimilitude of this *persona* to actual Negroes. . . was at best incidental. For the white man who put on the black mask modeled himself after a subjective black man – a black man of lust and passion and natural freedom which white men carried within themselves and harboured with both fascination and dread.
(Nathan Irvin Huggins[8])

In the 1984 issue of his magazine *Old Time Music*, Tony Russell has an entertaining account of the making of Malcolm McLaren's hit version of 'Buffalo Gals'. Russell had put McLaren in touch with the East Tennessee Hilltoppers, an 'old-timey' family string-band, and band-member Joel

Birchfield's fiddling duly took its place in the mix, together with McLaren's own square dance spiel, lifted directly from the work of the New York caller Piute Pete (as recorded on a 1949/50 Folkways LP). What McLaren did not mention in his gleeful appropriation of American 'roots' music for his own eclectic ends, was that back in the 1850s there were already men and women wandering London's streets in pursuit of a similar livelihood from mixed-up American sounds. These 'Ethiopian Serenaders' had switched from glee songs to minstrel songs under the influence of the visiting Afro-American dancer, Juba. They learnt the latest transatlantic tunes from the barrel organists, and, as one performer told Henry Mayhew, their favourite was 'Buffalo Gals', originally written as a minstrel number in 1844.[9]

Minstrelsy was the first American pop form to leave its mark on British musical culture. But in those days before recording, it reached its audiences more often in local adaptations than as performed by the occasional visiting American troupe. Peter Honri notes, for example, that his great-grandfather, a travelling showman in rural Northamptonshire, billed himself in the 1870s as 'The Original Black Cloud, Eccentric Jester and Funny Instrumentalist'. The 'blackface' songs were just one strand of his act, and when Honri's grandfather, Percy Thompson, began to perform with his father (at the age of five) it was as both a clog dancer and a Minstrel.[10]

The remarkably rapid rise of the minstrel show was as much an English as an American phenomenon, and while there were, no doubt, early complaints about 'foreign' influences, even the original minstrel songs were quickly absorbed into British ways of entertainment – as novelty numbers, as fashion markers, as standards. The music publishing company Francis, Day and Hunter was thus founded on Harry Hunter's songs for the Francis Brothers' Mohawk Minstrels, while David Day was their business manager. The Moore and Burgess troupe, which merged with the Mohawks in 1900, had by then given from nine to 12 performances weekly for more than 40 years – in the 1880s it employed 70 performers, including 18 vocalists, 10 comedians, and 12 'unrivalled clog and statuesque dancers'.[11]

Why were such shows so successful? What was the peculiar appeal to British audiences of these white people acting out black stereotypes? In straight commercial terms minstrels were valuable for their versatility – a minstrel show was a seamless package of pathos, humour and glamour. 'Good clean entertainment in which sentiment and laughter blended', as John Abbott puts it,[12] because what distinguished minstrel evenings from other variety nights was their air of uplift. By the 1850s, minstrelsy was 'a form of family entertainment' in a way that music hall was not: 'a husband and wife could take their children without fear of being asked embarrassing questions afterwards.'

Both real and fake 'blackness' contributed to this. Minstrel songs, particularly the sentimental songs, were drawn more or less directly from spirituals and plantation laments, and writers like Stephen Foster and

Leslie Stuart wrote ballads that were explicitly nostalgic: they gave melodic shape to the pervasive sense of homesickness that lay over the industrial landscape. British city audiences could identify with the pathos of black characters, could register their own yearning for rural simplicity, while being distanced from real blacks (from real working conditions) by the make-up and the comic turns. For the more exalted consumers, the racial connotations of minstrelsy gave the music a moral quality too – the middle class supporters of the anti-slavery movement were already patronizing the black performers who had begun to appear in the various stage versions of *Uncle Tom's Cabin*.[13]

Minstrel songs soon seemed so clearly expressive of British sensibility that some critics doubted their 'Americaness' anyway. Songwriter and *Illustrated News* Editor Charles Mackay concluded, after visiting the USA in 1857–8, that Americans 'have as yet done nothing in music'. He considered the airs called 'negro melodies', 'concocted for the most part in New York', as merely 'refacimenti' of old English, Scottish and Irish tunes. By then, the structure and emotion of minstrel songs had made them ideal fodder for family piano performance – hence the success of Francis, Day and Hunter, and the fame of Stephen Foster, who became friendly with Charles Dickens and the music educator John Hullah, sharing their belief in the necessity of 'home music' for domestic bliss.[14]

In being Anglicized, minstrel music had moved, then, from its early 'earthy robustness and frenzied excitement towards an appeal in refinement and sentimentality', as Michael Pickering explains:

> Much of the original appeal of negro delineators and minstrels had been founded on their singularity and quaintness, the catchiness of their tunes, and the way their odd comicality gave novel features to foolery and clowning. These attractions gradually waned, making minstrelsy's links with Afro-American culture itself even more tenuous. The comic parts became monopolised by the caricature of the 'negro' dandy with his constantly unrealised pretension to grandiloquence whereas the tatter-demalion plantation black became the object, in a much more concentrated fashion, of a sentimental pathos. Essentially 'the trend' was 'away from simplicity and primitive realism' towards a narrower seductive courting of senses and affects.[15]

Minstrelsy used blackface to 'bracket off a cultural space from the moral rules and regulated behaviour of mundane reality',[16] but it did so in a way that was particularly important to the 'respectable' end of the leisure market. Professional British ministrels defined an entertainment that was less vulgar, less materialistic than music hall, but with an equally satisfying emotional and dramatic range, and the suburban takeover of minstrel music did not mean that its racial messages were irrelevant. Rather, black Americans became coded as the 'other' of lower-middle-class relaxation, a source of musical access to one's heart and soul less daunting than bourgeois concert forms. This was to be highly significant for later attitudes to jazz and blues. If the minstrels

were an easy-listening version of strong feeling, black masks were later put on with more excitement – by British jazz musicians from the thirties to the fifties, by British blues and soul bands from the sixties to the eighties. A performer like Mick Jagger did not have to apply burnt cork (just slur his words); the underlying inspiration of 'the subjective black man' was obvious in the Rolling Stones' music (and success) anyway.

Taking care of business

I believe all the tendencies of modern living – of machine civilisation – are to make crippled, perverted things of human beings. The machines are standardizing everything. There never was before such an era of standard-ization as there is to-day in the United States. It invades everything, crushing all the normal impulses of human beings.
Paul Whiteman[17]

In November 1921, *Talking Machine News* (the world's 'oldest talking machine paper' and the first publication to review pop records) ran an aggressive editorial under the title 'Popular music on records – Is there too much of it?' The paper supported the suggestion in the Canadian *Phonograph Journal* that the 'best music' was being submerged by 'the popular hits, the latest fox-trots and jazz blues', and that this was beginning to have an adverse affect on total record sales – people were inevitably getting bored with jazz; it was a sound that could not sustain their interest. *Talking Machine News* added that it was, too, an American sound, and therefore had even less lasting value for Britons:

Jazz and ragtime have occupied the centre of the stage so long to the exclusion of things artistic, that it is high time they were buried further deep, whether in Canadian or American soil we care not.[18]

The hostility of this trade paper (the journal of gramophone and record retailers) to the most popular music of the moment may seem surprising, but the aesthetic objection to 'excessively syncopated song' reflected a commercial fear of being dependent on a fickle, shallow public taste. What would happen when times changed, if the British music industry simply aped the Americans? (The same question was asked 30 years later about rock'n'roll.)

By July 1922, *Talking Machine News* was arguing that in their own interest dealers should try to improve public taste. There was now firm evidence of people turning against the 'unsavoury fare' inflicted by America and wanting something 'more refined and beautiful', and the paper gave its support to the campaign to prevent military bands playing jazz in public – this was 'degrading' the musicians and 'vitiating' the listeners. Dealers were advised to take advantage of the free tuition offered by The Gramophone Company (of whom more later in this chapter). This would give them 'the foundations of a knowledge of

musical works' so that they could advise customers and guide them 'in the right direction' – towards European light and classical music, away from American jazz and ragtime.

The 'Americanization' of music then referred to its mechanization. But for the British pop establishment anti-Americanism did not mean denying music's new meaning as recording and radio play but, rather, trying to develop its own way of doing things. This was clearest in the most explicitly anti-American institution, the BBC. As Paddy Scannell points out,[19] the BBC's music policy-makers had to bow to two rules of radio as a mass medium: firstly, they were programming sounds for domestic consumption not social gatherings – music had to be defined in terms of its broadcast functions; secondly, every sound was now available to every license holder – radio music was a single field, and for the first time different tastes and taste publics had to be accounted for. This was when 'high-brow', 'middle-brow' and 'low-brow' music began to be distinguished, when listeners placed themselves accordingly. The mass-music paradox was, then, that as more people listened to more music in more private circumstances, so music became more important as a means of social (and ideological) identity (and certainly up to the end of the 1930s BBC audience identities were largely a matter of distinction *within* the middle-classes).

The BBC had an equally important part to play in the redefinition of what it meant to make music, in the reorganization of the music profession. Whatever the appeal of imported dance music or the impact of Tin Pan Alley tunes, the problem for British performers remained the same: how to take account of changing public tastes *in their own work*. For purists the issue might be whether British musicians *could* play jazz – no, thought, Paul Whiteman,[20] 'they lack the spontaneity, the exuberance, the courage' – but the real question was what happened to jazz when they did. If the 1920s dance craze meant a big demand for 'American' musicians, most of the new band members were, in fact, old musicians in new guises, moonlighting classical performers, seaside and music hall players adapting once more to the trends, 'their Hungarian gypsy outfits discarded in favour of tuxedos and horn-rimmed spectacles'.[21] They, like their listeners, depended on radio and records now to get a sense of how they were supposed to sound. But post-1918 'jazz' did also open opportunities to musicians who were untrained and unskilled by previous professional standards – the ability to improvize began to matter more than the ability to read, unusual instrumental sounds were as much in demand as the usual ones. At least a part of the objection to the 1920s 'American invasion' came, then, from established players disgruntled by both the new demands on them and their new colleagues. As Cyril Ehrlich puts it,

> Pedants, accustomed to the manipulation of inanimate notes, and players for whom the ability to read all 'dots' at sight was the *sine qua non* of professional status, were equally outraged. Their distress was compounded

by diverse prejudices and fears: moral disapproval, distaste for undignified cavorting, and apprehension at encroachment upon hard-won skills. Nothing could be more alien to their conception of music as written, studied, and instructed than the seemingly anarchic and untutored raw vitality of the new noise.[22]

Such attitudes were reflected in the initial reluctance of the Musicians Union to take the new dance music and musicians seriously, but in 1930 a Dance Band Section was established, primarily in response to the BBC's continuing demand for such popular performers. It was easier (and more important) to negotiate minimum wages and conditions for dance broadcasts than with dance halls, and MU members were increasingly concerned that radio work was being taken by 'semi-pros' and 'aliens'. The former could be brought into the union, the latter had to be excluded. As rank-and-file visitors already found it hard to get work permits, the MU's campaign now was to prevent foreign soloists sitting in with British bands. In 1935, after exchange deal negotiations with the American Federation of Musicians broke down, the Union persuaded the Ministry of Trade 'to impose a notorious and quite untenable ban which but for a few exceptions denied the entry of American jazz musicians for the next twenty years'[23] – the two unions did not come to mutually acceptable terms again until 1954.

The single most effective anti-American music move in the inter-war years was, then, a matter of job protection rather than cultural elitism, though the Musicians Union did exploit high-brow assumptions. Its classical members were equally worried about foreign competition but had been obliged to surrender to the art-music idea of individual genius – the government policy was that 'artists of clearly international standing will be admitted without conditions'. Now it was agreed that popular musicians were not 'of international standing'. They required labour permits that the Union could challenge and almost always did – the few black jazz musicians to play in Britain between 1935 and 1955 did so illegally or, occasionally, slipped in under the guise of 'international classical' musician or 'solo variety' act.[24]

For professional musicians the American issue was straightforward – they might play American music (or their version of it) but this was all the more reason why real American musicians should be prevented from competing for dance hall, radio and recording work. Other sections of the British business had a more ambiguous position. The BBC, for example, was under constant pressure from local songwriters for protection, and in 1936 set a quota of at least 20% British tunes in dance broadcasts. But much of this pressure was informal. The Performing Rights Society did briefly campaign for such a quota, but soon realized that this stance contradicted their role in collecting international royalties. And, anyway, Britain's larger music publishers, such as Chappells or Francis, Day and Hunter, were already using licensing deals to become, in effect, Anglo-American companies. It was left to the newly formed Song Writers Guild to promote specifically British interests.

In the record business, too, British and American interests were not easy to disentangle. As manufacturers, British companies were dependent on American technology and patents. For example the Gramophone Company was explicitly founded in 1898 to exploit American inventions and to sell American products – it was funded by British investment but most of its senior management came from across the Atlantic. It was soon assembling imported gramophone machine parts and selling records made under American license in Hanover, but its only local resource was its London recording studio. Even at the time of its merger with Columbia to form EMI in 1931, it was still essentially a marketing enterprise. Its role had been to provide British sounds for American equipment – the world-wide expansion of the recording industry had proceeded on the assumption that although the machines were international, local music was the best way to sell them.[25]

For the early British companies, national music taste meant middle-class music taste. The Gramophone Company was always reluctant to sell 'cheap' machines or music, and as I have already noted, offered an education service to retailers (another aspect of this policy was the initial funding of *The Gramophone*). Memoirs of the first record producers, men such as Fred Gaisberg and Joe Batten, make clear that they moved most easily in the European classical music world. For them, the long-term success of a record label depended on its catalogue of concert hall stars (beginning with Caruso), and, as Cyril Ehrlich points out,[26] this meant that record companies had much better relationships with the bourgeois music establishment than piano manufacturers had had. It was because they were cheaper than pianos that gramophones discouraged 'amateur fumblings' and restored proper criteria of musical excellence!

This comparison of piano and gramophone is a useful reminder that the development of music as a mass medium was not just a matter of mechanical production. Well into the 1920s the piano was a more popular domestic instrument than the record player and it played an equally important role in the Americanization of popular music culture. The significance of ragtime, for example, was not just that it was the first black music to be widely published, but that it put the piano at the centre of public dance music as it was already for parlour song and (minstrel-inflected) balladeers. It was piano manufacturers (led by the American company Steinway) who pioneered the music marketing techniques later taken up by Tin Pan Alley; it was the player-piano not the phonogram which was the first music 'machine' to be popular – piano rolls gave a better, longer, acoustic account of familiar music than the early discs.[27]

If the gramophone and wireless were first identified in Britain with the concert hall and up-market entertainment, the piano had long been sold as a truly 'popular' instrument, available for the pleasure of everyone, and this had important implications for mass music. The piano was, after all, a piece of family furniture, and even before the BBC defined the pleasures of the hearth, the pop market had been conceived in terms of domesticity. Both broadcasters and record companies had, then, to adapt

to *existing* marketing arrangements; they did not, initially, transform them. Here, for example, is the launching statement of *Popular Music Weekly*, a magazine from the early 1920s:

> POPULAR MUSIC WEEKLY needs no excuse for appearing at a moment when music and dancing is booming to the extent it is to-day; when all through the kingdom the people of all classes are catered for in the dancing halls, theatres and music halls.

The editor explains that he has no thought of giving his readers 'songs of the past, beautiful as some of them may be'. The paper would be devoted, rather, to the 'latest' numbers – 'the great song and dance "hits" of the day will appear week by week'. But while the gramophone's importance is thus acknowledged – as a convenient means of musical dissemination and education – what still matters most is 'the homely piano':

> POPULAR MUSIC WEEKLY is a paper pre-eminently for the home, and it is my earnest wish that it may provide you with constant happy evenings.
>
> There is nothing so jolly or so sociable as the little group clustered about the piano, singing the songs of the moment or happy amid the fun of a family dance.
>
> In my mind's eye I can see you so grouped, and as this, the first issue of my paper, passes into your hand I can already hear your feet upon the floor as the piano strikes up its tuneful strains, and as I lay down my pen I say: On with the dance, and let POPULAR MUSIC WEEKLY be your friend and partner!

What this captures is the essential *respectability* of the pop world in the early twenties – the piano was an icon of the respectable working-class, the record industry was being built on the basis of classical 'good taste', the BBC's musical mission was public 'improvement', professional musicians were united in defence of self-discipline. This was the setting in which 1920s American music was placed, the background against which it was heard as a threat – and a promise.

Making music safe for suburbia – jazz

> The argument that England is England still is an intellectual one to which the musical nerves refuse to listen. If the composer imagines that he can treat present-day Surrey with its charabancs, filling stations, hikers, road houses, dainty tea rooms, and loud speakers discoursing cosmopolitan jazz, in the way the Elizabethan composers treated the 'woodes so wilde' he is living in a narrow world of escape, incapable of producing anything more than a pretty period piece.
> (Constant Lambert[28])

At first glance the 1920s jazz argument seems straight-forward: 'true' jazz lovers thrilled at its power as the music of black America, 'synthetic'

jazz entertainers played easy-on-the-air dance music for the middle-class night out. The early history of jazz in Britain is usually presented, then, as the 'taming' of subversive sounds by the leisure market. As jazz dancing, for example, became mainstream entertainment, so it took on the trappings of bourgeois culture – teachers and 'exhibitions', rules and competitions. The first British dance championship was held in London in 1923 and 'strict tempo' became the order of the day.[29]

The colour of jazz was an issue in Britain from the start. 'We demand,' wrote editor Edgar Jackson in an early (1926) issue of *Melody Maker*, 'that the habit of associating our music with the primitive and barbarous negro derivation shall cease forthwith, in justice to the obvious fact that we have outgrown such comparisons.' The assumptions here – that 'negro' meant primitive, that jazz 'progress' meant its white takeover – was also commonplace among musicians. For Paul Whiteman[30] it was a question of turning a 'folk' music into art. 'What folk form would have amounted to anything if some great writer had not put it into a symphony?' he asked. The 'elemental' had to be given a 'beautiful garment'. For Paul Specht, who claimed to have been playing 'classical jass' long before Whiteman, it was a question of 'refining' black sounds, applying intelligence to instinct:

> I give full credit to, and have always expressed admiration for the splendid Negro advance in swing music, but it is simply idle logic to issue any such claims that real 'swing music' originated with the Negro bands. The Negro players may be born with swing in their hearts, and such musical souls have outnumbered the white jazz players, but it took the scholarly, trained musicians like 'Ragtime Frank' Guarente, to first analyze the swing motif, and to add this faculty of improvisation to the rudiments of American jazz music as was first written and then recorded on the phonograph disc by white musicians.[31]

These arguments were formalized in the first American jazz book, Henry Osgood's 1926 *So This Is Jazz*,[32] and had a particular resonance for white British performers, who were struggling to assert their own creative authority. Jack Hylton, writing in *The Gramophone* in September 1926, declared the superiority of his own 'symphonic syncopation' – 'a pleasing combination of harmony, melody and rhythm' – to jazz, 'an unholy row'. He dismissed the suggestion that his style was just lifted from Whiteman. It was, rather, an explicitly British development: 'In the dance hall or on the gramophone record alike, it makes a subtle appeal to our British temperament. It is fast becoming a truly national music,' satisfying 'the musical cravings of any normal person.' 'How I hate the word "jazz",' echoed Jack Payne in his 1932 autobiography. Jazz implied something crude, while Payne's task as the BBC's first dance band leader was 'to put happiness and sunshine over the air'. His successor, Henry Hall, was similarly contemptuous of the 'cacophonous discords of hot music', while the BBC's first disc jockey,

Christopher Stone, believed that the BBC 'lowered' itself by playing hot jazz, 'a primitive din'.[33]

For these writers, black 'jazz' had to be distinguished from their own 'swing' in terms of the balance of rhythm and melody. For jazz to 'develop', rhythm (understood as something 'natural') had to come under the civilizing influence of a composed, harmonic score. 'Syncopation,' Hylton explained in *Melody Maker* in January, 1926, 'is the compromise between rhythm and harmony, between savagery and intellectualism. It is the music of the normal human being, and because of this it will live – progressively of course and gradually evolving new forms.' This argument was expanded in the first British jazz book, R. W. S. Mendl's 1927 *The Appeal of Jazz*. Mendl assured his anxious readers that jazz had developed by necessity well beyond the 'primitive artless stock' of the negro. He argued that because jazz was, in itself, stimulating in rhythm but weak in melodic invention, it would have to become something else to survive as a popular form.[34]

These were the positions against which real jazz criticism was defined. Its tone of voice is encapsulated in Spike Hughes' 1933 *Daily Herald* review of Duke Ellington's first British appearance:

> It has remained for us to discover . . . that Duke is something more than a bandleader specializing in what are vaguely called 'voodoo harmonies' and 'jungle rhythms'. He is in fact the first genuine jazz composer. This may come as a shock to people who associate jazz with the 'Rhapsody in Blue' or who consider jazz to be any noise made by a dance band in the background to conversation or an excuse for those ungraceful, hiking movements which pass for modern 'dancing'.
>
> Jazz is not a matter of trite, unguarded melodies wedded to semi-illiterate lyrics, nor is it the brainchild of Tin Pan Alley. It is the music of the Harlem gin mills, the Georgia backyards and New Orleans street corners – the music of a race that plays, sings and dances because music is its most direct medium of expression and escape.[35]

Hughes' importance in British jazz criticism (as 'Mike' he started reviewing 'hot records' for *Melody Maker* in April 1931) was his pioneering analysis of *rhythm* (he was himself a bass player). By taking the beat seriously he changed people's understanding of where the 'art' of jazz lay, and explained why black musicians were superior to whites: they had a far more sophisticated grasp of rhythmic language. Jazz would inevitably progress from folk to art, he argued, but such progress would always be based on musical skills that were rooted in black history and black experience.

As Jim Godbolt has shown,[36] the Hughes line became dominant in inter-war British jazz writing and was particularly explicit in the pages of *Melody Maker*. Edgar Jackson, who had begun by dismissing black music, was soon favouring 'hot style' over 'popular' dance records. As the 'Dance and Popular Rhythmic Music' reviewer for *The Gramophone* (and hot record selector for Christopher Stone's BBC show), as well as

MM editor, he became an influential advocate of black jazz. This put *Melody Maker* itself (started by publisher Lawrence Wright as a trade paper for dance band musicians) in a paradoxical position: by 1927 it was championing hot sounds at the expense of the music played by most of its readers (and advertised in most of its display inches). But the relabelling of dance music going on here was repeated everywhere in the record press – for example, *The Gramophone Critic* (started in 1928) took the straight/hot jazz division for granted. By the time of the second British book on jazz, Stanley Nelson's 1934 *All About Jazz* (introduced by Jack Hylton), the real/fake distinction was part of musical common sense. Nelson started with the jazz-progress-from-jungle-to-ballroom line, but concluded that,

> most of the future development of jazz will come from the coloured race themselves and not from us. We have certainly played a great part in emancipating our present popular music from the crude form of an early cake-walks and we have standardised the instrumentation of the popular dance band. But our mania for order has led us into a cul de sac. We lack the spontaneity of the coloured people and their innate feel for the jazz idiom.[37]

Nelson noted that black musicians, unlike white, did 'not seem to be influenced by any dictates of commercialism' and this assumption was now built into hot/popular, black/white discourse. In 1937 Harman Grisewood, critically reviewing the BBC's 'swing programmes', tried to clarify for his colleagues the difference between authentic and inauthentic jazz.[38] The authentic, he explained, was produced by black musicians for black audiences and was therefore 'a natural and emotional expression' – 'it was played for the love of the thing'. Its commercialization meant its corruption – hence the effete sound of 'decayed, sentimental dance music'. Good swing (which meant American swing – Grisewood's point was that British musicians could not play it) had therefore to stay in touch with the 'genuine article'. For the British Marxist critic Iain Lang, writing in 1943, the same point was given a more class-conscious edge: if jazz had given voice to the Afro-American proletariat, 'a kind of people which had never before been so powerfully articulate', its subsequent use as mass-produced entertainment for the middle-classes was a mark of regression. The further a music moved away from its origins among the common people, the more it lost its expressiveness and integrity. As Ernest Borneman put it in 1946, at best jazz was the American negro's music of protest and assertion, at worst the white man's music of indolence and escape.[39]

The pattern of rhetorical shifts in inter-war jazz commentary is familiar from later responses to rock and roll: the initial treatment of the music as primitive and gimmicky, its survival depending on rapid assimilation into tried and tested forms of 'good' music; the later appreciation that such 'commercialization' is precisely what saps the

sounds of their distinctive energy and truth. But there were problems with the latter position. Take the crucial ideal of 'authenticity': how could a white British audience be other than 'entertained' by noises made meaningful only in terms of their black American roots? How on earth could British *musicians* claim to play jazz for real?

The answer was to make the music a matter of feeling, expressive of personal not social identity, of sensual not cultural need. So Robert Goffin (in what he later claimed to be the first serious article on the subject) praised jazz in *Le Disque Vert* in 1919 for its appeal to 'the senses' – classical music appealed only to the mind. Spike Hughes, who marvelled at the 'remarkable technical precision' and discipline of jazz musicians, usually chose, nevertheless, to celebrate jazz's 'primitive' qualities, its 'direct expression of fundamental emotions'. Hughes's friend and fellow *Melody Maker* columnist, John Hammond, suggested in 1932 that,

> it is about time we got over terms such as hot music, corny, commercial, etc., all of the expressions of the white man. Either music is sincere or it isn't. If it is the latter, we can overlook it completely without bothering to characterize it. The reason I so greatly prefer the Negro's dance music must be obvious by now; he knows only how to play from the heart. 'Tis the white man, with his patent lack of sincerity, who has given jazz the malodorous name it possesses.[40]

How do we recognise 'playing from the heart' when we hear it? By its contrast to 'white' music – as Ernest Borneman pointed out, because Western art-music signified order and control, syncopated rhythms came to signify disorder and abandon.[41] Jazz worked here not as an alternative, autonomous culture, low meeting high, but as the 'other' defined by bourgeois culture itself, the 'low' produced by the high. 'Authentic' jazz feelings thus referred less to the musicians' state of mind than to the release of the listeners' own 'repressed' emotions. This argument is vividly made by John Wain's 1962 novel *Strike the Father Dead*, in which the role of jazz in British *middle-class* 'liberation' is made clear.

This accounts, I think, for the difficulty 1930s jazz writers had with the place of commerce in their music – black jazz might be distinguished from white jazz as something played for its own sake, but all jazz musicians were professionals and had to make some sort of living from their sounds. The purism of suburban British jazz fans, their contempt for commercial dance music, reflected the fact that this was the first British musical culture dependent on recordings. (Their attitudes were not shared whole-heartedly by the would-be jazz players hanging around London's Archer Street music agencies, taking whatever work came along.) One consequence was a decided ambiguity about visiting stars' treatment of jazz as entertainment. But the suspicion of 'sell out' that nagged at the fans really marked an anxiety about their own place as

consumers in a supposedly uncommercial scene, and Roger Taylor suggests that in appropriating jazz as their own 'authentic experience', British audiences had, in the end, to appropriate it as *art* – a 'fantasy jazz' was thus put 'firmly within the grip of the aesthetics of Romanticism'.[42]

The question now was how jazz could make the move from folk to art without losing the qualities that made it an authentic means of expression in the first place. For many British fans in the 1930s (most notoriously Philip Larkin), the answer was that it couldn't – both Spike Hughes and Constant Lambert lost interest in jazz at the moment they were proclaiming Duke Ellington as a genuis. But for other more modernist writers, jazz 'primitivism' put it in advance of the avant-garde. Robert Goffin, for example,[43] described jazz as 'the first form of surrealism' – its musicians had 'neutralis[ed] rational control in order to give free play to the spontaneous manifestations of the subconscious' – and British versions of this argument were developed in *Jazz Forum*, a magazine launched in 1946. Among its contributors was Toni Del Renzio, who in the 1950s was to join the Independent Group, and get involved in the promotion of Pop art and the ICA's controversial jazz lectures. By then the art school appropriation of jazz was obvious. Writing in 1957, Paul Oliver concluded that jazz was the exact musical equivalent of modern art: it had 'broken with the orthodoxy of the past as emphatically as did the contemporaneous painting and sculpture of the first decade of the century', and in the exhilaration of collective improvization, experimental artists could grasp their own ideal of 'simultaneous unity and freedom'.[44]

Even before jazz became the sound of 1950s bohemia, it was clear that its British class-base was not the proletariat. Harry Melvill, writing in *The Gramophone* in January 1924, commented that 'Will Vodery's Orchestra from the "Plantation" appearing at a private party, proved once more that black-faces, like Oriental china, blend admirably with eighteenth-century decoration', a judgement echoed in Evelyn Waugh's novels of the period and the early 1920s high society vogue for 'Blackbird' parties, with guests from the Afro-American *Blackbirds* revue. What mattered here, though, was not that black music was a passing society fashion, but that its most articulate champions were highly cultured (Fred Elizalde, Spike Hughes and Edgar Jackson were all ex-Cambridge students). Hot jazz was first heard, then, as 'elitist'. Hughes, for example, was regularly attacked on *Melody Maker*'s letters page – hot music was 'alright for chaps at Oxford and Cambridge' but 'the public' had not got time for it. The 'commercial' Henry Hall equated hot jazz with the 'advanced' music of Schoenberg (both, he suggested, appealed to Jews) and claimed by contrast to perform for 'errand boys and fireside folks who wanted a good time'.[45]

'Real' jazz remained an elite taste into the 1930s. Constant Lambert took it for granted that Duke Ellington was only appreciated by 'the high-brow public', while the restricted audience for Louis Armstrong's 1932 tour was reflected in both box-office takings and Fleet Street 'shock

horror'. Gerald Moore concluded that Armstrong's music was 'not for the general public for whom his enormously advanced work cannot possibly have any appeal', while Hannen Swaffer in the *Daily Herald* described ordinary people walking out, leaving 'excited young men of the pseudo-intellectual kind. . . bleating and blahing in ecstasy'.[46]

Jazz elitism was by now less a description of the slumming upper-class than the aspiring lower-middle-class, who were soon organizing themselves (in good suburban style) in Rhythm Clubs, celebrating jazz fandom as the culture of collectors and scholars, people who took the music *seriously*. Such seriousness was reflected in the BBC's redefinition of its popular music output in 1937 into three categories: music for dancing, music for entertainment and music for the connoisseur. Jazz came under the last label (even now is more often heard on Radio 3 than Radios 1 or 2), and 'connoisseurship' is a good label for the use of jazz involved – a painstaking passion, a yearning for sensuous, earthy experience equated now with solemnly earned excitement and the 'furtive' release of real feeling. The typical British jazz fan of the late 1930s was a swottish provincial school boy, a Philip Larkin, who later wondered what happened to his fellow enthusiasts:

> Sometimes I imagine them, sullen fleshly inarticulate men, stockbrokers, sellers of goods, living in 30-year-old detached houses among the golf courses of Outer London, husbands of ageing and bitter wives they first seduced to Artie Shaw's 'Begin the Beguine' or The Squadronnaires' 'The Nearness of You' . . . men in whom a pile of scratched coverless 78s in the attic can awaken memories of vomiting blindly from small Tudor windows to Muggsy Spanier's 'Sister Kate', or winding up a gramophone in a punt to play Armstrong's 'Body and Soul'; men whose first coronary is coming like Christmas; who drift, loaded helplessly with commitments and obligations and necessary observances, into the darkening avenues of age and incapacity, deserted by everything that once made life sweet.[47]

Conclusion

In his book on the Harlem Renaissance,[48] Nathan Irvin Huggins suggests that white Americans took to minstrelsy in the mid-nineteenth century as a way of distancing themselves from European criticism of their vulgarity – vulgarity could still be enjoyed but was now projected defensively onto blacks. At the same moment as the British middle-class began to criticize its own materialism by denouncing it as 'American', the American middle-class was looking nervously to Europe for lessons in good taste. In 1853 the jury for musical instruments at New York's Crystal Palace Exhibition objected to the

> vulgar, tawdry decorations of American pianos, which show a great deal of taste, and that very bad. Not only do we find the very heroics of

gingerbread radiating in hideous splendors, fit for the drawing-room of a fashionable hotel, adorned with spitboxes among other savageries; but even the plain artistic black-and-white of the keys – that classic simplicity and harmonious distinction – is superseded for pearl and tortoise-shell and eye-grating vermilion abominations.[49]

The tone is exactly that of Albert Goldman on Elvis Presley, which reflects the fact that the major changes in the American music business have always been argued in terms of civilization (Europe) versus barbarity (Jews, Blacks, workers) – whether we examine the battle between the young Tin Pan Alley men and the established parlour song publishers at the turn of the century, or that between the young rock'n'rollers and the ASCAP establishment (the American Society of Composers and Publishers) in the 1950s. The point is that so-called 'American' music emerges from these conflicts. It reaches the rest of the world as something that has *already* moved from the margins to the mainstream (this was true of minstrelsy and ragtime, jazz and rock'n'roll). To hear it as corrupting or subversive is, then, to *reinterpret* the sounds, to read one's own desires into them, and in Britain the dominant desires – the ones that set the terms of jazz (and rock) criticism, formed musicians' jazz (and rock) ambitions, determined what it meant to be a true jazz (or rock) fan – have been suburban. To understand why and how the worlds of jazz (and rock) are young men's worlds, we have to understand what it means to grow up male and middle-class; to understand the urge to 'authenticity' we have to understand the strange fear of being 'inauthentic'. In this world, American music – black American music – stands for a simple idea: that everything *real* is happening elsewhere.

Notes

1 Stuart Cosgrove, 'Bad Language', *City Limits*, 25 June 1987, p. 16.
2 Trevor Blackwell and Jeremy Seabrook, *A World Still To Win* (Faber and Faber, London, 1985), pp. 86–7.
3 Ernest Short, *Fifty Years of Vaudeville* (Eyre and Spottiswoode, London, 1946), pp. 8; Richard Hoggart, *The Uses of Literacy* (Penguin, Harmondsworth, 1958), p. 163.
4 Mass Observation, *Britain* (Penguin, Harmondsworth, 1939), pp. 183–4. In the light of the recent activities of Red Wedge it is also interesting to read that '. . . the working class has taken up the Lambeth Walk with more enthusiasm than anybody – a fact recognised and made use of by both the Communist Party and the Labour Party. In the latter case, it was partly due to a long discussion between a leader of M–O and the Transport House propaganda experts, who could not see the faintest connection between the Lambeth Walk and politics until the whole history of dancing and jazz had been gone into.' (p. 169)
5 W. R. Titterton, *From Theatre to Music Hall* (1912) quoted in Mass Observation, *Britain*, pp. 148–9. Kipling quoted in *Music Hall: The Business of Pleasure*, ed. Peter Bailey (Open University Press, Milton Keynes, 1986), p. xiv.

6 Iain Chambers, *Urban Rhythms* (Macmillan, London, 1985), pp. 4–5.
7 Dick Hebdige, 'Towards a Cartography of Taste 1935–1962', *Block*, 4 (1981), p. 53.
8 Quoted in Michael Pickering, 'White Skin, Black Masks: "Nigger" Minstrelsy in Victorian Britain' in *Music Hall Performance and Style*, ed. J. S. Bratton (Open University Press, Milton Keynes, 1986), p. 80; and see J. S. Bratton, 'English Ethiopians: British Audiences and Black Face Acts, 1835–1865', *Yearbook of English Studies*, (1981) pp. 127–42.
9 See Tony Russell, 'Haywire in the Hills!' *Old Time Music*, 39 (1984), p. 5; and William W. Austin, *"Susanna", "Jeanie", and "The Old Folks at Home": The Songs of Stephen C. Foster from His Time to Ours* (Macmillan, New York, 1975), pp. 31–2.
10 Peter Honri, *Working the Halls* (Futura, London 1974), pp. 19–20.
11 See Short *Fifty Years of Vaudeville*, pp. 147–8; and John Abbott, *The Story of Francis, Day and Hunter* (Francis, Day and Hunter, London, 1952), chapter 1.
12 Abbott, *The Story of Francis, Day and Hunter*, pp. 5–6.
13 See Thomas L. Riis, 'The Experience and Impact of Black Entertainers in England, 1895–1920', *American Music* 4, 1 (1986).
14 See Austin '*Susanna. . .*' pp. 48, 160–2 and cf. Colin MacInnes, *Sweet Saturday Night* (Macgibbon and Kee, London, 1967), pp. 32–4.
15 Pickering, 'White Skin, Black Masks', p. 76.
16 ibid. p. 79.
17 Paul Whiteman and Mary Margaret McBride, *Jazz* (J. H. Sears, New York, 1926), pp. 153–4.
18 *Talking Machine News*, November 1921.
19 Much of my argument here is drawn from Paddy Scannell's as yet unpublished history of the BBC's music policy.
20 Whiteman, *Jazz*, p. 74.
21 Cyril Ehrlich, *The Music Profession in Britain Since the Eighteenth Century* (Clarendon Press, Oxford, 1985), p. 203.
22 Cyril Ehrlich, *The Music Profession in Britain Since the Eighteenth Century*, pp. 203–4.
23 Jim Godbolt, *A History of Jazz in Britain 1919–50* (Quartet Books, London, 1984), p. 116.
24 For an overview of Musicians Union policy see Ehrlich, *The Music Profession in Britain Since the Eighteenth Century*, pp. 219–21.
25 See Geoffrey Jones, 'The Gramophone Company: an Anglo-American Multinational, 1898–1931', *Business History Review* 59, 1 (1985).
26 Cyril Ehrlich, *The Piano* (Dent, London, 1976) pp. 185–6. And see Simon Frith, 'The Making of the British Record Industry 1920–64' in *Impacts and Influences* (Methuen, London, 1987) eds James Curran, Anthony Smith and Pauline Wingate; Joe Batten, *Joe Batten's Book: The Story of Sound Recording* (Rockliff, London, 1956); and F. W. Gaisberg, *Music on Record* (Robert Hale, London, 1946).
27 Ehrlich, *The Piano*, pp. 133, 171–2; and see Edwin M. Good, *Giraffes, Black Dragons and Other Pianos*, (Stanford University Press, Stanford, 1982), pp. 94–5, 175, 234.
28 Constant Lambert, *Music Ho!* (Faber and Faber, London, 1934), p. 177.
29 For a useful overview of this see Mark Hustwitt, ' "Caught in a Whirlpool of Aching Sound": the production of dance music in Britain in the 1920s',

Popular Music, 3 (1983), and, for the inside story, Josephine Bradley, *Dancing Through Life* (Hollis and Carter, London, 1947).

30 Whiteman, *Jazz*, pp. 283–4.

31 Paul Specht, *How They Become Name Bands: The Modern Technique of a Dance Band Maestro* (Fine Art Publications, New York, 1941), p. 121. And see Godbolt, *A History of Jazz in Britain 1919–50*, p. 28.

32 Henry Osgood, *So This Is Jazz* (Little, Brown, Boston, 1926).

33 See Jack Payne, *This is Jack Payne* (Sampson Low Marston, London, 1932), pp. 56–8, and Christopher Stone, *Christopher Stone Speaking* (Elkin Mathews and Marrot, London, 1933), pp. 95–6. Henry Hall quote courtesy of Paddy Scannell.

34 R. W. S. Mendl, *The Appeal of Jazz* (Philip Allan and Co., London, 1927), pp. 71–3, 165. Hylton quoted in Edward S. Walker, 'Early English Jazz', *Jazz Journal* (September 1969), p. 24.

35 Quoted in Godbolt, *A History of Jazz in Britain 1919–50*, p. 102. For Ellington's similar importance for American jazz writers see Ron Wellman, 'Duke Ellington's Music', *International Review of the Aesthetics and Sociology of Music*, 17, 1 (1986).

36 Godbolt, *A History of Jazz in Britain 1919–50*, chapter 3, for the MM story; for Hughes' critical career there, see Chris Goddard, *Jazz Away From Home* (Paddington Press, London, 1979), pp. 174–82.

37 Quoted in Godbolt, *A History of Jazz in Britain 1919–50*, p. 153.

38 Grisewood's argument courtesy of Paddy Scannell; and see Iain Lang, *Background to the Blues* (Workers Music Association, London, 1943), p. 18.

39 Ernest Borneman, *A Critic Looks at Jazz* (Jazz Music Books, London, 1946), p. 47.

40 Quoted in Goddard, *Jazz Away From Home*, p. 178; and see Robert Goffin, *Jazz from Congo to Swing* (Musicians Press, London, 1946), p. 1 and Spike Hughes, *Opening Bars* (Pilot Press, London, 1946), pp. 305–11.

41 Ernest Borneman, *A Critic Looks at Jazz*, p. 46.

42 See Roger L. Taylor, *Art, an Enemy of the People* (Harvester, Hassocks, 1978), p. 114.

43 Goffin, *Jazz From Congo to Swing*, pp. 3–4.

44 Paul Oliver, 'Art Aspiring', *Jazz Monthly*, 2, 12 (1957), pp. 2–3. For the problem of treating jazz as an art music see Mary Herron Dupree, ' "Jazz", the Critics and American Art Music in the 1920s', *American Music*, 4, 3 (1986). For jazz and the fine arts see Simon Frith and Howard Horne, *Art into Pop* (Methuen, London, 1987), chapter 3.

45 See Spike Hughes, *Second Movement* (Museum Press, London, 1951), p. 21. Hall quote from Paddy Scannell.

46 Moore quoted in Goddard *Jazz Away From Home*, pp. 182–3, Swaffen in Godbolt, *A History of Jazz in Britain 1919–50*, pp. 84–5.

47 Philip Larkin, *All What Jazz* (Faber and Faber, London, 1985), pp. 28–9. For an entertaining account of Rhythm Club culture see Godbolt *A History of Jazz in Britain 1919–50*, chapters 8–9 and, for a sociological analysis, Francis Newton, *The Jazz Scene* (Penguin, Harmondsworth, 1961), chapter 13.

48 Nathan Irvin Huggins, *Harlem Renaissance* (Oxford University Press, New York, 1971), p. 254.

49 Quoted in Good, *Giraffes, Black Dragons and Other Pianos*, p. 170.

PART 2

Working-Class Heroes
(and a Heroine)

Northern Soul – Gracie Fields

Before 1939 the most popular singer in Britain by far was Gracie Fields. Her shows always sold out and her records (released monthly) gave her record companies a steady income through the depression. In the 1930s she was Britain's best paid film star (she got £40,000 per film) and even Hollywood took note – at the end of the decade Twentieth Century Fox paid her a £200,000 advance to make four films for them. In 1924, when she first came to national fame, she even played three London venues simultaneously: a straight part in *SOS* at the middle-brow St James Theatre, top of the bill at the low-brow Alhambra, Leicester Square, the late night spot at the high-brow Cafe Royal. But she became a superstar as the media symbol of the working-class, its cheeriness under economic pressure, etc.

In 1934 the Tory Major Rawdon Hoare wrote:

> In her own way, she has done a tremendous amount of good. In the cinemas there is an absence of healthy amusement, there is too much sex appeal; but in the performance of Gracie Fields we get a breath of fresh air and an opportunity for some real laughter. This all helps to keep the right spirit of England together – clean living, with a total absence of anything bordering on the unnatural.

From Rochdale to Capri

When I first saw Gracie Fields, on television in the 1960s, she was the matron of British show business, a straight-backed, good looking woman in her sixties (she was born in 1898) who sang hymns on *Stars on Sunday* and variety shows and, later, spoke graciously to people like Russell Harty. She lived in Capri and the island seemed to share her appeal – respectable, self-made hedonism, tasteful vulgarity. She was a symbol of nostalgia – for some pre-war working-class community, for some pre-TV, un-American, British entertainment. Gracie Fields had become a character from *Coronation Street* and I never thought to take her seriously as a musician.

In the last couple of years, since her death, I've been listening to Gracie

Fields' pre-war records, learning to hear through her later, comfortable 'personality'. Gracie Fields was a huge star for a good reason – she was a great performer – and her mass-marketing *followed* her success. Her skills were developed in live performance.[1] As a stage-struck Rochdale child, she had brief spells with the Haley Garden of Girls and Clara Coverdale's Juveniles, which taught her to sing and dance in public. She learned comic techniques in a summer season with Cousin Freddy's Pierrot Concert Party, and became a full time professional in a travelling revue, *Yes I Think So*, when she was only 16. Her style was moulded by Archie Pitt, a cockney comedian turned writer/impresario (who became her husband). Security came with *Mr Tower of London*, which opened in 1918 and toured for nearly ten years – it did not reach the West End until 1924. By then its cast had become a strangely, tensely intimate team. Gracie had not only had to get used to the travel, the grotty halls, the cold landladies and bedrooms but she had also become the show's star, the reason for its success, and carried her family with her – her younger sisters and brother performed too, Archie's brother was the company's businessman.

Our Gracie

The public persona that Gracie Fields developed during these years reflected her private situation. She was the big spinster sister (the comi-pathetic figure of her own 'In My Little Bottom Drawer'), a shy, gawky woman who was, in 1920s terms, unfeminine, innocent and asexual (even her most broadly comic songs had no innuendo, no *doubles entendres*). On stage, though, she had no inhibitions. She was the noisy girl on the factory outing who led the coach party singing, was always good for a laugh and never paired off when the singing stopped and the bus got close to home.

Gracie Fields was a music hall comedienne who had no malice, a music hall singer who had no airs. Even in her films she played the friend rather than the lover, a star who was common not glamorous, and her stories moved to political rather than romantic resolutions, as Gracie brought together North and South, owner and worker, parent and child in a final singsong. In *Look Up And Laugh*, Gracie played an actress who led the local market stall-holders in a successful battle against both the local council and a national chain-store owner. In *Shipyard Sally*, Gracie was a variety singer who saved Clydebank from closure by getting its workers' petition to a benevolent peer politician. Graham Greene wrote:

> All Miss Field's pictures seem destined to show a sympathy for the working class and an ability to appeal to the best classes: unemployment can always be wiped out by a sentimental song, industrial unrest is calmed by a Victorian ballad, and dividends are made safe for democracy.

Keeping Up Appearances

Social historians, trying to make sense of Gracie Fields' popularity in retrospect, have developed their own cliches for her: she expressed 'the humour, doggedness and cynicism of the workers'; she symbolized 'a humourous, long-suffering but optimistic sentiment'; she and her audiences shared 'a vulgar, private language'. What such description misses is the tension involved in 'smiling through'. Gracie's was the voice of the respectable working-class hanging on to their tatters of lace-curtained pride despite everything (for the difficulties of this struggle in the 1930s see Walter Greenwood's *Love on the Dole*). Gracie could mock this part (on 'Turn 'Erbert's Face To The Wall, Mother', for example) but she could never express the rough, subversive working-class spirit of a Frank Randle (celebrated in Jeff Nuttall's *King Twist*). Her performances were always about keeping up appearances.

And Gracie had appearances to keep up. She had married Archie Pitt for business not romantic reasons, and, as her husband/manager/producer, he continued to bully her, to mock her claims to artistic autonomy. He threw doubt too on her sexual appeal, installing his mistress in their home, falling in with the Fields' family line that Gracie (unlike her sisters) was too plain, too ordinary, too sensible for passion. But on stage her energy rode through her self-pity. She was a 'natural' performer who was entirely self-conscious, and I'm sure that she was loved by her audiences – 'Our Gracie' was the affectionate slogan – because they understood the *work* that went into her cheerfulness. They were clapping her on.

The Mill Girl with the Operatic Voice

I started listening to Gracie Fields' records because I was interested in the way women have expressed themselves in British popular music. She was an unusual female star because she was not obliged (like virtually all female pop singers since) to sing for men, to limit her identity to the problems of getting/losing a partner. Her femaleness was a matter of domesticity rather than femininity; her songs were 'sentimental' because they described family rather than sexual affections, mother or daughter rather than lover problems. But Gracie Fields was an unusual female singer because her *voice* was so remarkable. Technically she was a soprano, and she had some of the vocal qualities of an opera singer – she could sing loudly while keeping a pure tone; her notes were open, sung from the chest rather than the throat; she made effective use of a controlled tremolo.

The joke was that such a grand bourgeois voice should belong to a shrill Lancashire mill-girl and as a music hall comic Gracie exploited this joke to the full. Her trademark was the burlesqued ballad. She would

begin straightforwardly, using all the signs of sincerity and romantic fervour that music hall singers had learnt from European operetta. She had the right emotional tremble, she invested the most banal words with physical urgency, she aimed the audience at the final melodramatic release. And then she would switch sounds, lapse into a Lancashire accent at the height of the melodic build, push her tremour into an uncontrollable *noise*. She put the conventional vocabulary of emotional expression under constant threat. Every time a song got serious Gracie would take on a voice of bemused innocence, move into the conversational mode of her comic patter songs. Her most important asset as a live performer was an ability to change the theatre into the front room. She sang both her comic and serious songs as if chatting while hanging up the washing over the wall.

The Singer as Mimic

There are numerous Gracie Fields records in the shops still, but they are mostly patchy, uninformative collections, drawing heavily on her post-war tracks when her audiences were content with the familiar routines which she mostly gave them. The best album I've found is *Gracie Fields – Stage and Screen* (World Record Club), which includes a recording of her performance at the Holborn Empire in 1933 and songs from the soundtracks of her 1930s films.

Listening to this I'm struck less by her warmth and timing (the usual music hall gifts) than by her mimicry. Listen to her version of 'Stormy Weather', for example. Gracie introduces the song – by then a standard Tin Pan Alley blues – with a rapid, exuberant scat and mutters a jokey aside to the audience, but when the lyric proper starts her interpretation is sober and moving. She doesn't pretend to be a blues singer, offers no marks of her own emotions; rather, she imitates, somewhat wistfully, the American blues mood in general. Her voice becomes a muted trumpet, the sounds drift like smoke out of a night club. (The same technique can be heard elsewhere, on 'Lancashire Blues'. Gracie pays tribute to black American music not by imitating its voices but by gesturing at the instrumental sound of the big band – the solos, the sustained, swollen notes.)

From Child's Play to Social Community

Even as a comic singer, Gracie was more concerned with sounds than words, with teasing hesitations, constant changes of tone, with trills and swoops and cries. Her pleasure in a narrative like 'Heaven Will Protect an Honest Girl' is less in the clever verse than in the different voices – the mother, the policeman, the naive Northern lass; by the end of the performance we don't know what the next sound will be.

The great popular singers can make the dullest songs into the most vital conversations. In black music what is at issue is the stylization of personal emotion. Glib tunes are invested with complex feeling. Gracie Fields came from a different expressive tradition. She also laid personal claim to standard catchy pop, but her claim was not emotional but playful. She sang as if reacting spontaneously to the possibilities of the sounds, rather than the meanings, of words. Repeating the ones she liked, swallowing the ones she didn't, milking each consonant and vowel for its connotations, endlessly shifting the ways the same words can be said. What she knew, of course, and what turned such child's play into social commentary, was that sounds and accents and tones of voice, just as much as words, have a public, political meaning. Gracie Fields' performances, in their very musical jokiness, still offer sharp and subtle accounts of class (and sexual) forms of talk. Her art was to make music (and mockery) out of everyday speech.

Making Conversation Sing

This skill – making conversation sing – has always been central to popular performance, but even as Gracie Fields was reaching the height of her popularity, pop singing was being turned into a stylish artifice by Tin Pan Alley's concern for mass, multi-national music. Song writers went on working with turns of speech, with cliches and catch phrases, but singers (the crooners, for example) had a new, personal, style. Their tone of voice was invariably intimate; it no longer took on the *sounds* of public conversation. These sounds (and not the sentimental singalongs of *Those were the Days* or Paul McCartney) had been the essence of British music hall; they are still explored by a music hall-influenced artist like Ian Dury. For Dury, as for Gracie Fields, performance is a chance to put on a persona, to make a manner of speaking a way of singing.

Gracie Fields' originality as a singer depended on her silence as a listener – charting the inflexions of her family and friends as they made their way up the social ladder, eavesdropping on the sexual banter that never seemed to be aimed at her, responding to the collective conversations of her audiences. She certainly was wholesome and bright and all those other things that people wrote; she certainly did hope to put the world to rights in a sentimental song. But she also took an infectious *pleasure* in singing. It was as if she was only in control of herself on stage, only in charge of language when moulding it for herself in song. And it is this pleasure, this expression of creative *power*, that I still find myself responding to, still find myself drawn to, over and over again. 1982

Notes

1 For the facts of Gracie Fields' life see Muriel Burgess and Tommy Keen: *Gracie Fields* (Star Books, London, 1980).

Something to Be –
John Lennon

'I read the news today, oh boy. . .'

'Death of a Hero' it said in big black letters across the front of the *Daily Mirror*, and if I hadn't known already I'd have expected a story about a policeman or soldier in Northern Ireland. The media response to John Lennon's death was overwhelming as what began as a series of private griefs was orchestrated by disc jockeys and sub-editors into a national event, but it was difficult to decide what all this mourning meant. The media themselves seemed less slick than usual, more ragged in their attempts to respond to a genuinely popular shock. What came through was not just Beatle-nostalgia but a specific sadness at the loss of John Lennon's Beatle qualities – qualities that never did fit easily into Fleet Street ideology. 'The idea', as Lennon once told *Red Mole*, 'is not to comfort people, not to make them feel better but to make them feel worse.'

The *Mirror*, its populist instincts currently sharpened by Thatcherism, got the mood most right. John Lennon was certainly the nearest thing to a hero I've ever had, but though I knew what this meant in fan terms (buying Beatle records at the moment of release, dreaming about my own Lennon friendship – 'I'll never meet him now,' said one friend when she heard the news), I'd never really stopped to think what the pleasure I got from Lennon's music had to do with heroism. 'What does it mean?' called another friend from long ago, who knew I'd share his sense of loss. He rang off without an answer and I watched the television tributes and tried to make sense of a sadness that was real enough, but that seemed somehow shameful and self-indulgent, according to the politics of culture which I usually pursue. Why should I feel this way about a *pop* star?

The answer began to push through the obituaries. John Lennon was a hero because he fought the usual meanings of pop stardom, because he resisted the usual easy manipulations, and in the newspaper editorials, the radio interviews, the specially illustrated supplements with full colour souvenir portrait, the struggle continued – everyone was still claiming

John Lennon as their friend, their cultural symbol. As Bryan McAllister put it in his *Guardian* cartoon, 'One has only to look at the people who claim to have known John Lennon to understand perfectly why he went to live in America.' As John Lennon put it himself in 1971, 'One had to completely humiliate oneself to be what the Beatles were, and that's what I resent. I didn't know, I didn't forsee. It happened bit by bit, gradually, until this complete craziness is surrounding you, and you're doing exactly what you don't want to do with people you can't stand – the people you hated when you were ten.'

The most repulsive of the Lennon friends ('I knew him quite well') was Harold Wilson, who explained on 'The World At One' that he gave John an MBE 'because he got the kids off the streets'. 'But wasn't he a bad example,' snapped Robin Day. 'Didn't he encourage youngsters to take drugs?' 'Ah yes,' agreed Wilson, 'he did go wrong, later.'

Lennon went wrong and it seemed then, and it still seems to me now, that a Beatle going wrong was an important political event – John Lennon knew just what sort of (working-class) hero Harold Wilson wanted him to be.

'You know it ain't easy. . .'

John Lennon was a 1950s not a 1960s teenager. He started playing rock'n'roll in 1956, the year of Suez, but the music fed his sense of adult rottenness in a more personal way – rock'n'roll was a sound made to accompany struggles at home and school, struggles against the insinuating pull to a career, to good marks and respectability. John Lennon became a teddy boy and a musician as part of his erratic opposition to the expected grateful conformities of a working-class grammar school boy.

So did hundreds of other 1950s school boys – Lennon was five days older than Cliff Richard – but they mostly lost their edge, softened by showbiz's own notions of steadiness and respectability. 'Teddy boys,' as Ray Gosling puts it, were 'tidied up into teenagers. The youngsters sang one good rock song and the next moment they were in pantomime and all-round entertainment on the pier.' Cliff Richard called his 1960 autobiography *It's Great To Be Young* and by then his way of being young seemed the 'natural' teenage way to be.

John Lennon didn't have such a great youth. For a start he lived in Liverpool. It was a cosmopolitan port with musical advantages (American R&B records could be heard in Liverpool whatever the metropolitan pop industry's successes in cleaning up white rock'n'roll) and unique material opportunities – Liverpool had clubs where groups were employed to play grown-up *gutsy* music. There was a public night-life, an aggressive way of leisure that had survived TV and the rise of family consumption. The Beatles' first manager, Allan Williams, explains the Liverpool Sound in terms of gangs and fights and territorial claims – the Beatles always had to *stand* for something, and they learnt to

'entertain' in circumstances far removed from the London Palladium. Whether in Liverpool or Hamburg, the music had to be loud and hard – there was no space for subtlety or self-pity. Equipment was poor, songs were built around the combined beat of drums, bass and rhythm guitar (Lennon's own pivotal role), around the combined voices of Lennon and McCartney. The Liverpool noise was hoarse and harsh, an effect of night after night of long, unrelieved sets.

While Tommy Steele and Cliff Richard were becoming family entertainers, the Beatles were learning street-survival tactics, and when they hit showbiz their defences were intact. As Liverpool's now veteran musicians remembered after Lennon's death, what was inspiring about the Beatles in their Cavern days was the *certainty* with which they claimed American music for themselves, and the most striking sign of this confidence was John Lennon's voice. The Beatles sang American music in a Liverpool accent – nasal rather than throaty, detached, passion expressed with a conversational cynicism.

Lennon's genius

Lennon's genius is usually described by reference to his song-writing ability, but it was his voice that always cut through. He conveyed a controlled, forthright intimacy that enabled him to rock out in early days with a barely suppressed fury, and in later, post-Beatle days to express remorse and optimism equally grippingly. Beatle fans 'knew' Lennon above all through this singing voice, and perhaps all his obituarists needed to say was that he was the only rock singer who ever sang 'we' convincingly. Certainly, when the Beatles finally had their extraordinary success story, they were different from other pop stars. Their qualities were not those of showbiz – they came across as arrogant and restless. Beatle trappings came to represent an attitude as well as the usual fan fervour, and the Beatles appealed to a mass audience that had previously been uneasy in its relationship to pop – sixth-form, student youth. The Beatles were the first English pop group that didn't insult the intelligence. They made an 'underdog' sound (to use Hobsbawm's description), pilfered from black American sources, and retained a grittiness, an awkwardness that couldn't quite be swallowed up in commercialism.

John Lennon was, in this context, the most obviously gritty, intelligent Beatle – the one with edge. He was street-sharp as much by choice as necessity. He was a grammar-school boy who, for all his rebelliousness, drew on a grammar-school boy's intellectual pride; he was an art school student who retained an art school student's radical cultural ambitions; he was a bohemian who had learned to scoff at 'nowhere' people in Hamburg's Reeperbahn. It was Lennon who leapt more quickly (more desperately?) than the other Beatles at the unfolding possibilities of 1960s rock and youth culture, and the importance of the Beatles in 1966–8 was not that they led any movement, but that they *joined in*.

They became (John Lennon in particular), for all their established star status, comrades in the mid-sixties 'liberation' of leisure. What's more, Lennon confirmed what I believed then and believe still – that it is not possible to separate the hippy aspects of 1960s youth culture, the drugs and mind-games and reconsiderations of sexuality, from the political process which fed the student movement, the anti-war movement, May 1968, the women's movement, gay liberation. It was thanks to his hippy commitments, to his open response to Yoko Ono's anti-pop ideas, that John Lennon survived the Beatles experience to make his most political music as the sixties came to an end.

'All I want is the truth. . .'

The week John Lennon was shot, the Clash released a three-record album called *Sandinista!* Infuriating, indulgent, exciting, touching, packed with slogans and simplicities, guns and liberation, images of struggle and doubt, it is a wonderful tribute to Lennon's influence – a record that would have been impossible to imagine without him.

Lennon believed more intensely than any other rock performer that rock and roll was a form of expression in which *anything* could be said, but more importantly (in this sense he was a 'proto-punk') he believed too that rock and roll was the *only* form of expression in which many things – to do with growing up working-class – could be said. His music (like the Clash's) involves an urgent eagerness *to be heard* (an eagerness which often obscured what was actually meant). As a 16-year-old, John Lennon heard in rock'n'roll an anti-authoritarian voice that everywhere else was silenced. This voice – essentially youthful – is still heard publicly only in rock music. Where else, for example, is the young's own experience of youth unemployment expressed or dealt with, except in the music of local bands, on the occasional independent record on John Peel's show?

Much of Lennon's musical life was about keeping this voice heard, keeping its edge cutting through the ideological trappings of pop, the commercial packaging of the Beatles, the ceaseless labels of the exploiters. In coping with the trivilizing tricks of the pop medium, John Lennon faced many of the issues addressed later by the punks. Yoko Ono's position was particularly important in making the problems of Lennon's star position explicit. She confronted him with the taken-for-granted masculinity of the rock and roll voice, she asked questions about musical meaning itself (particularly about the rock conventions of spontaneity and realism, about the 'truth' of the singing voice), she focused the problem of the rock relationship between the public and the private.

The energy of Lennon's music had always come from this tension – between the private use of song (as a way of handling emotion, a celebration of personal powers) and a sense of public duty. Lennon was committed to public music, accepted his 'responsibility' to his audience

(in a way that Bob Dylan, for example, did not). This was apparent not just in collective songs like 'All You Need Is Love' and 'Give Peace A Chance', but also in Lennon's continuing attempts in the early 1970s to use his song writing skills to illuminate *everything* that was happening around him.

Public music depends on a material community as well as an abstract commitment, and by the mid-seventies, Lennon, like most of the original rock stars (especially those isolated in international stardom), had lost this sense of audience (it took the punks to revive it). *Double Fantasy*, his comeback LP, reflected his withdrawal – comfortable and happy in its commitment to his wife and child and friends, it lacked the political tension that had always come from Lennon's nervous need to account for his feelings publicly as well. This was just a record to be sold. There was nothing, apparently, to be said about marriage and fatherhood that mattered enough to make Lennon challenge his audience again.

'You say you want a revolution. . .'

John Lennon understood the contradictions of capitalist music-making, but he didn't solve them, and he rarely pretended that he wasn't involved in a money-making process. 'Imagine no possessions,' he sang, but I never thought he could. There was a sloppyness to John and Yoko's concept of peace and love and changing things by thinking them so, that concealed what mattered more – the Lennons had an astute sense of the mass market and how it worked. Their happenings at the end of the 1960s drew not only on Yoko Ono's experience as a performance artist but also on John Lennon's own cynical appreciation of the peculiarities of the British popular press (Malcolm McClaren applied a similar combination of cynicism and artiness to his manipulation of the media with the Sex Pistols in 1977). 'Thank you very much for talking to us,' murmured Andy Peebles humbly at the end of Radio 1's final Lennon interview. 'Well,' said John, 'we've got a new record out and I needed to talk to people in Britain.'

The central contradiction of John Lennon's artistic life (of any attempt to make mass music in a capitalist society) lay in the uneasy enthusiasm with which he packaged and sold his dreams. The problem for the working-class, he told *Red Mole* in 1971, is that 'they are dreaming someone else's dream, it is not even their own.' The problem for a working-class hero is that he too is defined in other people's dreams. John Lennon was murdered by a fan, by someone who pushed the fantasies that pop stardom is *designed* to evoke into the appalling stupidity of a madness. The problem is that the grief that the rest of us Beatle fans then felt drew on similar fantasies, and the bitter irony is that John Lennon, whose heroism lay in his struggle against being a commodity, whose achievement was to express the *human* origins of pop ideas, should be trapped, finally, by a desperate, inhuman, nightmarish version of the pop fan's need to be a star. 1981

The Coventry Sound –
The Specials

Behind the house where Jerry Dammers lives in Coventry, there is a footbridge linking Spencer Park and the city centre. It is a long, oppressive bridge over the railway lines: at one end there is the park, student lodging houses, Edwardian domesticity: at the other end there is the ring road, under-passes, the moat and drawbridges of modern urban living. The bridge is the way to and from a city night out and it is covered, wall to wall, by graffiti.

They begin on the way there: Great Stuff The Jubilee! on a house wall, thick arrows along the path. Welcome To Anarchy Bridge, runny red letters announce, and every youth taste is here: Zep Flies (So Do Pickets!) (Who Are) White Boss? Earlsdon Troopers! Sham 69! Pakis In, Irish Out! R-E-G-G-A-E! And as a running commentary on the lot of them, yellow painted anarchism: Government Power Sucks! More Houses For Cops! Make The Most Of Mushrooms!

Jerry Dammers used to go to school along here. King Henry VIII's classrooms and playing fields back on to Spencer Park, and Jerry's been walking this route – from red brick respectability across the anarchy bridge – most of his life. Now he's writer and organist for the Specials who, in just a year, have had three top ten hits and a bestselling album, filled dancefloors in every corner of Britain and appeared on every TV pop show; they've become accustomed to photo-sessions and in-depth interviews, to features in the national press and film crews from the BBC; they've been acclaimed in America.

Rags-to-riches is a pop routine, but the Specials' success story has had wider ramifications than usual: their records have shifted the sound of the hit parade. The distinctive feature of the Specials' music is its rhythm: drawing on West Indian music of the 1960s – ska and rock steady – the group invested rock's usual 4:4 beat with the looseness, verve and cheerfulness that were missing from both punk's banged out messages and disco's expensive precision. The Specials' off beats, their rambling guitars and organ, have the warmth and ease of the sixties soul and mod clubs from which this pop sound emerged the first time round. The group became, overnight, the musical leaders of a subcultural revival: their

audiences filled up with mods and skinheads, white rude-boys in pork-pie hats. The Specials found themselves presiding over a new pop paradox: the decline of disco, the return of dance.

The music business hustlers began jostling against each other at Specials gigs, calculators in hand as they made quick translations of sweating queues into sales figures. The Specials were in a sellers' market and, as a post-punk band, were more interested in control than cash. What they wanted was their own record company: not an Apple (the Beatles' hippy fling) but a Motown, a label name to guarantee a sound. The idea was a singles showcase. 2-Tone would issue records the Specials liked, but it would be up to the musicians themselves to follow their success where they could. 2-Tone was to be a sound system, not a career structure.

The Specials eventually signed with Chrysalis. In addition to their own advance, they got a budget for their label. Chrysalis agreed to produce and distribute at least 10 of the resulting singles; the Specials agreed to carry any losses from their own royalties. From Chrysalis' point of view, all that this involved was a reduction of A and R risks and a slightly unusual accounting procedure: some of the advance they would have been willing to pay the Specials was paid into the 2-Tone account instead. What a concession! Every 2-Tone release has been a hit; every 2-Tone act a find.

Madness, a cockney-ska showband, made *The Prince* and then a massive selling LP for Stiff Records; the Selecter, friends of the Specials from Coventry (and co-controllers of 2-Tone) spent the autumn on the radio with *On My Radio*; the Beat, a young black and white group from Birmingham, signed a generous contract with Arista Records after the 2-Tone success of *Tears of a Clown*; Dexy's Midnight Runners joined the 2-Tone tour and got an EMI deal even before they'd recorded. The 2-Tone sound began to be heard on records which had nothing to do with the label at all, and the Specials had only to mention a band for a flurry of showbiz execs to be off in hot pursuit. People began referring to 'the Coventry Sound,' as if this bland Midlands city was going to become the Liverpool of the 1980s.

The Specials do still live in Coventry. It is, in Jerry's words, 'a privilege. People say we are wonderful for being based in Coventry, but we are lucky. Struggling bands go to London because they *have* to.' But ask why the 2-Tone sound came from Coventry in the first place and the band members can only shrug and mutter: 'It's dull.' 'Everyone knows everyone.' 'There is no other style to slip into.' 'There is no entertainment so you have to create your own.' They come up with negative causes.

In Jerry's living-room you can see the symbols of his Coventry past: art college debris — shining pop-art poster paintings from his days at Lanchester Polytechnic; stuffed faces in glass cases and a postcard of Ken Dodd; a union jack in the window and mod hats and uniforms on hooks. The front door is stuck with stickers for Urge, a local punk band, and on a board above the phone, among the 2-Tone designs, are publicity pics of

long-gone groups: Pharaoh's Kingdom, Earthbound, Breaker, the Ray King Band, the Sissy Stone Band, which once won a heat of *New Faces*.

Look closely at these photos, at the back-lit blacks in white vests and tight pants, at the long-haired rock poses, and you can spot Specials and Selecters in their previous disguise. These musicians spent most of the seventies as provincial professionals, touring working-men's clubs and would-be flash discos, playing pop and soul and reggae music. They have been making people dance, anonymously, for years.

The most obvious feature of the 2-Tone sound is its combination of black and white music and musicians, but the Specials' roots are more tangled than this. The Midlands soul professionals were themselves a part of the complex cross-culture of Coventry's leisure life, as art college schemers bumped into reggae kids from the Holyhead Road youth club and punks from the outer estates. They met on the dingy floors of the few musical pubs; they shared seedy nights at Mr George's, a once plush club gone punk decrepit; they came together in the hang-outs of the local bohemia – the drugs and party circuit, the back room at the Oak, late nights in the Domino Club, the room filled with gays, punks, musicians, drunks – everyone in Coventry who didn't have to get up in the morning.

What these late-night people had in common was a determination not to surrender to routine, not to give up their high talk of art and music and pleasure to the dread demands of work and marriage. Jerry wrote many of the Specials current songs long ago, when he was still at school, and they are much more desperate than their easy beat immediately implies. Singer Terry's flat punk vocal style compounds their anger – he adds the bitterest bites himself. *Blank expression, Stupid marriage, Too much too young*: the titles speak for themselves, as the Specials rail and despair at all their friends settling down around them. They come from a Coventry beat tradition that goes back to at least the 1950s and theirs are the yellow slogans on anarchy bridge: Say No!

This is not how the message comes out in the media and Jerry is still bemused by the reduction of the Specials' individualist urgency to careful consumer labels – 'ska', 'mod', 'revival'. 'We are reviving something that never existed in the first place,' he comments sourly. He prefers to think of the 2-Tone sound as 'second hand culture'. It rests on older brothers' cast-offs (Jerry's brother played in a sixties soul group), on old singles collections, Saturday night dance hall memories, bluebeat LPs picked up for 10p in back street junk shops. The Specials certainly don't see themselves as a ska band; they are inspired by *all* the Jamaican styles of the last 20 years and think little of that – reggae has replaced jazz as the cool noise of provincial bohemia everywhere.

Jerry has a halfway decent stereo system now, and buys new records. For a moment he talks as if his career was over: 'I can walk into the sea now. Retire with honour.' Like a hardened old star he goes through the pressures: 'I would like to go out of fashion, then we could relax.' And work out what 2-Tone's success means. The Specials still have Coventry plans – a club, a studio – but don't really know what money there is.

Jerry remains deeply suspicious of record companies, his own included. His favourite bit of the Chrysalis contract is its Ref's Clause: if Chrysalis do something the Specials do not approve, the company gets a warning: a second offence and the band has a legal right to walk off.

Jerry laughs (the clause has not yet been used) and I think that pop dreams come true so quickly that the musicians hardly notice the changes themselves. One week I was chatting to drummer Brad in Virgin records, where he worked – he was wondering how to get the Specials' single, *Gangsters*, to John Peel: the next week John Peel was playing the record obsessively, Brad had left the shop and the Specials were on the cover of *Melody Maker*. By the end of the year, the Specials had been joined on the 2-Tone tour by Rico, the Jamaican trombonist whose wonderful work on 1960s records had been the Specials' original inspiration. Now he was playing with them as a friend and the Specials had constructed their own myth.

The Specials are too experienced as pop fans not to know about musical fashion and the press backlash. They understand that the moment when the BBC and the national press are interested is the moment when they have become just another rock routine, their excitement rubbed off. But once you're on the rock treadmill it's difficult to get off, and there are ironies in the Specials' success, as they well know. They earn, now, about the same as the school friends who took the solid Coventry jobs (they still existed then) in Chrysler and Leyland. And as Julia said in *Alternative Sounds*, Coventry's sharp-featured punk fanzine: 'A car-worker doesn't have the pressure and extra hours of a professional musician. He doesn't have to make his work a way of life.'

Jerry agrees that the whole thing is a bit silly. But he hasn't written anything on the bridge for ages.　　　　　　　　　　　　　　　1980

Unreconstructed
Rock'n'Roller –
Ray Lowry

My favourite Ray Lowry cartoon is set in a record company office. The man with the desk addresses two minions who are idling through the *NME Book of Rock* and the *Rolling Stone Illustrated History of Rock and Roll*. 'What we need,' he muses, 'is a rock and roll history written from our side. How the great Colonel Parker defused Elvis Presley and turned him into a fifteenth-rate movie actor. How the Beatles were emasculated with silly suits and loveable moptops publicity guff. How punk was bought and sold as style at the expense of content. . .'

In another picture it is a rock star talking, his Rolls and his sidekick parked at the end of a city centre view – neon and office blocks and big stores. 'My record company felt that I was becoming elitist and out of touch with the street,' he says. 'So I got my manager to buy me this one.'

There is a long tradition of rock and roll cartooning, dating back to the days when the underground press was mostly comics plus record reviews. Some artists were the record reviewers, too. Each month in *Creem*, for example, Bob Wilson's blank teenagers muttered to each other about the latest releases. I remember best the Wilson review of the Rolling Stones' *Sticky Fingers* LP. After the excited process of putting the record on, everyone seemed to drift out of the room, leaving the strip empty but for the cliches floating loose as the band played on.

In Britain the music papers use cartoonists like newspapers do – to add pithy editorial comment to the week's events. Peter Till's brilliant Sid Vicious death drawing for *Melody Maker*, for example, said everything that needed to be said: The Last Pogo – Vicious pierced through by an immense hypodermic syringe he is using as a pogo stick. And commentary, in a way, has been Ray Lowry's function, too, for the *New Musical Express*.

He wasn't the paper's first strip comic. Tony Benyon's 'The Lone Groover', the weekly adventures of a loser musician, had been running for years when Lowry began 'Only Rock'n'Roll' in 1977, and Lowry's

"What we need is a rock and roll history written from our side. How the great Colonel Parker defused Elvis Presley and turned him into a fifteenth rate movie actor. How the Beatles were emasculated with silly suits and loveable moptops publicity guff. How punk rock was bought out and sold as a style at the expense of its content..."

format – four or five pen and ink frames, lots of words, talking heads, sketchy settings – was much the same as Benyon's. But his stance was different.

The Lone Groover, for all his hippy-dippyness, is affectionately presented; he is a sixties survivor. Lowry is a jaded rock'n'roll fan, a 1950s person, cynical and angry. He was stirred by 1976 excitement, the punk moment, but he had also seen it all before and knew that nothing was how it was sold, that everything was a matter of greed.

In his version of the Sex Pistols' story, the group appear with Bill Gradely ('the show that craps on the carpet') on London Weekneed Television. 'Okay sweeties!' shouts the director at the end, 'CUT!!! You were *ropey* dears, definitely twine-like. But I'm sure you will have it right in time for the live transmission!'

Lowry's *NME* strips (and some of his cartoons) have now been collected in a book, *Only Rock'n'Roll* (published by the New Manchester Review),[1] and they provide the best commentary there is on what happened to British rock between 1977 and 1980. Lowry was, for all his older roots, a punk ideologue. He laid into Radio One and disc jockeys generally; he pinned his colleagues down as rock press hacks; he raged at rock star indulgence. He hated America and scoured every rock happening for its lies and tricks. He was the official artist of the punk 'boom', the official chronicler of its decline; he followed its inevitable collapse into the normal ways of show business and star-making. In 1979 he designed the sleeve for the Clash's *London Calling* LP, the record that finally ceded the punks' defeat (it was a big American success), and changed the name of his *NME* strip to '*Not* Only Rock'n'Roll.'

Lowry's obsession is rock and roll authenticity, which he rarely finds, and his search for it means a search through the language of rock, through the words and attitudes that are used to sell and make sense of it. He has been a fine cartoonist, of course, for a long time (the only person I ever looked for in *Punch*) and even before his *NME* days his theme was showbiz cliche and the juxtaposition of images from two sorts of spectacle – war and entertainment. His jokes (and his political purpose) derive from the application of one way of reading a spectacle to another: Hitler as superstar, the Nazis as Hollywood extras, the Germans as a Palladium audience. 'Isn't this music great?' chirp a group of brown-shirts listening to a Nazi military band. 'It makes you want to get up on your feet and invade Poland!'

What matters in the 'Only Rock'n'Roll' strip itself is not the drawing – scrawled caricatures, just enough to get the picture – but the dialogue, the rock*speak*. And what makes Lowry's cartoons so interesting (what gave them punk resonance) is their assumption that the struggle for the meaning of rock is a class struggle.

Lowry claims that his brain froze in 1956 (when he was a pre-pubescent Eddie Cochran fan) and the degeneration of the music has, for him, been since then an almost continuous process. ('Over a decade now,' says a figure in one strip, 'and except for two debut albums in 1977

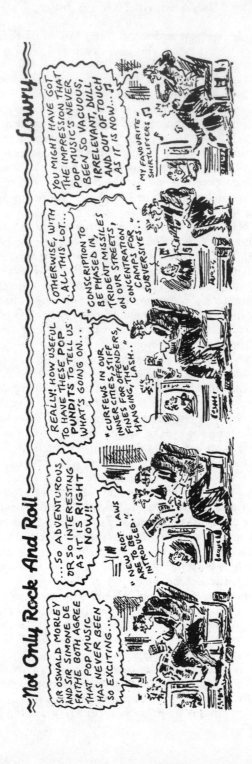

we might as well be back in the 1940s.') The problem is not only businessmen but also, worse, other rock fans. In the 1960s middle-class youth took over the only good thing that the sec mod kids ever had going for them, and people like Ray Lowry don't forget or forgive but sit in the pub and brood about it.

Only Rock'n'Roll argues that the same thing that happened to Eddie Cochran and Merseybeat happened to punk, only quicker – prole points were taken over by sixth formers, artists, young men in macs. The rock'n'roll secret, which Lowry had been guarding since 1956, was once more leaked – *his* music was claimed and laughed at, analysed and judged by *them*. Lowry's real hate-figures aren't businessmen but the *Sunday Times* bourgeois pop person, Derek Jewell ('Can't something be done about Derek Jewell. Rat poison? A weight dropped from a great height? This man is making my Sundays hell'), and the sotto voice of progressive rock, Bob Harris – a recurrent Lowry set is the 'Old Grey Whistle Test' as Bob respectfully interviews a dead Keith Richard, grovels about America, trades banalities with wet suburban stars.

In one of his strips, Lowry fantisizes a rock and roll strike. It is broken when the public schoolboys step in: 'Can you live with the Rolling Swats, the Sandhurst Pistols, Eton John, Sid Vigorous, the Cold Showers?' In another cartoon a musician is being interviewed: 'Of course we are not dismissive of the original punk bands. We are really grateful to them for creating a major upheaval and clearing the way for people like us to step into the limelight and deal with the really important subjects like school meals, household appliances, car numbers and striped shirts.'

Lowry is quite right. Rock and roll is now firmly back in the hands of the sixth-form. The most influential group is Joy Division ('Joke Division' in Lowry's terms – angst and sounds you have to sit down to); the pages of *NME* itself are dominated by A-level essays. ('The words can be read as poems,' I read this week: 'a nocturne/in the clean black air/ under their breath/they heard a pindrop/they and the routeless earth/oh and the dead light/and the frost.').

On Radio One disc jockeys are now encouraged to have an interest in music (and not just in themselves). The result is a curious sort of interest – an obsession with facts and figures, knowledge for some imminent rock and roll school exam. The matey school prefect tones of Mike Read set the BBC pace: music while you homework.

Rock history is usually written in terms of a struggle between the people (musicians, fans) and the record companies. The music develops through cycles of creativity and commercial control (punk is just the latest, fastest rock turn). But Lowry's cartoons are about the social effects of commercial control, as working-class music becomes middle-class leisure. His problem is community – who is rock and roll for? – and if it is ironic that an apparently unreconstructed fifties rock'n'roller should end up as the sharpest observer of rock hypocrisy in the eighties, it is also fitting.

Only Rock'n'Roll is a book about keeping faith. It expresses the

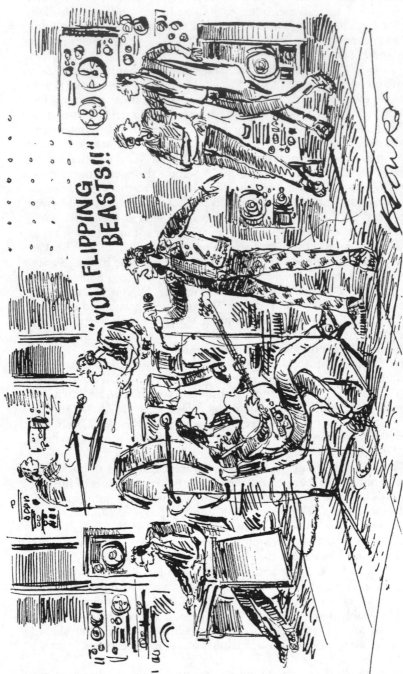

"There's all the pent-up fury and aggression of several years of excessive toilet training by a beastly nanny, a sheltered upbringing in the home counties and a minor place in an obscure public school, coming out here."

preoccupations of a usually hidden strand of British rock culture. There are more than 25 years worth of scattered rock obsessives now who *know* what rock and roll is for – to tell the truth of *their* energy, powerlessness and rage. They resent, more than anything, intellectuals, sociologists, careerists who indulge in the music, explain it, take what they want from it (money, good times) and run. 1980

Notes

1 Ray Lowry, *Only Rock'n'Roll* (New Manchester Review, Manchester, 1980).

Walls Come Tumbling Down
– Paul Weller

The central myth of British pop is style. Sociologists have built dense aesthetic theories around the formal rituals of youth subcultures, not noticing, close up, how gracelessly Brits move, how frayed most youth uniforms are. *The Face*, the style spread of the 1980s, is a success not as a reflection of street fashion but as a fantasy – like any other advertising magazine it signifies aspiration, offers each new look as an ideal.

The standards for youth styles were set by the mods in the early 1960s, but it's the memory not the reality of mod that matters. The current rerun of the mod TV show, 'Ready Steady Go', has been revealing. I remember watching 'RSG' as if it were a shop window – its studio audiences were models on display. It turns out, though, that these acquiescent, gauche Londoners were as much window-gazers as we were at home. 'Ready Steady Go' was a teen show, its youngsters tumbling self-consciously out of the way of the cameramen pushing them around. Even the performers spent much of their time in awe, watching the visiting black Americans.

Fast forward. My memory of the young Paul Weller and Johnny Rotten, 1976, 1977, has them in similarly wrinkled suits, high-street style on a tight budget. In reality, of course, their clothes worked as differently as their musics: Rotten, for all the Pistols' fashion-shop start, indicating a bohemian contempt for the consumer fetish; Weller obsessed by it. The only time I interviewed the Jam all they'd talk about was buying shoes.

What I didn't know then was how the story would work out. Nearly a decade later, John Lydon, the vicious, furtive voice of the underclass, who emerged into stardom like a rat from Britain's decay, lives in Los Angeles, an artist and a schemer; Paul Weller, in 1977 determined to be upwardly mobile, is now a militant Labour supporter, involved in every good cause – a voice of working-class youth as important to Britain as Bruce Springsteen is to the USA.

Lydon, an individualist in free-enterprise California, Weller the political conscience of the respectable working-class – in retrospect, maybe their future roles were determined by their styles, by the way the politics of culture work.

One aspect of the Sex Pistols' concern with shock effects was the distance it placed between them and their audiences. Rotten's assaults were *on* rather than *for* his fans; his 'contempt' meant a refusal to look out for anyone but himself. The legacy of the Sex Pistols to British working-class youth is a style of non-communication summarized in a brilliant single, the Jesus and Mary Chain's 'Never Understand.' There seems to be a great pop song there – the Beach Boys? The Ramones? – but it's impossible to get at it through the feedback. A genuinely disruptive record, 'Never Understand' is hard to hear without thinking something's wrong (radio programmers hated it), but this sort of gesture is essentially antisocial, and the Jesus and Mary Chain, like their 1970s punk models, are frustrated artists.

Paul Weller, by contrast, is a frustrated consumer. He has always identified with his fans, accepted a spokesman role, worried – a good liberal – about 'communication'. What makes his new group the Style Council even more interesting than the Jam is that Weller now defines consumption as a form of socialism.

In the USA, working-class aspirations have always been carried in the imagery of geographical mobility; in Britain, hope is expressed in small shifts of status and authority marked by consumer goods, by speech inflections, by style. If the American nightmare is stagnation (stuck inside of Mobile), in Britain the fear is that the facade will crack. Hence our obsessive need to preserve social differences, our chauvinism and racism – most obvious in the middle-classes but also the key to, say, the Brussels football horror.

On the new Style Council album, *Our Favourite Shop*, Weller and organist Mick Talbot have abandoned their awkward 'jazzy' experiments and gone back to 1960s mod sounds. The political strategy now is to get at the collective needs that impel retail choice, to point up the way Thatcherite policies are destroying positive pleasures; Weller (shades of Oscar Wilde) sees socialism as the necessary setting for the pursuit of self-interest. What to American ears will probably sound like an oddly second-hand white soul record is, in its British context, deeply moving. I doubt if there'll be a more exhilarating moment this year than Style Council's live audience laughing out loud at 'We don't have to take this crap, we don't have to sit back and relax. . .' 1985

Send for Your Free Trial Issue of Money Power Today! – Green

I'm reading an interview with Green Gartside of Scritti Politti. I've never much liked his music, but I've always been absorbed by his project. Scritti Politti were the most *right on* of the post-punk, post-structuralist British groups. Self-righteousness oozed through the murk of their early clatter. Even do-it-yourself recording became, for them, an aggressive ideological gesture, its anti-hegemonic significance spelled out on every record sleeve.

Ah, the art school class war. Green moved on, of course. He signed a half-million dollar deal with Virgin and bought the exclusive rights to the Scritti name (his original partners have just got their final pay-off). He writes familiar tunes now, his voice floating over carefully layered rhythmic programmes. He's no longer a Marxist, though he continues to be a smart aleck, dropping French names (a single called 'Jacques Derrida') and concepts (his publishing company is called Jouissance) like any good reader of *Enclitic*.

So, anyway, here's Green Gartside sitting pretty in the *Sunday Times* colour supplement, in the 'people' slot. He's wearing a button-down shirt and a tie, a young executive, alert and in control, and he's being profiled as a symbol. Green means success, 1985-style. The stars look down over new captions: fragments of Barthes and Wittgenstein interpreted by copywriters. The reading of the pop text (deconstruction) comes before the writing of the pop text (image), so this is an interesting interview, but I keep getting stuck on page two: 'Before having his picture taken for this article a fee had to be negotiated with Virgin Records for his make-up artist.'

It's harder and harder these days, reading interviews with British pop stars, to place them as musicians. They come across, rather, as advertising people, skilled at design and clothes and packaging (trained at art school), bringing in the sound-makers (Gamson, Maher, the rest of the New York session teams) after the creative event. All the musicians

do is give the drawing board 'product' its commodity form – as a record.

I don't care that Green has 'sold out'. If he gets rich from his well-educated grasp of consumer fetishism, good luck – in terms of political correctness, I'd take pop artifice over rock naturalism any day. What interests me is a different question: what is he selling?

Back to the interview. 'I asked if he knew who bought the product? Green replied that the singles were bought mostly by young girls.' Another memory occurred to me: Nick Heyward's first solo tour after he left Haircut 100 to become a serious star. The band, the bouncers, and I are the only adults there, the only men. Heyward is intense despite the din. The little girl standing next to me takes a new pair of panties from a Marks and Spencers bag and throws them on the stage. Heyward takes off his jacket; the screaming lifts the roof.

Green, like Heyward, is selling himself. His voice/image/body is the public site for pubescent fantasies. Music matters only as the vehicle for these fantasies; music mediated, that is, by a personality, by a star who seems to give his listeners intimate access to their own feelings. Green's 'use value', what makes his records sell, is his appeal as someone who can be had, materially in scrapbooks and on bedroom walls, erotically in dreams.

This is the traditional function of the teeny-bop idol, and it's certainly arguable that the only difference between Green and David Cassidy is that Cassidy did not explain his sex appeal by references to Foucault and Deleuze. For me, though, such knowingness about pop's 'desiring machinery' marks a loss. The joy of teenage pop isn't confined to teenagers (nor to adults wishing they were teenagers), but 'a perfect pop record' (Green's goal) works *despite* its packaging – 'Karma Chameleon', for example, touched people who hadn't the faintest idea who Boy George was or what he looked like. Good pop is heard obliquely; it offers unexpected versions of feelings we never knew we had. What's 'good' here usually is described by its straight musical elements (a haunting tune, etc.), but what matters is a tone of voice: suddenly there's this stranger, involved in a different conversation altogether, talking about you.

The aesthetics of pop rest on the musical tension between familiarity and novelty, but its emotional effects come from the play of recognition and surprise. Current British teen music has mostly got the balance wrong. There are certainly moments of recognition, but since the early days of Human League, Altered Images, and ABC, with the rise of consumer theorists, there's been less and less surprise. Every time I hear Scritti Politti's 'The Word Girl', I think, 'Aaah, what is this?' And then, every time, I think, 'Oh, yeah, it's Green.'

1985

The Critics' Choice –
Hüsker Dü

Downtown Minneapolis has the feel of a much smaller town – a stolid, friendly place, getting slowly malled. In the tourist shop, among the Mini-Apple tea towels and native American carving, there's a record stall, music made by local artists like Bob Dylan. Most of the other names I don't know, local folkies and raconteurs, but there's also a wadge of new talent – Prince, Jimmy Jam and Terry Lewis, the Replacements and Hüsker Dü, all of them still living and recording in the city.

Of these, Hüsker Dü are the most Minnesotan. Their name, the Danish for 'do you remember', reflects the state's Scandinavian heritage; their stance is rooted in the mid-Western contrast of big spaces and small concerns. They've been together since the end of the 1970s, started recording in 1982, and for the past couple of years have been recognized by critics as the best rock band in the world. They're certainly the most productive – five LPs since 1984 – and I share my colleagues' belief that this is the most important body of recent white pop music.

Hüsker Dü began as a 'hard-core' group, making music inspired by the Ramones and the US slam-dance version of British punk, mini-tunes bawled out with anxious speed and volume. As the group themselves explain, punk was made by musicians who had much to say but limited ability to do so; Hüsker Dü necessarily developed a style of compressed minimalism – the few chords they could manage had to stand, over and over, for everything.

From the start American hard-core musicians were formalists, less concerned than British bands with social and media gestures, more enraged by the constrictions of pop music itself. Hüsker Dü's cover versions – 'Ticket to Ride', 'Eight Miles High' – reinterpret psychedelic pop as music in the throes of collapse. The tunes are deconstructed, turned into a grinding noise – which is how this music was originally heard live anyway. To get the argument, play 'The Beatles Live at Hollywood Bowl' (the screaming never stops) against Hüsker Dü's 'Flip Your Wig' or the Jesus and Mary Chain's 'Psycho Candy'.

Hüsker Dü's formality is most obvious in live performance. They don't appear like pop stars or, indeed, suggest any visual sales plan. Drummer

Grant Hart grins like a hyped-up college boy, bassist Greg Norton looks like a Christopher Street clone, moustached, lithe and sparkling, guitarist Bob Mould, as consistent to his name as a Dickens character, is a slab of a man, close-cropped, a quarterback who has been pulled and squeezed out of shape. The group stride out with a job to do, no time for play or banter, no truck with male poses. Their din is concentrated.

Each song is short, bursts out and over, but there's no break between numbers – the band play as if pushing against a torrent of noise they can't hold back. The lead sound is a ringing in the ears. Mould wears his guitar low on his thighs, jabs at the strings high on its neck, Hart's drums are swathed in cymbals, Norton's bass lines blurred. Hüsker Dü don't set up a community of pleasure – shared good tunes and a dancing beat – but a collective tension. The band grip their emotions so tightly that we're bound in too, and wonder, with jagged nerves, whether Bob Mould will explode.

He gets the electro-symphonic effect Glenn Branca and other New York avant-gardists have always wanted, the creation of a sonic world so dense, so enveloping that, eventually, audiences are entirely subject to its logic.

At the end of Hüsker Dü's show in Birmingham I felt that I'd been on a long trip, heard strange, frightening notes, had glimpses of grace and rest, emerged cleansed and tired and bleary. And what makes the group so interesting – what reveals their mid-Western roots – is that buried in the heart of this soundscape were good old teenage pop tunes, teen pop feelings, shy, obsessive love, overwhelming boredom, Sunday afternoon, small town despair that life may offer no hope at all.

White suburban youth in cities like Minneapolis know, secretly, that Marx was right about alienation all along. The more insistent the capitalism, the more fraught the gap between the grand language of opportunity and the mean circumstances of work and home.

Rock and roll has always worked in this gap, been a vainglorious attempt to turn petty frustration into an epic, to win some lasting uplift from the intensity of sex and violence. Hüsker Dü do this job better than anyone at present, so well, indeed, that now they are signed to WEA their problem is not selling out but growing up. When they're skilled (and rich) enough to play what they want, will they still have the drive and desperation that limitation brings? 1986

The Real Thing –
Bruce Springsteen

Introduction

My guess is that by Christmas 1986 Bruce Springsteen was making more money per day than any other pop star – more than Madonna, more than Phil Collins or Mark Knopfler, more than Paul McCartney even; *Time* calculated that he had earned $7.5 million in the first *week* of his *Live* LP release. This five-record boxed set went straight to the top of the American LP sales charts (it reputedly sold a million copies on its first day, grossing $50 million 'out of the gate') and stayed there throughout the Christmas season. It was the nation's best-seller in November and December, when more records are sold than in all the other months of the year put together. Even in Britain, where the winter charts are dominated by TV-advertised anthologies, the Springsteen set at £25 brought in more money than the tight-margin single-album compilations. (And CBS reckon they get 42% of their annual sales at Christmas time). Walking through London from Tottenham Court Road down Oxford Street to Piccadilly in early December, passing the three symbols of corporate rock – the Virgin, HMV and Tower superstores – each claiming to be the biggest record shop in the world, I could only see Springsteen boxes, piled high by the cash desks, the *safest* stock of the season.

Sales success at this level – those boxes were piled up in Sydney and Toronto too, in shop aisles in Sweden and Denmark, West Germany, Holland and Japan – has a disruptive effect on the rest of the rock process. American television news showed trucks arriving at New York's record stores from the CBS warehouses – they were immediately surrounded by queues too, and so, in the USA, Springsteen was sold off the back of vans, frantically, like a sudden supply of Levis in the USSR. Within hours of its release, the Springsteen box was jamming up CBS's works. In America the company announced that nothing from its back catalogue would be available for four months, because all spare capacity had been commandeered for Springsteen (and even then the compact disc version of the box was soon sold out – not enough, only 300,000, had

been manufactured). In Europe the company devoted one of its three pressing plants exclusively to the box. Springsteen dominated the market by being the only CBS product readily available.

Whatever the final sales figures turn out to be (and after Christmas the returns of the boxes from the retailers to CBS were as startling as the original sales), it is already obvious that *Bruce Springsteen and the E Street Band Live* is a phenomenal record, a money-making achievement to be discussed on the same scale as *Saturday Night Fever* or Michael Jackson's *Thriller*. Remember, too, that a live record is cheaper to produce than a new studio sound (and Springsteen has already been well rewarded for these songs from the sales of previous discs and the proceeds of sell-out tours). Nor did CBS need the expensive trappings or promo videos and press and TV advertising to make this record sell. Because the Springsteen box was an event in itself (the only pop precedent I can think of is the Beatles' 1968 *White Album*), it generated its own publicity as 'news' – radio stations competed to play the most tracks for the longest times, shops competed to give Bruce the most window space, newspapers competed in speculations about how much money he was really making. The Springsteen box became, in other words, that ultimate object of capitalist fantasy, a commodity which sold more and more because it had sold so well already, a product which had to be *owned* (rather than necessarily used).

In the end, though, what is peculiar about the Springsteen story is not its marks of a brilliant commercial campaign, but their invisibility. Other superstars put out live sets for Christmas (Queen, for example) and the critics sneer at their opportunism; other stars resell their old hits (Bryan Ferry, for example) and their fans worry about their lack of current inspiration. And in these sorry tales of greed and pride it is Bruce Springsteen more often than not who is the measure of musical integrity, the model of a rock performer who cannot be discussed in terms of financial calculation. In short, the most successful pop commodity of the moment, the Springsteen Live Set, stands for the principle that music should not be a commodity; it is his very disdain for success that makes Springsteen so successful. It is as if his presence on every fashionable turntable, tape deck and disc machine, his box on every up-market living-room floor, are what enables an aging, affluent rock generation to feel in touch with its 'roots'. And what matters in this post-modern era is not whether Bruce Springsteen *is* the real thing, but how he sustains the belief that there are somehow, somewhere, real things to be.

False

Consider the following:

Bruce Springsteen is a millionaire who dresses as a worker. Worn jeans, singlets, a head band to keep his hair from his eyes – these are working clothes and it is an important part of Springsteen's appeal that we do see

him, as an entertainer, working for his living. His popularity is based on his live shows and, more particularly, on their spectacular energy: Springsteen works *hard*, and his exhaustion – on our behalf – is visible. He makes music physically, as a *manual* worker. His clothes are straightforwardly practical, sensible (like sports people's clothes) – comfortable jeans (worn in) for easy movement, a singlet to let the sweat flow free, the mechanic's cloth to wipe his brow.

But there is more to these clothes than this. *Springsteen wears work clothes even when he is not working*. His off-stage image, his LP sleeves and interview poses, even the candid 'off duty' paparazzi shots, involve the same down-to-earth practicality (the only time Springsteen was seen to dress up 'in private' was for his wedding). Springsteen doesn't wear the clothes appropriate to his real economic status and resources (as compared with other pop stars), but neither does he dress up for special occasions like real workers do – he's never seen flashily attired for a sharp night out. It's as if he can't be seen to be excessive or indulgent except on our behalf, as a performer for an audience. For him there is no division between work and play, between the ordinary and the extraordinary. Because the constructed 'Springsteen', the star, is presented plain, there can never be a suggestion that this is just an act (as Elvis was an act, as Madonna is). There are no other Springsteens, whether more real or more artificial, to be seen.

Springsteen is employer-as-employee. It has always surprised me that he should be nicknamed 'The Boss', but the implication is that this is an affectionate label, a brotherly way in which the E Street Band honour his sheer drive. In fact 'boss' is an accurate description of their economic relationship – Springsteen *employs* his band; he has the recording contracts, controls the LP and concert material, writes the songs and chooses the oldies. And whatever his musicians' contributions to his success (fulsomely recognized), he gets the composing/performing royalties, could, in principle, sack people, and, like any other good employer, rewards his team with generous bonuses after each sell-out show or disc. And, of course, he employs a stage crew too, and a manager, a publicist, a secretary/assistant; he has an annual turnover now of millions. He may express the feelings of 'little' men and women buffeted by distant company boards but he is himself a corporation.

Springsteen is a 37-year-old teenager. He is 20 years into a hugely successful career, he's a professional, a married man old enough to be the father of adolescent children of his own, but he still presents himself as a young man, waiting to see what life will bring, made tense by clashes with adult authority. He introduces his songs with memories – his life as a boy, arguments with his father (his mother is rarely mentioned) – but as a performer he is clearly *present* in these emotions. Springsteen doesn't regret or vilify his past; as a grown man he's still living it.

Springsteen is a shy exhibitionist. He is, indeed, one of the sexiest performers rock and roll has ever had – there's a good part of his concert audience who simply fancy him, can't take their eyes off his body, and he's mesmerising on stage because of the confidence with which he displays himself. But, for all this, his persona is still that of a nervy, gauche youth on an early date.

Springsteen is superstar-as-friend. He comes into our lives as a recording star, a radio sound, a video presence and, these days, as an item of magazine gossip. Even in his live shows he seems more accessible in the close-ups on the mammoth screens around the stage than as the 'real' dim figure in the distance. And yet he is still the rock performer whose act most convincingly creates (and depends on) a sense of community.

Springsteen's most successful 'record' is 'live'. What the boxed set is meant to do is reproduce a concert, an *event*, and if for other artists five records would be excessive, for Springsteen it is a further sign of his album's truth-to-life – it lasts about the same length of time as a show. There's an interesting question of trust raised here. I don't doubt that these performances were once live, that the applause did happen, but this is nevertheless a false event, a concert put together from different shows (and alternative mixes), edited and balanced to sound like a live LP (which has quite different aural conventions than an actual show). Springsteen fans know that, of course. The pleasure of this set is not that it takes us back to somewhere we've been, but that it lays out something ideal. It describes what we *mean* by 'Springsteen live', and what makes him 'real' in this context is not his transparency, the idea that he is who he pretends to be, but his art, his ability to articulate the right *idea* of reality.

True

The recurring term used in discussions of Springsteen, by fans, by critics, by fans-as-critics is 'authenticity'. What is meant by this is not that Springsteen is authentic in a direct way – is simply expressing himself – but that he represents 'authenticity'. This is why he has become so important: he stands for the core values of rock and roll even as those values become harder and harder to sustain. At a time when rock is the soundtrack for TV commercials, when tours depend on sponsorship deals, when video promotion has blurred the line between music-making and music-selling, Springsteen suggests that, despite everything, it still gives people a way to define themselves against corporate logic, a language in which everyday hopes and fears can be expressed.

If Bruce Springsteen didn't exist, American rock critics would have had to invent him. In a sense, they did, whether directly (Jon Landau, *Rolling Stone*'s most significant critical theorist in the late sixties, is now

his manager) or indirectly (Dave Marsh, Springsteen's official biographer, is the most passionate and widely read rock critic of the eighties). There are, indeed, few American rock critics who haven't celebrated Springsteen, but their task has been less to explain him to his potential fans, to sustain the momentum that carried him from cult to mass stardom, than to explain him to himself. They've placed him, that is, in a particular reading of rock history, not as the 'new Dylan' (his original sales label) but as the 'voice of the people'. His task is to carry the baton passed on from Woody Guthrie, and the purpose of his carefully placed oldies (Guthrie's 'This Land Is Your Land', Presley and Berry hits, British beat classics, Edwin Starr's 'War') isn't just to situate him as a fellow fan but also to identify him with a particular musical project. Springsteen himself claims on stage to represent an authentic popular tradition (as against the spurious commercial sentiments of an Irving Berlin).

To be so 'authentic' involves a number of moves. Firstly, authenticity must be defined against artifice; the terms only make sense in opposition to each other. This is the importance of Springsteen's image – to represent the 'raw' as against the 'cooked'. His plain stage appearance, his dressing down, has to be understood with reference to showbiz dressing up, to the elaborate spectacle of cabaret pop and soul (and routine stadium rock and roll) – Springsteen is real *by contrast*. In lyrical terms too he is plain-speaking; his songwriting craft is marked not by 'poetic' or obscure or personal language, as in the singer/songwriter tradition following Dylan, folk-rock (and his own early material), but by the vivid images and metaphors he builds from common words.

What's at stake here is not authenticity of experience, but authenticity of feeling; what matters is not whether Springsteen has been through these things himself (boredom, aggression, ecstasy, despair) but that he knows how they work. The point of his autobiographical anecdotes is not to reveal himself but to root his music in material conditions. Like artists in other media (fiction, film) Springsteen is concerned to give emotions (the essential data of rock and roll) a narrative setting, to situate them in time and place, to relate them to the situations they explain or confuse. He's not interested in abstract emotions, in vague sensation or even in moralizing. He is, to put it simply, a story-teller, and in straining to make his stories credible he uses classic techniques. Reality is registered by conventions first formulated by the nineteenth-century naturalists – a refusal to sentimentalize social conditions, a compulsion to sentimentalize human nature. Springsteen's songs (like Zola's fictions) are almost exclusively concerned with the working-class, with the effects of poverty and uncertainty, the consequences of weakness and crime; they trawl through the murky reality of the American dream; they contrast utopian impulses with people's lack of opportunity to do much more than get by; they find in sex the only opportunity for passion (and betrayal). Springsteen's protagonists, victims and criminals, defeated and enraged, are treated tenderly, their hopes honoured, their failure determined by circumstance.

It is his realism that makes Springsteen's populism politically ambiguous. His message is certainly anti-capitalist, or, at least, critical of the effects of capitalism – as both citizen and star Springsteen has refused to submit to market forces, has shown consistent and generous support for the system's losers, for striking trade unionists and the unemployed, for battered wives and children. But, at the same time, his focus on individuals' fate, the very power with which he describes the dreams they can't realize (but which he has) offers an opening for his appropriation, appropriation not just by politicians like Reagan but, more importantly, by hucksters and advertisers, who use him to sell their goods as some sort of *solution* to the problem he outlines. This is the paradox of mass-marketed populism: Springsteen's songs suggests there is something missing in our lives, the CBS message is that we can fill the gap *with a Bruce Springsteen record*. And for all Springsteen's support of current causes, what comes from his music is a whiff of nostalgia and an air of fatalism. His stories describe hopes-about-to-be-dashed, convey a sense of time passing beyond our control, suggest that our dreams can only be dreams. The formal conservatism of the music reinforces the emotional conservation of the lyrics. This is the way the world is, he sings, and nothing really changes.

But there's another way of describing Springsteen's realism. It means celebrating the ordinary not the special. Again the point is not that Springsteen is ordinary or even pretends to be, but that he honours ordinariness, making something intense out of experiences that are usually seen as mundane. It has always been pop's function to transform the banal, but this purpose was to some extent undermined by the rise of rock in the sixties, with its claims to art and poetry, its cult-building, its heavy metal mysticism. Springsteen himself started out with a couple of wordy, worthy LPs, but since then he has been in important ways committed to common sense. Springsteen's greatest skill is his ability to dramatize everyday events – even his stage act is a pub rock show writ large. The E Street Band, high-class professionals, play with a sort of amateurish enthusiasm, an affection for each other which is in sharp contrast to the bohemian contempt for their work (and their audience) which has been a strand of 'arty' rock shows since the Rolling Stones and the Doors. Springsteen's musicians stand for every bar and garage group that ever got together in fond hope of stardom.

His sense of the commonplace also explains Springsteen's physical appeal. His sexuality is not displayed as something remarkable, a kind of power, but is coded into his 'natural' movements, determined by what he has to do to sing and play. His body becomes 'sexy' – a source of excitement and anxiety – in its routine activity; his appeal is not defined in terms of glamour or fantasy. The basic sign of Springsteen's authenticity, to put it another way, is his sweat, his display of *energy*. His body is not posed, an object of consumption, but active, an object of exhaustion. When the E Street Band gather at the end of a show for the final bow, arms around each other's shoulders, drained and relieved, the

sporting analogy is clear: this is a team which has won its latest bout. What matters is that every such bout is seen to be real, that there are no backing tapes, no 'fake' instruments, that the musicians really have played until they can play no more. There is a moment in every Springsteen show I've seen when Clarence Clemons takes centre-stage. For that moment he is the real star – he's bigger than Springsteen, louder, more richly dressed. And he's the saxophonist, giving us the clearest account all evening of the relationship between human effort and human music.

To be authentic and to sound authentic is in the rock context the same thing. Music can not *be* true or false, it can only refer to *conventions* of truth and falsity. Consider the following.

Thundering drums in Springsteen's songs give his stories their sense of unstoppable momentum, they map out the spaces within which things happen. This equation of time and space is the secret of great rock and roll and Springsteen uses other classic devices to achieve it – a piano/organ combination, for example (as used by The Band and many soul groups), so that melodic-descriptive and rhythmic-atmospheric sounds are continually swapped about.

The E Street Band makes music as a group, but a group in which we can hear every instrumentalist. Our attention is drawn, that is, not to a finished sound but to music-in-the-making. This is partly done by the refusal to make any instrument the 'lead' (which is why Nils Lofgren, a 'lead' guitarist, sounded out of place in the last E Street touring band). And partly by a specific musical busy-ness – the group is 'tight', everyone is aiming for the same rhythmic end, but 'loose', each player makes their own decision as to how to get there (which is one reason why electronic instruments would not fit – they're too smooth, too determined). All Springsteen's musicians, even the added back-up singers and percussionists, have individual voices; it would be unthinkable for him to appear with, say, an anonymous string section.

The textures and, more significantly, the melodic structures of Springsteen's music make self-conscious reference to rock and roll itself, to its conventional line-up, its cliched chord changes, its time-honoured ways of registering joys and sadness. Springsteen himself is a rock and roll star, not a crooner or singer/songwriter. His voice *strains* to be heard, he has to shout against the instruments that both support and compete with him. However many times he's rehearsed his lines they always sound as if they're being forged on the spot.

Many of Springsteen's most anthemic songs have no addresses (no 'you') but (like many Beatles songs) concern a third person (tales told about someone else) or involve an 'I' brooding aloud, explaining his situation impersonally, in a kind of individualised epic. Listening to such epics is a public activity (rather than a private fantasy), which is why Springsteen concerts still feel like collective occasions.

Conclusion

In one of his monologues Springsteen remembers that his parents were never very keen on his musical ambitions – they wanted him to train for something safe, like law or accountancy: 'they wanted me to get a little something for myself; what they did not understand was that I wanted *everything!*'

This is a line that could only be delivered by an American, and to explain Springsteen's importance and success we have to go back to the problem he is really facing: the fate of the individual artist under capitalism. In Europe, the artistic critique of the commercialization of everything has generally been conducted in terms of Romanticism, in a state of Bohemian disgust with the masses and the bourgeoisie alike, in the name of the superiority of the *avant-garde*. In the USA there's a populist anti-capitalism available, a tradition of the artist as the common man (rarely woman), pitching rural truth against urban deceit, pioneer values against bureaucratic routines. This tradition (Mark Twain to Woody Guthrie, Kerouac to Credence Clearwater Revival) lies behind Springsteen's message and his image. It's this tradition that enables him to take such well-worn iconography as the road, the river, rock and roll itself, as a mark of sincerity. No British musician, not even someone with such a profound love of American musical forms as Elvis Costello, could deal with these themes without some sense of irony.

Still, Springsteen's populism can appeal to everyone's experience of capitalism. He makes music out of desire aroused and desire thwarted, he offers a sense of personal worth that is not determined by either market forces (and wealth) or aesthetic standards (and cultural capital). It is the USA's particular account of equality that allows him to transcend the differences in class and status which remain ingrained in European culture. The problem is that the line between democratic populism (the argument that all people's experiences and emotions are equally important, equally worthy to be dramatized and made into art) and market populism (the argument that the consumer is always right, that the market defines cultural value) is very thin. Those piles of Bruce Springsteen boxes in European department stores seem less a tribute to rock authenticity than to corporate might.

'We are the world!' sang USA For Africa, and what was intended as a statement of global community came across as a threat of global domination. 'Born in the USA!' sang Bruce Springsteen on his last great tour, with the Stars and Stripes fluttering over the stage, and what was meant as an opposition anthem to the Reaganite colonization of the American dream was taken by large sections of his American audiences as pat patriotism (in Europe the flag had to come down). Springsteen is, whether he or we like it or not, an American artist – his 'community' will always have the Stars and Stripes fluttering over it. But then rock and roll is American music, and Springsteen's *Live – 1975–1985* is a monument. Like all monuments it celebrates (and mourns) the dead, in this case the idea of authenticity itself. 1987

PART 3

Words and Pictures

Why Do Songs Have
Words?

In 1918 the chairman of Chappell and Co., Britain's largest music publishing company, wrote a letter to the novelist Radclyffe Hall. She had complained of receiving no royalties after a song for which she had been the lyricist, 'The Blind Ploughman', 'swept the country'. William Davey replied:

> Dear Miss Radclyffe Hall,
> I yield to no one in my admiration of your words for 'The Blind Ploughman'. They are a big contributing factor to the success of the song. Unfortunately, we cannot afford to pay royalties to lyric writers. One or two other publishers may but if we were to once introduce the principle, there would be no end to it. Many lyrics are merely a repetition of the same words in a different order and almost always with the same ideas. Hardly any of them, frankly, are worth a royalty, although once in a way they may be. It is difficult to differentiate, however. What I do feel is that you are quite entitled to have an extra payment for these particular words, and I have much pleasure in enclosing you, from Messrs Chappell, a cheque for twenty guineas.[1]

Davey had commercial reasons for treating lyrics as formula writing, but his argument is common among academics too. In the 1950s and 1960s, for example, the tiny field of the sociology of popular music was dominated by analyses of song words. Sociologists concentrated on songs (rather than singers or audiences) because they could be studied with a familiar cultural research method, content analysis, and as they mostly lacked the ability to distinguish songs in musical terms, content analysts, by default, had to measure trends by reference to lyrics. It was through their words that hit records were taken to make their social mark.

The focus on lyrics did not just reflect musical ignorance. Until the mid-1960s British and American popular music was dominated by Tin Pan Alley. Tin Pan Alley's values derived from its origins as a publishing centre and the 'bland, universal, well-made song' (Whitcomb's description) remained central to its organization even after rock'n'roll.[2] In concentrating on pop's lyrical themes in this period, sociologists were

reflecting the way in which the songs were themselves packaged and sold. Most of these songs did, musically, sound the same; most lyrics did seem to follow measurable rules; most songwriters did operate as 'small businessmen engaged in composing, writing or publishing music', rather than as 'creative composers'.[3] Etzkorn, one of the few sociologists to research lyricists not lyrics, discovered in 1963 that,

> the composing activity of songwriters would seem to be constrained by their orientation towards the expectations of significant 'judges' in executive positions in the music business whose critical standards are based on traditional musical cliches. In their endeavour to emulate the norms of successful reference groups, songwriters (even with a variety of back-grounds) will produce compositions virtually homogenous in form and structure, thereby strengthening the formal rigidity of popular music.[4]

This simply confirmed what analysts took for granted anyway – that it was possible to read back from lyrics to the social forces that produced them.

Content Analysis

The first systematic analyst of pop song words, J. G. Peatman, was influenced by Adorno's high Marxist critique of 'radio music' and so stressed pop's lyrical standardization: all successful pop songs were about romantic love; all could be classified under one of three headings – the 'happy in love' song, the 'frustrated in love' song and the 'novelty song with sex interest'.[5]

For Peatman, this narrow range reflected the culture industry's success in keeping people buying the same thing, but subsequent content analysts, writing with a Cold War concern to defend American commercial culture, took pop market choices more seriously. Thus in 1954 H. F. Mooney accepted Peatman's starting point – pop as happy/sad love songs – but argued that they 'reflected, as love songs always do, the deepest currents of thought; for as values change, so change the ideas and practice of love'.[6]

Mooney's argument was that pop song lyrics reflected the emotional needs of their time. The history of the American 'mood' could thus be traced through the shifting themes of popular songs: from 1895 to 1925 song lyrics were 'abandoned and unorthodox' and reflected the patriotism, proletarianism and hedonism of the rising American empire; from the 1920s to 1940s songs were 'negativistic and rather morbid' and reflected the disillusion, the quiet despair of the Depression; in the 1950s pop reflected a new zeal, as 'the mass mood' invested the post-war consumer boom with Cold War fervour; and, in a later article, Mooney continued his readings into the 1960s, examining songs' treatment of new 'liberated' sexual mores.[7]

Mooney related changing images of sex to changes in the class origins of pop, but his general point was that songs could be read as examples of popular ideology. Tin Pan Alley, he suggested in 1954,

> has responded to and revealed the emotional shifts of its public: sheet music and phonograph records are among the few artefacts which afford insight into the inarticulate Americans of the twentieth century.[8]

'The people' in a mass society may no longer make their own music, but choosing which songs and records to buy is still a means of cultural expression. Hits meet a popular need and so pop lyrics have changed over the century, despite corporate control of their production.

Mooney's survey of American cultural history is unsystematic, and he seems to choose songs to support his thesis, rather than vice versa; but his 'reflection theory' of pop lyrics has been shared by most of the more scientific content analysts who followed up his work. American sociologists have used song words, in particular, to chart the rise of a youth culture, with new attitudes to love and sex and fun, and to document the differences between romance in the 1950s and 1960s. In both eras the love drama passed through four acts – search, happiness, break-up, isolation – but 1960s pop stressed hedonism, movement, freedom and choice. Courtship no longer led to marriage (relationships had a natural history, died a natural death); happiness meant sexual happiness; love was no longer an 'elusive quarry' but a passing, to-be-seized opportunity.[9]

The theoretical assumption here is that the words of pop songs express general social attitudes. But such song-readings depend, in practice, on prior accounts of youth and sexuality. Content analysts are not innocent readers, and there are obvious flaws in their method. For a start, they treat lyrics too simply. The words of all songs are given equal value; their meaning is taken to be transparent; no account is given of their actual performance or their musical setting. This enables us to code lyrics statistically, but it involves a questionable theoretical judgement: content codes refer to what the words describe – situations and states of mind – but not to how they describe, to their significance as language.

Even more problematically, these analysts tend to equate a song's popularity to public agreement with its message – the argument is that songs reflect the beliefs and values of their listeners. This is to ignore songs' ideological work, the way they play back to people situations or ideas they recognize but which are inflected now with particular moral lessons. The most sophisticated content analysts have, therefore, used lyrics as evidence not of popular culture as such, but of popular cultural confusion.[10] Songs, from this perspective, articulate the problems caused by social change, so that Di Maggio, Peterson and Esco, for example, analyse the post-war history of the American South by looking at the tensions revealed by country music lyrics: in the 1950s country love songs took the ideal of romantic love for granted, but increasingly

explored the argument that 'a battle between the sexes is inevitable'; country drink songs described alcohol as both a solution to and a cause of emotional problems; country work songs celebrated 'the strong self-reliant worker', while despairing at the effects of the factory routine – 'by day I make the cars/and by night I make the bars'. Country lyrics, in short, expressed contradictions as old communal values were used to measure the quality of the lives of the urban working-class. The authors conclude that songs 'reflect' their listeners' concerns at the level of fantasy – such reflection means, in fact, giving people *new* shapes, new symbolic forms for their hopes and anxieties.[11]

Mike Haralambos has treated the history of black American song in this period similarly. Blues lyrics, he suggests, were essentially passive, bitter, sorrowful and fatalistic; soul words concerned activity, pride, optimism and change:

> Whereas blues concentrates almost entirely on experience, usually the experience of failure, soul songs state the ideal. Moral principles are laid down, rules of conduct advocated, right and wrong involved. Blues merely states this is the way it is, and this is how I am suffering. By comparison, soul music implies life is not to be accepted as it comes, hardship is not to be borne, but life is to be made worth living.[12]

Haralambos argues that soul represented a lyrical as well as a musical merging of blues and gospel, as the free-flowing language and imagery of the church were applied to the socially realistic narratives of the blues. The resulting songs both drew on and gave shape to the new mood and vocabulary of 1960s ghetto streets. In the words of disc jockey Job Cobb:

> 'We're Rolling On' and songs like that gave a lot of people, and even a lot of civil rights organizations, hope and great strength, and made people believe in it, because actually within the record itself, it was telling you like what to expect, and what happened thus far, so like hold your head up high and keep on going, your day will come.[13]

This interpretation of lyrics as uplift – asserting ideas in order to shape them, describing situations in order to reach them – complicates the concept of 'reflection' but retains the assumption that popular songs are significant because they have a 'real closeness' with their consumers.[14] The implication now, though, is that this is only true of 'folk' forms; only in country music, blues, soul, and the right strands of rock, can we take lyrics to be the authentic expression of popular experiences and needs. In the mainstream of mass music something else is going on.

Mass Culture

Most mass-cultural critiques of pop derive from 1930s Leavisite arguments. Pop songs are criticized for their banality, their feebleness

with words, imagery and emotion; the problem is not just that lyrics picture an unreal world, but also that pop ideals are trite:

> One and all these refer to the world where June rhymes with moon, where there is no such thing as struggle for existence, where love does not have to be striven for through understanding.[15]

In *The Uses of Literacy*, Richard Hoggart argues, similarly, that real needs to dream are being satisfied by debilitatingly thin fantasies, concepts of well-being defined in terms of conformity. Mass culture has turned visions of the extraordinary into cliches of the ordinary, and pop song lyrics have been subordinated to the performing conventions of 'forced intimacy' – 'the singer is reaching millions but pretends he is reaching only "you" '. Love, the dominant topic of pop songs, is represented now as a solution to all problems, 'a warm burrow, a remover of worry; borne on an ingratiating treacle of melody, a vague sense of uplift-going-on'.[16]

For Leavisites, the evil of mass culture is that it corrupts real emotions. Wilfrid Mellers (*Scrutiny*'s original commentator on popular music) notes that pop songs 'do insidiously correspond with feelings we have all had in adolescence'.

> Though these songs do not deny that love will hurt, they seek a vicarious pleasure from the hurt itself. So they create an illusion that we can live on the surface of our emotions. Sincere, and true, and touching though they may be, their truth is partial.[17]

The critical task, he argues therefore, is to discover 'the amount of "felt life" in specific words and music', and Mellers and Hoggart agree that pop songs should not be dismissed without a proper hearing. Other Leavisites have been less generous. Edward Lee, for example, denounces the romantic banality of pop lyrics in terms of their social effects (citing the divorce rate in his disdain for silly love songs) and this argument about the corrupting consequences of the hit parade has been taken up by Marxist critics in their accounts of pop's 'class function.'[18] Dave Harker, for instance, reads Tin Pan Alley lyrics as straightforward statements of bourgeois ideology. Take 'Winter Wonderland' – 'In the meadow we can build a snowman/Then pretend he is Parson Brown/He'll say "Are you married?" We'll say "No man/But you can do the job when you're in town".' This song, writes Harker,

> articulates the key fantasies not only about the Christmas period but, crucially, about the pattern of sexual relations felt to be most appropriate for a particular social order.[19]

Love and romance, the central pop themes, are the 'sentimental ideology' of capitalist society. Like Lee, Harker stresses the importance of pop

romance for marriage – it is thus that songs work for the reproduction of social relations. Love lyrics do express 'popular' sexual attitudes, but these attitudes are mediated through the processes of cultural control. Harker makes this Leavisite comment on Elvis Presley's 'It's Now Or Never':

> Of course, the song was popular in a commercial context precisely because it did articulate certain key strands in the dominant ideology. The denial of female sexuality, the reduction of love to ejaculation, the inability to come out with emotion honestly, the habit of implying intercourse is a 'dirty little secret', the acceptability of emotional blackmail on the part of man, and so on, tell us a good deal about the paradigms of femininity in the late 1950s, *and* about the paradigms of masculinity, for all those men who had to try, presumably, to imitate Elvis Presley.[20]

Songs are, in this account, a form of propaganda. As Goddard, Pollock and Fudger put it, from a feminist perspective, 'lyrics constantly reflect and reinforce whatever ethos society currently considers desirable'.[21] They express dominant sexual ideologies through their recurrently exploitative images of women, their stereotypes of sexual subjugation, their treatment of femininity as at once 'mysterious' and 'dependent', and, above all, through their systematic denial of the material reality of sexual exploitation. As Germaine Greer once wrote,

> The supreme irony must be when the bored housewife whiles away her duller tasks, half-consciously intoning the otherwise very forgettable words of some pulp lovesong. How many of them stop to assess the real consequences of the fact that 'all who love are blind' or just how much they have to blame that 'something here inside' for? What songs do you sing, one wonders, when your heart is no longer on fire and smoke no longer mercifully blinds you to the banal realities of your situation? (But of course there are no songs for that.)[22]

Most critics of mass music assume that there are, nonetheless, alternatives to commercial pap. Hoggart, for example, praises pre-war pop songs by reference to their *genuineness*:

> They are vulgar, it is true, but not usually tinselly. They deal only with large emotional situations; they tend to be open-hearted and big-bosomed. The moral attitudes behind them are not mean or calculated or 'wide'; they still just touch hands with an older and more handsome culture. They are not cynical or neurotic; they often indulge their emotions, but are not ashamed of showing emotion, and do not seek to be sophisticatedly smart.[23]

Harker praises the 'muscular compactness' of Bob Dylan's language, and makes a telling comparison of the Beatles' 'She Loves You' with Dylan's thematically similar 'It Ain't Me Babe':

The Beatles' song drips with adolescent sentiment. It is structured around the person of a go-between, and cheerfully reinforces the preferred mode of courtship in a capitalist society, using guilt-invoking mindlessness ('you know you should be glad', 'you know that can't be bad'), and generally relying on emotional blackmail at the shallowest of levels. To their inane 'Yeh, yeh, yeh' Dylan counterposed a full-throated 'No, no, no'. Instead of their emotional tinkering and patching up, Dylan insists on breaking the conventions of bourgeois courtship, refusing to accept anything less than full-hearted love. Instead of their magic 'solution', he reminded us that it's sometimes better to call it a day. While they denied individuality he celebrated it – even in those forms with which he could not agree. While they underwrote the surface chatter of socially acceptable but emotionally stifling forms of interpersonal behaviour, Dylan raises a wry pair of fingers at the conventions, *not* at the woman.[24]

For Harker, 'authentic' lyrics express 'authentic' relationships, expose bourgeois conventions with an honest vital language – a language which reflects experience directly, is not ideologically mediated. A similar argument underpinned Hayakawa's classic 1955 critique of American pop songs. He analysed lyrics in terms of

the IFD disease – the triple-threat semantic disorder of Idealization (the making of impossible and ideal demands upon life), which leads to Frustration (as the result of the demands not being met), which in turn leads to Demoralization (or Disorganization or Despair).[25]

Hayakawa compared pop lyrics with blues lyrics, in which there was no 'chasing rainbows', no search for the ideal partner, no belief in love as magic, but an exploration of all the problems of sex and romance, 'a considerable tough-mindedness', and 'a willingness to acknowledge the facts of life'. Francis Newton wrote in parallel terms about the corruption of blues lyrics by pop publishers in what he called the 'mincing process':

Essentially it consists of a rigid restriction of themes which excludes the controversial, the uncomfortable, or unfamiliar, and above all the exclusion of reality. For the main industrial innovation of the pop-music business is the discovery that the daydream, or the sentimental memory (which is the daydream reversed) is the single most saleable commodity.[26]

In the 1960s this process was reversed as young musicians and audiences rejected Tin Pan Alley for rhythm and blues – pop's vapidity was replaced by blues 'realism'. The function of rock lyrics became the exposure of false ideology so that, for Harker, Bob Dylan's lyrics ceased to matter (and Dylan himself 'sold out') when they ceased to be true, when (with the release of *John Wesley Harding*) they began to 'sentimentalize the family, legalized sex and the home, in ways wholly supportive of the dominant ideology'. The implication here – an

implication embedded deep in rock criticism – is that all songs have to be measured against the principles of lyrical realism. The problem for Dylan and the other 1960s rock stars arose when they began to make music according to the logic of commercial entertainment, for, as Eisler had put it, entertainment music

> expresses a mendacious optimism that is absolutely unjustified, a flat pseudo-humanity, something like 'Aren't we all?' a stuffy petit-bourgeois eroticism to put you off. Feeling is replaced by sentimentality, strength by bombast, humour by what I would call silliness. It is stupid to the highest degree.[27]

Realism

At its simplest, the theory of lyrical realism means asserting a direct relationship between a lyric and the social or emotional condition it describes and represents. Folk song studies, for example, work with a historical version of reflection theory: they assume that folk songs are a historical record of popular consciousness. Thus Roy Palmer describes orally transmitted folk songs as 'the real voice of the people who lived in the past', and folk ballads as 'a means of self-expression; this was an art form truly in the idiom of the people'. With the development of industrial capitalism, according to A. L. Lloyd, 'the song-proper becomes the most characteristic lyrical form through which the common people express their fantasies, their codes, their aspirations':

> Generally the folk song makers chose to express their longing by transposing the world on to an imaginative plane, not trying to escape from it, but colouring it with fantasy, turning bitter even brutal facts of life into something beautiful, tragic, honourable, so that when singer and listeners return to reality at the end of the song, the environment is not changed but they are better fitted to grapple with it.[28]

The question is: how does folk 'consolation' differ from pop 'escapism'? The answer lies in the modes of production involved: folk songs were authentic fantasies because they sprang from the people themselves; they were not commodities. If certain folk images and phrases recur ('lyrical floaters', Lloyd calls them) these are not cliches (like the equivalent floaters in pop songs) but mark, rather, the anonymous, spontaneous, communal process in which folk songs are made. Lloyd continually contrasts the 'reality and truth' of folk lyrics with the 'banal stereotype of lower-class life and limited range of sickly bourgeois fantasies that the by-now powerful entertainment industry offers its audiences to suck on like a sugared rubber teat', but such comparisons rest almost exclusively on an argument about production.[29]

The problem of this 'sentimental socialist-realist' argument is its

circularity: folk 'authenticity' is rooted in folk songs' 'real' origins, but we recognize these origins by the songs' authenticity and, in practice, the assessment of a song's realism is an assessment of its use of assumed *conventions* of realism. Folk song collections are folk song selections, and, to be chosen as authentic, songs have to meet literary or political criteria – authenticity lies in a particular use of language, a particular treatment of narrative and imagery, a particular ideological position. The problem, then, is not whether folk songs *did* reflect real social conditions, but why some such reflections are taken by collectors to be authentic, some not. Whose ideology is reflected in such definitions of folk 'realism'?[30]

Authenticity is a political problem, and the history of folk music is a history of the struggle among folk collectors to claim folk meanings for themselves, as songs are examined for their 'true working-class views', for their expressions of 'organic community', for their signs of nationalism. For a Marxist like Dave Harker, some 'folk' songs are inauthentic because they obviously (from their use of language) were not written or transmitted by working-class people themselves; others are judged inauthentic because of their ideological content, their use not of bourgeois language but bourgeois ideas. Left-wing intellectuals can write authentic working-class songs (though not working-class themselves) as long as they represent the *real* reality of the working-class – Alex Glasgow, for example, is heard to penetrate 'the elements of bourgeois ideology which have penetrated working class culture'.[31]

This raises an important question: is lyrical realism a matter of accurate surface description or does it mean getting behind appearances, challenging given cultural forms? Taylor and Laing argue that 'cultural production occurs always in relation to ideology and not to the "real world" ', and I want to examine the implications of this by looking at the blues.[32]

The original blues analysts assumed, like folk theorists generally, that the blues could be read as the direct account of the singers' and listeners' lives. Paul Oliver, for example, treated blues lyrics as a form of social history. The blues reflected American social conditions and personal responses to those conditions. They gave

> a glimpse of what it must mean to be one among the many rejected, homeless migrants – to be one single unit in the impersonal statistics that represent millions of rootless men and women.[33]

Charles Keil read post-war urban blues lyrics similarly, as the direct expression of their singers' attempts to handle conditions in the new urban ghettos. He suggested that,

> a more detailed analysis of blues lyrics might make it possible to describe with greater insight the changes in male roles within the Negro community as defined by Negroes at various levels of socio-economic status and

mobility within the lower class. Certainly, the lyric content of city, urban and soul blues also reflects varying sorts of adjustment to urban conditions generally. A thorough analysis of a large body of blues lyrics from the various genres would help to clarify these patterns of adjustment and the attitudinal sets that accompany those patterns.[34]

The blues, according to Oliver, was 'a genuine form of expression revealing America's gaunt structure without a decorative facade.' In its treatment of love and sex the blues was 'forthright and uncompromising. There is no concealment and no use of oblique references.' Blues were expressed in realistic words, uninhibited words, words which were 'a natural transposition of the everyday language of both users and hearers'. Even blues' fancy terms, its rich store of imagery, were derived from everyday life – the blues was a 'tough poetry', a 'rough poetry'. In the words of Francis Newton, blues songs are not poetic 'because the singer wants to express himself or herself in a poetic manner', but because 'he or she wants to say what has to be said as best it can'. The poetic effects 'arise naturally out of the repetitive pattern of ordinary popular speech'.[35]

Linton Kwesi Johnson makes similar points about Jamaican lyrics. Jamaican music, he writes,

is the *spiritual expression* of the *historical experience* of the Afro-Jamaican. In making the music, the musicians themselves enter a common stream of consciousness, and what they create is an invitation to the listeners to be entered into that consciousness – which is also the consciousness of their people. The feel of the music is the feel of their common history, the burden of their history; their suffering and their woe; their endurance and their strength; their poverty and their pain.[36]

Johnson stresses the spiritual aspects of this process – 'through music, dreams are unveiled, souls exorcized, tensions canalized, strength realized' – and notes the ways in which shared religious metaphors of hope and damnation enable Jamaican lyricists to intensify their political comment (and Rastafarian songs draw on the store of religio-political imagery accumulated by Black American spirituals – 'Babylon' as a symbol of slavery and white oppression, for example).[37]

Black songs do not just describe an experience, but symbolize and thus politicize it. For Newton, the lyrical world of the blues was 'tragic and helpless' – 'its fundamental assumption is that men and women must live life as it comes; or if they cannot stand that they must die,' Johnson, by contrast, argues that in Jamaican music,

consciously setting out to transform the consciousness of the sufferer, to politicise him culturally through music, song and poetry, the lyricist contributes to the continuing struggle of the oppressed.[38]

We are back to the original question in a new form: does 'realism' mean an acceptance of one's lot or a struggle against it, the imagination

of alternatives? And there is a new question too. If blues lyrics express the suffering of an oppressed people, express them realistically, why do we enjoy them? In the words of Paul Garon, 'how is it that we gain definite pleasure by identifying with the singers' *sadness?*'[39]

Garon suggests that the blues, like all poetry, gives pleasure 'through its use of images, convulsive images, images of the fantastic and the marvellous, images of *desire*'. Blues power comes from its 'fantastic' not its 'realistic' elements. What makes a blues song poetic is not its description 'without facade', but the games it plays with language itself. Take a simple erotic blues like 'You Can't Sleep In My Bed':

> You're too big to be cute, and I don't think you're clean,
> You're the damnest looking thing that I have ever seen.
>
> What you got in mind ain't gonna happen today
> Get off my bed, how in the world did you get that way?
> (Mary Dixon, 'You Can't Sleep In My Bed')

The point of this song is not its acceptance of the 'non-ideal' sexuality of real life, but its humour – the humour of its tone of voice, its descriptive terms – and humour involves not just the acceptance of reality, but also its mockery. Humour is a form of *refusal*. The blues singer, in short, 'functions as a poet through his or her refusal to accept the degradation of daily life'.

To give another example, in Bessie Smith's 'Empty Bed Blues' her emotional plight is described 'realistically', but the description is invigorated, made pleasurable, by the fanciful pursuit of a sexual language:

> Bought me a coffee grinder,
> The best one I could find.
> Bought me a coffee grinder,
> The best one I could find.
> Oh, he could grind my coffee,
> 'Cause he had a brand-new grind.
>
> He's a deep, deep diver,
> With a stroke that can't go wrong.
> He's a deep, deep diver,
> With a stroke that can't go wrong.
> Oh, he can touch the bottom,
> And his wind holds out so long.
>
> He boiled first my cabbage,
> And he made it awful hot.
> He boiled first my cabbage,
> And he made it awful hot.
> When he put in the bacon,
> It overflowed the pot.
> (Bessie Smith, 'Empty Bed Blues')

Refusal does not have to be expressed in political, ideological or even collective terms and, indeed, for Garon, *individual* imagination is what gives it resonance: 'the essence of the blues is not to be found in the daily life with which it deals, but in the way such life is critically focused on and imaginatively transformed.' Garon attacks the argument that 'it is only through "realism" ("socialist" or otherwise) that human desires find their most exalted expression'. The blues is poetry, rather, in so far as it is *not* simply documentary – 'for it is poetry that seeks to illuminate and realise the desires of all men and women'.[40]

Ames had earlier argued that,

> regardless of the attitudes of any individual singer, the objective social necessity of American Negro songs over a period of time was to create forms, patterns, habits and styles which would conceal the singer. Perhaps the commonest technique of concealment has been to disguise meaning in some kind of fantastic, symbolical or nonsensical clothing.[41]

Irony, rather than direct description, is the essence of blues realism, and Garon suggests that the techniques involved gave blues lyricists their poetic potential, their ability to 'eroticize everyday life', to use language itself to shock and shake the dominant discourse:

> New modes of poetic action, new networks of analogy, new possibilities of expression all help formulate the nature of the supersession of reality, the transformation of everyday life as it encumbers us today, the unfolding and eventual triumph of the marvellous.[42]

Ian Hoare makes a related point about soul songs. The soul singer, like the blues singer, expresses 'personal feelings in a very public manner, stating the problems and drawing the audience together in a recognition that these problems are in many ways shared', and soul is, again, a form of realism – 'the grassroots strength of soul love lyrics lies partly in the fact that the most indulgent pledges of devotion are characteristically accompanied by a resilient sexual and economic realism'. But Hoare goes on to suggest that soul lyricists' 'realism' is simply a frame for their use of pop's romantic conventions – 'the containment of the otherworldly in the worldly is close to the essence of the soul tradition'. Soul songs are not simple statements – 'life is like *this*' – but involve a commentary on the terms of pop romanticism itself.[43]

One of Britain's first jazz critics, Iain Lang, remarked in 1943 that 'there is much material in the blues for a Cambridge connoisseur of poetic ambiguity'. His point was that it was precisely blues realism, its use of everyday talk, that made it so poetically interesting – the blues is popular music's most literary form, contains the most sophisticated explorations of the rhythmic, metaphoric and playful possibilities of language itself. And blues singers' use of the vernacular does not make them simply vehicles for some sort of spontaneous collective composition

– if the blues are a form of poetry, then blues writers are poets, self-conscious, individual, more or less gifted in their uses of words.[44]

There is a tension in jazz criticism, then, between theorists who root blues power in the general, diffuse social realism of black popular culture, and critics who search out individual writers for particular praise or blame. It is a tension which has re-emerged, more recently, in white critical commentaries on 'rap', the contemporary Afro-American use of the rhythms of street-corner gossip, threat and argument. Rap is rooted in a long history of jousting talk, formalized in a variety of names – 'signification', the Dozens, the Toast, the Jones.[45] These are rituals of name-calling, boasting and insult, in which rhyme, beat and vocal inflection carry as much meaning as the words themselves, and the irony is that while the participants are clearly engaged in individual competition – some people are simply better at the Dozens than others – white fans admire rap as a collective cultural form, a spontaneous street sound. Unless acts claim specifically to *be* poets (like some Jamaican dub performers or a relatively arty New York act like the Last Poets) they are not heard to write poetry, and rock fans have always gone along with the idea that 'naturally' realistic forms (folk, blues, soul, rap) have to be distinguished from 'art' forms, which are 'original', elaborate, rooted in personal vision and control.[46]

From the start, rock's claim to a superior pop status rested on the argument that rock songwriters (unlike New York's Brill Building hacks and folk and blues circuit 'primitives') were, indeed, poets. Beginning with Richard Goldstein's *The Poetry of Rock* in 1969, there has been a series of pompous rock anthologies, and while Goldstein had the grace to include rock'n'roll writers like Chuck Berry and Leiber and Stoller, subsequent anthologists have been quite clear that 1960s rock lyrics represented something qualitatively remarkable in pop history:

> Despite the fertile sources on which rock music of the 1950s drew, it was musically innovative and vibrant but lyrically almost unrelievedly banal and trivial. If it contained any poetry at all, that poetry was pedestrian doggerel full of unrefined slang and trite neoromantic convention. But in the early 1960s there burst upon the scene a number of exceptionally talented artists, perhaps even poets, who managed to bring together in various degrees all the many elements of what we now call rock and to make something of quality.[47]

What is most striking about anthologies of rock poetry is their consensus – no black songs, no country music, no Lou Reed even. Rock 'poets' are recognised by a particular sort of self-consciousness; their status rests not on their approach to words but on the types of word they use; rock poetry is a matter of planting poetic clues, and the rock singer-songwriters who emerged from folk clubs in the 1960s thus followed Bob Dylan's seminal example, drawing words from classic balladry, from the beat poets, from 150 years of Bohemian romantic verse.[48]

Rock 'poetry' opened up possibilities of lyrical banality of which Tin Pan Alley had never even dreamt, but for observing academics it seemed to suggest a new pop seriousness – 'the jingles and vapid love lyrics' had evolved into a genuinely 'mystical vision'.[49] This was to suggest a new criterion of lyrical realism – truth-to-personal-experience or truth-to-feeling, a truth measured by the private use of words, the self-conscious use of language. And truth-to-feeling became a measure of the listener too. 'True songs,' wrote Paul Nelson, *Rolling Stone*'s Record Editor, are 'songs that hit me straight in the heart.' Alan Lomax had once written that the 'authentic' folk singer had to 'experience the feelings that lie behind his art'. For Nelson the good rock singer made the listener experience those feelings too.[50]

Making Meaning

All comparisons of lyrical realism and lyrical banality assume that songs differ in their effects – effects which can be read off good and bad words. For mass-culture critics, as we have seen, the problem of pop is that fans treat *all* songs as if they were real and accordingly have a false view of life. Pop lyricists themselves have always found this suggestion bemusing. Ira Gershwin, for example, made his own mocking reply to his critics:

'Every night I dream a little dream,/And of course Prince Charming is the theme. . . ' One is warned that this sort of romantic whimwham builds up 'an enormous amount of unrealistic idealisation – the creation in one's mind, as the object of love's search, of a dream girl (or dream boy) the fleshly counterpart of which never existed on earth'. Sooner or later, unhappily, the girl chances on a Mr. Right who, in turn, is certain she is Miss Inevitable; and, both being under the influence of 'My Heart Stood Still' (which even advocates love at first sight) they are quickly in each other's arms, taxiing to City Hall for a marriage license. On the way he sings 'Blue Room' to her – she 'My Blue Heaven' to him. But, alas, this enchanted twosome is wholly unaware of the costs of rent, furniture, food, dentist, doctor, diaper service, and other necessities. There is no indication in the vocalising 'that, having found the dream-girl or dream-man, one's problems are just beginning'. It naturally follows that soon the marriage won't work out, when 'disenchantment, frustration' and 'self-pity' set in. Shortly after, they buy paper dolls, not for each other, but ones they can call their own. This comfort is, however, temporary. Subsequently, he, helpless, is in the gutters of Skid Row; she, hopeless, in a mental institution.[51]

Back in 1950 David Riesman had argued that 'the same or virtually the same popular culture materials are used by audiences in radically different ways and for radically different purposes'. Riesman accepted

the critics' description of pop's lyrical message ('a picture of adolescence in America as a happy-go-lucky time of haphazard behaviour, jitterbug parlance, coke-bar sprees, and 'blues' that are not really blue'), but distinguished between the majority of pop fans, who took the message for granted but did not listen to it, and a minority of 'rebels', who heard the message but rejected it.[52]

Subsequent empirical research has confirmed Riesman's scepticism about the importance of song words, and by the end of the 1960s Norman Denzin was arguing that pop audiences only listened to the beat and melody, the *sound* of a record, anyway – the 'meaning of pop' was the sense listeners made of songs for themselves; it could not be read off lyrics as an objective 'social fact'.[53]

This argument was the norm for the sociology of pop and rock in the 1970s. In *The Sociology of Rock*, for example, I ignored lyrical analysis altogether and simply assumed that the meaning of music could be deduced from its users' characteristics. In the USA, empirical audience studies measured pop fans' responses to the words of their favourite songs quantitatively. Robinson and Hirsch concluded from a survey of Michigan high school students that 'the vast majority of teenage listeners are unaware of what the lyrics of hit protest songs are about', and a follow-up survey of college students suggested that the 'effectiveness' of song messages was limited: the majority of listeners had neither noticed nor understood the words of 'Eve of Destruction' or 'The Universal Soldier', and the minority who did follow the words were not convinced by them.[54]

The implication of this sort of research (which continues to fill the pages of *Popular Music and Society*) is that changes in lyrical content cannot be explained by reference to consumer 'moods'. Instead American sociologists have turned for explanations to changing modes of lyrical production, to what is happening in the record industry, the source of the songs. Paul Hirsch, for example, argues that during the period 1940–70 song performers gained control of their material while the music industry's censors lost it. Peterson and Berger extend this analysis (looking at 'the manufacture of lyrics' since 1750!), concluding that 'the outspoken rock lyric of the 1960s (and the counter-culture it animated) were largely unintended by-products of earlier mundane changes in technology, industry structure and marketing'. In the rock era, airwaves and studios had been opened to competition, and

> the proliferation of companies competing for audience attention together with the broadening range of radio programming formats of the 1950s reversed the process which had created the Tin Pan Alley formula tune in the previous era of oligopoly. With competition, there was a search for lyrics that would be ever more daring in exposing the old taboo topics of sex, race, drugs, social class, political commentary, and alternatives to middle-class standards generally.[55]

Songs did change the audience ('by gradually creating a self-conscious teen generation'), but the general point is that 'the amount of diversity of sentiments in popular music lyrics correlates directly with the number of independent units producing songs', and more recent research has shown how a tightening of corporate control (in the country music industry) leads to a narrowing range of song forms.[56]

In this account of pop the banality of Tin Pan Alley words is taken for granted and explained in terms of the organization of their production, but pop is defended from charges of corruption on the grounds that nobody listens to the words anyway. This became one way in which 'authentic' rock was distinguished from its commercial, degenerate versions – real rock lyrics matter because they can be treated as poetry or politics, involve social commentary or truth-to-feeling; bad rock words are just drivel. What most interests me about this position, though, are the questions it begs. Mainstream, commercial pop lyrics – silly love songs – may not 'matter' to their listeners like the best rock words do, but they are not therefore insignificant. Popular music is a song form; words are a reason why people buy records; instrumental hits remain unusual – to paraphrase Marilyn Monroe in *Seven Year Itch*, you can always tell classical music: 'it's got no vocals!' People may not listen to most pop songs as 'messages' (the way they are presented in all that American empirical research), and the average pop lyric may have none of the qualities of rock realism or blues poetry, but the biggest selling music magazine in Britain by far is still *Smash Hits*, a picture paper organized around the words of the latest chart entries. And so the question remains: why and how do song words (banal words, unreal words, routine words) work?

The Poetry of Pop

In songs, words are the sign of a voice. A song is always a performance and song words are always spoken out, heard in someone's accent. Songs are more like plays than poems; song words work as speech and speech acts, bearing meaning not just semantically, but also as structures of sound that are direct signs of emotion and marks of character. Singers use non-verbal as well as verbal devices to make their points – emphases, sighs, hesitations, changes of tone; lyrics involve pleas, sneers and commands as well as statements and messages and stories (which is why some singers, such as the Beatles and Bob Dylan in Europe in the sixties, can have profound significance for listeners who do not understand a word they are singing).[57]

I do not have the space here to describe how these techniques work in particular songs but from the work that has been done it is possible to draw some general conclusions.[58] Firstly, in analysing song words we must refer to the performing conventions which are used to construct our sense of both the singers and ourselves, as listeners. It is not just what

they sing, but the way they sing it, that determines what singers mean to us and how we are placed, as an audience, in relationship to them.

Secondly, in raising questions of identity and audience I am, implicitly, raising questions of genre – different people use different music to experience (or fantasize) different sorts of community; different pop forms (disco, punk, country, rock, etc.) engage their listeners in different narratives of desire. Compare, for example, the different uses of male/ female duets in soul and country music: the former use the voices to intensify feeling, the latter to flatten it. In soul music, realism is marked by singers' inarticulacy – they are overcome by their feelings – and so duets, the interplay of male and female sounds, add a further erotic charge to a love song. In country music, realism is marked by singers' small talk – the recognition of everyday life – and so duets, domestic conversations, are used to add further credibility to the idea that we are eavesdropping on real life (an effect heightened when, as is often the case, the couples *are* lovers or married or divorced).

The immediate critical task for the sociology of popular music is systematic genre analysis[59] – how do words and voices work differently for different types of pop and audience? But there is a third general point to make about all pop songs: they work on ordinary language, and what interests me here is not what is meant by 'ordinary' but what is meant by 'work'. Songs are not just any old speech act – by putting words to music, songwriters give them a new sort of resonance and power. Lyrics, as Langdon Winner once put it, can 'set words and the world spinning in a perpetual dance'.[60]

'In the best of songs,' according to Christopher Ricks, 'there is something which is partly about what it is to write a song, without in any way doing away with the fact that it is about things other than the song.' Sociologists of pop have been so concerned with these 'other things' – lyrical content, truth and realism – that they have neglected to analyse the ways in which songs are about themselves, about language. Tin Pan Alley songs are customarily dismissed as art (in those anthologies of rock poetry, for example), but they have their own literary importance. Bernard Bergonzi describes the resonance that pop lyrics had for writers in the 1930s, for example. W. H. Auden, Louis MacNeice and Graham Greene all wrote and used such songs for their own purposes. Brecht was similarly concerned to draw on 'the directness of popular songs', and for him the appeal of pop lyrics lay in their ability to open up language – Brecht used the rhymes and rhythms of popular cliches to say significant things *and* to expose the common-sense phrases in which such things are usually said. As David Lodge writes of slang generally,

> Slang is the poetry of ordinary speech in a precise linguistic sense; it draws attention to itself *qua* language, by deviating from accepted linguistic norms, substituting figurative expressions for literal ones, and thus 'defamiliarises' the concept it signifies.[61]

'What could a popular song be which scorned or snubbed cliche?' asks
Ricks, and Clive James, another literary pop critic, answers that the best
lyricists are bound to celebrate common speech. The Beatles' genius, for
example, was that they 'could take a well-worn phrase and make it new
again'. They could spot the 'pressure points' of language, 'the syllables
that locked a phrase up and were begging to be prodded':

> The sudden shift of weight to an unexpected place continually brought the
> listener's attention to the language itself, engendering a startled awareness
> of the essentially poetic nature of flat phrases he'd been living with for
> years.[62]

The songwriter's art, suggests James, is to hear 'the spoken language as
a poem', to cherish words 'not for their sense alone but for their poise
and balance', and this is a matter of rhythm too – the rhythm of speech.
This was what rock writers should have learnt from blues and soul and,
indeed, from Tin Pan Alley. If, in many pop songs, the regularity of the
beat seems to reduce the lyrics to doggerel, on the other hand, as Roy
Fuller puts it, music can 'discover subtleties in the most commonplace of
words'. Fuller gives the example of George Gershwin's setting of the line
'how long has this been going on?'

> When he has to set that, a line of regular iambic tetrameter, surely he sees
> how banal it would be to emphasise the word 'this' as the underlying stress
> pattern of the words requires: 'Hŏw lóng hăs thís bĕen góiňg ón?' What he
> does is to give the line three beats only – on 'long', the first syllable of
> 'going' and on 'on'. The three middle words, including the word 'this', are
> unaccented, giving the effect of a little skip in the middle of the line – 'Hŏw
> lóng hăs thĭs bĕen góiňg ón?' It is the action itself and the action's duration
> that Gershwin brings out, and how right it seems when he does it.[63]

Last Words

In his study of Buddy Holly, Dave Laing suggests that pop and rock
critics need a musical equivalent of the film critics' distinction between
auteurs and *metteurs en scene*:

> The musical equivalent of the *metteur en scene* is the performer who
> regards a song as an actor does his part – as something to be expressed,
> something to get across. His aim is to render the lyric faithfully. The vocal
> style of the singer is determined almost entirely by the emotional
> connotations of the words. The approach of the rock *auteur* however, is
> determined not by the unique features of the song but by his personal style,
> the ensemble of vocal effects that characterise the whole body of his
> work.[64]

Ever since rock distinguished itself from pop in the late 1960s, *auteurs* have been regarded as superior to *metteurs* and lyrics have been analysed in terms of *auteur* theory. But Laing's point is that the appeal of rock *auteurs* is that their meaning is *not* organized around their words. The appeal of Buddy Holly's music, for example, 'does not lie in what he says, in the situations his songs portray, but in the exceptional nature of his singing style and its instrumental accompaniment'. My conclusion from this is that song words matter most, as words, when they are *not* part of an *auteur*ial unity, when they are still open to interpretation – not just by their singers, but by their listeners too. Billie Holiday, the greatest *metteur* Tin Pan Alley pop ever had, wrote:

> Young kids always ask me what my style derived from and how it evolved and all that. What can I tell them? If you find a tune and it's got something to do with you, you don't have to evolve anything. You just feel it, and when you sing it other people feel something too.[65]

The pleasure of pop is that we can 'feel' tunes, perform them, in imagination, for ourselves. In a culture in which few people make music but everyone makes conversation, access to songs is primarily through their words. If music gives lyrics their linguistic vitality, lyrics give songs their social *use*.

This was, indeed, the conclusion that Donald Horton reached in his 1950s analysis of the lyrical drama of courtship. 'The popular song,' he wrote, 'provides a conventional language for use in dating.' The 'dialectic' of love involved in pop songs – the conversational tone, the appeal from one partner to another – was precisely what made them useful for couples negotiating their own path through the stages of a relationship. Most people lacked skill in 'the verbal expression of profound feelings' and so a public, impersonal love poetry was 'a useful – indeed a necessary alternative'. The singer became a 'mutual messenger' for young lovers, and pop songs were about emotional possibilities. The singer functioned 'in dramatizing these songs to show the appropriate gestures, tone of voice, emotional expression – in short the stage directions for transforming mere verse into personal expression'.[66]

Pop love songs do not 'reflect' emotions, then, but give people the romantic terms in which to articulate and so experience their emotions. Elvis Costello once suggested that

> most people are confused regarding their identities, or how they feel, particularly about love. They're confused because they're not given a voice, they don't have many songs written for or about them. On the one hand there's 'I love you, the sky is blue', or total desolation, and in between there's a lack of anything. And it's never that clear-cut. There's a dishonesty in so much pop – written, possibly with an honest intent – all that starry stuff. I believe I fulfill the role of writing songs that aren't starry eyed all the time.[67]

But even Costello knows that what matters is the availability of fantasy. We need still to heed, that is, the words of Marcel Proust:

> Pour out your curses on bad music, but not your contempt! The more bad music is played or sung, the more it is filled with tears, with human tears. It has a place low down in the history of art, but high up in the history of the emotions of the human community. Respect for ill music is not in itself a form of charity, it is much more the awareness of the social role of music. The people always have the same messengers and bearers of bad tidings in times of calamity and radiant happiness – bad musicians... A book of poor melodies, dog-eared from much use, should touch us like a town or a tomb. What does it matter that the houses have no style, or that the gravestones disappear beneath stupid inscriptions?[68]

Notes

1 Lovat Dickson, *Radclyffe Hall at the Well of Loneliness* (Collins, London, 1975), pp. 45–6.
2 See Ian Whitcomb, *After the Ball* (Penguin, Harmondsworth, 1972) and Charlie Gillett, *The Sound of the City* (Souvenir, London, 1971).
3 Terms used by an American Congressional Committee on song publishing, cited in K. Peter Etzkorn, 'On Esthetic Standards and Reference Groups of Popular Songwriters', *Sociological Inquiry*, 36, 1 (1966), pp. 39–47.
4 K. Peter Etzkorn, 'Social Context of Songwriters in the United States', *Ethnomusicology*, VII, 2 (1963), pp. 103–4.
5 J. G. Peatman, 'Radio and Popular Music', in eds. *Radio Research*, P. F. Lazersfeld and F. Stanton, (Duell, Sloan and Pearce, New York, 1942–3).
6 H. F. Mooney, 'Song, Singers and Society, 1890–1954', *American Quarterly*, 6 (1954), p. 226.
7 H. F. Mooney, 'Popular Music since the 1920s', *American Quarterly*, 20, (1968).
8 Mooney, 'Popular Music since the 1920s', p. 232.
9 See D. Horton, 'The Dialogue of Courtship in Popular Song', *American Journal of Sociology*, 62, (1957); J. T. Carey, 'Changing Courtship Patterns in the Popular Song', *American Journal of Sociology*, 74 (1969); R. R. Cole, 'Top Songs in the Sixties: a Content Analysis', *American Behavioural Scientist*, 14 (1971). In recent years the most prolific content analyst, B. Lee Cooper, has traced a variety of ideological issues through pop and rock songs, though he seems less concerned to identify changing values than to point to the recurring problems of American ideology. For a summary account of his work see his *A Resource Guide to Themes in Contemporary American Song Lyrics* (Greenwood, London, 1986). Very little similar work seems to have been done in Britain but for the 1950s/1960s contrast see Antony Bicat, 'Fifties Children: Sixties People', in *The Age of Affluence 1957–64*, eds V. Bogdanor and R. Skidelsky. (Macmillan, London, 1970), and for the rock/punk contrast in the 1970s see Dave Laing, *One Chord Wonders* (Open University Press, Milton Keynes, 1985), pp. 63–73.
10 For an interesting use of music hall material this way see G. Stedman Jones, 'Working-class Culture and Working-class Politics in London 1870–1900', *Journal of Social History* 7, 4 (1974).

11 P. Di Maggio, R. A. Peterson and J. Esco, 'Country Music: Ballad of the Silent Majority', in *The Sounds of Social Change* eds R. S. Denisoff and R. A. Peterson (Rand McNally, Chicago, 1972).

12 M. Haralambos, *Right On: from Blues to Soul in Black America* (Eddison, London, 1974), p. 117.

13 Haralambos *Right On: from Blues to Soul in Black America*, p. 125.

14 'Real closeness' is a term used by Richard Hoggart to distinguish authentic from commercial working-class ballads – see *The Uses of Literacy* (Penguin, Harmondsworth, 1958), pp. 223–4.

15 D. Hughes, 'Recorded Music', in *Discrimination and Popular Culture* ed. D. Thompson, (Penguin, Harmondsworth, 1964), p. 165.

16 Hoggart, *The Uses of Literacy*, p. 229.

17 W. Mellers, *Music in a New Found Land* (Faber and Faber, London, 1964), p. 384.

18 E. Lee, *Music of the People*, (Barrie and Jenkins, London, 1970), p. 150. For a Marxist reading of the 'genteely romantic' bourgeois ideology of British pop music until rock and roll began to use blues and folk idioms that expressed 'bottom dog consciousness' and to 'speak for the excluded and rebellious', see Eric Hobsbawm, *Industry and Empire* (Penguin, Harmondsworth, 1968), p. 284.

19 Dave Harker, *One for the Money* (Hutchinson, London, 1980), p. 48.

20 Harker, *One for the Money*, p. 61.

21 T. Goddard, J. Pollock and M. Fudger, 'Popular Music', in *Is This Your Life*, eds J. King and M. Stott, (Virago, London, 1977), p. 143.

22 Germaine Greer, *The Female Eunuch*, (Paladin, London, 1971), p. 164.

23 Hoggart, *The Use of Literacy*, p. 163.

24 Harker, *One for the Money*, p. 129.

25 S. I. Hayakawa, 'Popular Songs vs the Facts of Life', *Etc*, 12 (1955), p. 84.

26 Francis Newton, *The Jazz Scene* (Penguin, Harmondsworth, 1961), p. 162.

27 Hans Eisler, *A Rebel in Music* (International Publishers, New York, 1978), p. 191.

28 R. Palmer, *A Touch of the Times* (Penguin, Harmondsworth, 1974, pp. 8, 18; and A. L. Lloyd, *Folk Song in England* (Paladin, London, 1975), pp. 158, 170.

29 Lloyd, *Folk Song in England*, p. 369.

30 For full discussion of these issues see Dave Harker, *Fake Song* (Open University Press, Milton Keynes, 1985), and Vic Gammon, 'Folk Song Collecting in Sussex and Surrey, 1843–1914', *History Workshop* 10 (1980).

31 Harker, *One For the Money*, p. 189.

32 J. Taylor and D. Laing, 'Disco-Pleasure-Discourse', *Screen Education*, 31 (1979), p. 46.

33 Paul Oliver, *Meaning of the Blues* (Collier, New York, 1963), p. 68. And see Iain Lang, *Background of the Blues* (Workers Music Association, London, 1943), and Samuel Charters, *The Poetry of the Blues* (Oak, New York, 1963).

34 Charles Keil, *Urban Blues* (University of Chicago Press, Chicago, 1966), p. 74.

35 Oliver, *Meaning of the Blues*, pp. 133–4, 140; and Newton, *The Jazz Scene*, pp. 145–6.

36 Linton Kwesi Johnson, 'Jamaican Rebel Music', *Race and Class*, 17 (1976), p. 398.

126 *Words and Pictures*

37 See R. Ames, 'Protest and Irony in Negro Folksong', *Science and Society* 14 (1949).

38 Newton, *The Jazz Scene*, p. 150, and Johnson, 'Jamaican Rebel Music', p. 411.

39 Paul Garon, *Blues and the Poetic Spirit*, (Eddison, London, 1975).

40 Garon, *Blues and the Poetic Spirit*, pp. 21, 26, 76, 64.

41 Ames, 'Protest and Irony In Negro Folksong', p. 197.

42 Garon, *Blues and the Poetic Spirit*, p. 167.

43 Ian Hoare, 'Mighty Mighty Spade and Whitey: Black Lyrics and Soul's Interaction with White Culture', in *The Soul Book*, ed. Ian Hoare (Methuen, London, 1975), pp. 157, 162.

44 Lang, *Background of the Blues*, p. 39. For a suggestive general study of 'oral poetry' see Ruth Finnegan, *Oral Poetry* (Cambridge University Press, Cambridge), 1977.

45 See Claude Brown, 'The Language of Soul', in *Black America*, ed. R. Resh, (D. C.Heath, Lexington, 1969); Ulf Hannerz, *Soulside*, (Columbia University Press, New York, 1969); Geneva Smitherman, *Talkin' and Testifyin': The Language of Black America* (Houghton Miflin, Boston, 1977); David Toop, *The Rap Attack* (Pluto, London, 1984).

46 For an unusually intelligent version of this argument see Peter Guaralnick, *Feel Like Going Home* (Vintage, New York, 1971), pp. 22–3.

47 David Pichaske, *Beowulf to the Beatles and Beyond*, 1972 edition (Macmillan, New York, 1981), p. xiii. And see Richard Goldstein, *The Poetry of Rock* (Bantam, New York, 1969); B. F. Groves and D. J. McBain, *Lyric Voices: Approaches to the Poetry of Contemporary Song*, (John Wiley, New York, 1972); Bob Sarlin, *Turn It Up (I Can't Hear the Words)*, (Simon and Schuster, New York, 1973); *Rock Voices: The Best Lyrics of an Era* ed. Matt Damsker, (St Martins, New York, 1980).

48 For a brilliantly detailed discussion of Dylan's poetic sources see Michael Gray, *Song and Dance Man: the Art of Bob Dylan* (Hamlyn, London, 1981).

49 R. R. Rosenstone, ' "The Times they are A-Changin' ": the Music of Protest', *Annals of the American Academy of Political and Social Science*, (1969). The English poet Thom Gunn, writing in 1967, suggested that the Beatles represented a completely new pop sensibility, and had at last seen off Tin Pan Alley, 'the fag-end of the Petrarchan tradition'. The change had come with the line 'I've been working like a dog'. 'As soon as that line had been written immense possibilities became apparent. For what lover in a Sinatra song ever *works at a job?*' (*The Listener*, 3.8.67).

50 Paul Nelson, 'The Pretender' in *Stranded*, ed. G. Marcus, (Knopf, New York, 1979), p. 120.

51 Ira Gershwin, *Lyrics on Several Occasions* (Elm Tree, London, 1977), pp. 112–3.

52 David Riesman, 'Listening to Popular Music', *American Quarterly*, 2 (1950), pp. 360–1.

53 Norman Denzin, 'Problems in Analysing Elements of Mass Culture: notes on the Popular Song and other Artistic Productions', *American Journal of Sociology*, 75 (1969). And see J. Johnstone and E. Katz, 'Youth and Popular Music: a Study of Taste', *American Journal of Sociology*, 62 (1957).

54 J. P. Robinson and P. M. Hirsch, 'Teenage Responses to Rock and Roll Protest Songs', in *The Sounds of Social Change*, eds. Denisoff and Peterson. p. 231; R. S. Denisoff and M. Levine, 'Brainwashing or Back-ground Noise?

The Popular Protest Song', in the same collection; S. Frith, *The Sociology of Rock* (Constable, London, 1978).

55 Paul Hirsch, 'Sociological Approaches to the Pop Music Phenomenon', *American Behavioural Scientist*, 14, 1971, and R. A. Peterson and D. G. Berger, 'Three Eras in the Manufacture of Popular Music Lyrics', in *The Sounds of Social Change*, eds. Denisoff and Peterson, pp. 283, 296.

56 Peterson and Berger, 'Three Eras', p. 298; and see J. Ryan and R. A. Peterson, 'The Product Image: the Fate of Creativity in Country Music Songwriting', *Sage Annual Review of Communication Research*, 10 (1982).

57 For a very interesting discussion of Bob Dylan's 'meaning' in Germany see Dennis Anderson, *The Hollow Horn: Bob Dylan's Reception in the US and Germany* (Hobo Press, Munich, 1981), chapters 9, 20.

58 For detailed readings of lyrics in performance see, for example, the comparison of Kate Bush's 'The Kick Inside' and Millie Jackson's 'He Wants to Hear the Words' in S. Frith and A. McRobbie, 'Rock and Sexuality', *Screen Education*, 29 (1978), and the psychoanalytic account of Buddy Holly's 'Peggy Sue' in B. Bradby and B. Torode, 'Pity Peggy Sue', *Popular Music*, 4, 1984. For general discussions see S. Frith, *Sound Effects* (Pantheon, New York, 1981), pp. 34–8; Alan Durant, *Conditions of Music* (Macmillan, London, 1984), pp. 186–95, 201–11; and the introduction to Mark Booth, *The Experience of Song* (Yale University Press, New Haven, 1981).

59 This approach has been developed most interestingly in the Italian work of Franco Fabbri and Umberto Fiori. See, for example, Fabbri's 'A Theory of Musical Genres: Two Applications' in *Popular Music Perspectives*, eds. D. Horn and P. Tagg (IASPM, Goteborg and Exeter, 1982). From a continental European perspective one of the more intriguing aspects of contemporary pop lyrics is their use of a 'foreign' language – English. One of the defining features of the punk music that swept Europe in the late 1970s was its use of the different performers' 'native' tongues – the question rose as to what, in pop and rock, is a native tongue. Dave Laing suggests that even in Britain it means bands determinedly *not* singing in 'American' – see Laing, *One Chord Wonders*, pp. 54–9.

60 See L. Winner, 'Trout Mask Replica' in *Stranded*, ed. Marcus.

61 D. Lodge, 'Where it's at: California Language' in *The State of the Language*, eds. L. Michaels and C. Ricks (University of California Press, Berkeley, 1980), p. 506 and see C. Ricks, 'Cliches' in the same collection; B. Bergonzi, *Reading the Thirties*, (Macmillan, London, 1978), chapter 6, and C. Ricks, 'Can This Really Be The End?' in *Conclusions on the Wall: New Essays on Bob Dylan*, ed. E. M. Thompson (Thin Man, Manchester, 1980).

62 Clive James, 'The Beatles', *Cream*, (October 1972).

63 Roy Fuller, *Professors and Gods*, (Andre Deutsch, London, 1973), p. 86. Compare Ace's solution to the same problem in their hit song, 'How Long'. Their more maudlin emphasis is on the initial syllable: 'Hów lŏng, hăs thĭs bĕen gŏiňg ŏn'. Stephen Sondheim suggests another example of the precise attention to words necessary in good lyric writing: 'The opening line of *Porgy and Bess* by Dubose Heyward is "Summertime and the livin' is easy" – and that "and" is worth a great deal of attention. I would write "Summertime when" but that "and" sets up a tone, a whole poetic tone, not to mention a whole kind of diction that is going to be used in the play; an informal, uneducated diction and a stream of consciousness . . . The choices of "ands" and "buts" become almost traumatic as you are writing a lyric – or should

anyway – because each one weighs so much.' (S. Sondheim, 'Theatre Lyrics' in *Making Music*, ed. G. Martin (Muller, London, 1983), p. 75.)

64 D. Laing, *Buddy Holly* (Studio Vista, London, 1971), pp. 58–9.

65 Quoted in Mellers, *Music in a New Found Land*, p. 379.

66 Horton, 'The Dialogue of Courtship in Popular Songs', p. 577.

67 Elvis Costello interview in *New Musical Express* (21.8.82), p. 10. And see Steve Coombes, 'In the Mood', *Times Education Supplement* (12.2.82), p. 23. He writes: 'Writing for shows, thirties lyric writers were in both the best and worst senses of the word in the business of creating fictions. The moods of their lyrics do not reflect emotions they had actually felt nor that they expected anyone to think that they had felt nor even that they expected anyone else to feel for that matter. Nothing would have disturbed the cosmopolitan Cole Porter more than the idea that people might think that he actually did sit and moon over lost love – that emphatically was not his style. The moods of thirties lyrics are about what you ought to have felt or more accurately what you might like to have felt given the chance to think about it. Paradoxically, then, the tone is at the same time extremely sophisticated yet highly idealised.'

68 Quoted in Eisler, *A Rebel in Music*, pp. 189–90.

Hearing Secret
Harmonies

The Polish musicologist Zofia Lissa has written that 'silent' films needed, in fact, to be accompanied by music for a variety of reasons – to cover the noise of the projector and the passing traffic, to maintain or switch moods more smoothly than early cutting and editing devices, to give early cinema a veneer of respectability – but the point she makes that most interests me is that silence in a cinema is embarrassing.[1] This is obviously true nowadays – to show students silent films on a course is to call forth a shuffle of nervous feet, stifled giggles, stagey whispers – and it suggests one of the central uses of popular music in this century: to conceal the furtive pleasure of indulging in private fantasies in public places.

I want here to examine some of the ways in which film music works, but I will begin with the Barry Manilow problem.[2] My question is not why is Manilow so successful, but why does his music have an *emotional* impact when he seems so personally anonymous, so uninteresting in terms of vocal style or arrangement? The first clue to his pop appeal is that he started his career as a commercial jingle writer, but I am sure that the reason for his impact – even the wariest listeners can feel their 'heart strings pulled' – is that he makes the sort of music that these days comes at the end of a Hollywood film, writes the sort of song that plays as we leave the cinema and re-arrange our feelings.

Theme songs (rather than soundtrack excerpts) have been an important source of pop hits since the 1950s ('High Noon' is an obvious example, or Henry Mancini numbers like 'Moon River'). This is clearly an aspect of how Hollywood film music is planned – part of the promotional drama surrounding a new James Bond film, for example, concerns who is going to be chosen to write and sing the theme tune; and in the 1960s traditional film scorers like Bernard Herrmann denounced the degeneration of film music into pop song. But if such songs have a straight commercial object – there is extra money to be made from pop (the American charts, in particular, have been dominated by film themes in recent years)[3] and a well-timed theme record release is an extremely effective film trailer – they have also a filmic significance, particularly

given their function of closing a film. Theme songs work, first, as *summary*, they reprise a melody we have been hearing all through the film. Secondly, the songs capture the *mood* of an ending – romantic harmony, new wisdom, social uplift. And thirdly, theme songs often seem to have a built-in sense of sadness or *nostalgia*: the film is over, we have to withdraw from its experience, get 'back to reality'.

What interests me here, though, is not these musical functions as such, but the fact that *songs* are now conventionally used to perform these functions – music, that is, with voices and words neither of which need have anything to do with characters or dialogue in the film (usually, indeed, the only obvious link between a film and its song is the shared title and even that is becoming less common). The effect of this is that the song becomes a kind of *commentary* on the film: the singers represent us, the audience, and our response to the film, but also become our teachers, making sure we got the film's emotional message.

These songs do this by using pop's own emotional conventions and thus place films in a much wider framework of pop romance and pop common sense. The 1983 norm for such songs, for example, was the male/female duet, which enabled the music both to articulate vocally the male/female basis of Hollywood love, and also to stylise emotional intimacy. Hit examples are Joe Cocker's and Jennifer Warnes's 'Up Where We Belong' (from *An Officer and a Gentleman*) and James Ingrams's and Pattie Austin's 'How Do You Keep the Music Playing?' (from *Best Friends*). Both songs draw on black musical techniques of emotional expression (which have nothing to do with the films in question) and both make generalised references to the future – 'who knows what tomorrow will bring?', 'how do you keep the music playing, how do you make it last?' – which link the mood of the end of the film to the mood of the end of watching the film. (And both songs reveal how useful the synthesiser is in preserving the Hollywood equation of love and the sound of massed strings.)

My conclusion from these examples is that we cannot develop an explanation of how music works in film without reference to an explanation of how popular music works more generally. From this perspective, it is surprising how often in film studies it is asserted, in Schoenberg's words, that 'music never drags a meaning around with it', that it is nonrepresentational, 'abstract art par excellence' (Eisler), 'useless' (Adorno). Such assertions are the basis of numerous accounts of how a film's 'musical system' supports or counters its 'visual system'. My sense of pop music is that, in fact, it drags all sorts of meanings into and out of films. There is a standard musicological exercise, for example, in which people are played pieces of instrumental music and asked to write down their 'associations'. The results suggest both that there are widely shared conventions of musical meaning and that these conventions are partly derived from people's shared experiences of film soundtracks.

Claudia Gorbman (who has written the best essay on narrative film music) suggests that we should think in terms of three sorts of musical

code: (a) pure musical codes, generating musical discourse, music referring to music itself; (b) cultural musical codes, music referring to the usual cultural context of its production and consumption; and (c) cinematic musical codes, music in formal relationship to co-existent elements in a film.[4]

In practice, though, these different 'levels' are hard to separate. Take the distinction between pure and cultural musical codes. The concept of a pure musical code draws on an account of 'classical' music, on the possibility of a formal, structural analysis of rational, tonal music organised by certain compositional regulations. But this is a peculiar form of music, music without words or direct social function, which is, Eisler suggested, specific to bourgeois culture and has to be understood as such.[5] The 'purity' of the music is, in other words, itself a cultural code and, in fact, music in the classical tradition is heard to express the 'soul' of its composer and to convey or invoke particular sorts of imagery. Both these readings of classical music are important for the continuous use the cinema has made of nineteenth-century romantic music. One early use of film, for example, was to show the images taken to lie in the accompanying music (just like rock videos now). Miklos Rozsa provides an entertaining account of the possible complexity of the interplay between musical and filmic images:

> Billy Wilder approached me at a party and said he loved my violin concerto, and that he had worn out his copy of the record and wondered if I had another one. I was as intrigued as much as flattered but all he would say was, 'I've got an idea'. Some months later he called me into his office and revealed the idea: he had written a screenplay called *The Private Life of Sherlock Holmes* and he had written it around my concerto, inspired by the fact that Holmes liked playing the fiddle. The theme of the first movement is somewhat nervous and this apparently suggested to Wilder Holmes' addiction to cocaine. The theme of the second movement of the concerto brought a lady spy to Wilder's mind, and the turbulent third movement conjured up for him the Loch Ness monster. He said, 'This is perfect monster music'. I wasn't flattered but he was right, it did work out quite well. I agreed to score the film for him using the concerto. He seemed to think this would be easy because I wouldn't have to think up any new themes. Actually it was very difficult. The concerto was not written with any images in mind and the timings had to be altered to fit the film sequences. It would have been much easier to invent something fresh.[6]

The most interesting current approach to musical 'mood' conventions is being developed in Sweden by the musicologist Philip Tagg. He cites an experiment performed by one of his Gothenburg colleagues in a postgraduate seminar:

> A psychologist from Lund read what a patient had said while listening to a particular piece of music under hypnosis (the instructions to the patient had been to say what the music made him/her see, like in a daydream). The

seminar knew neither the identity nor anything else about the piece of music which had given rise to the patient's associations which were roughly as follows. Alone out in the countryside on a gently sloping field or meadow near some trees at the top of the rise where there was the view of a lake and the forest on the other side. Using this information only, the seminar was asked to make a rough score of the sort of music they thought might have evoked such associations. The seminar's sketch consisted of high notes (perhaps flageolets) sustained in the violins and a low pedal point in the cellos and basses. These two pitch polarities were in consonant (either octave or fifth) relations to each other. A rather undecided, quiet but slightly uneasy figure was put into the viola part now and again while a solo woodwind instrument (either flute, oboe or clarinet) played a quasi-modal legato melodic line which wandered slowly and slightly aimlessly piano over the rest of the almost static sounds (pianissimo). The seminar's quick sketch proved to correspond on most counts with the original musical stimulus which was the taptoe from Vaughan Williams' *Pastoral Symphony*.[7]

Tagg's own research interest is in the 'mood music collections' that are used by companies making film commercials, industrial documentaries, government promotions and a variety of cinema entertainments. The coding of musical moods dates back to the ways in which nineteenth-century music was taken to carry meanings, and Tagg suggests that there were material reasons why the cinema took over these 'classical' conventions:

> There was no technically, commercially, socially or culturally viable music for use in the early years of the capitalist film industry other than that provided by the bourgeois musical tradition. There was no other storable music, neither in graphic, mechanical, optical nor electronic form, neither was there any other sort of transculturally viable 'nature music' other than that of the bourgeoisie (p. 8).

Tagg's point here is that such 'nature music' is ideologically loaded; the music represents a particular account of 'nature'. Today the mood music catalogues cross reference 'nature' themes and sounds with various emotional labels, such that 'nature is mainly viewed as a positive, pleasant source of relaxation and recreation, as a leisure facility, as a backcloth for romance, as a historical-meditative retreat'.[8]

Similar assumptions lay behind the use of cue sheets in silent film accompaniment, pioneered by Max Winkler, a music publisher's clerk with an exceptional musical memory, whose catalogue 'listed all the compositions under categories – action music, animal music, church music – sinister, chaste, sad, mysterious, majestic, furious etc., etc.'[10] In this context (especially as Winkler later confessed to 'dismembering the great masters. We murdered the works of Beethoven, Mozart, Grieg, J. S. Bach. . .') it is difficult to lay bare 'pure musical codes'. The question becomes how we come to have associations for sounds and structures, how the pure and cultural musical codes relate to each other.

Cultural and cinematic musical codes are similarly entangled, if only because our 'cultural' understanding of musical meanings is, by this stage of cultural history, so dependent on their recurring film contexts. As film composer George Antheil put it in 1945:

> Hollywood music is very nearly a public communication, like radio. If you are a movie fan (and who isn't?) you may sit in a movie theatre three times a week listening to the symphonic background scores which Hollywood composers concoct. What happens? Your musical tastes become molded by these scores, heard without knowing it. You *see* love, and you *hear* it. Simultaneously. It makes sense. Music suddenly becomes a language for you, without your knowing it.[9]

This is to raise a number of historical questions. How, for example, did silent film pianists develop their sense of 'appropriate' accompaniment? How significant were cue sheets? To hear someone play for a silent film today is to hear someone drawing on the expectations of solo piano (whether Chopin or Russ Conway) and on implicit assumptions about how silent films *should* sound – the piano now is played to connote the piano then. The interplay of music's cultural and cinematic meanings has its own history (and it would be interesting in this context to compare Hollywood's effect on popular music with the development of popular film and music in India). In cinema's early history, accompanying music was part of the process in which cinema became 'respectable'; nowadays the absence of music is taken as the sign of a film's seriousness. Music may carry a meaning in film, in short, by drawing attention to the 'cultural conventions of its cinematic use', by drawing on genre rules, for example, which may or may not be confirmed by other aspects of the film.

If popular forms (jazz and country music, rock and roll and disco) first get used in films to signal their 'outside' social source (black culture, southern culture, youth culture, and so on), their use is often soon so stylised as to refer, rather, to their place in previous films. Early 1970s black action films, for example (*Shaft, Superfly, Trouble Man*, etc.), so encoded the 'wah wah' guitar that its use in a film score now (in 1982's *Vortex*, say) inevitably appeals to our ability to draw on *film* references. (Rock has often been taken to be a problematic form for film scorers – its very *presence* can swamp surrounding visual images. Rock videos, though, reveal that rock's musical meanings can soon be closed down by the systematic use of visual cliches.) The most interesting film composers draw on music's ability to cross and *confuse* cinematic and cultural codes in their construction of sound 'narratives'.

One paradox of film music is that while 'high theorists' have paid much less attention to aural than to visual codes, 'ordinary' film viewers (low theorists?) take the complications of musical reference for granted. In one public discussion of television commercials, for instance, I noted the following casual musical descriptions: 'middle-of-the-road', 'back-

ground', 'up-beat', 'Close Encounters climactic', 'new-exciting-world-just-around-the-corner', 'youth music', 'homely, healthy, folky'. Everyone present seemed to understand and agree with such descriptions even though they draw on a remarkable jumble of references and assumptions, and fuse musical, cultural, historical and cinematic allusions. I want to keep this in mind in addressing the three issues that have most fruitfully occupied more systematic approaches to film music.

Realism

In common-sense terms it might seem that music is the 'non-realist' aspect of films, yet audiences take it for granted that strings accompany a clinch. Indeed, a clinch without strings may seem *less* real, though another film convention is to climax a sex scene with silence, as if to register its 'privacy' (and our voyeuristic embarrassment). The point of this example is to stress that music is as essential to the perceived 'truth' of a film as everything else, but the reality music describes/refers to is a different sort of reality than that described/referred to by visual images. Film composers themselves often take their cue on this from Wagner, who argued that the purpose of music was 'to amplify what can't be shown' – and what cannot be shown is regularly called 'atmosphere' or 'mood'. Broadly speaking, two strands of reality seem to be involved here.

Firstly, *emotional reality*. Music, it seems, can convey and clarify the emotional significance of a scene, the true 'real' feelings of the characters involved in it. Music, in short, reveals what is 'underneath' or 'behind' a film's observable gestures. Thus, for composer Jerry Goldsmith, the aim of film music is 'emotional penetration', while in Elmer Bernstein's words:

> The job of the composer is really very varied. You must use your art to heighten the emotional aspects of the film – music can tell the story in purely emotional terms and the film by itself cannot. The reason that it can't is that it's a visual language and basically intellectual. You look at an image and you then have to interpret what it means, whereas if you listen to something or someone and you understand what you hear – that's an emotional process. Music is particularly emotional – if you are affected by it, you don't have to ask what it means.[11]

Secondly, *reality of time and place*. Another recurring point made by the film scorers interviewed by Tony Thomas is how much research they do. In writing music for a film set in a particular historical period or in a particular geographical place, they must produce sounds which current audiences believe relate to what people in that time or place would have 'really' heard. This is a more complicated matter than it might seem. The 'reality' of film musical settings actually refers to historical and

geographical myths (themselves constructed, in part, by previous music in previous films set in these places and times). Thus the music for *Zorba the Greek* became so powerfully connotative of Greece that Greek restaurants (even those in Greece itself) have to use the music to convince customers of their 'Greekness'. And a time and a place can have an emotional meaning too (this is one of the functions of 'nature music'). The Australian *Picnic at Hanging Rock* thus conveyed the 'mystery' of the rock by using Gheorghe Zamfir's eastern European pan pipes (underscored by a cathedral organ), while Michael Nyman's score for *The Draughtsman's Contract* used the appropriate historical musical form but scored instrumentally according to the rules of contemporary minimalism, thus making the apparent celebration of 'order' distinctly unsettling.

All these examples of musical realism raise the question of how audiences *recognize* musical authenticity. It is easy to move (like Elmer Bernstein) from the directness of music's emotional impact to an assertion of its 'natural' meaning, so it is worth citing another cautionary musicological story. A group of African musicians, invited to tour the American folk festival circuit, found that their music was getting a decidedly cool response, was being dismissed as 'commercial'. After a few weeks the musicians sat down and worked out a new arrangement of their material, designed specifically to signal 'authenticity' in American folk terms. With this 'fake' sound (it bore little relationship to the music they played in their home country) they became widely praised for their 'ethnic' flair. More recently, Jeremy Marre's series of films for Channel 4 on popular music in Asia was criticized by critics because, in the words of the *Sunday Times* (18 March 1984) it did not include 'enough indigenous melody as opposed to processed western pop'. Marre's point, of course, was to show that this distinction is nowadays meaningless.

Diagesis

The most systematic theoretical approach to film music begins by distinguishing its diagetic use (when it has a place in 'the narratively implied spatio-temporal world of the actions and characters', for example, when it is made by the band in a night-club scene) and its non-diagetic use (when the music heard has no source within the film's own world). The important point here, as Claudia Gorbman has made clear,[12] is that in practice music straddles this apparently clear divide. How, for example, do we classify the moment when someone remembers a tune and we hear it on the soundtrack – the physical production of the music is non-diagetic, but its emotional production is diagetic. Is the character 'really hearing something'?

More generally, it seems that our classification of music in terms of diagesis depends on an implicit sense of sounds' *appropriateness* to a scene; in terms, that is, of musical realism (which, as I have already

suggested, is not the same thing as visual realism). If, for example, the diagetic/non-diagetic distinction refers to the source of a sound, then this is not just a question of what we can actually see in a scene but of what we might *expect to see* as part of the film's realistic 'soundscape'. In *The Godfather*, for example, Nino Rota's score uses and makes deliberate reference to Italian street music, to 'live' sounds, even when the musicians could not possibly be present in the narrative. This is a non-diagetic use of music, but one which is drawing our attention to the music's previous 'real' presence. In youth films from *American Graffiti* to *The Big Chill*, rock and roll is so much part of the 'diagesis' (and we do indeed see radios and record-players turned on, even records being played by Wolfman Jack himself) that it is misleading to assert that in those scenes when such music has no 'real' source it suddenly becomes non-diagetic. Disco music is used similarly in *Saturday Night Fever*: in the love scene, 'How Deep Is Your Love' is the sort of song that *could* have been on the radio or record-player – the implication is that the film characters are 'hearing' it as clearly as we are in the audience. By the time we get to a film like *Blade Runner* we find that the 'reality' of this future Los Angeles is guaranteed precisely by the invisibility of the ever-present synthesised sounds – outside the cinema too we are increasingly surrounded by music which has no apparent source.[13]

Subjectivity

The third important question raised by theoretical debate is how music works to position film spectators (or auditors), and this is to address the question of emotional realism from a slightly different perspective: one function of film music is to reveal our emotions as the *audience*. Film music is often said to have physical effects – sending shivers down the spine, bringing a lump to the throat – and sounds, more obviously than visions, have collective effects – we hear a beat and tap our feet (or march or work) together. Film scores are thus important in representing *community* (via martial or nationalistic music, for example) in both film and audience. The important point here is that as spectators we are drawn to identify not with the film characters themselves but with their emotions, which are signalled pre-eminently by music which can offer us emotional experience *directly*. Music is central to the way in which the pleasure of cinema is simultaneously individualised and shared; like political rhetoric it can cue responses by applying general rules of crowd arousal to particular circumstances.

There is, in this context, another sort of approach to musical meaning – the Barthian analysis of music as a *sensuous* pleasure, in which we are overwhelmed by sound (as in *Blade Runner*?). Barthes himself raised the question of why certain sorts of voice give pleasure (speaking as well as singing voices), why we take delight in the experience of meaning *being*

made. This is to widen the question of film music in two directions – firstly by linking it to non-musical but human sounds; secondly by referring us to films, musicals, which are explicitly about music-making. In the long run any analysis of music in film will have to cover all this ground. Here I have been specifically concerned with music's coded pleasures and so my closing questions is this: where do emotional codes come from? This is to go back to the issue of the clinch and the strings: to have meaning, emotions must be shaped, and this is as much a public as a private process, one in which music (and music-making) seems central. Do people 'hear harmonies' when they kiss *outside* films, too? To develop the theory of film music we need, in Antoine Hennion's words, 'not so much a sociology of music as a musicology of society'.[14]

Notes

1. Zofia Lissa, *Asthetik der Filmmusik* (Berlin, Henschelvelg, 1965).
2. What follows was first presented as a talk at the SEFT Sound Cinema weekend, Triangle Arts Centre, Birmingham, 29–30 October 1983 and appeared in a slightly different from in *Screen* 25 (1984). Thanks to Philip Tagg for his help.
3. In Britain, by contrast, television themes are more likely to have chart success – like the themes from 'Minder', 'Hill Street Blues' and 'Auf Wiedersehen Pet', or more bizarrely, the arrangement of Ravel's *Bolero* used by Torvill and Dean in their skating triumphs.
4. Claudia Gorbman, 'Narrative film music', *Yale French Studies*, 60 (1980), p. 185.
5. Hanns Eisler, *A Rebel in Music* (International Publishers, New York, 1978), p. 66.
6. Quoted in Tony Thomas, *Music for the Movies* (New York, A. S. Barnes, 1973), pp. 96–7.
7. Philip Tagg, *'Nature' as a Musical Mood Category* (Gothenburg, IASPM, 1983), p. 31.
8. ibid. p. 24.
9. Thomas, *Music for the Movies*, p. 171.
10. Quoted in Thomas, *Music for the Movies*, p. 171.
11. Quoted in Thomas, *Music for the Movies*, p. 193.
12. Gorbman, 'Narrative film music'.
13. *Blade Runner* has an interesting score for other reasons. Its composer, Vangelis, refused to allow the release of his electronic performance and so it was reproduced, remarkably accurately, by the strings of The New American Orchestra.
14. Antoine Hennion, 'Music as social production', in *Popular Music Perspectives*, eds. David Horn and Philip Tagg, (Gothenburg and Exeter, IASMP, 1982), p. 40.

PART 4

Screen Idols

Sound and Vision –
Ennio Morricone

There's a moment in *The Harder They Come* when Jimmy Cliff and his fellow 'rude boys' sit through a spaghetti western, enthralled by its images of retribution. Other people in this Kingston crowd are concentrating on the soundtrack – Ennio Morricone is the line that runs from Puccini to dub.

Morricone's music is familiar even to rock fans these days, but Morricone himself remains (in Britain at least) an unknown figure. On the sleeve of the Italian anthology of his greatest titles, *Un Film, Una Musica*, he is photographed in a dark shirt and black-rimmed glasses, a pensive intellectual. And his career certainly has not been limited to Westerns. Morricone was conservatory-trained: he is a composer and orchestrator with an obviously 'serious' facility – for example, his scores for *1900* and *The Battle of Algiers*. He is also a trumpeter and, more unusually, an improviser; and he performs regularly in Rome.

Improvisation and film scoring would seem to be opposite ways of making music: film music is programme music, determined by the extra-musical events on which it comments; improvized music is music of the moment, determined only by its immediate conditions of production. But both sorts of music-making depend on a precision of sound reference – the wrong note can damage the mood of an improvized piece or a film scene; both sorts of music depend on shorthand, on the economical production of emotional and musical cross-references. Good film music, like good improvized music, creates atmosphere and mood with unexpected elements of pastiche and parody. And in some ways film scorers, like improvisers, are freed from compositional norms: they can leave it to the pictures to make sense of the sounds. All sounds ('musical' or not) tell a story. Soundtrack composers, indeed, think harder than anyone else about the non-musical meanings of music – consider the amount of thought that goes into the brief sounds that accompany TV commercials.

'Background music' is a term of critical abuse, but all popular music works as background – background to stars and lyrics which give songs their specific meaning; even popular instrumental music is defined by its

function in dance. The idea that music should be 'only music', something
to sit and listen to, is a bourgeois idea which reflects the peculiar
conditions of classical music. And, in practice, even such 'serious' music
is heard as a soundtrack: descriptions of classical pieces routinely refer to
the visual images they invoke. The assumption is that such networks of
aural/visual association are emotionally fixed – it is taken for granted
that this noise conveys the sea, this the moonlight, this a battle, and so
on. Nineteenth-century grand opera was predicated on such connections,
as Hans Eisler points out:

> If a dog is mentioned, then the orchestra barks, if a bird then an orchestra
> cheeps, if death is mentioned then the gentlemen of the trombones have to
> exert themselves, if it is love then there are the divided high violins in E
> major, and at the triumph the trusty percussion also joins in. It is
> unbearable!

Sound films, rather than for the first time subordinating sounds to
pictures, in fact liberated European music from bourgeois sentimentality.
As Eisler said in 1935:

> Sound film is making the masses unaccustomed to listening to music in the
> abstract but accustomed to seeing pictures of real life while they hear
> music. So a more realistic type of listener is arising in contrast to the old
> idealistic concert-goer.

These days, most of our assumptions about sound and vision are
derived from our experience of film: the private images we run through
our heads when we hear music are determined by the soundtrack codes
we've learnt from hundreds of public viewings. Rock music has
contributed little to these codes ('youth-oriented' film scores are, by
definition, made up of familiar, autonomous hits) because until recently
Afro-American musical principles were difficult to follow in film scores:
black music is physical, intense, spontaneous and vocal; it registers in
films as interference. Thus 1950s 'jazz' soundtracks (by people like
Andre Previn and Quincy Jones) were, in practice, the usual European
compositions but with jazz instrumentation. It took disco, with its
abstraction and its plastic studio effects, to establish black sounds in
films and commercials. Indeed, the disco genre itself emerged from the
pioneering film work of soul writers like Isaac Hayes (*Shaft*), Curtis
Mayfield (*Superfly*) and J. J. Johnson (*Across 110th Street*).
 But even disco tracks are confined in their references and the
conventional Hollywood film score, even after 30 years of rock and roll
and popular black music, remains the romantic symphony, as translated
into film segments by 1930s composers like Max Steiner. Films are still
edited according to temporal/harmonic rules; they follow the develop-
ment of a plot/theme through various dramatic and emotional move-
ments; they bring together a limited number of identifiable characters/

melodies whose relationships pose problems/dissonances which are resolved in a happy, harmonic ending.

The paradox of movie music (and the reason for its loss of status since the 1930s as a 'serious' form of composition) is that its romanticism – conventionally the expression of the composer's own subjectivity – is, in fact, an objective exercise. The film scorer's task is to express the film's emotions (not his or her own), and the technical rules of this exercise were so quickly learnt that film companies soon divided their musical labour, employing specialists in love, action, comedy and so on. The vast majority of film scores (John Williams' for example) are so functional that they have no interest outside the cinema. Every picture is needed to tell the story and there is no gap left between sound and vision at all.

Hollywood music doesn't have to be so dull. Its 'falseness' is also the source of its interest and the best Hollywood composer since the war, Bernard Herrmann (whose career stretched from *Citizen Kane* (1941) to *Taxi Driver* (1976), taking in much of Hitchcock along the way), was an intellectual whose pleasure lay in the games he could play with genre conventions. Rather than leitmotifs (the Hollywood means of character reference), Herrmann used repeated riffs: his films' cross references, their plot points, were made with rhythmic rather than harmonic relationships. Listen, for example, to the way the string-only orchestra in *Psycho* (1960) makes music that is neurotically unfulfilled. And for Herrmann (who was inspired by Charles Ives and Béla Bartók) any sound could contribute to a rhythm (harmonic rules were suspended). Herrmann scores feature unusual instruments (four electric organs and a cathedral organ in *Journey To The Centre Of The Earth* (1959); massed tubas in *Jason and the Argonauts*, (1963)), and everyday sounds (birdsong in *Psycho*, anything percussive in all his films). Herrmann took particular delight in making familiar noises strange.

Bernard Herrmann took it for granted that the cinema audience was familiar enough with movie music to enjoy having its expectations confounded. In *Obsession* (1976), for example, the references to Verdi's *Requiem* point up the sweet sickliness of religious fever, and the waltz is a rhythm of despair, a swirling urge to death. Herrmann exploits the artificiality of film romanticism and he was, not surprisingly, always fascinated with electronic sounds – *The Day The Earth Stood Still* (1951) used an orchestra supplemented with two theramins and an electronic bass/violin/guitars.

In Hitchcock's films self-expression is self-deception, and the point of Herrmann's music is to whip away the stable meaning of symphonic sounds, to plant doubts about the symphonic form. Ennio Morricone's Western scores comment similarly on the music itself, but Morricone went much further than Herrmann in his (post-rock and roll) use of a beat, electronics, the recording studio. Sergio Leone's films stripped the Western of its personality – he was interested in archetypes, strangers living out their destinies in one of the inner circles of hell – and Morricone's task was to match musically such objectivity.

The resulting music uses conventional Western elements – twangy, he-man guitar, trumpets from both Mexican and US Cavalry bands, big country strings (as used by Dvorak), a melancholy chorale of the women left at home – but Morricone changes their context. Like Herrmann, he creates rhythmic textures, but his timing is more subtly unsettling. His favourite instrument is the electric piano, and while his Western instruments are marking out a slurred, passive beat, his keyboards are rhythmically, anxiously, punctual. Morricone's percussive effects seem thus to be improvised against a tape loop – the beat recurs, but against a random series of other sounds; the resulting tensions can never be resolved (just as Leone's men with no names can never settle with their human condition). The most dramatic Morricone score in this respect is *Il Gatto A Nove Code* (1971) in which there is no pretence even at melodic phrasing; every instrument (voice and trumpet included) is concerned only with its own time, and the music is so intellectually absorbing that it is impossible to make any emotional assumptions about what the accompanying pictures might be.

Morricone's grandest score, *Once Upon A Time In The West* (1969), was composed before the film's shooting script; the film was cut to the pulse of the music. The score is a showcase for Morricone's usual gifts: his mastery of a range of sounds, from oboe and cello to xylophone and electric bass; his ability to play off orchestral against electronic arrangements; his ease with Western codes (the harmonica, the country bar band) but what makes a Morricone score so distinctive is harder to describe – it concerns his musical sense of space and calm.

It is a paradox of film music that in a situation where music has apparently little to do (it just has to accompany the visual) it actually does so much. Film composers are not noted for their restraint and scores tend to be packed with information. Bernard Herrmann was, in this respect, a typical Hollywood composer: his music is busy, rich, melodramatic and deliberately excessive in its pursuit of effects – Herrmann never used one bass drum when he could use eight. Morricone's music is, by contrast, remarkably disciplined: his riffs are minimal (usually a three- or four-note syncopation); his textures, whatever their range of sounds, are sparse (often resting on a simple high/low or staccato/legato effect); he is as aware as any dub producer of the silences between the beats. Morricone's Western scores, composed for violent action, are, indeed, remarkably static: they don't narrate, they don't solve problems; they don't offer catharsis – their appeal, like that of the films themselves, is as much intellectual as emotional.

In one of Morricone's non-Western titles, *La Classe Operaia In Paradiso* (1971) he moves abruptly from factory-floor rock to pastiche Puccini to the cabaret sound (trumpet and piano) of a Brecht/Weill musical. It was Brecht's argument (taken from Eisler) that the use of music in film as an emotional power, an 'enveloping' effect (Herrmann's description) is reactionary. Progressive artists in film had to use sound and vision to argue against each other. In Eisler's words:

A new way of using vocal and instrumental music is above all to set the music against the action in the film. That means that the music is not employed to 'illustrate' the film, but to explain and comment on it.

Morricone's music is, by this criterion, exemplary. His Western scores draw attention to the glib sentimentality of the Western myth, to its shallow, ahistorical treatment of violence. But Morricone's music meets another Brechtian criterion too: it is not just clever, it is also popular and funny. There is, unfortunately, not much other music like it. 1981

Pretty Vacant – John Barry

Britain's first number one single of 1986 was Pet Shop Boys' 'West End Girls'. It's the first record for months that I've rushed out to buy, too, caught by one radio play.

My favourite version is the Shep Pettibone mastermix. He gets the Boys' pretentions just right, pointing up the record's anomaly – its thumping, imported New York beat is filtered through prissy English voices. Pet Shop Boys are, after all, just another British pop group, showroom dummies with electronic equipment and a memory bank of old club and disco riffs.

There are hundreds of duos like this. Pretty packages, synthetic centres, they roll off record company assembly lines like new sweets from a candy factory. What makes Pet Shop Boys special is their sense of tacky drama. 'West End Girls' is the Naked City as conceived by design students, a confused glimpse of menace in which even paranoia has the right shirt on. It is the chart version of the cinema ads currently aimed at young Brits, Canadian Club-drinkers and Levi-wearers flattered by being given roles in Cold War stories and futuristic thrillers.

My Christmas present to myself was the most expensive record I have ever bought, the soundtrack of Lawrence Kasden's *Body Heat*. This was officially released when the film came out in 1981 but immediately withdrawn. It's now available only as an 'Official Collectors' item' – I found it in my favourite London record shop, 94 Dean Street, soundtrack specialists.

Body Heat's music is redolent with the film's sticky, languorous, fetid mood. A breathy sax plays over a nagging, four-note keyboard phrase that comes back again and again, like waves on the sand; strings long for a climax that never comes. Like all great film scores this has nothing to do with pictures, but works at the highest level of abstraction pop music can reach. (I love soundtracks for formal reasons.) But there is another story here, too. *Body Heat* is a John Barry score and John Barry is the key to 30 years of Brit-pop atmospherics.

He started his career as an arranger and bandleader in the 1950s – he seized the moment when established British musicians had to adjust to rock'n'roll. What's forgotten now is how this meant, in practice, seizing images of the US, images taken from American films and, more

particularly, from the newly available American TV series. British instrumental groups – the Shadows are the most famous example – derived large chunks of their repertoires from American themes and soundtracks.

Barry did this best of all. He was a trumpeter who idolized the Stan Kenton Band and learned how to arrange from American postal courses. He was just 24 when he formed the John Barry 7 in 1957. They were quickly popular in the dance halls, and their blend of professional *nous* and rock verve gave them a permanent place in Britain's first teen TV shows. Barry began to arrange for singers and, in launching Adam Faith to stardom, invented 'stringbeat', his band, twangy guitar to the fore, supplemented by a *pizzicato* violin section, based on Buddy Holly's 'It Doesn't Matter Anymore'.

In 1960 Barry scored Adam Faith's debut film – *Beat Girl* was the first British soundtrack album and Barry's opportunity to show off his jazz-arranging skills. In 1962 his hit version of the James Bond theme was so obviously right that he was booked to score the next Bond film himself. By the mid-1960s he was in demand in Hollywood as well as London. Hence, eventually, *Body Heat*.

But the point of this brief life of one of my oldest heroes (his father owned the cinema where I saw my first rock'n'roll show) is not Barry's destination but his roots. *Beat Girl*, for example, is a pretty silly film – the British B-movie version of beatniks and juvenile kicks is earnestly innocuous – and Barry's score worked brilliantly both as a pastiche of the US beat originals and as a kind of stylized yearning for the real thing.

As a film scorer Barry has classic virtues – a mastery of texture, an imaginative use of fringe instruments, an instinct for restraint. But his best soundtracks and, in particular, 1960s scores like *The Knack*, *The Ipcress File* and the various Bond films, work with a peculiarly British grasp of sex and glamour and violence at second-hand.

Which is where the Pet Shop Boys come in, their eyes pressed to the window of American street life. On the American side of the glass that means, along with much else, panic and death and madness; from the British side everything is just a pose to play with. 1986

PART 5

Playing with a
Different Sex

From Bobbysox to Dungarees

The last time Sister Sledge had a hit was with 'Mama Never Told Me' in 1975. The next time will probably be 1983 and in between they'll be forgotten again – just another black group. Most reviewers treat Sister Sledge as session singers: *He's The Greatest Dancer* is covered as the latest record from Chic – only the voices have changed.

Sister Sledge must sometimes feel this way themselves, as they're moved from one hot producer to another, from Philadelphia to New York to Munich to New York. Each time a new set of sounds – Tony Sylvester's and Bert DeCoteaux's shuffling, sugary rhythms, Michael Kunze's and Sylvester Levay's elegant machines, Chic's cool concision; each time a new search for the disco Grail.

But the more I listen to Sister Sledge's sly involvement in 'He's The Greatest Dancer', the more I'm convinced that it's wrong to hear the group as just another disco noise: their function is not to provide disco's customary simpering sex appeal. Sister Sledge are a black girl group and, as such, they represent an honourable pop tradition.

Not the tradition of the Supremes or the Three Degrees, though. Theirs is not really a group sound, but is based on the appeal of a single singer, either supported by her group or multiplied by them. Their appeal is intimate, a sex appeal directed at the listener as lover, a carefully costumed availability. This is not Sister Sledge's way (which is why Sylvester and DeCoteaux got them so wrong). The Sledges are too young, too gauche, too clumsy, too excitedly innocent to make convincing sexual saleswomen.

They come, obviously, from a different group tradition; theirs is the sound of girl-talk. Listen again to 'Mama Never Told Me'. Amid the shoobie-doos, the strings, the hustle, the sheer physical verve of the Philly Sound, was an older-styled teenage narration. The singer pointed out, half-rueful, half-proud, that her Mama had never said, while warning her off the wolves, that the real *slick* guys, the ones who get their way, are the quiet ones, with tender eyes, so shy, so bashful, so sneaky.

Sister Sledge's best records – 'Mama Never Told Me', the 'Together' album from Munich, the singles with Chic – draw on sixties girl-talk

conventions. In this genre the singers don't address the objects of their affections, but discuss them.

We get to listen in as the girls talk – in the toilets, in their bedrooms, in the whispering booths of coffee bars. I have no idea if girls did/do talk in these terms, but it was/is a satisfying male fantasy (and one written and produced, of course, by men).

Girl-talk producers like Shadow Morton took the essence of their groups' sound – a bunch of girls singing to each other – and used it to recreate conversation.

Morton's Shangri-Las were the most dramatic talkers; 'Leader Of The Pack' remains the classic example of how girls' voices could be used to challenge the story-teller, to question and comment on her plot. But the same effect was worked by numerous bands, and the best exponents were, in fact, the Shirelles, a black group to whom Sister Sledge owe an obvious debt – the Shirelles provided their own account of what 'Mama Said'.

The girl-talk genre was surprisingly rich. There were comparing-notes records, which rapidly slipped into battles of boasters like the Crystals. There were a mass of songs in which girls warned their friends off their boys – as in the Marvelettes' 'Don't Mess With Bill'. There was the back-biting of the Angels' 'My Boyfriend's Back'; the smug told-you-so of a song like the Shirelles' 'Foolish Little Girl'; the worldly-wise narrative of 'I Met Him On A Sunday' (by Saturday it was 'Bye, bye, baby'). There were endless discussions of how to keep him – discussions which reached their depths of eager self-abnegation on the Four Pennies' 'When The Boy's Happy (The Girl's Happy Too)'.

I've made girl-talk records sound slickly sexist, and I certainly don't want to pass them off as innocent artifice, but I'd still defend the genre.

In the male equivalents of these records (not so much boy-talk as sob-sob) all that was possible was a huge display of self-pity, and the important thing about girl-talk records was not the romantic ideology that informed them (and all other aspects of teenage culture) but the setting.

Girl-talk records mocked romance, trivialized it, pricked its pretensions; they exposed the delusions of romance even while glorifying them. These records were, after all, *funny*.

The point is cleverly made by 'Summer Days, Summer Nights' in *Grease*. The song takes the girl-talk convention – 'Tell me more!' demand the chorus, just as they did in the Shangri-Las' 'Give Him A Great Big Kiss'. The questions the girls and boys ask are clearly contrasted: 'Was it love at first sight?' ask the girls; 'Did you get very far?' gloat the boys.

But the contrast gradually gets subtler. Olivia Newton-John's romantic illusions are steadily mocked by her friends; John Travolta, for all his stud front, ends up believing them. The record's final wistful note is his.

Which may seem a long way from 'He's The Greatest Dancer', but isn't

because it is actually just an updating of another girl-talk classic, the Ad Libs' 'Boy From New York City'. Both records celebrate a dancing stylist, and both mock at romance.

Still, the seventies aren't the sixties, and the most fascinating aspect of Sister Sledge's Chic work is the possibilities it suggests for girl-talk records now.

The most obvious difference is in terms of sophistication. Sister Sledge move the action to San Francisco. Their sound is Chic-slick, their man shops at Gucci and takes home someone different every night – we've come a long way from the boy from NYC, cute in his mohair suit, keeping his pockets full of loot.

The musical contrast represents an ideological shift too. Sister Sledge's singer is still recounting her night to her friends, but she is the active partner now. She's the one who cruises the disco with her gang, and when she spies her Adonis she wants him now, tonight, and not for ever.

On the new Sister Sledge album there is an even more startling girl-talk song, the title track, 'We Are Family', which doesn't mention men at all. Girl-talk records were always about boys because boys were, supposedly, the female obsession. But because the boys themselves were never there, the records' tensions and excitement came, in fact, from the girls – they spent most of their time competing, bitching, boasting, putting each other down.

'We Are Family' is, in contrast, an anthem of solidarity. It's a song of independence and self-assertion, marching music, and my role is suddenly changed – from voyeur to by-stander, as I rush to keep in step. 1979

The Voices of Women

The record I've listened to most this year is Carol Jianni's 'Hit'n'Run Lover', a 12-inch disco track on Champagne Records. It is an absorbingly dramatic work-out of the current American dance floor routine: relentless beat and busy cross-rhythms, a chaos of percussive noise driven through by a passionate woman's voice. 'He's a hit'n'run lover/Who gets you when you're down/He might seem heartless, he might seem cruel/But you can't arrest him when you're feeling blue.' And every time I'm swept up in sympathy.

Since last week I've had a new obsession: the Belles' 'You Told Me a Lie', a track from *Making Waves*, an exuberant anthology of music by women's bands just released on the independent Girlfriend label. 'You Told Me a Lie' is an old-fashioned teenage love song: 'You broke your date last night by phone/So I went walking all alone/I wish that I had stayed at home, oh yeah/I saw you there/with her/you walked right by me!' Another passionate performance, each line jabbed home by the nagging chorus: 'You told me, you told me a lie. . .'

Both these songs draw on the same conventions of female pop. Carol Jianni is talking to her friends in the club cloakroom; we overhear her wry romantic wisdom. The Belles address the lying man direct, but we listen to them egging each other on. This formula – music as a conversation for three or four voices, songs as love comics – was written into the pop charts by the Shirelles' 'Dedicated To The One I Love' in 1960. What is most fascinating about *Making Waves* is the unexpected continuity it suggests between girl groups and women's bands. The old ambiguities of public and private voice, the tensions between collective verve and individual hesitation, the doubts about romance itself, are now expressive of the woman's point of view.

All pop singers, male and female, have to express direct emotion. Their task is to make public performance a private revelation. Singers can do this because the voice is an apparently transparent reflection of feeling: it is the sound of the voice, not the words sung, which suggests what a singer *really* means. In fact, there's nothing natural about the singing voice at all (compare the popular vocal sounds of Britain and Italy, say, or the USA and Iran), and so the conventions of male and female pop-

singing are different, reflecting general assumptions about the differences between women and men.

The female voice in Anglo-American pop has usually stood for intimacy and artlessness – this is the link which has given women access to pop (they have been excluded from most other productive roles). We hear women as better able than men to articulate emotion because femininity is defined in emotional terms. The public world is masculine and there is no agreement about how public, unemotional women should sound (which is why the tone of Margaret Thatcher's voice keeps changing). By the same token, the intimate male voice is unmasculine, unnatural. In pop this is registered by the recurrent use of the falsetto, by the high-pitched, strained vocal that has been a feature of mainstream rock singing from Yes to the Police.

The conventions of female pop singing have both reflected and shaped the idea of femininity as something decorative and wistful, secret and available, addressed, by its very nature, at men. The voice is so intimately connected with the person that sound and image cannot be separated in this respect. As a man, I've always taken it for granted that rock performances address male desires, reflect male fantasies in their connections of music and dance and sexuality. The first time I saw a women's band perform for women I was made *physically* uneasy by the sense of exclusion. The Mistakes played infectious party music, but at a party in which men could only move on the sidelines.

There has been much discussion in the last few years about the relationship of rock and feminism. The questions – Is rock male music? Do women music-makers need a new form? – have been raised by feminist musicians like Jam Today and FIG, by the more general campaigns of Rock Against Sexism, and it is still depressingly unusual to see women's bands on the rock circuit. *Making Waves* is important, then, for political reasons. Even as an 'informed' rock critic I hadn't heard of half the bands involved (all but the Mistakes are from London), and the record's producer, Korina from the Androids of Mu, is unique as a female studio engineer.

Nonetheless, *Making Waves* confirms my belief that there is no difference between male and female music as music. It is sometimes suggested, for example, that women's music is distinctive because it is made in a non-competitive, sororial spirit, because it expresses a distinctive female experience. But *Making Waves* is distinctive for its range of sounds – not just the Belles' and the Mistakes' pop, but also a blues ballad from Gueststars, guitar-dominated rock from Rock Goddess and the Nancy Boys, electronics from the Tango Twins, punk from the Real Insects, and so on. There is even a wonderful big band track from the Sisterhood of Spit (a homage to now forgotten women's bands of the 1930s and 1940s like Ina Ray Hutton's).

What binds these sounds together is not a lyrically expressed feminist ideology, nor an essential female aesthetic, but, rather, a particular sense

of audience. Popular music is a social event. Its cultural (and commercial) purpose is to put together an audience, to construct a sense of 'us' (and 'them'). Such pop consciousness depends primarily on the use of the voice to express the identity at issue. And what *Making Waves* reflects is a particular use of the female voice – not only to express women's experience, but also to reassemble the relationship between rock performer and audience so that the music is dependent too on a female response.

This is not as simple a matter as it sounds. The legacy of punk to women's rock was that in making ugliness an aspect of authenticity, it opened up to female singers sounds that had previously been regarded as unfeminine and therefore unmusical. In punk, 'strident', 'grating', 'screening', 'squawking' (once applied dismissively, for example, to Yoko Ono) were terms of praise. But punk did little else to change the sexual basis of rock culture, and the best of the punk-inspired female musicians, notably Siouxsie Sioux and the Slits, ended up by avoiding the problem of self-expression altogether.

On *Juju*, the latest Siouxsie and the Banshees LP, Siouxsie's voice is full and sure but quite impersonal. Her style has obviously been influenced by Nico, who was used by Andy Warhol and the Velvet Underground for her unsettling impassivity. Both singers play with the idea of female mystery; their songs draw deliberately on lurking images of madness and witchcraft. The Slits, by contrast, improvise round sparse rhythms in high-pitched, tentative voices, but if they have a less gothic sense of mystery than Siouxsie they still believe in magic. On their latest LP, *Return of the Giant Slits*, they present themselves as wood nymphs.

Other post-punk singers use the female voice as an instrument of personal assault – listen, for example, to Lesley Woods' venomous, rancorous performance on the Au Pairs' current single, 'Inconvenience'. This is a style that works better on record than in performance, and it still takes the male rock audience for granted. An Au Pairs live show can be a surprisingly straight rock event – men push to the front, they can still preen themselves as the focus of all this scornful attention.

The Raincoats, to my ears the subtlest and most exciting of Britain's women's bands, follow the opposite strategy. On the remarkable *Odyshape* LP they relax with the 'natural' feminine qualities of their voices (soft, sweet, demure), point them up in a luminous texture of guitars/voice/violin. Using hesitation as a form of rhythmic repetition, the Raincoats make stillness a strength, and what is most striking about their live performances is the absence of any reference to previous rock sounds (on record there are occasional echoes of the Incredible String Band). They perform as if discovering their music on the spot, and their success depends on the trust and support of their listeners.

Lucy Whitman has pointed out that women have been pushed into rock music-making in the last few years by their audiences: feminists have needed singing voices to express sexual solidarity, fluid rhythms to move marching and dancing feet.

But politics and pop don't have a straight-forward relationship, and so *Making Waves* is not simply a feminist record. It is music made for women as well as by them, but it opens up questions for all pop fans: can girl-talk hits be reinterpreted? I've started listening to the Shangri-Las again, hearing their conversations as signs of female friendship, their stories as tales of the pitfalls of romance, their pathos as a mocking, playful irony.　　　　　1981

Hooked on Love

'Do you hear wedding bells, ringing, ringing. . . ?'

The high point of the Gang of Four's live show used to be *Love like anthrax*; one voice singing, emoting, 'love will get you like a case of anthrax/and that's something I don't want to catch'; the other voice speaking, puzzling, 'love crops up quite a lot as something to sing about . . . these groups and singers think they appeal to everyone by singing about love because apparently everyone has or can love or so they would have you believe . . . I don't think we're saying there's anything wrong with love, we just don't think what goes on between two people should be shrouded in mystery.'

Mystery, indeed. My favourite record at the moment was made in 1962 by the Jive 5, the last of the great New York doo-wop groups. *Do you hear wedding bells* is an exuberant up-tempo day dream – 'do you hear wedding bells too?' – but the flip, 'These golden rings', takes the story on a few months. The wedding bells are pealing now for real. 'These golden rings I give you tonight/In the chapel on the hill with the stars shining bright/These golden rings mean I love you/And I'll promise my dear to always be true.' The scene is set by rumbling doobedoos, shrill oohs, and suddenly the mood shifts: 'Please don't cry my darling/No. Stop. Don't run away/No, no, no, on this our wedding day. . .'

Pre-Beatles pop had simple themes – love will make you happy/love will make you sad – but the two themes rarely came together so abruptly and never on a wedding day. I still can't decide what 'These golden rings' really means.

These days groups are clearer in their ideological intentions. *Penis Envy*, the latest LP from the anarcho-punk band Crass, is a blunt assault on love and marriage: 'the ring on your finger, the sign of protection/Is the rape on page 3, is the soldier's obsession/How well you've been taught to support your oppression.' The album ends with Eve Libertine's untitled old-fashioned pop song (Crass recorded it originally, under another name, for distribution by a teen-romance mag): 'Listen to the wedding bells/Say goodbye to other girls/I'll never be untrue my love/Don't be untrue to me.' The church bells ring out, falter, collapse.

Crass's love song was meant to be subversive in its very simple-mindedness; the idea was to push romantic cliches to their limit. For

Crass romance is a sales-device, it wraps up marriage, the institutional form of bourgeois sexual oppression. Following Germaine Greer's comment in *The Female Eunuch* that 'women must recognize in the cheap ideology of *being in love* the essential persuasion to take an irrational and self-destructive step', Crass's ambition on *Penis Envy* is to *expose* romance.

I'm not convinced (in my present obsession with the Jive 5) that the pop ideology of love is cheap or simple. If the musical message is still that love is the basis of good sex, it is rarely suggested by pop singers these days that marriage is the basis of true love. As Germaine Greer also stressed, love is an obsession, marriage a routine; the love story ends when the wedding bells ring. For the last 30 years at least pop songs have been youth songs, concerned with courtship; the working assumption has been that young love is just far more interesting than the routine passion of adults.

'If the fire is out, we should both be gone,' sing Champaign in this year's smoochiest hit. 'Some people are made for each other, some people can love one another for life. How 'bout us?' The answer is, as usual, that it's time to move on.

Pop song lyrics have been criticized since the 1920s for their romantic fictions, their 'exclusion of reality', but no one except the mass-culture critics has ever listened to pop songs as if they were sociology. What's at issue is fantasy. *Double Fantasy* is what John Lennon and Yoko Ono called their last LP together, and their pop songs – 'I love you, yeah, yeah, now and forever' – described a 'real' relationship. John and Yoko knew that their relationship, like everyone else's, could only be articulated through fictions. The problem of romantic ideology is not that it is false to life, but that it is the 'truth' against which people measure their desires. And love and sex songs (the sixties' legacy) are as important in this context as love and marriage songs.

Crass, like many analysts, take it for granted that romantic ideas are aimed at women. There are, in fact, just as many love songs for men – 1960s pop involved the *male* romanticization of sex. My favourite source book is *Love Love Love*, the anthology of 'the new love poetry' that Corgi issued on the crest of the pub poetry boom in 1967. Out of the 31 poets represented in it, 26 were men. The verse read like advertising copy: love as the product for male consumption. On offer were women running naked in the rain, school girls, orgasms as acid trips, sex as sentimentality.

The 'new love' was summed up by Alan Jackson: 'Here's to the girl who stands up straight/And lies down so/No faiths no fears no promises/We come and we go.' The dominant romantic image in this poetry (and in most subsequent rock lyrics) isn't the Regency buck of women's romantic fiction but Julie Christie in *Billy Liar*. For these writers ordinary women are oppressors (dragging men into commitment, responsibility, and so on); the ideal woman wafts through their beds like a wraith.

I'm sure that pop romance, of all sorts, means more to men than women. In youth cultures it is the boys who draw the sharp distinctions between 'casual' sex and 'true' love, who possess their partners with a special fervour. Girls' fantasies are about babies, home-making; they have no illusions about husbands. The best contemporary pop song writer, Elvis Costello, writes as a man who grew up on pop and has had to cope ever since with a world in which romantic male fictions don't work, in which women don't play the same game. For Costello what is at stake is the language of love. He is obsessed with puns because they represent the possibilities, the ambiguities, the confusions of sex – 'your mouth is made up, your mind is undone'.

Costello's influence is obvious in all good pop LPs these days: listen to Squeeze's *East Side Story* or the Undertones' *Positive Noise*, songs about songs, about the cliches in which lives have to be led. 'Love will tear us apart again,' as Joy Division sang last year. The writers of these contemporary love songs don't believe that if the restraints and regulations of romantic love were thrown off the natural sexual juices would somehow just flow. Their love problem is not the gap between fantasy and reality but between fantasy and fantasy – sex has to be shrouded in language to make it possible.

This is the theme of the Au Pair's wonderful debut LP, *Playing with a Different Sex* – how to talk about hetero-sex in the post-feminist bedroom. 'Come again', the group's most stunning song, explores the articulation of desire with an almost embarrassing directness – this is sex being *worked* for. An assertive female voice – 'You're one of those/Who changed the game/You brought in new rules – which you obey/And coping, coping, coping – or nearly anyway.' An anxious male refrain – 'Am I doing it right? Am I doing it right? Do you like it this way? Do you like it this way?' Harsh nagging music: 'Equal shares! Equal shares!/It's frustrating, aggravating, annoying!'

The suggestion (incredible in pre-punk rock) is that sex outside marriage might not be much fun either, and so I'm still listening to the Jive 5; 'There is a story, yeah, that I must tell/Of two lovers whom I knew well/Names have been changed dear/To protect you and I/But now we must cry, cry, cry. . .' 1981

Breaking the Mould

Showbiz has always been a term of abuse in rock ideology; it is seen as essentially fraudulent, a way of cobbling together 'personality', which rock rejects in both its spontaneity and its artistry.

For women musicians, though, there's a problem. Rock is a man's world, and women musicians are still treated as something unnatural, as needing some sort of gloss. From Helen Shapiro through Lulu and Cilla Black to Kate Bush and Toyah Wilcox, a showbiz personality has made for more valuable cultural capital than rock stardom. Rock performing conventions are male-dominated and women singers are pushed, for economic survival, into a showbiz package. The move usually marks a squandering of talent. But this week, after being disappointed by Alison Moyet and stunned by Shirley Bassey, I decided that the rock package is even more restricting.

Alison Moyet has my favourite voice of young British pop singers, rich and conversational, and in Yazoo she had the perfect setting for it – the combination of little Vince Clark's dry, fixed-time electronic patterns and Moyet's large scatty, thoughtful vocals was both funny and unsettling, the sound of passion doggedly pursued through the shopping mall. Moyet is a solo act now, though, a CBS investment, and there is a new question: how to turn her into a long term success?

On her debut LP, *Alf*, Moyet is working with writer/producers Tony Swain and Steve Jolley, the men behind Imagination and Bananarama, and the results are more typical of their previous work than hers – a hi-tech sheen, every space filled with little riffs and harmonies. It's an effective commercial sound, but does little to sell Alison Moyet herself. No sense of personality comes through and the unique quality of her voice, its ability to turn casual thoughts into broody gestures, is subordinated to the normal noise of a good session singer. Moyet's talent is squandered here not on showbiz but on being just another singer in the band.

Moyet's Birmingham Odeon show last Sunday fed my doubts. Her do-it-yourself musical roots remain in a kind of parade of ordinariness, charming for the audience but leaving Moyet herself unable to dominate her band. And what a dull band it is – soggy bass drum, flat back-up singers, unresponsive guitars. Moyet's got a 'bluesy' voice but this doesn't mean she's at ease with the rock version of the strut. Her power lies in her ability to create atmosphere with voice alone. She's a balladeer

not a cheer leader, and in concert she sang best when she had no other sounds to contend with. Alison Moyet is a commercial success already but she's not yet a star, and to keep her career going that will matter.

Shirley Bassey is a star, the sort of showbiz figure who was meant to be outdated years ago. Watching her wonderful performance in the Albert Hall on Monday, though, I realised that Frankie Goes to Hollywood still have lots to learn. Her show was mostly an exact re-creation of her latest Towerbell LP, *I Am What I Am*, but what was really on offer was someone in exuberant control of her own packaging, her own imagery, her own sexuality.

Bassey's art is her personality. She's not a great singer technically – her enunciation is odd, her range of sound quite small, she can power a melody forward but doesn't have the jazzer's skill in holding it back. But then the task of her voice (and her songs) is not to make musical points but to project a character, and in this she can't be faulted – I've never seen any other performer suggest such an extravagance of emotion. She may no longer have the remarkable sustained energy of her 1950s performances, but she's developed her vocal technique accordingly – hurrying lines in order to get the note, the word, the sound on which she can let her voice rest and swell.

What most fascinated me was how clear she was about her own artifice. She presented 'Shirley Bassey' as a showbiz archetype – all those hand gestures, frozen poses, and iconic songs – while alluding, in asides, to the tricks involved, to her grandmotherly age and experience. No wonder she has such camp appeal. What she offers her audience is a chance to be in on the public construction of feeling. Who hasn't decided in moments of high or, more often, low emotion that the world should stop and pay attention? Shirley Bassey, singing 'This Is My Life', her orchestra soaring behind her, makes you believe that it has.

Shirley Bassey is an exceptional performer, even in showbiz terms, and certainly no feminist model. But watching her and Alison Moyet on successive nights, and reading Sue Steward's and Sheryl Garratt's cheering book on female musicians, *Signed Sealed and Delivered*, has made me think that 'women in pop' is just as illuminating a category as any other critical label.

This book is less concerned with the pictures lying on the press office desk than with the hidden history of women in pop, the 'true life stories' behind the make-up. *Signed Sealed and Delivered* is a feminist history and, as such, revels in reversing prejudice. What, at first glance, are tales of male boorishness and power become celebrations of the obstinacy and cunning and talent of the women musicians who made it anyway.

Discussing this at the Triangle in Birmingham last Saturday, the American feminist singer Holly Near (here for a brief concert tour) remembered negotiating with a major record label for a contract as a rock singer-songwriter in the early 1970s. They liked her songs and stage show, but, in the end, turned her down – her voice lacked the necessary 'submissive quality'. 1984

Confessions of a Rock Critic

There was, it seems, a moment last summer (my source is a baffled Australian tourist) when the only pop stars left in Madame Tussaud's were David Bowie and Boy George (Michael Jackson was added later). 'Gender bending' had got its final accolade; Britain's peculiar contribution to Western pop music was preserved, appropriately, in wax.

The Australians weren't the only people baffled. For more than a decade now American youth magazines like *Creem* have been filled with anxious readers' defences of rock and roll masculinity, and as a travelling rock critic last year I was repeatedly asked to explain Culture Club. I couldn't give much of an answer, just reply that the sexiest performer I'd seen was, in fact, a boy in Depeche Mode, a dyed blonde in mini-skirt and skimpy top. His shoulder straps kept slipping, leaving me, a 'heterosexual' man, breathlessly hoping throughout the show to get a glimpse of his breasts.

1984 was, in general, a playful pop year. It began with Annie Lennox's appearance on the American Grammy Awards Show, not with her usual close-cropped unisex look but in full drag, as a convincing Elvis Presley. It ended with the British record biz awards. Holly Johnson opened the envelope for Prince: 'Oh yes, I've had telephone sex with him!' A huge bodyguard rose up (I thought he was going to thump Holly) and cleared a path for the little master, who walked daintily behind. Prince sings about incest, oral sex, pornography, obsessional lust and masturbation.

Otherwise it was Frankie Goes to Hollywood's year. They made records about sexuality: Welcome to the Pleasure Dome! Their triumph was 'Relax', a huge-selling single that was banned by the BBC for 'sexual offensiveness', but the importance of the Frankie story wasn't its outrage but its cosiness. Their very success made them part of the Radio 1 pop family – by the end of the year, Mike Read, the disc jockey who'd initiated the ban on 'Relax', was the voice-over on Frankie's TV commercials. They had become family entertainment. What did it mean?

In 1978 Angela McRobbie and I wrote an article on 'Rock and Sexuality' for *Screen Education*. It was not a very profound piece but it was,

surprisingly, a 'pioneering' attempt to treat rock's sexual messages analytically. It was reprinted in an Open University reader and is, to our embarrassment, still regularly cited. To our embarrassment because the piece was a jumble of good and bad arguments. We confused issues of sex and issues of gender; we never decided whether sexuality was a social fact or a social discourse.

Our aim was to counter the common assumption that rock and roll somehow liberated sexual expression; we wanted to pick open terms like 'raunchy', to challenge rock naturalism. Rock, we suggested, works with conventions of masculinity and femininity that situate both performers and audiences along clear gender lines – males as active participants, females as passive consumers. Musically, the distinction is marked by the contrast between 'cock rock' and 'teenybop'.

In terms of who controls and consumes music, our points still seem valid. For all the current celebrations of the post-punk post-modernist condition, teenage courtship rituals have changed remarkably little since the 1950s and pop still plays much the same part in the organization of adolescent gender roles. We described a pattern of power in the music industry, men in charge, that hasn't altered since. Punk did have an effect on images of sex and romance but it did little to improve women's career opportunities in or out of showbiz. The most important female stars – Madonna, Cyndi Lauper, Tina Turner, Sade – are still important because of their complex (and contradictory) relationships to femininity. Male and female sexuality alike are still referred to male desires; if homosexual, bisexual and asexual men can now use their confusions (and zest) as a source of pop success, lesbianism remains a secret.

And this is where the problems of our original piece start: our account of how music carries sexual meaning now seems awfully dated. We rejected rock naturalism but we retained the suggestion that sexuality has some sort of autonomous form which is expressed or controlled by cultural practice.

We were writing, ironically enough, just as the fashion in pop cultural analysis became do-it-yourself structuralism and critics were quick to point out our 'essentialist' view of sex. We were reminded that 'cultural production occurs always in relation to ideology and not to the "real world" '; we were instructed that rock is not about something other than itself – sexuality – but is a 'signifying practice' through which a particular 'discourse of sexuality' is constituted. The task of criticism, in short, is not to show how performers articulate a predefined ideology, but to trace the way sexuality is constructed by the performing conventions themselves, by the responses they compel listeners to make.

Take Frankie's 'Relax'. Everyone knew this was a 'sexy' record, sexy in a way most records aren't, but nobody could quite say why, as the BBC found, to its discomfort, when it tried to explain the 'Relax' ban. Sound as such isn't offensive – BBC bannings always refer to lyrics. But the key word in 'Relax' was the innocent 'come', and, in the end, the Head of Radio 1 had to refer his decision to what the group said about the record

in interviews, how they put pictures to it on the video. The record was offensive for what it *represented*.

The irony of this is that a 'deconstructive' reading of 'Relax' reveals a commonplace account of desire (which is why Frankie so quickly found their place in the British pop establishment). 'Relax' is a naughty record, a singalong party pooper from the tradition that brought us Gary Glitter's 'Do You Wanna Touch Me' and Dave Dee, Dozy, Beaky, Mick and Tich's 'Bend It'. The original 'Relax' video (which, seen on 'The Tube' by Trevor Horn, led to Frankie's ZTT contract) had a limited budget, crude camera angles, and a tacky sado-masochistic imagery that was much more unsettling than ZTT's big budget, snickering lust.

The ZTT 'Relax' was a knowing record not just as a production number but also as a marketing exercise – Frankie were the first pop group to be sold by a huckster, Paul Morley, inspired by the French critics Barthes and Foucault. And Morley was, in turn, the child of a particular pop age. In the 1960s, when value-judgments about music rested on notions of authenticity, musicians were respected for their sexual honesty. Built into the original rock aesthetic was the idea that sexual feelings/preferences/desires/anxieties were either expressed (a good thing) or concealed (a bad thing). Sexuality was either spoken out – lustily, painfully – or made false by pop's treacly, romantic norms. John Lennon is the most complex example of this opposition of romance and reality: having rejected pop's romantic lies, Lennon could only authenticate his love of Yoko Ono by public accounts of their sex life. And it is instructive too to remember that the Rolling Stones, who now sound ridiculously camp, were once honoured for their truthfulness in revealing hidden, unrespectable desires.

Since David Bowie and early 1970s glam-rock, the aesthetics of British popular music have changed. Pop stars became valuable for their plasticity and so their sexuality too became a matter of artifice and play, self-invention and self-deceit. As rock entered its modernist, formalist stage, punk and disco became the key codes. The Bowie/Alice Cooper/Donna Summer/Malcolm McClaren/Blondie lessons in star-making were learnt by everyone. These days, indeed, heavy metal bands, cock-rockers writ large, are the most elaborately made-up groups of all.

Put together glam/punk/disco dressing-up with the history of British youth posing (and, as Jon Savage has pointed out, every style, from Teds to New Romantics, took inspiration from the gay underworld), and you get a sociological explanation for Boy George. The general implications for rock and sexuality are, though, less clear. Sociologists themselves are still wedded to the misconception that boys' concern for fashion somehow 'feminizes' them (and it's hard not to assume that skinheads are more 'masculine' than their more fancily dressed peers, even in this age of football terrace 'casuals'). Rock critics, equally, still draw an instinctive line between the 'natural' sexuality of rock tradition and the 'artificial' sexuality of the gender-benders. This has become obvious in

1985's New Authenticity movement (and the rise of Bruce Springsteen as a popular icon). Part of the appeal of the new generation of guitar/pub/ roots bands (and the musicians are almost all male) is their restatement of old rock and roll truths of sex and gender – rutting, romantic men, mysterious, deceptive women.

Such nostalgia can't undo the changes the 1970s made. The best evidence I know for this is Fred and Judy Vermorel's remarkable book, *Starlust* 'the secret fantasies of fans.' These obsessive, devotional voices supply the missing strand in accounts of rock and sexuality, the consumer view.

The most misleading of our original arguments was the distinction we made between male activity and female passivity when, in fact, consumption is as important to the sexual significance of pop as production. Teenybop culture, for example, is as much made by the girls who buy the records and magazines as by the boys who play the music and pose for the pin-ups, and once we start asking how pop produces pleasure then notions of passivity/activity cease to make much sense. There's pleasure in being fucked as well as fucking, and how these pleasures relate to gender is the question at issue. What's obvious in the Vermorels' book is that fan fantasies (however masochistic) are a form of vengeance – in dreams we control the stars who in our fandom seem to control us. What's equally apparent is that these private games with public faces are for many fans, male and female, a way of making sense of their own sexuality.

Pop stars' sexual games have changed the rock and sexuality questions. What is interesting now is not how the objects of desire are made and sold – as pin-ups, heroines, stars – but how sexual subjectivity works, how we use popular music and imagery to understand what it means to have desires, to be desirable. The most important effect of gender-bending was to focus the problem of sexuality onto males. In pop, the question became, unusually, what do men want? And as masculinity became a packaging problem, then so did masculine desire – whether this was resolved by Boy George's espousal of chastity, by the careful shot of Marilyn's hairy chest during his drag appearance on 'Top of the Pops', or by the record company instructions to the director of Bronski Beat's first video: he had to make a promo clip that would be, simultaneously, obviously gay in Britain, obviously straight in the USA. . . In its attempt to make normal such 'abnormal' men, the pop process simply drew attention to the fragility of sexuality itself.

Part of the fun of pop lies in this tension between reality and fakery, between experience and expression. *Smash Hits* became Britain's most successful music magazine precisely because of the delight it takes in the collision of pop star myth and mundaneness. Its editors know that pop's sexual come-on lies in the way stars tantalize us with the suggestion that we can get to know them as they *really* are (all those interviews). All fans dream of casual intimacy with their idols (I thus count Dylan, Jagger and John Lennon among my friends) and even the most torrid sexual fantasy

rests on the assumption that to fuck a star is to get to know them most intimately – their sexuality and reality are equated (an equation we make in everyday life too).

In the Vermorels' book the key term is *possession*. Fans want to possess their idols just as they feel possessed by them. In material terms this comes out as manic consumer fetishism: every sight and sound of the star is collected, stored, inspected (and the replay button on the VCR adds a new dimension to what can be lovingly yours, again and again and again). In fantasy terms possession is, by its nature, erotic.

Pop effects are usually explained in terms of identity – the key words in most pop songs are 'I' and 'You', and in 'Rock and Sexuality' we suggested that, for the most part, boys identify with the performing 'I', girls with the addressed 'you'. But once we start looking at pop genres in detail, the play of identity and address becomes rather more complicated. Whether in the teenybop education of desire, sixth-form miserabilism (from Leonard Cohen to the Smiths), the Springsteenian community or torch-singing, the best records (the ones that give most pleasure) are the ones that allow an ambiguity of response, letting us be both subject and object of the singers' needs (regardless of our or their gender).

And what's crucial to this, of course, is the grain of the voice, the articulation of sexuality, the body, through its timbre, texture and pulse. Great voices, the ones that make us fans, are distinctive sounds that seem to hold in perfect balance words, rhythm and personality. (One of the effects of video promotion has been a displacement of the pop voice – Simon LeBon simply isn't as evocative a singer as say, Cliff Richard. On video, music can be mediated through the body directly; sexual representations are taken from established film codes like pornography and advertisement.)

Most pop songs are love songs but the critical problem is not, as I once thought, to contrast love as showbiz cliche (or romantic ideology) to real life, but to find out first what love is meant to mean. Obsession? Pain? Beautiful feelings? Power? Love songs give private desires a public language, which is why we can use them (and our uses are not necessarily gender-divided).

The Vermorels show how much resentment there is in fans' feelings for their idols. Pop stars demand our attention and use their power (the weight of their public presence) to keep it. And the more their songs mean to us as private messages the more we can be unsettled by their public display. The voyeurism involved in pop concerts works both ways; it's not just the *stars*' emotions on show. The power struggle between stars and fans is what gives concerts their sexual charge.

In *Adam Bede*, George Eliot writes of her teenage heroine, 'Hetty had never read a novel: how then could she find a shape for her expectations?' Nowadays our expectations are shaped by other media than novels, by film and television fictions, by pop stars and pop songs.

Popular culture has always meant putting together 'a people' rather than simply reflecting or expressing them, and the popularity of popular singers depends on their emotional force, their ability to build a mass following out of intensely personal desires. There's a way of reading pop history, then, that is profoundly depressing. Who, except for a Barry Manilow fan, could be heartened by his effect on his followers? But what is involved here is not just the appropriation of people's fantasy lives by some very silly love songs (and some very hackneyed porn imagery). The *Starlust* fantasies also express a kind of sexual utopianism, a dream world in which care and passion, abandon and affection can coexist.

What amazes me about pop history is how little the fantasies it has put into play have impinged on everyday life, how few demands they've made of it. The 1960s for all their bad press now, remain important, therefore, as an expression of hedonistic greed – which is why Frankie Goes To Hollywood videos returned, in the end, to hippie imagery, why Paul Morley remains caught on the cusp of provincial bohemianism and metropolitan poise. For him, as for many of us, Patti Smith was the key to the link between modernism and post-modernism, punk and beat, sexual liberation and sexual play. As children now of Barthes and Bowie rather than Marx and Coca-Cola, we may understand the discourse of sexuality better than we did in the 1960s, but the coordination of theory and practice seems as difficult as ever. 1985

Oh Boy!

My favourite account of the stupidity of British rock'n'roll is Peter Sellers's 'So Little Time', a track on his 1959 LP, *Songs for Swinging Sellers*. It's an interview with Major Rafe Ralph, horsebreeder turned pop star owner (Clint Thigh, Nat Lust), and the joke is on pop's cheap management and goofy youth. The underlying smirk, though, is sexual. 'To me,' says the interviewer, 'the most fascinating part is that you always have five or six of these rock'n'roll stars in your own home.' 'Well it's not all that eccentric,' says the major. 'Some of them can be house-trained.'

At boarding school we got the implications immediately, but it was only later that I realized Sellers was making a sociological point. In the words of Simon Napier-Bell (manager of the Yardbirds and Marc Bolan), in the early days, managers' sexual tastes determined rock'n'roll talent – 'most of the managers were men and most of them liked boys'.

This is a delicate subject (Brian Epstein is the manager whose homosexuality has been most widely publicized only because he's dead). But for 30 years now British pop iconography, our understanding of what makes music and musicians *sexy*, has depended on a confusion of sexual address. Since David Bowie, such ambiguity has been self-conscious. Bowie's seizure of the means of his own sexual signification is touchingly documented in the memoirs of his first manager, Kenneth Pitt, a showbiz thinker who never did get to grips with the idea of pop as art. Pitt quotes a friend's comment on his protege.

> He seemed always to be playing a cat and mouse game with you. He flirted, he really did. I said then that he would either be a gigantic star or make a lot of money in the Piccadilly men's loos.

The rent-boy act became familiar, but mainstream pop idols still pose with the moody innocence of the 1950s – look at 1984's pin-up kings, Andrew Ridgely and George Michael of Wham, managed by Napier-Bell. George and Andy's career began with 'Wham Rap!', a do-it-yourself celebration of unemployment – 'you've got soul on the dole!' – but this year's number ones, 'Wake Me Up Before You Go Go', 'Careless

Whisper', and 'Freedom', root their stardom in more familiar territory: the cult of The Boy.

On Wham's last tour they broke up their show with home movies – the boys in bed and bathroom, at breakfast with their parents. The point of these domestic scenes wasn't just to establish Wham's ordinariness but also to eroticize it by letting us peep behind the net curtains. Their appeal came over as neither passive nor aggressive but, rather, as a sort of ripeness: they were laid out for seduction, begging to be consumed. Teeny-bop idols like Wham are sexual but their sexuality is as yet inchoate, and thus they tender to their fans pop's most appealing offer – a chance to shape someone else's libido. The classic image is still Cliff Richard, pouting expectantly on a leopardskin in *Expresso Bongo*.

Napier-Bell suggests that the cult of The Boy put together (with satisfying commercial success) the teenage fantasies of the older man and the younger girl, but in the 1950s the attraction wasn't just a matter of sex. Rock'n'roll was also a class relation, petty capitalists packaging young proles, and British showbiz then had no criteria of working-class boy appeal except those of the bourgeois gay tradition. Uncouth youth wasn't yet the romantic lead in films or fashion, wasn't yet seen as stylish.

Albert Finney's explosive arrival in *Saturday Night and Sunday Morning* changed this. He made available a new working-class image – nervy, abrupt, unsettling; very different from that of his sultry pop peers. And after mod, British pop was suburbanized anyway – teen idols ceased to be lower-class. Wham, who use soul rather than rock and roll conventions, are essentially brilliant plagiarists of the disco sound that now orders affluent youth mores. For accounts of growing up working-class you have to go elsewhere – both Billy Bragg (heterosexual) and Bronski Beat (gays) offer much more painful explorations of masculinity than Wham.

But then teenybop music has never been about sex as knowledge (or power), always about sex as make-up and pose. Foreigners seem puzzled by our current pop scene: where did all these leather pretty-men and boys in frocks come from? The answer is that Boy George and Frankie are, like Wham, just new variants on our inherited pop equation of sexual conceit with sexual deceit. I find the USA's 'normal' rock tastes much odder – do people really cut pin-ups out of *Creem*? 1985

PART 6

Watching the Wheels Go By: Pop in the Eighties

A Different Drum

The best word is 'after-punk', I think. 1979 is the year of afterpunk and there is a battle of ideas going on that is much more interesting than the original punk argument about commerce and cop-out.

Punk groups were absorbed into the commercial mainstream with hardly a hiccup. They have been slotted into their market genres, and there's nothing much we can do about that.

But now the ideas that kept punks uneasily together are whirling apart. The debate is furtive, implicit, bitchy. It surfaces, from week to week, in the *New Musical Express*. It was given its clearest account in Richard Williams' *Melody Maker* Pop Group piece last week.

The Pop Group are, indeed, central to the argument. The issue is popularity, not money; the debate is about the meaning of music not as a commodity but as art.

In the tattered corner, bouncing aggressively, traces of glitter on their shorts, disco boots on, Sham 69 T-shirts and Jam dressing gowns, are the populists.

From their point of view, punk's importance was as a form which gave direct expression to working-class teenage concerns – explicit concerns about work and home and sex and style, implicit anger, frustration, class contempt and narrow dreams.

Punk rescued rock from the artsy-fartsies and now needs a fighting defence. It doesn't matter where the music comes from – Polydor or Rough Trade, it doesn't matter how it sounds – disco, heavy metal, pop – as long as it speaks to/comes from the people's heart.

They're great romancers, the populists. They believe in community, and their criterion of musical excellence is accessibility. Joyous music is obviously joyous. It needs no expertise to know this, no training, no boring sociology. It is even bad faith to mutter anything about manipulation.

We're back to an old principle: if it's popular, it *must* be good.

Populism has a left-wing language – through its account of class anger, its class contempt for bourgeois art and artiness – but reactionary consequences. Populism slides, with a plop, into philistinism. Its disdain for difference and difficulty is a familiar form of prejudice. ('All artists are poofs!')

The populists are complacent. So they jump about in their corner. Leading the chants, swelling their chests, riding for a fall.

In the smooth corner, drawling to their friends, with dungarees and ascetic hair, left ear-rings and nervous fingers, are the progressives.

Their mission: to break the regime of rock and roll truth. Their tools: new structures, new textures, a new discourse.

These are the self-conscious masters of indirect expression. Their music comes from the drawing-board; their experiments are calculated. Improvisation is *not* the same thing as spontaneity, no way.

The progressives are no more anti-biz than the populists – money's lovely. They oppose only the limits of the market, the constipated musical language of carousal and release, the fixed leisure of the working-class weekend. The progressive are concerned with accessibility, too, but they have a complex notion of popularity that I'm not altogether sure I understand.

From the progressive point of view, the point of punk was its threat to established means of consumption. Traditionally, 'accessible' pop gave access only to a void, to social habits that made no sense of people's needs at all. *Really* accessible music reaches the parts that other musics can't.

These avant-garde amateurs hear the sounds of music everywhere – bird-song, the pips on the telephone line, the grunts as people sleep, the sighs as they awake. They hear the music that rock and roll, in its tight composure, has made inaccessible.

And so the Pop Group are, apparently, after popularity not in terms of the usual social practices of mass sales, but in terms of the 'tribe', in terms of the communal language that is inchoate except at the very moment of communication.

No wonder the populists get so cross. There's a slick move here: the progressives draw on the populist ideal – performer/audience fused in one emotion – to legitimize an account of performance in which intellect is as important as feeling. The populists end up with consumer choice as the criterion of excellence; the progressives leave all such judgements to the musicians. If audiences like progressive punk, that's fine; if not, that's because they're too deeply embedded in traditional pop discourses, too firmly held by the structure of commodity production.

This is an irritating means of having it both ways, and I can appreciate the populist response: 'Bourgeois elitists! Effete snobs! Take your weedy fingers off the People's Music!'

I went to see the Pop Group play a church in Covent Garden. It was like outguessing a psychologist: see the jug, blink, see the faces.

On stage, a bunch of intense boys. Their music an unformed din. In the half-light people stare, quiver, jump uneasily up and down, eye each other's responses. I'm thinking that these people could play *anything* on stage, any note, any sound, and the response would be the same.

Blink! The drums, at once flat and echoed, take hold – abrupt, tight, someone has listened to a lot of funk and dub. The sound pulls at me rhythmically until the other notes, too, flow less frantically, the beat forming its own texture. Only the voice remains apart, its clipped, shrill comments lost in a jumble of words.

Blink! There's that din again. The church is a vision of hell: other people grooving on a noise I can't quite hear.

Back at home, I listen to the single and let its corny dramatic device (the guitar as challenge) draw me into the Pop Group's odd world of scurrying feet and lost voices echoing through the sewers.

The record won't be a hit.

Is it popular?

The populist/progressive debate has no conclusion. Its terms were held together in the punk movement, but only because punk was originally incoherent. Everyone is an artist now. This is the flow in the populist position: these days *no* music is innocent OK. Even the simplest teen-beat is carefully measured.

I guess I'll have to be on the side of the progressives, for all their sniffy ways. I've been writing about rock for 10 years now, and faced by the Pop Group my words sound wrong.

A good sign: I've got to blink to a different beat. 1979

The Art of Posing

When I first came to Coventry, in 1972, I used to see them at the bus stop: the boys with green hair, the Bowie boys, their style shifting with the record sleeves. There were a handful of Bowie boys in every provincial town and I thought them the bravest of all the youth cults: everything they did was determined by their pose and every youth pose since has owed something to them.

British pop fans have always liked to dress up like the stars, but the Bowie boys didn't just get ready on their nights out. Bowie-ism was a way of life – style as meaning – and no other idol has had such an intense influence on his fans as David Bowie. His example of self-creation was serious and playful – image as art as image, and his tastes, the selves he created, were impeccably suburban: he read romantic literature; he was obsessively, narcissistically, self-effacing. Bowie wasn't sexy like most pop idols. His voice and body were aesthetic not sensual objects; he expressed semi-detached bedroom fantasies, boys' arty dreams; there were few Bowie girls. Bowie was youth culture not as collective hedonism but as an individual grace that showed up everyone else as clods.

In the event, then, it was ironic that punk became such a cloddish music, because it was the Bowie boys' intense concentration on style that inspired Malcom McLaren (the Sex Pistols' inventor) to make his move from clothes to music fashion. McLaren, like several other professional image-sellers, was fascinated by the Bowie nights which were a feature of London life from about 1975 – David's records on the turn-table, his styles on the dance floor, private desires gone public.

Punk fashion soon went the way of all youth subcultures (routinized, uniformed, dulled) but the Bowie boys stayed locked into their original dreams. By 1978 the most stylish Bowie night was Tuesday at Billy's. Rusty Egan (then in a pop-punk band, the Rich Kids) was the disc jockey; Steve Strange, a longstanding punk club parasite, was the doorman, the arbiter (the idea was taken from New York's Studio 54) of who was smart enough to be allowed in.

By 1979 these Bowie nights had moved to the Blitz and there were as many photographers present as posers, as many professional designers as amateurs. The Bowie fixation had been diluted into an art college ball, and as the Blitz style became an academic exercise (come dressed as the

Weimar Republic), as Blitz music became the standard electric sound of the 'futurist' disco, so the Blitz pose became a very self-conscious, media-aimed affair. Everyone was calculating the commercial possibilities of a national Blitz culture – hence Spandau Ballet, four boys, a manager and graphicist from the Blitz dance floor; hence Visage, the band put together by Rusty Egan for Steve Strange.

Visage and Spandau Ballet have had such an instant pop success that the Blitz kids, new romantics or punk peacocks are now a full-scale, media-charted 'movement'. Most of its observers don't much approve. Since punk, the sociological assumption has been that British youth are living in a state of mental siege. Music is expected to express the consequences, whether through the collective muddle of the Clash or in the raincoated despair of Joy Division. From this perspective the new romantic approach seems straightforwardly decadent.

This is to take the Blitz kids at their own pose value. Much of what's going on, in fact, is a punk reshuffle – new more melodramatic versions of old McLaren themes (tartan bondage trews, face paint), as punk's musical failures now relievedly follow the imperatives of pre-Pistols pop: look flash, gob first, make money!

The most successful pop group in 1981 is Adam and the Ants. Adam wasn't a Bowie boy, but he was a punk failure and every day there's a picture of him somewhere in the *Sun* or the *Mirror*. The style of his success is a clue to the meaning of the whole 'new romantic' scam: Adam is a teenybop idol, a cross between Gary Glitter and Marc Bolan; and Spandau Ballet are obviously Sweet – big lads dolled up, red faced, for a camp issue of *Vogue*.

There was a noisy group of girls behind me in the newsagent the other week, 11- and 12-year-olds arguing about the cover of the *Face* magazine. 'If that's Adam,' said one girl disgustedly, eyeing a nice-looking boy with a Dirk Bogarde quiff, 'then I'm Debbie Harry.' She wasn't, it wasn't – rather, Martin Kemp of Spandau Ballet. Adam is on the cover of this month's *Face*, holding a rose like a social democrat, ribbons in his hair. His appeal is more solid than Kemp's; he is the ageing juvenile lead in a low budget children's swashbuckler. But both Adam and Kemp have the asexual, pinned-up looks of the authentic teenybop star; both are too well groomed to suggest anything. . . messy.

The *Face* is an interesting music paper. It is an independent monthly with a brave advertising policy (never more than eight pages out of 64) which has, remarkably, survived for a year now, getting better all the time. It is published and edited by Nick Logan, who edited the *New Musical Express* in its readable days. But it reflects, more obviously, Logan's experience with *Smash Hits*, a teenybop lyric magazine which he turned into a bestseller. The *Face* is, essentially, a picture paper: it has the best musician photos there have ever been and it has flourished (luckily? presciently?) on the recent emphases on style.

There is, in fact, an odd disjunction between the cultural claims of the

new pop stars themselves and the reality of their *Face* appeal. The official Blitz-kid mythologist, Robert Elms (bright and banal as a button), writes in the magazine about the electric dancefloor and organizes loving fashion-spreads for his mates' clothes-makers, but the pictures, which are all anyone reads, have a different reference point – those poster mags (appearing in the shops again) that flourished in the days of T. Rex and the Osmonds. Blitz clothes look nice enough pinned up on the bedroom wall, but most people who buy the *Face* dress like Sheena Easton.

Cult fashions in Britain have always tended to the tacky. The images may be neat, but the reality has to be cheap clothes, badly made, ill-fitting; these fashions aren't chain-stored (like mainstream mod) and most young people can't afford their own costumers. Some youth styles, like skinhead and punk, have turned their tackiness into an aspect of the look itself; other styles – the 1967 summer of love, for instance – always looked better in the colour supplements.

The new romantics, precisely because of their elaboration, are particularly tacky, and it is ironic that the Bowie boys, who were genuinely elegant (using simple clothes: their effort went into hair styling and make-up) should have given birth to such a clumsy fashion montage. These clothes (see the *Face*) are merely costumes: sewn on for the performance, seams showing from the back and sides. The point of Blitz posing is less the night itself than the pictures in the papers that follow; the Blitz kids don't wear clothes but model them.

There is now a fashion fanzine, *i-D*, which articulates this ideology of style. The *i-D* staff go into the streets and use passers-by as their dummies, snapping them as fashion plates, documenting their details. (Where did this come from? How much did it cost?) The argument is that we are what we dress ourselves up to be, and everybody is dressed up to be something. But the sociological implication is different: despite *i-D*'s selective tastes, the magazine mostly turns up people not *inventing* ways to express themselves but making do with what they can get.

i-D documents a street fashion which is essentially second-hand. The *i-D* models are not part of a new subculture (romantic or not) but draw eclectically on late hippie (the clothes stalls in Kensington market are lively again), mid-period punk (short hair and streaks and badges) and the 1970s feminist anti-feminine look (baggy, primary colours, pre-pubescent). *i-D*'s models share only a non-fashion fashion that takes its stylistic signs from wherever it can find them; these clothes are worn, and in taking them out of their daily routine, posing them, *i-D* undermines its own fashion-trade assumption – such unself-conscious coats and blouses are more emotional, more expressive than anything drawn by the new romantic designers. They're working clothes; they've earned their right to be tatty.

The art college theorists, of course, are fascinated by the idea of the Blitz. In her magazine ZG, Rosetta Brooks interprets posing as a performance art in which subcultural signs are deliberately jumbled up and thus made ambiguous, brought into question. She rightly points to

the nostalgic elements of posing – the stylistic allusions are to past youth styles, to a lost community of 'innocent' male fun. Much of the so-called 'futurist' concern with style is, in fact, deeply reactionary. At the same time, the treatment of youth style as performance art makes for an immense condescension to the youth cultures involved: the history of rock and roll is trawled for the poses it can yield; the implication is that the music had no substance at all.

The new romantics, for all their clever ideas, end up with a conventional teenybop appeal – they've got a detached, entrepreneurial concern to get the formulas right. Their art of posing is still defined by the middle page of *Jackie*, and Adam's teeny-fans have the right response to all this – they laugh at him.

The only new pop person with an interesting idea is Malcolm McLaren, who encouraged Adam to dress up and go 'tribal' and has been explicitly pursuing teenybop sales with his own group, Bow Wow Wow. McLaren (who with the Sex Pistols drew loosely on situationism) is drawing loosely now on autonomism – the concept of the young as an American Indian tribe, for example, was developed by the youth movement in Zurich. The message of the latest Bow Wow Wow single, 'W.O.R.K.', is plain enough: Demolition of the Work Ethic takes us to the Age of the Primitive!

'T-E-K Technology is DEMOLITION OF DADDY is A-U-T Autonomy,' sings Anabella, 'There's no need to work ever!'

Bow Wow Wow's records have not yet swept the nation. McLaren's scheme has foundered, as always, on bohemian arrogance, on the assumption that he is an expert on other people's fun. He continues to treat pop style both too seriously and not seriously enough. If the vast majority of fans (punks, Blitz kids and Antpeople alike) dress up just for a laugh and do not follow McLaren's general arguments at all, for the stylish minority dressing up is not a matter of fun even to start with. The art of posing, as the Bowie boys discovered, is a matter of commitment: the problem is not to turn work into play, but to turn play into a precise, disciplined work. 1981

Get Funky,
Make Money

It began on 'Round Table', the weekly BBC show on which the stars get to comment on everyone else's new releases. That week's star was from Duran Duran, the most stylishly vacuous of the new pop groups. He was commenting on Odyssey's 'Going Back To My Roots' 'I'm so bored with this sound,' he exclaimed. 'They haven't *done* anything with it. Have you heard the new Spandau Ballet? That's a *really* funky record'.

On 'Chant Number One' Spandau Ballet use a horn section – dancefloor credibility and all that. But funky? The claim is obviously foolish; if, say, James Brown and Spandau Ballet are both 'funky' then the word is musically meaningless. But the claim is equally obviously sincere. In 1981 everyone *wants* to be funky (and the Gang of Four and the Rolling Stones are competing for the services of Busta Cherry Jones).

What initially startled me about the 'Round Table' talk was the confidence with which a routinely incompetent white musician dismissed black musicians' ability to play black music (like hearing Pat Boone patronizing Fats Domino; like reading Glenn O'Brien on James Chance's combination of 'bebop' and funk: 'Miles Davis might have started this trend but James completes it'). What I realize now is that Spandau Ballet are, indeed, going back to their own roots too. Their 'modern' music is, essentially, nostalgic – nostalgic for their own teen age, for the UK soul days of 1973–5, for the hot disco drive of Kool and the Gang, the Ohio Players, The Fatback Band, etc. Spandau Ballet turn out to be (beneath their working-class preppie trappings) just the most successful of all those British disco bands whose skill it was and is to package the beat sharply enough for the dancers not to notice that the disc jockey is taking a break. In the mid-seventies, of course, such British 'funk' bands were despised for their derivativeness; now (and this is apparent in 'modern' discos in every provincial town) the surviving players are honoured for their 'style'.

Funk is, in this context, an accidental label – if refers to a mode of consumption more than to a form of music – but the urgency with which each new pop band asserts its 'funky' credentials reflects the depressing feature of this year's British pop sound: the nostalgia is pervasive. The

charts are filled with cobbled-up old hits and the Stars on 45 Beatle mix turned out to be only the beginning: the Caribbean, the '60s, the Classics, the Bee Gees, the Four Seasons, the '70s, the Beach Boys, every previous disco hit, 1976 punk, all are reproduced over the 4:4 handclap as producers scour the country for club musicians who can do Robin Gibb or Harry Belafonte, who have been peddling exact cover versions for years and are now (patience pays) getting their rewards.

Along with the memories there seems to be a desperate dancefloor need for novelty, and in the continuous bounce of the newest thing black music is being pilfered increasingly superficially – for instant noise, a snappy rhythm that the boys and girls can pose to and drop in the flash of a lens. Last month the Burundi beat, this month salsa. The day's wacky new group is Blue Rondo a la Turk and even before 'the salsa craze' reaches out from its London cult-club base I read that it's over. Salsa is, after all, according to this morning's paper, 'a limited musical form at best, although Blue Rondo clearly have the ability and the ideas to move with the changes when the time comes'. Unlike all those dull Cuban bands.

If I'd been running Radio 1 this gloomy August I'd have organized compulsory readings of Joseph C. Smith's *The Day The Music Died*, which is about the best trash novel of rock and roll life I have ever read. I don't mean this description in a derogatory sense: in trash fiction, literary elements (characterization, plot, style) are subordinate to the formula or thesis, but Smith's thesis is gripping and illuminating. Smith is a black musician (he began playing R&B in the early 1950s, under the name Sonny Knight) and the purpose of his book is to make sense of the history of rock and roll from 1956–63 (though he includes some later 1960s developments too, for the argument's sake) from a black point of view. What matters, then, is not the 'truth' of Smith's history (the Beatles emerge as a big business/Mafia conspiracy), though the rock types are described accurately and recognizably enough, but the truth of Smith's response to this history. He keeps clearly in the foreground the *fact* that rock and roll has always meant the seizing of black culture as a white plaything. What, for black musicians, is a form of politics and belief, is, for white listeners, a style, a trick, a piece of fun (yesterday the blues, today salsa. . .).

This paradox ('a cheap holiday in other people's misery', as the Sex Pistols put it) – acknowledged, evaded, dealt with, disguised – has to be the driving subject-matter of white funk (which is why Spandau Ballet is not a funk band and the Contortions are). This is a matter of form, not content. White funk music is uneasily aggressive. Its hesitation, its liquidity, is a musical matter. And so Debbie Harry, a good white pop singer, sounds deadly dull on *Koo Koo* because her earnest monotone can make no sense of the Chic textures at all. She leaves no spaces, nags at the beat, sings along in chirpily depressing ignorance. Compare the fluidity of a good dancefloor singer like Taana Gardner, whose skipping

round the lethargic beat of 'Heartbeat' makes the song utterly involving.

Vocals have always been the problem for white funk bands. It matters to me that James Chance can't sing and there is a sharp point to the apologetic refrain through Material's wonderfully bubbly *American Songs* – 'This dance is no white man's business!' Was (Not Was)'s music works so well because it uses real singers – and the Was (Not Was) LP is the true 1981 white sound of mid-seventies soul, George Clinton and Earth Wind and Fire run through art and a synthesizer.

'Funk' used to be a descriptive term carrying intimations of crudity, earthiness, sex, emotion punched out with no finesse, a bold heart, jumbled harmonies, a clear command to dance. White funk bands, these days, are, by contrast, intellectuals. In Britain, at least, following the pioneering work of the Pop Group, white funk has become the basis of rock as a political art. 'To hell with poverty' sing the Gang of Four, and for them funk means simply rhythm *power*: battered drums/bass-guitar, cutting the beat as insistently as a police siren. Pigbag's 'Papa's Got A Brand New Pigbag' has a lighter beat, more bass, saxes, no words and an urgent, rehearsed roughness. The Higsons' 'I Don't Want to Live with Monkeys' has silly words, a jerky bass riff, slashed rhythm guitar and trumpets.

Clever dancefloor moves – all these records have a desperate edge, pleasure being worked for *through* the physical pulse. I guess that my favourite British funk sound is A Certain Ratio's *To Each. . .* LP, a record that no one else seems to like ('a dirge' the people in this house called it). Pretentiously packaged (and I still don't understand Factory's obsession with fascist aesthetics), the music hypnotizes me with its thinned-out dramas. I'm not really sure that A Certain Ratio are a funk band – the elements are there, textures and rhythms, but strung together in the studio to have quite other, unsweaty effects.

But then this may be the paradox of all these funk intellectuals. The old signs of passion, emotion, subjectivity, spontaneous delight and desire, are the new signs of objectivity, musical cool, anonymous (authoritative) statements of dancefloor detachment. These musicians (unlike James Brown) seem obsessed with musical causes, suspicious of social effects. Contort yourself! 1981

A-Blinga-A-Blanga,
A-Bippity Bop
I'm Going Down to the
Record Shop

Most of my life I've had to go to the record shop at least once a week. Record-buying is my only cure for depression, and I can't imagine that I'll ever be happy with cassettes. There's no thrill like the old thrill of cleaning the deck of last week's consumption, putting on this week's style.

Record-shopping is a surprisingly sociable activity. Propping up the counter (and I'm talking about small shops, provincial shops, special shops, record shops, not the audio hypermarkets) are disc jockeys, cultists, collectors, knowalls, obsessives, the unemployed. They watch with amused contempt the 'ordinary' buyers, the parents with a scruffy request list for their children, the routine rock fans, the desperate 12-year-olds trying to collect all 1976's punk hits now. The record shop is where gigs and clubs and musics are publicly discussed and placed, where changing tastes are first mocked and marked. British pop culture has always been dependent on this sort of active consumption, and on the constant entrepreneurial move from the organization of record-selling to the organization of record-making (think, most recently, of Rough Trade or Graduate or Small Wonder).

I've always liked shopping for this sense of audience power. The pleasure of hanging out in the store is that what is played and judged isn't determined by programmers and promoters, by press and publicity, but by me. And I can listen too to other people's tastes, hear them being worked out, watch sense being made of music by the listeners themselves.

Thanks to my weekly shop addiction, my own tastes have always been determined by fashion – what everyone else is talking about inevitably interests me, too. I'm game for every rip-off known to retailers – the 12-inch single, coloured vinyl, pre-release reggae collectors' sleeves, disco imports – and my critical judgement can always be swayed by the week's

coolest view, by Tim-behind-the-counter's disdain for virtually anything I ask about. This week, for instance, I went in to town to get the new Sound LP (well reviewed everywhere) and was convinced by one and a half tracks and a lot of muttering that this leaden, pompous style, this whingeing overblown music, must have weighed more heavily on reviewers' consciences than their pleasure centres. Instead I bought Simple Minds' 'Sweat in Bullet', a much more expansive account of the possibilities of looping guitar riffs and declaimed vocals (or, to put it another way, Roxy music lives).

'Sweat in Bullet' was one of this week's buzz records. Shop buzz precedes radio and even disco buzz and is more reliable than the music papers' London-based tips. I can never resist it, and so I bought too (this is Coventry) the Fun Boy Three's 'The Lunatics Have Taken Over The Asylum', a song which in mood and sound and theme follows straight on from 'Ghost Town'. It has the same concern to translate political anger and weariness into a lurching control of good spirits. The Specials' split was not surprising (the difficult question is always why groups stay together, not why they split) and the music – the percussive knock, the intensely flat vocals – remains the same. And I discuss this, buy the records, remember that I first met Jerry Dammers propping up the counter – musicians are part of this consumer collective, too.

In those days I was writing incessantly about punk without knowing quite why – it was before the records or even the gigs had reached town. Now I know it was because punk was all anyone ever spoke about in the shop so that now, for the same reason, I find myself thinking only about British 'funk' – not because I like much of this music, but because it's the recurring theme of present shop-talk. The urgent problem has become to place these records, to decide which funk sound works, which doesn't. Everyone is comparing dance-floor notes, remembering live shows, putting the record reviews in context.

These public hearings have good critical consequences. For a start, the cross-references – to history, to black music, to the disco mainstream – are much more sensible than the funk bands' own claims to 'novelty'. Last week everyone was agreed, for example, that the ace dance record of the moment is Rick James's *Street Songs* LP, the best version of the current sound of young, black, sexist America: a crisp, guitar-driven beat; mannered, pouting vocals; the strutting arrogance that makes all the British synthesizer bands seem weedy. And this week I bought the Four Tops' 'When She Was My Girl' because I'd heard it on the radio, because I can't resist the harmonica solo, because when the airwaves are dominated by the Human League I need to hear some *shouting* soul.

Now in media terms neither Rick James nor the Four Tops are fashionable, but they still set a dancefloor standard, and the fact is that the only British band that can make music as tight, as controlled, as swinging, is Linx. No one in the shop seemed to like their new LP, *Go Ahead*, but I bought it anyway. It's a wonderfully elegant display of a rare British technical mastery of American disco tricks: rhythm guitar

figures, effete vocals, understated bass, sensuality as hook. Linx are the dancefloor swells that hyped-up groups like Blue Rondo and ABC aren't.

My conclusion from listening to funk sounds in the shop week after week is that the only British beat music that makes sense now is crude not cool, eager not aloof. Haircut 100's 'Favourite Shirts (Boy Meets Girl)', for example, has a rapid, chattering beat. The frantic rhythm guitar is pulled into line by acoustic percussion, the singer is held to the pace by horn bursts, plucked guitars, unfinished sax solos. On the 12-inch version, at least, 'Favourite Shirts' is a riot of joyous music-*making*.

Pigbag's new instrumental single, 'Sunny Day', is a much more composed record, but the essence of its appeal is still that Pigbag sound so surprised – and pleased – with themselves. The record is orchestrated around a guitar phrase almost in the style of a big band – each musician taking the spotlight in turn, neatly bowing in and out.

23 Skidoo's 'The Gospel Comes To New Guinea' is more deliberately atmospheric – a rhythmic figure this time, with slow addition of tropical noise. The drummer is not quite sharp enough to play such a prominent part, but the musical accompaniment – the echoes, vocal hints, slices of sound – is gripping.

I haven't seen any of these bands yet and I don't know if they realise their 12-inch promise on stage, but what I like about them (and the freer funk bands like Rip, Rig and Panic) is their concern to make music rather than an effect. It is always impossible to chart shifting tastes until afterwards, but I believe there is a new musical sense of rhythm emerging. While the fashionable still follow August Darnell and the smooth Latin bump of cocktails and cruises, people in the shop are quietly picking up old lovers' rock and listening to African pop.

Island have cannily released *Sound D'Afrique*, an excellent sampler LP, which only scratches at the surface of my ignorance, but points up the alternative approach to disco and dub. The music on this LP, at any rate, has a gentle beat, its propulsion comes from very brief melodic forms, usually played on a high-tuned guitar, which are repeated hypnotically (as if on an eternal tape loop). The other sounds – horns, voices – use the pleasure of repetition but shift tone, bust out, just often enough to keep the music on the edge of surprise. I can only describe the resulting music as *circular*. What African pop seems to do is suggest simultaneously spontaneity *and* necessity, it arouses both the body and a sense of spiritual awe.

I think this effect is what Britain's good funk bands are now after too. What these musicians want is a revived sense of *party* (similar, I'm reluctant to admit, to the teenybop effect of Ant music). And to understand the complexity of this message – *Join the Party!* – you have to read as well as listen. The new edition of Fred and Judy Vermorel's *Sex Pistols* is not only the best book on them, but also the best exploration of a cultural moment – the politicization of consumption – that is still being worked through. The Sex Pistols' story started, of course, in a shop. 1982

Singing in a Strange
Land

Unfortunately I was surrounded by public school boys, home for the holidays. Aswad's appearance at the Venue was a sell-out, but the audience was decidedly uncool. Tall boys blocked my view (at least punks are small), passed each other self-conscious joints, and jogged on the spot with a sort of loose-limbed foppishness. 'Fantastic!' they kept agreeing, and I got distracted from whatever was actually happening on stage. My sense was that Aswad hovered around but rarely hit the perfect pitch of their records. However, I brooded more about what was happening on the dancefloor, shuffling to the beat as Aswad sang imperviously about African Children, mused in their odd, sweet, cloudy way about inner city concrete, the dingy white tenement setting of the Afro-Caribbean diaspora. 'Fantastic!' exclaimed the boy next to me.

After a quarter-century of rock and roll, 20 years of pop blues and soul, 15 of ska and reggae, black and white musical worlds in both Britain and the USA remain remarkably distinct. Musicians mix; audiences mostly don't. Pop and rock shows are primarily white occasions; reggae gigs are primarily black (Aswad at the Venue was a rock event). Black and white youth taste does meet on the disco floor but the average provincial disco is still an obviously white place (numerous clubs still operate an illegal 'quota' system of black admissions). When reggae records are picked out by white deejays and dancers from the mass of music made in Jamaica and London they become hits as novelties: what sells is not an artist or theme but an unusual sound.

This goes for rock fans too. The two records I'm playing most compulsively at the moment seem so exultant and surprising partly because I'm too much the rock dilettante to place them in their proper musical context. Prince Far I and the Arabs' *Cry Tuff Dub Encounter Chapter IV* (Trojan) is less a dub record (engineer at the controls) than a set of sparse instrumentals. The recurring pattern is for the cool lead (melodica/organ/guitar) to be cut off by the assembled percussionists just as a tune is getting into shape. The random crash of the bass drum, the sudden silences, still make me jump every time. Rita Marley's 'One Draw' (Tuff Gong) was a disco hit in Kingston and New York months

ago but is still available in London only as an import. It would undoubtedly be a Radio 1 pick too if it weren't for its message – 'One Draw' is a speedy celebration of 'sinsemilla'. The song builds to a classroom confrontation between a straight teacher and some very crooked pupils: Herbie, Smokie and Milla don't just tell her what they did over their holidays, they also *explain* the connection between music, rhythm, ganja, pleasure.

The Prince Far I album comes with a message: 'The Earth is the Lord and the fulness of God, I've found another Moses.' On the other side of 'One Draw' Rita Marley sings 'The Beauty of God's Plan': 'Takes a woman and a man to show the beauty of God's plan/She is the mirror of her man, forever beside him she will stand ' The organization of reggae around Rastafarianism brings into sharp focus the complications of the white rock response to it. Are these beliefs only part of the novelty? Can they just be ignored? Most rock reggae fans certainly aren't believers (white Rastafarianism, Slits-style, involves too peculiar a racial reidenti-fication) but Jah can't just be shrugged off.

Aswad's excellent new album, *New Chapter* (CBS), is, quite obviously, a religious record. Aswad are British and they use Rastafarian music to make sense of black British experience, but the sense they make is spiritual. The 'you' of the love songs is, in one way or another, God; the mood of the political songs is the distinctive Rastafarian blend of anger and resignation; and the message is at once defiant and despairing – war in a Babylon must come.

I'm quite accustomed to listening to reggae without taking much notice of the musicians' faith except as a series of key words, and the immediate appeal of *New Chapter* is rhythmic – the intensity with which each player follows his beat, the grace of the resulting flux of percussive sound. But what soon becomes clear is that this grace, this sense of musical certainty, is as important an aspect of the band's Rastafarianism as the biblical, lyrical accents. Aswad's music is made not to please but to uplift its audience, to bind them in a collective experience (like gospel or hymn singing). The problem for Aswad's new record company, CBS, is how to sell this experience in the mass rock market.

The pop critical rule of thumb has always been that black musicians are, by definition, better (more authentic, more soulful, more expressive, more real) than white musicians. In *Elvis Presley*, for example, Albert Goldman takes it for granted that a Presley version of a black song is worse than the original. If it is true that black musicians have provided the language of contemporary pop, while whites have amassed most of the fame and fortune, the specific nature of racism in pop is, though, rarely analysed.

Pop music has always been sold on personality, on the identity made between listener and performer, on a direct (sexual) audience response, on the successful marketing of intimacy, on idol worship. Elvis Presley became a pop star when Little Richard didn't (Goldman's comparison) not just because of his colour, but also because of the style of his

individuality – his voice and body could be 'known'; Little Richard's remained bizarre. The problem, in short, is not simply that black stars are rejected as idols by racist rock fans (there are anyway exceptions to that rule) but that much black music doesn't make sense in star terms.

This is CBS's Aswad problem. It seems clear that the company signed the group with at least half an eye on the rock reggae vacuum left by Bob Marley and the Wailers, but the latter had an irreplaceable charisma. Marley was a Rastafarian, a religious music maker too, but he also had pop 'personality', an ability, as a singer, to demand individual attention. Brinsley Forde, Aswad's lead, doesn't make such a demand. As the innocent, obstinate star of *Babylon* he made it easy enough for white viewers to identify totally, but as Aswad's singer he is part of a more subtle line-up; his vocals are deliberately calm, dull even, and the back-up singing (echoes of mainstream American soul) is just as important.

At the Venue Aswad didn't put on a show like the Wailers used to. The only spectacle was a small boy, side-stage, dancing determinedly. Aswad played as if their messages – spiritual and political – were *already* absorbed into their audience's lives, contrasting 'the ways of the Lord' with 'the ways of the world' and spelling out the consequences of righteousness and wickedness with the unexcited assurance of church elders at a family service. 'Fantastic!' said the boy next to me and I wondered again about the relationship between black performance and white pleasure.

A couple of weeks before Aswad played the Venue, I went to see James Brown at the Odeon in Birmingham. Brown also uses a religious form of expression, gospel, but long ago translated it into secular terms, became the Minister of Funk. The Odeon was half empty (so much for the British funk 'revival') and the sound was appalling (the mixers had decided to treat the JBs as a disco band). James Brown, at 50, remains a remarkable star but the atmosphere told against involvement and what we got to watch instead was the skeleton of the soul spectacle that Brown invented 20 years or more ago. All eyes (the JBs' too) are on the star. If attention slips, there's a dapper master of ceremonies hovering in the wings, ready to rush out even mid-song to lead the cheer: 'Ja-mes Brown!' Brown has always worked for his response, and his funk show is nowadays a work ritual – band as hands (ironically enough, the JBs now have a white foreman), music as discipline, emotion as effort. Brown looks like an old sportsman, straining for the funk-fitness that used to ripple easily across the stage.

Current British funk is cooler, more about play than about work, but the impetus to show and tell remains, and the sharpest and most successful black British musicians aren't reggae players at all. Peter 'Sketch' Martin and Dave Grant have made Linx the first British band ever to outsmart the Americans on the dance floor and their image is, as a result, oddly elusive. As Martin told *The Face*:

Anytime anyone in England tries to portray Black life it's always reggae culture they portray. Yet there's this vast apparently unheard of middle-class black group – of whom the jazz funkers are part – who have been assimilated so much into British life that they are virtually invisible in English society apart from their colour. . . The Rastas want their own part of town, where they can go and do what they want, but then you've also got people like the rollerskate kids who just want to go out and about.

Linx have so far made two superb albums for Chrysalis, and *Intuition* and *Go Ahead* are packed with songs to go out and about to. Grant and Martin make the music, put on the show, that best understands the flash and strut of the modern disco. And yet, for all their sales success, the two aren't really pop stars, won't win, as they should, the *Daily Mirror*/Radio 1 British pop awards (it's Phil Oakey of the hammy Human League who gets his love life discussed in the papers). This reflects the way Linx work – the model is the Chic organization, back-room musicians who write the songs, assemble the sounds, deliver the goods as skilled craftsmen. The differences between Aswad and Linx are not, perhaps, as great as their contrasting genres imply. Both make impersonal music – thoughtful, crisp, infectious, but subject to the gods of music, not to the whims of stardom. The pleasure, even for the rock audience, is the constant realization that all the sounds fit, just so. 1982

And Now, the Message

There were two chilling moments during The Commodores show at the Hammersmith Odeon on Wednesday, though they chilled me in different ways, for different reasons.

The first came during Gary Byrd's support spot. Byrd is a dapper salesman of black pride, a rapping youth leader. But a version of his hit 'The Crown' aside, his performance on Wednesday was confined to introducing clips from the recent American TV celebration of Motown's twenty-fifth anniversary.

It seemed like a pretty good TV show – glimpses of how the stars used to be, classic old stage routines, framing a grand reunion concert, everybody back to perform, past splits and bitterness forgotten. Enjoyable, nostalgic, touching and comfortable until the sudden moment when we cut from the Jackson Five singing 'I Want You Back' as children, to Michael Jackson singing 'I Want You Back' now, stalking the stage with such venomous grace that shivers shot through me – I haven't been so gripped by a TV presence since the awesome first glimpse of Elvis Presley in his 1969 come-back.

Michael Jackson is undoubtedly the sexiest performer in popular music to-day – his androgyny has the risk, the neurosis, that Boy George's lacks. Jackson's sex appeal refers back to Little Richard's rock'n'roll madness, across to street fears and disco narcissism; and all that Motown training didn't diminish his threat but, rather, left him with a wonderfully flexible body language. Slight, tough, aggressive, submissive, Jackson has the remarkable ability to focus competing fantasies.

And if it seems odd to review a live concert by reference to a filmed insert then that's how the show went – not only did Jackson's TV appearance get the most fervent audience response, but the Commodore's own version of his 'Billie Jean' (in their parody spot) got more applause than anything else they did.

After this the Commodores seemed smooth and efficient and . . . old. More enjoyable than I expected without Lionel Richie – there's always joy to be had from a good soul band and a good soul audience working out together – until we got to the band introductions, the 'I'm a Pisces and come from Florida' bit.

'I'm from Planet Earth,' announced the keyboard player, 'and I believe

in peace, and I believe in the right to defend that peace and when there are nations that kill 269 innocent people[1] then there are nations that don't believe in peace, aren't fit to be part of Planet Earth. . .' Boos broke out and counter-cheers as the message ground out, and I was chilled by this proud assertion of Motown as all-American entertainment, showbiz as morality, morality as showbiz, the Cold War as a comic strip, patriotism as a sloppy song.

The Commodores played on, but soul's usual ability to bind a community seemed hollow now. There was a tension in the audience, a sour sense of righteousness on the move. 1983

Notes

1 The reference was to the Korean airliner shot down over the Soviet Union.

All Wrapped Up

Two years ago I wrote that 'British pop music is more interesting, more exciting, more adventurous than it's ever been'. Today I'm convinced that it has rarely been so trite and dull. Day-time radio is intolerable and I don't even care anymore if I miss 'Top Of The Pops'.

The charts are dominated by twitchy young men who all sound the same. Pre-packaged pop is back and without even a saving veneer of vulgarity. The new acts (Fiction Factory, Talk Talk, China Crisis, Blancmange, Howard Jones, etc. – can anyone tell the difference?) make music as if they're on a Youth Opportunities Programme, keen to show how well they can adapt to career discipline.

What went wrong? The quick answer is video promotion, which altered the terms in which music reaches people. Power to define the charts has shifted back to record companies (who put up the video making capital) and, more importantly, to TV producers, whose ideas of 'good pop television' provide the dominant rock aesthetics. Current pop packaging reflects, in short, a change in the way pop is *placed* – in the market place, as entertainment.

In this video context (especially given the financial rewards opened to British acts by American Music Television) it's not surprising that there is a new generation of pop-biz opportunists, nor that so many current pin-ups are young conservative types like Simon Le Bon. What's offensive is not their showbiz ambition as such (no-one, not even Billy Bragg, starts a pop career without wanting to be a star) but its banality – their video fantasies are so *dull.*

But then pop has always been full of creeps (Gary Numan, after all, was the big star of late 1970s indie pop) and the question is not why the current charts are so vacuous but why I ever thought they could be otherwise.

What's at issue here is not music (there are no more and no less good records around now than there ever were) but ideology. It's a matter of buzz.

In the 1960s, for example, when the rock/pop distinction was first established, *authenticity* was the key critical term – the question was whether there could be a politically or emotionally authentic commercial music. This debate was stalled by punk, which was so over-determinedly

authentic in rock terms that it threw the very concept into confusion.

By the end of the 1970s the most interesting critical debates revolved, instead, around *artifice*. Avant-garde questions about form – how is meaning constructed? how can it be deconstructed? – had a particular resonance for pop theorists: firstly, because pop works so publicly – making hits means thinking about the meaning of 'popular'; secondly, because the pleasure of pop can't be separated from the pleasure of its packaging – the most 'authentic' star (Billy Bragg again?) works with elaborate conventions of personality and truth.

There was a moment, then, when 'rockist' became a term of abuse, when the *Face* and even *Smash Hits* became crucial reading, when Barthes's name was routinely dropped into *New Musical Express* reviews. That moment is over.

Artifice is once more a matter of the rules applied by record company straights, not those broken by record company subversives. Or, to put it another way, *Smash Hits* and even the *Face* are now just boring.

It's difficult to pin down clearly when cultural meanings shift – can anyone remember the moment when the Beatles' 'Love Me Do' wasn't just another pop single? – but my sense is that the 'new pop' ceased to be the central site of struggle over musical meaning the night that Haircut 100 first appeared on 'Top of the Pops' and it turned out that Nick Heyward's goofiness, far from inflecting the teeny-bop mode with irony, was *real*.

The point of the new pop story is this: the ordering of the music public into a series of discrete, serviceable markets means that the centre of cultural argument drifts, inevitably, back in the rock direction. Authentic stars like the Smiths, Simple Minds, U2, Echo and the Bunnymen, are the necessary flipside of synth and video pop (not for nothing are the editors of *Smash Hits* also the presenters of TV's 'Whistle Test'), and these are the acts that people now most *care* about.

Jim Morrison has already replaced David Bowie as the star model, and it is easy to make other progressive predictions: the reemergence of *Melody Maker*; the return of John Peel's shows to their pre-punk mood; the blooming of a label like Rough Trade on the student servicing model of 1960s Island and Virgin.

What matters here is not whether the resulting music is good or bad but how it is going to be *judged* good or bad (note Morissey's odd suggestion that the guitar is more 'human' than the synthesiser). And the shift in aesthetic politics does open up one important critical opportunity: to get stuck into commerce again.

In recent years (the Malcolm McLaren era) it has become the custom to celebrate the pop process, with the result that information about who owns what and whom and why is less available now than it was even in the 1950s.

Memo to the *City Limits* music desk: skip the cultural theory, it's investigative journalism time again! 1984

Whistling in the Dark

In Britain 1984 turned out to be the year of the miners' strike and Frankie Goes to Hollywood. Repeating images – the miners' stolid anger, Frankie's smirking leatherware; juxtaposed stereotypes – pickets as hooligans, gays lounging promiscuously in the night. If pop is a sign of its times, then Frankie's social message during the key political struggle of the 1980s is decidedly oblique.

Frankie are a pop phenomenon just for their numbers. Their first two releases were million sellers – 'Two Tribes' was the inescapable sound of the summer, going straight into the charts at number one after 'Relax' had established itself as a permanent hit, the most successful 12-inch ever. And Frankie took over the message T-shirt, using the large print originally designed by Katherine Hamnett for better causes to promote 'Relax', and spawning a cacophony of 'Frankie Say' and 'Who Gives a Fuck What Frankie Say' slogans. Walking down Oxford Street in August, watching the tourists snap up the pirate editions of 'Frankie Say Arm the Unemployed', I decided this was the final triumph of the 'new pop', the eclipse of content by form.

Frankie themselves are five lads from Liverpool, typical veterans of the 1970s post-punk provincial scene in which Bowie boys became punks and skins, dyed their hair repeatedly, hung out in the gay clubs with the furtiveness that marks everyone on provincial streets in the small hours. This was the scene – musicians and dancefloor posers drawn from the same pool, sex as a slippery transaction – that produced Soft Cell in Leeds, Boy George, and the early, sleazy Duran Duran in Birmingham. Frankie had nothing much more to say, till they signed to ZTT, the label formed by *New Musical Express* theorist Paul Morley and ABC-McLaren producer Trevor Horn. Morley had the concept (it's rumoured he was first interested in Bronski Beat for the Frankie role and was turned down), but Horn had the sound, the remarkable ability to create epic spaces in ordinary songs. Frankie's records make best sense in a cheap British disco, where the elementary chorus chants, the beat machines' seedy grandeur, and the stodgy vocals offer distinct echoes of Gary Glitter.

As an *NME* writer, Paul Morley was the most influential theorist of 'new pop', combining a traditional reading of music's emotional power

with a modernist celebration of that power's fleeting ambiguity. His problem was to translate theory into practice. Frankie's success is a triumph of rock journalism. But the question, even in Morley's terms, is not whether Frankie are popular but whether their popularity is subversive.

I don't doubt Frankie's radical intentions. 'Relax' may only have become a scandal when the BBC in belated confusion (and in response to teasing video-clips) banned it, but singers Holly Johnson and Paul Rutherford are explicit gays, and 'Two Tribes' is a bitterly satirical response to nuclear defence policy. It's the smoothness of Frankie's success that unnerves me – it's hard to find anyone (other than ZTT) who thinks that Frankie, or their records, are changing the way people understand their lives. They're a best-selling group without real fans, more like the Archies than the Sex Pistols. And this reflects the way they've made it – through marketing rather than live performance. Their energy is the energy of pop's sales team rather than its consumers – there are, presently, more TV pop shows than ever before, more knowing pop people in record company control, more competitors for the leisure pound. Frankie is *their* success, and this brings us back to the current crisis.

The Tory solution to Britain's economic recession is a new version of the nineteenth century's two nations. Growth is now supposed to come from the leisure goods industries. The new jobs will be low skilled and low paid; the non-affluent will service the affluent; the new working-class will work on other people's leisure. The miners' strike is one response to this – a struggle for community and the dignity of labour, a rejection of market definitions of 'economic' pits (and a fight which is incomprehensible to the Southern, bourgeois media). But another response is a new youth subculture, the 'casuals'. At first glance the casuals epitomize Thatcher's leisure-class, neatly dressed in designer-label sports goods, clutching their walkmen and videotapes. But just as much as punks and skins, the casuals have emerged from the dole queues and football terraces, from the 'delinquent' world of drugs and brawls and menace. Their flaunting of their 'free time' is a reminder, like the miners' strike, that a leisure society creates its own forms of disorder. Frankie's success has a casual background. They are not so much subversive as desperate – that strained voice ordering us to relax, selling gay sex as a bargain. Frankie – who come, after all, from Britain's most devastated city – capture better than anyone else the neurosis of a society told, amid the wastelands of dead factories and eked-out social security, that the solution to our problems is to have fun. 1984

Pop Go the Graduates

For almost a decade now it has been decidedly uncool to be a student except, perhaps, at an art college. The music papers most dependent on the college market do their best to disguise it – it's only the pages of ads for Polytechnic courses and student banking deals that give the game away – and even the obviously student-aimed TV show 'Whistle Test' introduced Andy Kershaw as a presenter without emphasis on his successful career as a student entertainments officer. His rock credibility lay, rather, in his briefer role as Billy Bragg's roadie. Pop's only public celebration of student life remains Anne Nightingale's touching Radio 1 request show.

The fact is that pop is now a graduate career much like any other. Harvey Goldsmith may have been the first person to move from organizing university concerts to success as Britain's top rock promoter, but college entertainment secretaries find music business jobs now as surely as student union presidents used to get work in the Labour Party.

It's difficult to exaggerate the significance of the college circuit for live music-making in Britain since the mid-1960s. Even such a legendary punk event as the Sex Pistols/Clash tour in 1976 was mostly hosted (to their immediate horror) by student unions, and today college venues are more important than ever. As students go back to college so the new rock touring season begins. Last Saturday, for example, the Coventry Polytechnic Freshers' Ball featured B-Movie (who were due in Nottingham University on Wednesday, Newcastle University on Friday), Del Amtiri (on their way to Oxford Polytechnic on Thursday, Keele University on Friday), and top-of-the-bill Terry and Gerry (who played Loughborough University on Wednesday, Durham University on Friday).

In Coventry itself, there are no rock venues left bigger than pub back-rooms, except the Poly and the University. Here, as in many cites, out of term-time there is nowhere for ambitious bands to go. And what student unions can offer them is not just a place to play but a semi-captive audience and a guaranteed, underwritten fee. There's no way, in short, that a new band can make the move from the local to the national scene without playing to students.

Whether the students will appreciate them is a different question. Last summer Sigue Sigue Sputnik, the current music biz buzz group, who have just signed a six-figure deal with EMI, played a 'whip-round' gig at

Warwick University. Whip-rounds mean free entry. People pay what they think fit as they leave, and on this night most people left early and paid nothing. Only the cultural affairs officer, brooding on his losses, knew he'd seen the Next Big Thing.

And this is the peculiarity of the student audience: it's vital to the continuing health of the rock scene but is, by its nature, essentially conservative – which is why the pop trend-setters ignore it. Most students go to college gigs because they are there, not because they have much interest in the bands booked in. End of term balls, in particular, are notorious as times when colleges pay out for the latest American and British cult groups who then play to an uncaring mass.

In this setting what makes for entertainment has less to do with a band's musical originality than with its way with an audience and with its familiarity. Most colleges have their own local favourites (like Terry and Gerry) and there are, from year to year, obvious national student bands, groups which captured their fans in the sixth-form and incite a sort of freshers' fervour – last year that meant the Smiths, this year the Waterboys. But the biggest college stars draw on even earlier memories: 1970s groups like the Boomtown Rats, Mud, and, above all, Gary Glitter, students' number one idol, whose original hits coincided with their first pop memories.

In those days students certainly weren't Gary Glitter fans, and it is ironic that colleges are now the place where pop routines long forgotten by their original followers are preserved. The usual rock/pop, student/teenage distinctions need revision. College audiences had their tastes shaped at school; their favourite new bands have echoes of those days. Avant-garde acts don't survive the college circuit. The importance of the student audience is, rather, to support musicians who can fit new sounds into old forms – so that the Boomtown Rats and Damned were the most popular 'punk' groups, Simple Minds the most popular post-punks. Orchestral Manoeuvres in the Dark the most popular electro-poppers.

This isn't the whole college story. There's also hall-of-residence rock, the records (Lloyd Cole and Prefab Sprout presently) that people listen to in their rooms, and most campuses have 'progressive music societies' where cultists gather to denounce their fellow students' tastes. But what the student music scene is really about is professionalism.

It's not surprising that college entertainment officers do so well in the music business – they learn cynicism young. This partly comes from their direct dealings with the stars – the Smiths' demand last year for supplies of flowers to fling at their fans was only one sign of a new pop quirkness.

But what really drives student entrepreneurs into a premature commercial detachment is their audiences. Every new ents officer learns from first-term results: black music has no student draw; known bands are always preferred to unknown bands; no one in the union cares who the latest critical cult figures are. Students are the great middle-class, middle-brow bastion of British rock, and after 20 years their tastes aren't about to be shaken. 1985

Artistic Ambitions

At some point in the late 1970s, the favourite art school exercise became designing pop stars. The meaning of 'art rock' had changed completely since the 1960s. First, glamrock (and, in particular, Newcastle fine arts graduate, Bryan Ferry), and then punk (and, in particular, ex-Croydon art students, Malcolm McLaren and Jamie Reid) had revealed the creative possibilities of star images and packaging. Self-expression no longer mattered; pop art was a matter of market intelligence, not strong feeling.

The first person to apply this lesson successfully to mainstream music was Stuart Goddard (ex-Hornsey College) who, as Adam Ant, was the grubby sex object in Derek Jarman's punk film, Jubilee, and then became a teeny-bop idol. But Adam was a Boots Gallery version of the artist as pop star, and it was the next generation of art school students who made new pop interesting.

Marc Almond and David Ball started Soft Cell as Leeds art students in 1979. Ball captured the sound of provincial nightlife, part northern soul, part dressed-up new romanticism. Almond dyed his hair black, wore leather and eye-liner, and celebrated sexual sleaze. He took the bohemian's walk on the wild side, but past Chapeltown's street-walkers and dirty bookshops. His decadence was obviously made up, his songs were young and confused, and Soft Cell became teen pop stars despite themselves.

Even then, though, Almond's artistic ambitions transcended the charts. Soft Cell's best numbers – 'Torch', 'Say Hello, Wave Goodbye' – were grand emotional gestures, and, as a solo artist, Almond has been more a cabaret than a rock act.

In Coventry on Wednesday, he appeared in a black singlet, arms tattooed, a pork-pie hat releasing just a wisp of hair. He looked like a young Keith Moon with bedroom eyes, like Julie Covington in a headscarf, but he reminded me most of Shirley Bassey, holding up his hands in supplication, revelling in the sheer power of his feelings.

There's an element of camp in this, but also something more original. Almond is not a drag act, playing a man, acting a woman. He's using showbiz gestures as his material, reshaping them to get at the experience of romantic ambiguity itself. He's got no interest in musical schmaltz – his band, the Willing Sinners, is plainly modern.

It's a five-piece – synthesizers, guitar, drums, bass, with occasional use of accordion and cello – and what's fascinating is how luxuriant Almond makes it sound, singing tightly with the rhythm section.

The great band singers of old, the Sinatras and Judy Garlands, worked closely with their arrangers, using a conventional instrumental short-hand, different sounds and textures standing for different moods. Willing Sinners are attempting the same thing with post-punk, post-electro noise. Almond offers entertainment as brilliant paradox – a blues done straight and giggly, 'a woman's story' sung with male sincerity. His tutors would be pleased.

Watching Sade in Birmingham on Friday, I decided, though, that she is the most extraordinary art school graduate of them all. She made the move from Colchester and St Martin's to international pop stardom without any passing reference to youth or bohemia or rock and roll at all.

Sade was known as a face and a look before she made a record, and her initial releases seemed arranged to sound like she looked – cool and elegant. She drew most obviously on 1950s Latin-tinged supper-club jazz, but her references were actually wider. Both her LPs encapsulate the sound of the expensive British night out, ranged across 30 years of classy pop and jazz and soul.

The Sade sound – sophisticated music for unsophisticated people – has given her the widest social appeal of any current pop star, and allowed her to ignore virtually every cliche of female performance. Her only stage reference to spot-lit sexiness is her backless shirt; the only titillating moment in her show comes, symbolically, when she turns her back on the audience. Otherwise, she reveals nothing. She doesn't ask for her audience's love or confirmation; she doesn't use her crooning style to hint at private grief or passion.

This can make for tedium; Sade is a better studio than stage singer, her sound, which is all, coarseness with volume. And she's an awkward performer, finding it difficult to get from one still pose to another. Her show works anyway, though, because of the fantasy she represents. Sade is a model of restraint. 'This song is about uncontrollable emotion', she says, and sings 'Fear' in just the same graceful way she's sung everything else. 1985

Revenge of the Nerds

I met two members of We've Got a Fuzzbox And We're Gonna Use It in the London building of the BBC World Service. I was there as an on-air guest to talk about the Velvet Underground; they were there to talk about themselves. In the control room their record company chaperone spoke in bemused tones about her drive down the M1 from Birmingham, 'They never stopped talking about their careers teacher!' In the studio the Fuzzboxes, teenagers who learnt how to be pop stars from close readings of *Smash Hits*, were the most spontaneously funny interviewees I've ever heard. Part parody sex symbols – innocent Madonnas in 'revealing' frocks slashed with primary colours; part playground punks with teased hair and blunt nicknames – Potato Face! – they retold the story of their start, how they were dared up on-stage quite unable to play any instrument at all. What they really revealed, though, despite themselves, was that they'd sung together in the school choir. The charm of their music lies not in its studied incompetence, but in the casual grace of their girl group harmonies.

The Fuzzboxes are, so far, the most successful of the new wave of British bands affectionately labelled by John Peel as 'shambling', a cross between shambolic and rambling. The shambling movement is the product of Peel's late night BBC radio shows, the coming-to-music-making-age of a generation of playground eccentrics, bred on Peel's post-punk, anti-glam pragmatism and now sending him their own jokey messages and tapes. This is the sound of romantic pretension made mundane by a lifetime of Thatcherism. It is best captured on *New Musical Express*'s admirable C86 cassette, 22 self-produced bands, 22 indie-pop singles. Mostly boys' bands, rhythm guitar-based, drawing self-consciously on the golden age of British Pop, on the psychedelic jingles of 1966–8, but, in practice, most reminiscent of British punk's respectable 1976–8 suburban strand. Then singers like Jilted John and groups like the Boys did-it-themselves, but coyly, with a sense that this was a passing adolescent phase. And so the shambling bands avoid social issues and write unrequited love songs, or else, like Peel's favourites, Half Man Half Biscuit, build cabaret turns around the icons of lower-middle-class mass culture.

What's most striking about these groups is their lack of ambition, the

absence from their records of any strong feeling at all. There's no anger here, none of the loose avant-garde interests of the early 1980s. This has been, unusually, a British pop movement without a proselytizing theory, and while the music papers therefore flounder, the only commentary worth reading is in *Monitor*, put out by a solemn group of ex-Oxford students dedicated to reconstituting a regressive white bohemia. Their most endearing ideologue, Simon Reynolds, has made the best sense so far of the shambling movement.

He suggests that at a time when every sign of teenage rebellion since rock'n'roll is part of some sales campaign, the only unpolluted source of nonconformity is childhood – the polymorphous perversity of pre-pubescence itself, and the infancy of British rock – the 1960s innocence embodied in the new groups' names: the Pastels, the Mighty Lemon Drops, the Woodentops, the Soap Dragons. For these groups, in Reynolds's words, 'the primal scene of consumption is the bedroom', and love is experienced as sensibility not sensuality. These musicians are non-subcultural, dressed in the sensible clothes that parents buy, and pre-postmodern, rejecting the possibilities of the new technologies:

> Faced with a leisure paradise that promises satisfaction, what's radical is not just to make more demands, but to insist that satisfaction itself is an illusion. Faced with the infinite accommodation of consumer capitalism, the radical response is to abstain, to cling stubbornly to the will to misfit.

This is convincing but premature. We've only just reached the moment when this pop becomes interesting – not in its statement of difference (most shambling records are twee or ugly) but in its bid for power. As the major labels show interest and the bands sell out, as it becomes obvious that the Smiths were the precursors of the new (the Jesus and Mary Chain are the last gulp of the old), so the needs of the body will disturb the mind and the drive for success will sap pride in failure. 1986

On and On and On

The most terrific moment in the 1987 General Election campaign was the finale of the Tory Party's showbiz rally in the Wembley Arena. These star-studded events seem to have become *de rigeur* for all the parties the weekend before polling day, but the Conservatives tend to have trouble finding true-blue stars to stud their shows. This year they had a couple of sheepish cricketers, some ageing racist comics telling ageing racist jokes, a theme song composed by Andrew Lloyd Webber, Tim Rice, and (judging by the TV pictures) nobody else well-known at all. After the speeches, though, buoyed by Maggie's great entrance and address, the crowd all rose to sing 'Imagine'.

It always was a soppy song, but to watch those well-scrubbed, well-heeled, unembarrassed young Conservatives solemnly mouthing John Lennon's pieties was to see hegemony at work. This was the lunatic period of the campaign when newspapers' liberal columnists all began to have 'gut feelings' that Labour would win, and that same weekend both the *Observer* and the *Guardian* rounded up their usual intellectuals to declare which way they'd vote. The difficulty (as the *Guardian* wryly admitted) was to persuade any well-known novelist or critic (besides Kingsley Amis, that is) to come out as Conservative at all.

The music press, doing a similar trawl of pop stars, had similar problems – IRS's Miles Copeland seems nowadays to be the only pop person prepared to argue publicly what is, in fact, self-evident, that, yes, rock *is* a free enterprise. Otherwise the stars, from Bono (at Wembley the week before Mrs Thatcher) on down were united in their sense of collective responsibility, mouthing caring pieties with the same rapt fervour that those Tories had imagined no possessions (and getting the same shiver of goodness all down the spine).

The hegemonic point is that, whatever the strength of the Labour rock gesture, however tacky the Tories' response, the market-force version of Lennonism is now everybody's common sense, and Thatcher duly won her thumping third majority. Amidst the mass of post-electoral readings of the voting entrails one statistic stood out: the only age-group to show a preference for Labour over Conservatives were the 25- to 40-year-olds; the youth vote itself (the under-25s) was as fully for Mrs Thatcher as everyone else (not very fully, that is, but still more fully than it was for

Neil Kinnock). Which may explain why Red Wedge had so muted a campaign. They worked hard enough, touring Labour marginals, the usual crew singing with the usual fervour (Billy Bragg cancelling his American tour to join in) but there was no real buzz to their evenings: the audiences – young, apathetic, down-at-heel – seemed grateful to be entertained but clearly didn't think that anyone not driven by glittering self-interest could *change* anything.

It tends to be forgotten these days that punk was the cultural consequence of a Labour government. The imagery anticipated Tory Britain – boarded-up inner-city shops and welfare officers, dole-queue boredom, Jubilee bunting hanging in tatters round squeezed-out tubes of glue – but it also contained a sense of glee and anger that was profoundly, *socially* optimistic. Under a Labour government, even a confused and reactionary Labour government, politics – organization and argument for one's own idea of change – was still possible. Under a Conservative government, under this Conservative government, it isn't. There's now a voting generation of people for whom politics means Mrs Thatcher and Mrs Thatcher means a force of nature, a Britannia riding the waves of capitalist necessity. Anyone who suggests that capitalism might not in fact be *so* necessary is seen to be either a hopeless nostalgic or a little loopy or (like Kinnock and Paul Weller) both.

Political pop music as it exists here at all now is, then, old-time music, and however savage it may be (for example Elvis Costello's new attack on Thatcher) it always invokes (like the Labour Party itself) a struggling past. What this means is not so much a folk revival (though traditional Irish, Scots, American, and English workers' songs are now a common-place of the concerned rock repertoire) as the reading of rock and roll and punk (and even avant-garde noise) as themselves folk forms, the sounds of heroic times, their performance a momentary means of access to stirring communities now gone.

And meanwhile, back in the charts, Tory music flows on. The most successful current production team – Stock, Aitken, Waterman – even sounds like a firm from the City and what we've got to look forward to is. . . the Pet Shop Boys' new LP? Prince on tour? No, preparations already for the next nostalgic binge: 20 years since May 1968. 1987

Afterword
Making Sense of Video:
Pop into the Nineties

Introduction[1]

In the music business itself the view of video is straightforward: the rise of TV promotion is the symptom (and partial cause) of a profound shift in the organization of corporate entertainment; as an art form, though, it is insignificant. There are interesting clips, of course, but the value of even good visuals is dependent in the end on the quality of the soundtrack. The working rule is that a good video can't sell a bad song, but a good song can drive a bad video. Video pop channels like Music Television may, then, be good for business, but no-one would pretend that there's much more to them aesthetically than a flow of mediocrity.

No-one, that is, except academics, because the strangest video effect can be found in university lecture theatres and on the pages of scholarly journals. Pop video is now more heavily theorized than pop music, and has generated more scholarly nonsense than anything since punk. Much of this nonsense derives from the emergence of postmodernism as the most puzzled-over term in the academic vocabulary – pop video was taken to be the exemplary postmodern form because it was the most accessible, available at home 24 hours a day.

'Why MTV?' asks the editor of a special MTV issue of the *Journal of Communication Inquiry*. Because

> we wish to locate and perhaps dislocate, the debate between modernism and postmodernism in the world (on the screen) of everyday life.

Because

> the critical categories of modernism – signification, representation, ideology – are radically questioned by the seductive intensity, the speedy flow, and the open audio-visual textuality [of music television]. These

somewhat 'incommunicable' or 'unrepresentable' effectives call for the
necessity of re-thinking our conditions of existence.[2]

'MTV is orgasm,' explains John Fiske, 'When signifiers explode in
pleasure in the body in an excess of the physical.'[3]

For these writers the rock video is TV's 'only original art form', the
first real challenge to passive TV consumption. What is odd about such
statements is their similarity to the video-makers' own sales pitch. Fiske
finds 'freedom' in precisely those elements of rock videos which situate
them as commercials (and his argument is just as applicable to ads for
cars, Levis, beers, etc.). He may be the silliest expert on the subject so far,
but even the shrewder commentators in this vein, such as E. Ann Kaplan
(who appreciates that MTV is an advertising medium), interpret videos
by reference to a tension between 'a potentially disruptive form, critical
of bourgeois hegemony' (i.e. rock) and the 'commercializing' practices of
MTV – as if rock were not itself a commercial form, as if all
advertisements did not play on the disruptive qualities of desire.[4]

Music videos are, in fact, far from being free-floating signifiers. They
are conceived for a purpose – to create a public for their stars – and, as
Jody Berland argues, this means that they are almost always designed to
reassert the authenticity, the *rootedness* of performance:

> The rock performer plays himself, and promises a continuity of self with
> the space beyond the stage. Among the successful, it takes a rare musician
> not to look like a video quotation of the image of a musician.[5]

In their command of familiar associations of sound and image, video-
makers are experts in the economy (not the anarchy) of signs, they use
visual stereotypes, narrative cliches and generic pop rules to set a place
for the spectator as consumer. What makes pop videos 'postmodern' is
not their 'exploding signifiers' but their equation of art and commerce.
Their aesthetic effect can't be separated from their market effect; the
desires they address can't be realized except, vainly, in exchange. The
fashion industry, as Pat Aufderheide notes, was quick to realize the video
point:

> Since 1977, when Pierre Cardin began making video recordings of his
> fashion shows, designers have been incorporating video into their
> presentations. Videos now run continuously in retail store windows and on
> floor displays. For many designers, what sells records already sells fashion,
> and some foresee a fashion channel. The Cooperative Video Network, a
> television news service, already offers a half-hour program, '*Video Fashion
> News*', with three-minute segments on current designer models. Some
> designers regard video as a primary mode of expression. Norma Kamali
> now shows her work only on video, both in stores and on programs. One
> of her best-known works is a video called 'The Shoulder Pad Song'.[6]

Pop videos draw, then, on familiar commercial routines, and the

question is why they are so appealing to postmodern theorists as something 'new'. I suspect that this is just another ivory tower effect, scholars gazing enraptured at pop clips in their dens with little idea where they came from. But the treatment of videos as purely visual texts is also an effect of the current orthodoxy of *Screen* theory in film and cultural studies departments. The legacy of *Screen*'s 1970s mix of psychoanalysis and linguistics is a politics of culture in which anything that disrupts narrative 'coherence' can be interpreted as radical, but what *Screen* theory mostly ignored was the place of music in its scenarios. Colin MacCabe's famous piece on 'Principles of Realism and Pleasure', for example, took as one of its crucial texts *American Graffitti*, known to rock fans as 'the film that almost single-handedly invented fifties rock & roll nostalgia'. It was possible to read MacCabe's analysis without realizing that there were any songs in the film at all.[7]

Given *Screen*'s concern at the time to theorize visual pleasure, there was some excuse for this. But apply the argument to pop video and the result is bizarre – the images are discused without reference to the sounds. Scratch beneath the Baudrillardian surfaces and you will find a remarkably naive view of how music works – rock, it seems, *means* rebellion, sexiness, and so on; any subtler musical message, it turns out, can only be derived from songs' words.[8] For all their theoretical swagger the postmodern analysts have much the same 'common sense' view of video as those other prolific writers of nonsense on the subject – the moral right. The moralists, too, root video meaning in visual imagery (with lyrics quoted for firmer evidence); they too generalize about video's 'youth' audience, scorning empirical work as irrelevant to the real psychic struggle going on. Postmodern theorists and such groups as the Parents' Music Resource Center have opposite political and aesthetic views, but their judgements are based on similar video readings (and like the theorists, the PMRC didn't seem to notice rock until it appeared on their TV screens).

Faced with both sorts of nonsense, it is important that academics studying pop culture should know what they're talking about. The most effective counter to the moral video panic is thus systematic audience research, and although this does indeed raise problems of 'empiricism', useful sociological studies of the young video viewer do now exist.[9]

Here, then, I will concentrate on the postmodernists' points. My starting premise is that MTV may well be fascinating for the desires and identities it puts into play, but that its pleasure-principles can only be understood by reference to its material reasons for existing. As a means of ideological (and sensual) production, pop videos are rooted, on the one hand, in a music industry, on the other, in a television industry. To approach them only from the standpoint of film and literary theory is therefore not only illogical but also misjudges completely what, indeed, makes them something new.

Video and the Music Business

Record companies don't use promo videos just because they're there. As Paul Attallah argues, it is not new technology that reorders the public sphere, but shifts in the public sphere which make possible new uses of technology.[10] The crucial shift for the use of pop video was the reorganization of TV. The deregulation of broadcasting by market-force governments and the development of cable and satellite services have made possible two new kinds of carrier: specialist channels, putting together a tighter market than the traditional TV audience, 'narrow-casting' with no pretence at (or reason for) public service programming; and multinational channels, putting together a looser market than the national TV audience, 'global-casting' with no pretence at (or reason for) regional programming. In commercial terms it is the potential size of the cross-border audience that makes narrow-casting a profitable option (and in Europe the resulting confusion of advertiser- and subscriber-funded programming stands in sharp contrast to previous TV accounts of the public interest).

The new satellite and cable companies (and their advertising-agency and subscription-chasing clients) realized quite quickly that one potentially lucrative market for their wares was youth. Young people, 16–25-year-olds, have traditionally been treated as the least significant TV audience. They watch for the least number of hours; they are the least committed viewers; they have the least interest in 'family entertainment'. But market research into the use of video recorders had revealed their particular appeal to young people, and it began to make commercial sense to talk about a distinct teenage TV market. For cable companies, looking for ways to carve a new slice out of the old TV viewing cake, the advantage of this market was precisely that it was not otherwise being catered for. It was, therefore, both a possible source of new advertising revenue (youth commercials tended still to be concentrated on radio and cinema, in young men's and women's magazines) and a pressure point for household cable subscribers – Virgin's Richard Branson argued that British cable take-up would depend on the influence of teenagers on their parents, and his 'Pan-European' service, Music Box, was duly set up to be 'slicker, brighter and closer targetted into the young market than any other cable service available today'.

It seemed equally clear that the way to reach this audience was with existing youth entertainment, with the star and music already played on youth radio and reported in the youth press. And so in August 1981 Warner-Amex cablevision offered its subscribers Music Television, MTV, a 24 hour music service, the first specialist TV pop channel.[11] Its immediate success (providing a quarter of Warner's cable profits by 1984) led to imitators like Canada's Much Music (24 hours a day, in three repeated blocks of six hours, since September 1984) as well as Music Box (carried by Sky Channel from 1982, independent in 1984 and

now a ten hour a day service on Super Channel – Sky has developed its own music service, Sky Trax). Various European countries also now have a local video music outlet, and in August 1987, to complete the circle, MTV Europe was launched. It reaches a dozen countries and, although it is unlikely to have much immediate impact in Britain, where cable services have yet to attract subscribers and satellite dishes are not widely available, there are already parts of Northern Europe (Holland and Belgium, for example) where the majority of the population is cabled up. By 1987 Sky and Super Channels were claiming access to respectively 9.6 and 8.6 million households (this compares with MTV's 28 million homes in the USA).[12]

What is striking about these services is their use of a broadcasting model taken directly from radio – hence their organization of time, their concept of programme flow, their playlists and 'light' and 'heavy' rotations, their 'veejays' (videojockeys, in Europe, at least, often recruited straight from radio), the pop 'news' bulletins, competitions, etc.[13] Most significantly the video itself is treated as 'a single', not just in the literal sense, as the promo-clip for a single record, but ideologically too, as a form for transient concentration and an erratic attention span, as shorthand for a sense of change and fashion. The implication is that pop TV, like pop radio, is a context, a background, for other sorts of activity altogether. In the words of Robert Pittman, the man who defined the MTV approach:

> People don't watch these clips to find out what's going to happen. They watch to feel a certain way. It's a mood enhancer. It's the essential appeal of music translated into visuals.[14]

Pop TV stations are designed to deliver a particular youth market to particular advertisers, and MTV has always justified its playlist policy (the exclusion of black acts, for example) by using the commercial radio analogy: MTV is an advertising service not a public service (it sells about 8 minutes per hour of straight agency space); the crucial thing is to prevent the desired viewer from switching off. This makes for a rather different account of the youth audience than that previously common on TV. Shows like 'American Bandstand' or, in Britain, 'Ready Steady Go' and 'The Tube' simulated a youth group on the screen itself. Their emphasis was on a 'live' atmosphere. The young people dancing in the studio were the audience among whom we, as viewers, could place ourselves. MTV (like radio) sets up in contrast a 'community' of consumption, an atmosphere to be entered through individual opportunity, mood and fancy. In the words of Mark Booth, Managing Director of MTV Europe: 'It's an environment that's created around the centrepiece of music and a youth culture lifestyle you can buy into.[15]

For the record business, music TV was an immediately familiar sales device (and each televised clip duly carries artist/title/label information), but if MTV itself was like pop radio it was also significantly different.

For a start, it had a bolder playlist than most FM or AM outlets. This was partly because it was aiming at a younger, more novelty-conscious audience, partly a matter of necessity – there was suddenly a huge demand for promo clips just to fill up the air-time and the most readily available sources were Australia and, more importantly, Britain.[16] Furthermore, MTV was really the first promotional tool since the decline of network radio to make possible fast *national* record-selling. It gave record companies an alternative to both the clumsy regional-breakout model of radio marketing and the slow LP-and-tour or youth-movie-soundtrack strategies. MTV, to put it another way, had an effect on the *velocity* of sales and was soon being given credit for turning around the American record industry from a five-year recession.

MTV's immediate marketing success had longer-term business ramifications. By putting the relatively costly video clip at the centre of the sales process, it gave new advantages to the major companies over the indies (in 1985, for example, CBS and Warners produced half the videos shown on Much Music) and focused their attention on the video audience at the expense of broader notions of the music market. There is now no major pop or rock performer who has not done videos for MTV transmission, and it has become American industry wisdom that a place on the MTV playlist can increase sales fourfold, that exclusion from it means no sales at all.[17]

It is not surprising in this context that MTV became the target of hostility from the established rock audience – in the pages of *Rolling Stone*, for example. It seemed to mean the replacement of rock values (sincerity, musical dexterity, live communion) with old pop conceits (visual style, gimmickry, hype); it was accused of denying viewers the right to 'imagine' songs for themselves. But such arguments only made sense in the abstract. In practice MTV has given more of a sales boost to old rock performers like Steve Winwood, Genesis and Bruce Springsteen than to new British pop acts, and it is more fruitful to consider how musicians and the music business made MTV possible than to complain that MTV 'changed everything'. As Andrew Goodwin points out,[18] it was the rise of electro-pop (the decline of folk-based notions of authenticity) that validated music videos as an expressive form – it did not matter if these musicians faked it, and British stars' post-punk concern for (and skill in) packaging and promotion meant that their videos carried a certain sort of personal authority. Art school video acts like Human League, Soft Cell, ABC and Scritti Politti made early MTV seem more like a legitimate mode of entertainment than the tacky exercise in selling it would have appeared even a couple of years earlier. Thanks to their 'gimmickry', 'real' rock acts like Springsteen and U2 can now be video-sold with 'integrity'.

Additionally, as Will Straw argues,[19] the record industry in 1981 was in desperate need of an effective new sales device. A dangerous gap had opened between the audience which radio wanted for its advertisers and the audience which the record industry needed for its sales. More and

more stations were playing the tracks their listeners already knew – pop 'oldies', 'classic' rock, album cuts; record companies needed some other means of launching new acts, building new stars, increasing the sales turnover.

MTV was immediately successful, in short, because its idea – an entertainment service delivering the TV youth market to (mostly) music advertisers – coincided with both a real need for such a service (given the ageing of youth radio) and the availability of video tracks (British new pop) which could legitimate this sales process with their sheer style. What is less clear is whether the MTV idea has actually been realized in terms of viewing figures and behaviour, and 1984's commercial optimism may have been misplaced. There is some evidence, for example, that pop video channels don't have the overwhelming youth appeal that once seemed likely – European satellite services have cut back their hours of pop transmission in the last couple of years and even MTV has had its financial troubles. Once the novelty effect wore off, the teen audience seemed to lose its concentrated interest and it could be that the TV pop market is dividing up *around* youth. On the one hand, there's an older strand of casual viewers, the over-30s, career-tied new parents for whom TV rock is important because they are not going out so much. This audience is appealing to advertisers (if not to record companies trying to break new names) and a second Warners cable music service, VH-1, has been designed accordingly. On the other hand, there's a younger strand of steady viewers, the under-10s, children who aren't allowed out anyway. Chet Flippo notes that

> some studies have claimed that MTV's real hardcore audience is made up of children aged from three to eight years and that in fact many parents leave MTV on to distract their kids as an electronic baby-sitter. These children, it's said, are the perfect MTV viewer; they have the leisure time, they have absolutely no attention span whatsoever, they possess little memory, they have no judgemental facility to deal with what is presented to them on-screen, they love flashy images and bright colours and lots of action.
>
> In short, they are the ultimate non-linear viewing generation. That's why MTV continues to be ridiculed by parts of the advertising community as the 'baby-sitting channel'. The only draw back to MTV's role as baby-sitter, advertisers say, is that 3- to 8-year-olds unfortunately possess absolutely no consumer purchasing power . . .[20]

As the promotional efficiency of MTV and other music stations has come into question, so record company video policy has begun to shift – from using TV as a means of selling records to consumers, to using it as the consumer itself, videos becoming the product on sale. One sign of this is that record companies in all countries now charge TV stations for using their videos – they expect the clips to be a 'self-funding art form' (Dick Asher's words) and European industry estimates suggest that the returns from video licensing already cover production costs.[21] Probably

more significant has been the general move by record-makers into the film/tv/video production business itself.[22] The key to profit here is not private consumption (pre-recorded video is as yet a tiny market) but entertainment packaged on demand for the ever more voracious public outlets around the world. Hence the current industry emphasis on 'long form' videos – concert recordings and biographical specials which need have no special 'youth appeal' at all.

What has become apparent to everyone is the contradiction at the heart of outlets like MTV. Their stress on the single record as *the* mode of promotion comes up against the fact that the single as such is an increasingly heavy loss-maker. It has long been used in rock and pop only as a means to the end of real profits (from LP sales and star-making) which was necessary because of the central role of radio in the sales process. Although MTV began by taking over the radio format, future music TV need not to be so limited. The question becomes: why proceed with the TV pursuit of the teen consumer if she or he is not the best source of profit? And the even more interesting question then is: why go on selling records so hard when there are much more *manageable* ways to market entertainment?

Video and Television

What MTV has done has been to revolutionise the way people view and use television and listen to and consume music. We took the two pastimes of a generation – watching TV and listening to music – and wedded them. (MTV President, Tom Preston)[23]

Music videos are made for public viewing and their meaning depends on their setting. 'Art videos', for example, are seen in different ways than pop videos – in galleries and clubs, as part of a 'live' performance – and there is no easy way to take a work (or arguments about it) from one setting to another. What is at issue here is not 'the pleasure of the text', but the mode of reception determined by the context. In considering the specificity of TV as a video outlet I must begin, then, with two obvious points.

Firstly, TV has always been significant for record-selling and central to youth music's meaning. It was the crucial source of the imagery which explained rock and roll, for example – Elvis Presley became a youth icon through his appearances on network variety shows – and ever since it has been rock's most effective window display. Secondly, such star-making has always worked within particular constraints – as a strand of family entertainment (the guest appearance), as a strand of youth entertainment (TV studio as teenage club). In the latter case, as I have already mentioned, 'fun' meant the simulation of a dance or show, the re-presentation of the assumed live context of youth culture. In rock terms, TV was always *after* the event – young viewers might have learned to

move and dress directly from the TV screen, but the assumption was that it was a window on the real youth world that was somewhere out there.[24]

This was one sign of the different ways in which rock and TV audiences were constructed (and why rock appeared on TV as something between a threat and a fad, as something *other*). As Paul Attallah argues,[25] what's involved here are two accounts of pleasure. TV entertainment works on what audiences have in common across class/gender/race/generational divides, it rests on an ideology of the *family* as ideal and real TV viewer. Rock, by contrast, is about difference and what distinguishes us from people with other tastes. It rests on an ideology of the *peer group* as both the ideal and reality of rock communion.[25]

In rock ideology itself, music and TV are usually distinguished as 'active' and 'passive' cultures,[26] but the important point is that they are structurally (and historically) bound together. The music was an effect of the TV set: it was the 'alternative' media (radio, records, magazines) that produced a self-conscious (anti-television) 'youth' audience (so that the first TV generation ended up claiming, like Frank Zappa, that 'TV is slime'). To reorder the relationship of rock and TV does not just mean bringing two previously separate cultures together but changing what they each mean – whoever MTV addresses it can't be 'youth' as defined by rock and roll. Despite those post-modern readings, then, the rise of pop video has, in fact, been dependent on (and accelerated) the decline of the ideology of youth-as-opposition. It is true that the video recorder made possible, for the first time, a youth use of TV – peer group-watching, content control, telly culture as something apart from grown-ups (hence the moral panic about children and video nasties, the PMRC's concern with heavy metal imagery). But public broadcasting, even subscriber- and advertiser-based public broadcasting, can't depend on this sort of delinquent sense of difference (in fact the TV in the suburban teen bedroom pre-dated video, but the only obvious network response was children's programming, which still ran along family lines).

In other words, if TV is moving towards narrow-casting, its mode of address remains domestic entertainment, and its use of video is therefore dependent on shifts in rock culture, on rock's own changing account of itself. This is not really a question of changing listener statistics, but refers to how the 'youth' demographic is now being treated. Rock, too, has become a form of domestic entertainment; TV, radio, tape and compact disc can at last be integrated in a single 'music centre'. This is partly a matter of hardware (the promotion of stereo TV sets, the marketing of Compact Disc Videos), partly a matter of personnel (the emergence of programme-makers who straddle the rock and TV worlds), and partly an effect of video's economic logic – what is relatively expensive for record company promotion departments is a relatively cheap form of TV programming. It is only worth a company making a video if it can be sure of its TV use, and so record companies (as I have already argued) have a powerful incentive to control television com-

panies' policies (and share in their returns). This is the institutional setting in which the audience for rock and the audience for TV are set up to be the same thing, and one consequence of the rise of pop video has been the decline of traditional youth television – not because videos win the competition with 'live' shows for young people's time, but because the ways in which TV and rock stars now construct their audience are no longer distinct – there is no longer any need for an 'other' sort of pop programme.[27]

The use of video techniques across the media – in films like *Flashdance*, in TV series like "Miami Vice" – is, then, less a threat to narrative closure and the realist text than a further confusion of entertainment and packaging; as Jon Savage suggests,[28] video style works in these shows primarily as a marketing device. This is most obvious in a film like *Top Gun*: the musical moments are designed as self-contained clips for TV rotation, and in the cinema the film seems to be made up of endless advertisements for itself. But even in a more sophisticated TV product like "Moonlighting", the recurring use of hit songs to freeze-frame the action works less to unsettle the viewers – what's the story? – than to implicate us in the producers' glee that there is no story, just a series of Maddy and David star routines. It's not surprising that video techniques have been absorbed most easily by TV commercials (where many of them came from in the first place), or that the TV use of video to promote rock has also meant the TV use of rock to promote everything else.

Reading Video

Peter Gabriel used his winner's speech in the 1986 American video awards to plea for video to be treated as art and not promotion. This has become a recurrent call from video-pop stars, and making one's own clip is beginning to be a badge of rock authenticity (like writing one's own songs). Here is Thomas Dolby, interviewed in 1984:

> I write songs from a visual standpoint to begin with. A video can extend a song but I do try to leave a lot of loose ends for people's imaginations. Too many artists just allow themselves to be used by record companies and packaged into cliched videos. In the same way that singers weren't involved in songwriting in Tin Pan Alley days, too many artists aren't involved in their own videos.[29]

Such attempts to distinguish video promotion from video art are not just a matter of star-conceit. They reflect long experience of the material conditions in which most promoclips are made – conceived after the musical event, filmed quickly and cheaply to cash in on unexpected sales figures, to coincide with a tour. Budgets and time-pressure are the best explanation of the standard video look – the platitudes, the fragments,

the ever-present 'found' footage of movement and disaster – and Gabriel's 'video art' is a coded call for more resources and more time. But there are issues of imagination involved too – as the most interesting academic readings suggest, most videos are organized according to the aesthetics of advertising.[30]

The question, though, is exactly what pop videos are advertisements for. The obvious answer is for themselves. They aim to get viewers to buy a sound because of its association with a visual fantasy – the pictures give people a way to 'relate to the music' – and from this perspective it is initially difficult to imagine how a 'real' advertisement for a record would be any different from its MTV clip. But there is a difference. A real advertisement involves an explicit exhortation to buy; in Andrew Goodwin's words, it has to fill with sales talk the space between what it is selling and what it is showing (think of the frantic voice over the 'That's What I Call Music' campaigns). An MTV clip offers the whole product and doesn't need the market pitch. All that need be added is sales information (artist, title, label) – the record itself, as a physical object, is not shown (as it would be in straight advertisements). The model for MTV in this respect was radio: the radio play of a record is both the product itself and an advertisement for the product – what you hear is what you get. But video clips are different here too. They foreground not the product but the packaging: the video relates to the record only as a means of fantastic appropriation, and the video experience is not what anyone expects to get.

But videos are not quite like non-music advertisements, either. They are taken to express the meaning of their merchandise in a different way than, say, Levis commercials express the meaning of Levis. The difference lies in the assumption that a song (unlike a pair of jeans) is *authored*. In both pop and fashion ads (both pop and fashion photographs), we're offered images with which to identify, bodies and faces on which to project desire. But whereas fashion models are essentially blank, objects on which clothes hang and eyes and cameras gaze, we relate to rock and pop stars as subjects, as 'personalities'.

I will come back to the implications of this shortly, but it is anyway doubtful that pop videos – at least on stations like MTV – straightforwardly sell the records which they illustrate. At least two other advertising effects are as important: the build-up of an audience for the messages between the clips, and the selling of the TV service itself to its subscribers. Even for the record industry, what matters most about the pop channels is not their particular sales effect (this play selling this song), but their contribution to the general sales flow. Companies assess their clips' success in terms of the star-making (not song-selling) process. And the particular value of video is not just its power to 'cosmeticize' musicians (making dolts seem attractive by visual association, for which moving pictures are even more effective than stills),[31] but also the control it gives labels over their musicians' 'public' appearances.

Whether as video-art or as video-promotion, clips work as self-

portraits: they represent their performers to their fans. The 'author' of the images is taken to be the 'author' of the music they accompany (this is formalized in the various pop video awards, though nowadays clips do flash up the names of their directors and producers as well). This puts video directors in an odd position. Despite the occasional critical attempt to celebrate them, as *auteurs*, they are usually invisible (and would probably be better labelled 'designers'). Even when well known film-makers are employed, it is usually to confirm the artistic status of the performer, as if only a great film-maker can realize the ideas of a great pop star (and even now, when pop video is used as an entertainment in itself, it remains legally unclear whether its 'maker', its rights- and royalties-owner, is the commissioning client, the production company/ agency or its director).[32]

For most watchers, what matters is the performers' authority, and this must be the starting-point for any discussion of how videos work. It explains, for example, the ambiguity so beloved by the postmodernists. As Will Straw points out,[33] video stars must be present in the video narrative – they get to act out the fantasies – but also apart from it – they must also be seen as they 'really' are, as musicians. The fantasy confirms their reality; the packaging, in its very elaboration, draws attention to their underlying substance (and the most astute video stars, like Madonna, give meaning to their ever-changing imagery in the narrative of their own careers).

This move in and out of the imaginery is equally significant for our construction as viewers. The object is to turn us into fans, into consumers, to identify us not so much with the performers themselves as with their audiences, the community they create. Straight identification – I am the star – is less important than the identity reached via the star, through our willingness to *share* their fantasies – videos (not surprisingly) work more like songs than films.

For rock stars the question is how to reconstruct on the small screen the sense of communion that depends in live performance on noise. For video-makers the answer is twofold. On the one hand, movement becomes the metaphor for sound – in visual excess, fast cutting, fragmented swirling bodies, purposeless speed – we are overwhelmed with images to compensate for the essential feebleness of TV sound. On the other hand, visual fantasies of (street) power substitute for its aural experience: there is a recurring rock storyline in which the stars are not rich but poor, own nothing but attitude. They are set in a world of destitution not luxury, with heroes bold enough (these are white suburban fantasies) to walk through the inner city kicking shit (and if the biggest stars feel obliged to intersperse such images with their usual glam poses, so, more bizarrely, do other advertisers in pursuit of the rock audience – both cars and banks have been sold in Britain with 'street' scenes and blues soundtracks).

Other genres rest on different accounts of musical (and audience) 'reality' and so use different styles and stories – promo clips don't just

represent the stars, they have to make instantly clear what kind of stars they are. 'The pop video' can be subdivided many ways. Record companies divide them into three broad types: performance, narrative, conceptual; the postmodernists labour to classify clips according to their film language. But the surest guides to the different ways in which videos work are the *musical* labels involved – the industry has always been organized around 'taste publics', and videos give the various markets dramatic form.[34] The reason country music videos are interesting, for example, is, as Mark Fenster shows,[35] because of their use of a variety of styles to solve the same basic problem, the representation of 'simplicity and ordinariness'; for the music to 'crossover' from the country to the pop market the video has to crossover too, drawing on pop or rock iconography without undermining the essential country 'truth'. Crossover black music videos are similarly concerned with what blackness means for a white audience (and invariably feature dance, bodies dispersed in motion). The visual complexity of such clips reflects the subtlety of marketing rather than film-making techniques.

What videos of the various pop genres do have in common is a sense of star-power. The much-used (much-discussed), across-the-board, sexist images thus matter less in themselves than according to who is seen to be in their control. Lisa Lewis points out[36] that video selling has actually opened up new pop possibilities for female performers – not because they are immediately available as objects for the male gaze, but because selling women as stars means showing them in charge of their femininity (and its construction as a way of looking). Hence Madonna, of course, but think also of the video success of Cyndi Lauper, Tina Turner, Grace Jones, the Bangles, Bananarama, Kim Wilde (and even Samantha Fox).

Authority and control are also what pop is about musically – the song is the central pop form, the voice our way into what it means. We are used to hearing singers as 'authors' – the people in charge of the emotions; who actually wrote the song is, in this context, irrelevant (as is the question of whether singers speak 'from experience'). Pop fans have always understood the difference between the protagonist of a lyric and the singer (even though they are the same 'person', the same voice), which is why most videos are not, in fact, structured according to a song's most obvious 'meaning' – its lyrics. To focus on song words would be to subordinate singer-as-star to singer-as-lyrical-protagonist; the point of the video is to underline star control, to *distance* singer from song. Performers have to be seen to carry on beyond the immediate plot, and in most rock genres this means, despite all that 'dream imagery', showing them really perform – even Duran Duran had to be sold as musicians.

The 'authentic' musician is, in fact, just as elaborate a fiction as anything else on display. From an analytical point of view, video construction of the 'real' is more interesting (because more furtive) than the upfront shards of fantasy. It accounts, in particular, for what is most obvious about the pop video as an art form – its obsessive use of movie quotes. As Brian Eno once put it: "most video art is like someone

describing, not very well, a film they saw."[37] Film references are not just used for their own playful postmodern sake (and are not, or not always, simply a sign of cheap imaginations). They are, rather, a quick and easy way for musicians (and their audiences) to signal their knowingness about what is going on (another such device is the use of the TV screen itself within the visual narrative). By acting out an obvious Hollywood scenario, musicians indicate their own detachment from the fantasy, their identity with the fans seeing through it.[38] At the same time, Hollywood itself has long defined what real youth, real rock'n'rollers, look like – Elvis Presley, after all, modelled his look, his body language and his sexuality on the Hollywood version of fervid adolescence, on Marlon Brando and James Dean.

It is impossible, in short, to understand video imagery without reference to the *history* of rock on film and TV (and stage), to the shifting ways it has been signified from fifties to eighties 'youth' movies, fifties to eighties teen pin-ups, fifties to eighties live events. These images don't only explain the extraordinary sameness of pop videos beneath the glittering surfaces – genre by genre, performers look and behave just like each other – but also make clear that for all the postmodern celebration of videos' non-narrative non-realism, they usually do contain an implict narrative, a true story that we can fill in for ourselves. One consequence, as Greil Marcus notes in discussion of a Big Country clip, is that

> everything you see is second-hand, third-hand – received and reified. To highlight a solo, the singer leans on the guitar player's shoulders as the guitarist thrashes out the notes. Within all-male rock bands, this is a gesture so tired, so stereotyped, as to be no longer capable of signifying what it's supposed to signify: camaraderie, fraternity, solidarity, or just the delight of making physical contact. All the gesture signifies is that the guys in Big Country know what male rock stars are supposed to do on stage. They're not touching because they want to, because the music drove them together, or because a gesture of solidarity symbolizes peace, but because it's in the male-rock-performer script, and that's signification enough: the movement just says that these people are, in fact, rock stars. It walks like a duck, it talks like a duck, it must be a duck. The semiology is circular, but that's all there is to MTV semiology, the only course it can describe is a loop.[39]

Sound and Vision

But my purpose here is not to move from the mindless optimism of new wave academicism to the considered pessimism of old wave rock criticism, and I want to end with a different set of issues. I began this chapter with my surprise that so many people analyse pop videos as if they were not, among other things, musical events, and what is particularly odd about academic video work is its neglect of studies of the use of music in the cinema. The common-sense argument seems to be that

with soundtracks the image determines the music (and in most cases precedes it) – the scorer works to a sequence of images, the narrative which it is her/his task to enhance and comment on. With videos, by contrast, the music determines the image and the video-maker thus works to a sequence of sounds, a narrative of performance. The balance of the power of sound and image is thus quite different. Most videos are cut straightforwardly to the rhythm of the song, as defined by either its beat or melodic structure, and *montage* is the video-maker's basic tool simply because it is the visual equivalent of music built up out of studio sound layers.

The problem is that repetition does not have the same pleasure visually as aurally. The taken-for-granted 'rightness' of repeated harmonic tension and release does not have an obvious narrative equivalent, and recurring rhythm patterns do not translate easily into images – the TV version of a tape loop, an exactly repeated image, soon seems dull. The visual counterpart of the pleasure-of-the-same is, in fact, the pleasure-of-the-similar, and because the exact matching of images takes thought (it is an intellectual as well as a visceral exercise, it means decoding) most pop videos just seem a mess (are certainly duller quicker than most pop records). It is striking that the musicians who have best translated the *rhythmic* appeal of rock into video are musicians with links to performance art, with training in the drama of simplicity and restraint.

But there is another way of approaching the film-music/video-pop contrast: soundtrack writers use a shorthand of sound references, an economy of instrumental noises, melodic quotes and aural textures which can do instant narrative work without needing the attention that might distract us from the screen; video-makers use a shorthand of image references, an economy of photo-codes, movie fragments and televisual textures which can do instant narrative work without distracting us from the sound.[40] What this suggests is that despite the argument that videos deprive people of their freedom to imagine music for themselves, most videos are aesthetically banal because the visuals don't overwhelm the music. Rock music at least doesn't seem to have the necessary *density* to take on interesting or complex imagery. In order not to overwhelm it, video work has to be both obvious and thin (this was most apparent in the BBC's benighted attempt to make videos for 1960s hits).

On the back of Michael Nyman's LP *The Kiss* there's a recurring line: 'Images were introduced because many people cannot retain what they hear but they do remember if they see images.' This is a familiar argument, but it is wrong. We may describe sounds in terms of images, but we remember them because of their musical logic, their patterning as a 'good tune' or riff. Most musical 'images' work not as a direct link of sound and sight but as a set of resonances that come to us via other sounds. Music has always been bound up with imagery, whether the sight (or implied sight) of the performance itself – the act of music-making – or a network of emotional, geographical, and historical associations. And from this point of view, rock sounds have a

surprisingly limited range of meanings: precisely because of its youth
roots, its sociological overdetermination, on a film soundtrack rock
cannot do much but signify itself. This is another closed loop.[41]

All the evidence suggests, then, that music video is a marriage of
industrial (and audience) convenience rather than a match made in any
artistic heaven. Promotional clips took off because they were a highly
effective short-term solution to 1980s problems of selling records and
programming cable TV, but they do not hold much long-term promise as
a new (postmodern?) form of entertainment. This is partly for commercial
reasons, too: now that the rock and TV industries are used to living
together, there is more fun (and money) to be had from devising
entertainment services which use rock as the score but which are no
longer just a means to generate record sales. In ten years time, I am sure,
straight promo-video channels like MTV and Music Box will have ceased
to be. Even in their own youth terms it is already obvious that videos
cannot replace music. You can't dance to a TV set, you can't meet new
people by watching it, you can't set out with it to have something
unexpected happen. You can't even use it (whatever the sales success of
CDVs) as a mobile soundscape, a context, a jukebox, a noise – which is
why video will not replace radio, either.[42]

I should clarify what I'm saying here: firstly, that music video is not
going to replace existing pop processes and pleasures – it is already taken
for granted as just another way of selling records, another means of
musical enjoyment, to be integrated with all the others; secondly, that
whatever the continuing importance of clips to selling goods (the
industry now assumes that CDVs will have a significant domestic
market), they will no longer define either the commercial or the aesthetic
value of music video. The association of video art with TV pop
packaging is, in short, a passing circumstance. But it has, as Peter Gabriel
suggested, so far limited discussions of what music video could be –
something which need have nothing to do with rock or youth (or even
TV) at all. What the technology actually makes possible is the
simultaneous recording of sound and image, and this is the paradox of its
use in record-selling: a tool which enables us to give an account of events
– sound events – *in the making* is predominantly used to wrap up
finished goods.[43] The postmodernists have got things wrong even in their
understanding of the avant-garde. They celebrate disruption based on
montage and deconstruction, the old radical film terms, meanings
unpicked. But the real video frontier lies where there is no finished
product or idea to start with, where complexity lies in unfolding things
from within, where dub artists strive for a sound they cannot quite reach.
In this increasingly electronic setting, the sound units to which images
attach need have no human source at all. Video itself will be the
humanizer, making personal, emotional sense of – *noise*.

Notes

1 This paper is based on my Baird Lecture, Facing The Music, delivered in the Glasgow Film Theatre, May 29 1987. Many of its ideas were changed or refined by the subsequent John Logie Baird Centre seminar and I am especially grateful for suggestions and criticism to John Preston, Dave Laing, Claudia Gorbman, Jon Savage, Alan Durant, Sally Potter and Georgie Born. Many thanks, too, to Larry Grossberg and Andrew Goodwin for their sharp and helpful comments on an earlier draft.

2 Editorial in *Journal of Communication Inquiry* 10, 1 (1986).

3 John Fiske, 'MTV: Post Structural Post Modern', *Journal of Communication Inquiry* 10, 1 (1986) p. 75.

4 See E. Ann Kaplan, *Rocking Around the Clock* (Methuen, London, 1987). My own argument here is taken from Simon Frith and Howard Horne, *Art into Pop* (Methuen, London, 1987), chapter 1.

5 Jody Berland, 'Sound, image and the media', *Parachute*, 41 (1986), p. 17.

6 Pat Aufderheide, 'The Look of the Sound' in *Watching TV*, ed. Todd Gitlin (Pantheon, New York, 1987), pp. 133–4.

7 See Colin MacCabe, 'Theory and film: principles of realism and pleasure', reprinted in his *Theoretical Essays: Film, Linguistics, Literature* (Manchester University Press, Manchester, 1985); and David Ehrenstein and Bill Reed, *Rock on Film* (Virgin Books, London, 1982), p. 108.

8 For an example of such naivete see Mary Ellen Browne and John Fiske, 'Romancing the rock: romance and representation in popular music videos', *OneTwoThreeFour*, 5 (1987). They compare Madonna's song-and-dance routine in the 'Material Girl' video with Marilyn Monroe's 'Diamonds are a Girl's Best Friend' in *Gentlemen Prefer Blondes*. 'The two songs,' they assert, citing the lyrics in each case, 'are basically similar.' The differences are 'differences of tone'. Anyone who can hear a 1980s disco hit as 'basically similar' to a 1950s theatre song is obviously deaf. Alas, it has been the deaf who have so far dominated pop video theory.

9 The best research on the young video audience has been done by the Media Panel at Lund and Vaxjo Universities in Sweden. See, for example, Keith Roe, *Video and Youth: new patterns of media use* (Report 18, Lund 1981), and *The influence of video technology in adolescence* (Report 27, Lund 1983). The Media Panel's project (to follow adolescent use of TV over time and place it in its everyday social context) is rather more fruitful than US-based social psychological attempts to measure the 'effects' of a TV clip on teenage 'attitudes' in a laboratory setting – see, for example, Reed Larson and Robert Kubey, 'Television and Music. Contrasting media in adolescent life', *Youth and Society*, 15, 1 (1983). Though this research challenges the more simple-minded moral-influence models of the right, it does not really get at the social organization of media meanings. Roe's team, for example, found that rather than heavy video-use leading to school failure, poor discipline, violence, sexual aggression, etc., it was school and peer-group failure which led to heavy video-use. Regular viewing of 'nasties' thus reflected boys' *prior* investment in a culture of semi-delinquent 'toughness'.

10 See Paul Attallah, 'Music Television', in *Working Papers in Communications* (McGill University, Montreal, 1987).

11 Warners were already familiar with youth-market TV-use through their tie-up with Atari and their (brief) domination of the computer games market. The company had also conducted more systematic research into the home-

taping problem and its leisure implications than any of its rivals, and had long been seeking to have a more influential role in the world record market (through its abortive deal with Polygram, for example). MTV reflected fairly precisely Warners' particular music industry expertise and ambition.

12 Subscription figures are not the same as viewing figures (it is the relatively poor viewing figures which have so far discouraged advertisers from buying space on Sky and Super Channel) and so MTV's precise 'success' remains a matter of some debate. Matters are further complicated by the speed with which cable companies change ownership (or with which their owners change corporate name) – MTV-America is presently owned by Viacom International; its European version is being launched by Robert Maxwell and British Telecom. Sky is majority-owned by Rupert Murdoch, Music Box by Richard Branson and Super Channel by a British television company consortium (though all this may be out of date on publication). For basic information on the industry see Michael Shore, *The Rolling Stone Book of Rock Video* (Quill, New York, 1984); Mark Hustwitt, *Sure Feels Like Heaven To me*: Considerations on promotional videos (IASPM (UK), Working Paper 6, 1985); Dave Laing, 'Music video: industrial product, cultural form', *Screen* 26, 2 (1985); David Marshall, 'La Musique Video: Un marriage de convenance entre la television et la musique populaire', *Communication*, 8, 2 (1986); Maria Viera, 'The Institutionalisation of Music Video', *OneTwoThreeFour*, 5 (1987).

13 In Canada, Much Music is, in fact, operated by Chum Limited of Toronto, the largest private pop and rock radio chain, chosen by CBC as thus the most suitable operator of a new TV channel. In Europe a service like Music Box is immediately reminiscent of Radio Luxembourg – an English-language programme beamed from and across the Continent, confusing advertisement and entertainment in ways that are still illicit on national British TV. Sky's music service, Sky Trax, even puts out its own pop magazine, *Sky*, an upmarket teen echo of Luxembourg's successful 1970s publication, *Fab 208*. Like Luxembourg too, these stations raise questions about national cultures – is there any distinction left between French pop, Belgian pop, Dutch pop, Swedish pop, (Canadian pop), and Anglo-American pop? Several governments have sought to protect their local industry and/or sounds from the satellites' incursions. Both Finland and Canada, for example, take a levy from the satellites' advertising income to fund local video manufacture; Holland requires that a percentage of the videos screened on Music Box be Dutch. What is less clear is that the 'pan-European' (or pan-American) viewer notices any national difference between one video and the next.

14 Quoted in *Q*, February 1987, p. 40.

15 Quoted in Jon Savage, 'Latched onto the Loop', *Observer* 16.8.87.

16 There was some irony in this situation. Australia had a supply of videos or, rather, a supply of video-makers (like Russell Mulcahy) because of the importance of TV for showing and selling American and British rock bands who rarely toured so far from home. To compete, Australian musicians had to produce their own videos too. Britain was already into video promotion because of the importance of TV as the national sales alternative to Radio 1 – there was a well established tradition of TV promotion (by packagers like K. Tel – TV-sold albums have dominated the British charts for years) and a captive youth video market on the Saturday morning children's and young teenagers' shows (videos aimed at this audience turned out to be particularly suitable for MTV). It remains a pleasing paradox that Britain is still the most

important pop video source while having the least opportunities for anyone to watch them, and that a British singer like Eddy Huntington can become a teen idol in Germany, the Benelux countries, Italy and Portugal without anyone in England ever having heard of him.

17 MTV is thus blamed for declining recording opportunities – the number of acts on CBS, for example, dropped during 1980–5 from 375 to 200.

18 See Andrew Goodwin, 'From anarchy to chromakey: music, media, video', *OneTwoThreeFour*, 5 (1987).

19 See Will Straw, 'The contexts of music video: popular music and post-modernism in the 1980s', *Working Papers in Communication* (McGill University, Montreal, 1987).

20 Chet Flippo, 'MTV – the American Revolution', *Q* (February 1987), p. 43, MTV's response to this situation was to tighten its market identity (as a station aimed at suburban white male teens) by narrowing its playlist, employing new (white male), video jockeys, speeding up clip turnover, and putting on numerous 'special' events – reacting, in other words, just like a radio station. By the summer of 1987 the policy seemed successful in terms of both audience figures and record-selling power, but as a commercial rock outlet MTV no longer much resembles the service described by the postmodernists – it no longer has a continuous flow, it does have a sense of rock's past, its imagery is dominated by performance clips. See Barry Walters, 'MTV Lives', *Village Voice*, 2.6.87.

21 To give some idea of the figures involved: the BBC paid £150,000/year for a licence to show pop videos in 1986, Music Box £75,000 + 9% of advertising revenue, Sky Trax £50,000 + a percentage based on the number of subscribers. Video Performers Ltd (the collecting agency on behalf of the video rights-holders) has also negotiated rates for the one-off showing of clips, which vary from £120/4 minutes in Austria to £400 in France, with most countries paying something in between. American figures are less easy to come by, but MTV has 'exclusive' deals with all the majors (CBS, RCA, WEA, MCA, Polygram) and some smaller labels like Geffen. In return for a 'substantial' payment, it can select up to 20% of new releases for exclusive 3–6 week showings. Otherwise the usually cited figure is £800 per network clip, £125 per showing on cable.

22 Most record companies now have a separate video production and licensing division but, on the whole, it has been the smaller, 'independent' rock labels that have made the video running. Island, Chrysalis (who make Max Headroom) and Geffen have all moved into film and television production and distribution with considerable success, and Virgin, in addition, is now centrally involved in the European satellite business not just through Music Box but in its financial holdings and managerial involvement in Super Channel and British Satellite Broadcasting.

23 Quoted in Flippo, 'MTV – American Revolution', p. 40.

24 There is now a flourishing video underground, collectors with hours of the Beatles, Presley, Stones, Pistols, taped from every TV appearance they ever made. As Bruce Eder comments: 'At some point, the serious collector enters into a Twilight Zone of his own device. How else can you describe watching "The Beverly Hillbillies" to tape the Enemies (a mid – '60s garage-punk outfit) doing "Got My Mojo Workin' " for Jethro and Miss Jane, catching Sky Saxon and the Seeds in the "Mothers-in-Law' episode "How Not To Manage A Rock Group", or the Dillards as the "Darling family" on "Andy Griffiths"? For me, the thrill is in the recovery of lost moments: it's watching

the Standells and the Chocolate Watch Band in "Riot on Sunset Strip", or Neil Young at his eeriest and best on "The Smothers Brothers Comedy Hour". (Bruce Eder, 'The music video underground', *Village Voice*, February 24 1987, pp. 35–6.)

25 See Attallah, 'Music Television'.

26 See, for example, Michael Boodro, 'Rock Videos: Another World', *ZG* Breakdown issue, (nd).

27 And so, for example, 1987 marked the death of the last classic British youth club show, 'The Tube', which could no longer provide a sense of community any different from that anywhere else on TV. The pressing problem for British TV companies now is to attract the 16–34-year-old viewers who the advertisers most want. Music shows are still taken to be the necessary draw but so far the new examples – 'The Roxy', a chart show, and the weekend 'Night Network' – seem an uneasy mix of old-fashion teen fervour and cooler 'life-style' consumerism.

28 Jon Savage, 'Pop Video', *The Rock Yearbook 1981*, Al Clark ed. (Virgin Books, London, 1980).

29 Quoted in *Videofile*, May 1984, p. 9.

30 See, for example, Marsha Kinder, 'Music video and the spectator', *Film Quarterly*, 38, 1 (1984); Deborah E. Holdstein 'Music video: messages and structure', *Jump/Cut*, 29 (1984); Aufderheide, 'The Look of the Sound'; and Hustwitt, 'Sure Feels Like Heaven To Me'. Larry Grossberg has noted a similar shift in the aesthetic of sport on TV – many of the techniques used to turn it into a star-centred sponsored spectacle in the 1970s were gleefully appropriated by pop video-makers in the 1980s.

31 For the continuity between still and video 'corporate imagery' see Boodro, 'Rock Videos: Another World'. The video that made a-ha's reputation, the band coming to life from the pages of a comic romance, echoed the way, the group Japan first became successful, by packaging themselves to look like the models in Japanese young women's comics – their initial success was in Japan.

32 See Andrew Lipman, 'Mud in your video royality', *Guardian*, June 24 1985. French copyright law does now treat directors of audio-visual works as their 'co-authors'. The most systematic attempt to define video *auteurs* is Shore, *The Rolling Stone Book of Rock Video*.

33 See Straw, 'The contexts of music video.'

34 E. Ann Kaplan (*Rocking Around the Clock*) does try to relate her visual classification – romantic, modernist, postmodernist – to musical styles – soft rock, art rock, punk, new wave and heavy metal – but in doing so reveals her misunderstanding of pop genres.

35 See Mark Fenster, 'Country Music Videos: Development, Maturity and Crossover', *Popular Music* 7 (3), 1988; and Kobena Mercer, 'Monster metaphors: notes on Michael Jackson's ' "Thriller" ', *Screen*, 27, 1 (1986).

36 Lisa A. Lewis, 'Form and Female Authorship in Music Video', *Journal of Communication Inquiry* (1987).

37 Quoted in *Artforum*, 24, 10 (Summer 1986), p. 79.

38 Ralph Willett's UK research for the IASPM 'Warm Kiss' project found that teenagers discussed video imagery almost exclusively with reference to films or other videos.

39 Greil Marcus, 'Speaker to Speaker' *Artforum* (January 1987), p. 12. And see his 'Rock Films' in *The Rolling Stone Illustrated History of Rock & Roll*, ed. Jim Miller (Random House, New York, 1980).

40 For an example of what happens when a film is scored with video principles, see the Giorgio Moroder version of Fritz Lang's *Metropolis* in which the music clearly is too much for the images.

41 See Simon Frith, 'Mood Music', *Screen*, 25, 3 (1984); and Claudia Gorbman, 'Narrative Film Music', *Yale French Studies*, 60 (1980).

42 Consider this press release about the VJ Videodisc Jukebox: 'Jukeboxes are still very popular and what is more natural than to convert to a video disc jukebox. Record Companies put a lot of creative effort into making stunning promotional videos which may get just one or two plays on TV.' The interesting word here is 'natural' – what could be more unnatural than to watch a jukebox while drinking, dancing, chatting!

43 My argument here is partly taken from Ian Penman, 'Scratch the Surface', *New Statesman*, May 22 1987. One problem he and other good video writers like Andrew Goodwin have pointed to is the absence of an appropriate *language* for music video criticism, which is why it is still treated in the inadequate terms of film theory, on the one hand, and rock ideology, on the other.

Name Index